BOLSHEVISM IN ART

Christopher Middleton

BOLSHEVISM IN ART,

and other expository writings

Carcanet New Press / Manchester

Acknowledgements

Some of these essays have appeared in the following magazines and periodicals, to whose editors acknowledgement is made: *Agenda, Arion, Delos, German Life and Letters, Germanic Review, Liberté* (French version of the talk in Part 2), *Publications of the English Goethe Society, Revue de langues vivantes, Texas Studies in Literature and Language, The Times Literary Supplement*.

The studies on mountain symbolism and on primitivism appeared respectively in *Literary Symbolism: A Symposium*, edited by Helmut Rehder, Austin, University of Texas Press, 1965, and in *The Discontinuous Tradition: Studies in German Literature in Honour of Ernest Ludwig Stahl*, edited by P. F. Ganz, Oxford, the Clarendon Press, 1970.

SBN 85635 155 5

First published in 1978 by
Carcanet New Press Limited
330 Corn Exchange, Manchester 4

The publisher acknowledges the financial assistance of the Arts Council of Great Britain.

Printed in Great Britain.

CONTENTS

INTRODUCTION

1

THIS IS not a book of essays in the proper sense. There is no explicit theme to which an argument is addressed. All the same, a broad unity of concern does connect some of these writings, regardless of the section they happen to be in. In this introduction I hope to show how such connections may be discerned. The reader will also notice that these writings are of several kinds. Some are scholarly studies, but others are more like workshop talks; elsewhere a series of fragments appears, and there is a 'position paper', if the 'Letter' in Part 2 can be read as such.

Many of these studies first appeared under the name of J. C. Middleton, a shadowy London Germanist of the later 1950s and the 1960s. I wrote them because I was curious about quite specific authors, texts and topics, for their own sakes. My curiosity was aroused most often by matters hitherto ignored or believed marginal, sequestered in scarce books or abstruse old magazines. The learning I could muster fell short of that strict passion for system and completeness which is the mark of the trueblue scholar. I also tended to be expository, rather than critical; I was trying to establish facts, to rescue things from oblivion, and theoretical considerations were implied, rather than explicit—a sort of penumbra.

2

To some of these theoretical implications I shall be attending in a moment. First, a practical consideration regarding the Dada studies in Part 1. They were written over a period of about eight years, and they arose from a desire to investigate an attractive field of fairly recent intellectual and artistic life—to figure out what really did happen. Part of the attraction, at that time, was the scarcity of original texts and commentaries. Nowadays there are scores of reprints and monographs. Yet it is unfortunate that the authors of some monographs should still be careless as to numerous facts. Manuel Grossman's book of 1971 is a case in point. Even Hans Richter's important book on Dada is not free from some erratic dating, misquotation and so forth. The studies I wrote are now part of the history of recent retrospect on Dada, so I have not edited or updated them, let alone recast them as a single essay. Nor have I removed one or two slight

overlappings. The patchwork effect has co-ordinates within the subject itself. Subsequent research has enlargéd the picture offered, adding a host of nuances; but to my knowledge it has not changed that picture, even though certain more or less tacit socio-political components of Zürich Dada might merit more investigation.

As for theoretical implications, the study of Dada and politics (1962) ends with a reference to Dostoevsky which might be developed in such a way as to show how Dada enacted, or reflected, some curious tremors in cultural morphology. What I have in mind is the cross-cultural faceting of Dada. On the one hand, Dada is in spirit akin to the Yoruba trickster god, Eshu Eleğba, maker of dangerous mischief, bringer of salutory chaos ('liminoid situations'). In its pursuit of the sublime—of which Expressionism has curious tales to tell—modern Europe had suppressed such gods as Eshu. After Alfred Jarry, the time was ripe for the invention of a new one, and that was Dada—'a quantity of life in transparent, effortless, giratory transformation' (Tzara). On the other hand, quite apart from this African tangent, Dada has more than a touch of Leon Chestov's prophetic and existential anti-rationalism, which has Ukrainian, Nietzschean and Judaic elements. Dada and Chestov no doubt ignored one another, empirically speaking. Yet the former does seem to cling, like a fierce sprite, to Chestov's coat-tails, as the philosopher lambasts the idolatries of rationalist thinking, and reveals not only perturbing truths of paradox but also his own quizzical Hasidic joy in concrete human infinitesimals. In regard to Socrates, Chestov (flourishing in the same period as Dada) wrote:

> In the field of metaphysics, there are neither cooks nor carpenters, neither their 'good' nor 'bad'. There rules the daemon of whom we are not even entitled to assume that he is interested in any 'norm' at all. Norms arose among the cooks and were created for cooks. What need is there to transfer all this *empiria* thither whither we flee to escape *empiria*? ... The whole art of philosophy should be directed [. . .] to finding that frontier
> beyond which the might of general ideas ceases. (1)

These words might have come straight out of Hugo Ball's diary for June 1916, when he was formulating what Dada had by then come to mean.

The later study of Primitivism (1970) has conclusions which might seem to be pointing toward a withdrawal of revolt into

'purely aesthetic' domains. To those conclusions I would now be tempted to give a more challenging accent, especially after reading Frank Kermode's *The Sense of an Ending*. Kermode seldom touches on matters external to his Anglo-American field, but it is just this limitation that injects a bland note into his eloquence. Outside his field, there were some concerns that relate to the questions he was raising, but there were also others. To start with, the notion of radical change in social and cultural patterns preoccupies many artists and revolutionaries during the early modernist period in Europe (1905-14). That is self-evident. But the notion itself was a mass of variables, and the motives of revolt, rarely unambiguous among artists and writers at the best of times, were either shattered or abused, once revolution and counter-revolution took possession of the social scene (as in the U.S.S.R. and Germany). There exists an authentic poetry of revolt. The authenticity of the poetry of revolution is, however, thrown in doubt by the dogmas and horrors perpetrated by revolutionary authoritarianism. One has only to think of the way in which the carpet was snatched from under Mayakovski's feet. Next, as signals of revolt, works of art can be agents of social transformation; and they can also be misinterpreted. Here lies the difficulty. The monsters brought forth by the sleep of reason, in Goya's phrase, do not only appear in city streets, in torture chambers and jungles, and at conference tables. In all sorts of ways, modern artists deserve the *conscience malheureuse* that they have got. On the other hand, it is rank fetishism to suppose that any but false works, the pseudoforms of art or of anti-art, poetry or anti-poetry, were actually pernicious, or that somehow they connived in the degradation of human beings during the first half of this century. The connivers were people (and still are), people who for reasons of their own failed to think and act otherwise. Even with regard to the false works, simulacra of sleep or of boredom, not to mention the non-art of more or less witting propaganda, opportunism, compromise, fear, pernicious as they were, these represent a mere fraction of the whole stupefying farrago of word-noise and picture which framed the evils of the time. The responsibilities laid on the conscience of the modern artist or writer are very delicate indeed. Many and subtle are the ways in which art and political attitudes impinge on one another. Now my point is that scholars who care for the study of the early modernist period should not varnish or talk around, or pretend to tame, the irreducible

complex extremes to which that period's dangerous genius penetrated (relative to norms then obtaining). This is no obvious task. Extremism has become normal; the heroes, martyred or not, have become history. Chestov's frontier has been horribly snarled by people whose motive is profit, using money to manipulate human values. Or that frontier has been rolled up and tucked away by the safe-players and constraint-worshippers who control the hatcheries of academic criticism. Enlightened as those academics may be, supreme as their 'fictions of concord' may be, their historicizing does tend to wink at the living moment of revolt, and to dull the mystery of the new.

The workings of primitivism, in retrospect, would be more finely nuanced if the study in question included some remarks on Tristan Tzara's poem 'Maison Flake'. This text dislocates French semantic and syntactical norms in a way that differs from, say, Arp's German dislocations. As a text which keeps knocking against the limits of comprehension, it is a good model of the primitivizing methods of the time. What happens in the poem is a structuring of a flow of subliminal perceptions, in the form of elegant zigzags whipping between polar images, points of crystallization—'variable succession formulated in the instant', as Tzara wrote of poetry in 1919. Poetry here has become, even more radically than in Apollinaire, an activity, not a deposit, of *esprit*, the ecstasy itself, not its aftermath. In his book *The Illusion*, David Caute questions this whole matter in his incisive way, and comments (without reference to Tzara): 'One of the most fertile features of modernist writing has been its attempt to capture by means of language the red-hot moment of preverbal experience, the moment before the "I" is aware of itself as the subject of perception or feeling'. (2)

3

The second part of the book consists of miscellaneous studies. The one on Robert Walser (1958) stands as it first appeared, although much more is now known about Walser's life and writings. The biographical gaps have been filled (see the biographical appendix to the study), thanks initially to the work of Jochen Greven, Jörg Schäfer and others, and then to Robert Mächler's biography (1966). During the last ten years one American, one English and numerous German monographs on Walser have appeared. Some of these, to my thinking, belabour Walser without responding to his spirit. My own—quite preliminary—

study, warts and all, shows at least how one enthralled reader (not a wary doctoral candidate) was responding before Walser's star began to rise. He is now regarded by some writers as one of the most important prose artists of the age, notably by his namesake Martin Walser. To the reader who knows no German but finds these remarks interesting, I recommend my translation of the novel *Jakob von Gunten* (1970), which includes an introduction. (3)

The 'Fragments on Metamorphosis and Tangents' hardly belong within the Germanistic framework, and that is no bad thing. The reader will find that they do relate diversely and deviously to matters in other writings. Certainly there are links between the thoughts on metamorphosis, participation and dream objects, and the thoughts on relations between sound and meaning in the articles on Rilke and Mörike. I would have liked this part of the book to be much more diverse and impudent than it is. Two more studies were projected, but have never been tackled: 'The Hermetic Geometry of Giorgione's *La Tempesta*', and 'William Law's Prose and the Metric of the Vermilion Flycatcher's Song'. Such topics fascinate, but frighten me whenever I consider the two volumes of Matila Ghyka's *Le nombre d'or* (1931), on the Pythagorean rites and rhythms in the development of western civilization. Beside the polymathy and connoisseurship of that work, my own kinds of investigation into structure (in Parts 3 and 4) are mere beginnings.

So far, then, the writings in Parts 1 and 2 comprise several views of a phenomenon which, although it does have an historical frame, did vary in character from place to place, and may crop up at almost any time when norms become oppressive and intelligent life is feeling stifled. That was Dada, which, to be sure, was in its time a jackdaw, adding to its own central concern with the aesthetics of chance, various goods borrowed from movements of kindred spirit, such as Cubism and Italian Futurism (Tzara was competing with Marinetti, Ball was for a time an nth degree Nietzschean revolutionary dandy). Two further elements in these parts of the book are the thumbnail sketch of Franz Jung and the 'Picture of Nobody', Robert Walser. Both of these men were lone eccentrics, both were badly ravaged by the fight for independent creative life. In Part 3 there begins a kind of descent, from the ongoing scintillations of the modern, down toward questions of poetics which involve deep deposits in the strata of language and the psyche as transformers of history.

4

I have placed the article on translating a text by Franz Mon first
in Part 3. Here one can see a difficult interval opening between
an older poetics of congruity and a new poetics of chance, dis-
location, non-comprehension. Or it is a contest between two no-
tional models of reality in language: 'harmonia mundi' and 'the
majesty of the absurd' (in Paul Celan's striking phrase). The
studies of Rilke and Mörike were attempts to think about har-
monic parallelism of sound and meaning without too much
technical or impressionistic phraseology (I am neither a phoneti-
cian nor a technical linguist). These poems are certainly open to
different readings. Professor Robert Browning once castigated
the Mörike discussion for being merely impressionistic, but I
think he had not grasped what I was talking about. Variant in-
terpretations of this poem can co-exist; but the sound-meaning
nexus, even if it cannot be formulated in absolute terms, is not
a matter of choice. (4)

My subsequent thoughts on sound (including rhythm) are not
orthodox. I believe that in some poems parallelism, or better,
interanimation, between sound and meaning (iconic types of
utterance is what I was calling them when I wrote the Mörike
study), hark back to very ancient linguistic behaviour, still to
be found in some aboriginal chants (even today in crazy im-
promptu sayings exchanged between lovers). This kind of
speech-event may never occur in some languages. Yet the possi-
bility of it exists in many European languages to this day, as
one kind of poetic possibility. Such forms may have arisen
during a participatory phase in the evolution of human con-
sciousness, which Owen Barfield has explored in his book
Saving the Appearances. (5) What we call phenomena were not
in that phase alien externals at all. They were presences, and
sensation brought them into the midst of mind, or it brought
mind into the midst of them. It should be realized, too, that
Barfield is not merely attempting to rehabilitate Lévy-Brühl;
and that I am not arguing that 'participation', or some such ap-
titude, offers a new theory applicable to all western literature.

The transmutation of nature into mind may be a chemistry
vastly complicated by environmental controls. None the less, at
some stage in the evolutionary dynamic, that chemistry was
precognitive, becoming problematic, in the field of aesthetics,
only through inversion, a typically creative inversion—the doc-
trine of mimesis. In the frame of reference I am suggesting,

Aristotle's hints should be coupled with zoological studies of mimicry, like H. E. Hinton's essay 'Natural Deception', (6) with Loren Eiseley's careful insistence on the creative mind's being 'indigenous and integral to nature itself in its unfolding', (7) and with J. Z. Young's neurological concept of 'disinhibition'.

Even in the Middle Ages, Barfield argues, it was still possible for a person to consider the world as a 'garment' which he could wrap around himself. I would suppose that the sound-meaning nexus of such poems as those I was exploring, marks a survival of a tradition of the sacred word, of the word which initiates being. This tradition empowered the poet (as shaman, in certain social contexts) to make utterances from that 'centre' in which what we call soul and world are felt to be magically homogenous. Arthur Waley's *The Nine Songs* shows how the phases of spirit-possession actually worked out—with the public presentation of the 'spirit' usually, or often, occurring not as language, but as music and dance. (Some shamans also mumble with their spirits: language need not be communication between people.) Quite apart from the archaeological allure of such reconstructions as Barfield's, there is ample evidence in the work of modern poets as divergent as Yeats, Mandelstam, Lorca and Khlebnikov, that this tradition remains fundamental. A poem with this kind of magical centredness transmits, live, older or perennial forms of linguistic behaviour into a present in which people have become puzzled, if not dumbfounded, by the blank obstruction of the world, by all the clichés, and by the arbitrary nature of the sign. 'Lapping up a word,' writes Oswald Wiener, 'I get the feeling that my mind just doesn't exist for the world.' (8)

The 'Letter' in Part 2 is relevant here, for one of the major social disasters in the U.S.A. during recent years has been the withering effect of behaviourist thinking on 'language attitudes'. The stain coming from behaviouristic ideology has even spread so far that would-be poets talk of language as a 'tool' for 'self'-expression, as if language, like the opaque wall of phenomena, were something irretrievably 'out there'—as indeed it might seem to be in the twisted perspective of instrumental thinking. Meanwhile there are young people who choose, with or without willing to do so, not to feel at all, rather than be blasted by meaningless impressions or told what to feel. At the other extreme, there is the ill-founded 'groupy' notion that 'primal experience' can be directly expressed in the usual hackneyed phrases, or that it must be, for therapeutic reasons. Such

delusions wrought by ideology give cause for alarm. They rule out (or actually obliterate) the human faculty for initiating language. Such delusions lie close to the actual evils brought on by ideology—in this area not so much those of the prison state, as mapped by Solzhenitsyn, but certainly those of mind-manipulation, soul-amputation and mass-deception.

I shall mention only in passing the relation between the imagery of the circle in Mörike's poem and the archetypal imagery of mountain and cosmic centre, discussed in the article on Novalis. The problem of extremes in modernism is also pertinent here: at certain points we watch the extremes in question reaching beyond boundaries, toward centres that are not 'normally' explored.

<div align="center">5</div>

Roman Jakobson has written of the 'poetic function' in language as that which 'deepens the fundamental dichotomy of signs and objects.' (9) In general terms of the world-view of 'original participation', as presented by Barfield, Jakobson's position does not contradict the idea of the significance of sound in the context of language-initiation, as sketched above. The 'object' which is animated into poetry of this kind, brought across, and thus given a changed function in the field of perception, becomes in the poetic structure a new kind of object. It is not a thing, independent of consciousness: such things cannot enter language at all. It is also not merely a conventional representation of an object. It is a sign which creates, with other signs, in a consortium, the sense of the relational system intrinsic to the poem as language. The sign, fraught with the intangibility of life itself, is set free by the poetic system it occupies. Thus the new form is at variance with, or it 'objects' to, what normally goes for things and words. But one might also say, as to this objecting variance, that a creation comes to light, a creation which is language, and that it rises from a level of linguistic possibility till then held in abeyance by the prevailing set of linguistic habits. Till then, most people had been prevented, by habit, from even faintly conceiving of that kind of language, that kind of *reality* as language. The variance may be slight, but, if it is true, if it fulgurates with truth, then a new sensibility has entered the evolutionary dynamic, rising up, under unthinkable pressure, from the depths. There is a statement by Osip Mandelstam which may be read as saying as much: 'The word is Psycheia. The living

word does not denote an object, but as though taking up resi-
dence in it, freely chooses some objective meaning or other, a
thing in all its concreteness, a nice body to inhabit.' (10)

If you study the grammar of a poem by Brecht—and 'Schlechte
Zcit für Lyrik' (c. 1936) is a fair example—you can see the same
principle of transformation at work. For Brecht, true, language
was no longer sacred, but positively secular, as Walter Benjamin
pointed out in connection with his theory of 'lost aura'. In
Brecht's poems after 1933, it is grammar rather than sound
which works the transformation and carries the poem's intrinsic
semantic design. He cut down on the sound, what is more, in
order to eliminate enchantment, and to goad readers or listeners
into thinking and action. Brecht may have broken with the tra-
dition of the sacred word. His context was revolution, not re-
demption. And still (or for that reason) his craftsmanship shows
precisely in terms of grammar what Barfield calls a 'directionally
creator' relation to phenomena and to the word. Mörike and
Rilke with sound, Brecht with grammar—all three in their differ-
ing ways do what Keats did with the sparrow: 'If a sparrow
come before my window, I take part in its existence and pick
about the gravel.' (11)

I would like my reader (you too, Elizabeth, who are going
into medicine and giving up literature) to link this notion of
creative participation with the sketch of the children who imi-
tate the lovemakers in the last of the fragments on metamor-
phosis. Pass then in mind to those rooms in the National Museum
in Athens, where archaic Greek figures in bronze and alabaster
are housed. These figures do not 'duplicate' what they repre-
sent. They are realities, *sui generis*. The formal genius of ancient
artisans enabled them to dwell inside 'objects' and afterward to
return to themselves, making or having made, as the poet, like
Mandelstam, makes with his voice, what he has dwelt in, or
what he had for a time actually become. That kind of 'esem-
plastic' power, which signifies experience itself and may leave
no other message, would require of some contemporaries,
staring at the phenomena 'out there' as if they were fixed and
impenetrable ultimates, a violent turning away from what Bar-
field calls their 'idolatry', and from what Chestov called 'the
seductions of reason'.

Part 3 ends with two informal statements about poems of my
own, both of which were invited. The first of these is a slightly
edited version of a talk given to students in 1965. I include

these pieces for their bearing on questions about the making of poems, questions which matter in this book.

<div align="center">6</div>

The four studies in Part 4 have to do, in one way or another, with symbolism or with myth. My approach here was altogether pre-structuralist; but I hope that the findings are not without truth and interest. I should point out that the two Hesse pieces date back to 1953, when I was writing a dissertation in Zürich; also that the piece on mountains was written in 1963, and not published until 1965. My main concern with Hesse was to ask how the figuration of his narratives is actually composed. A highly subjective symbolism, the fiction as differentiated monologue, with certain traditional ingredients, seemed to be the case (I was tracing his roots back through the Pietism of eighteenth-century Swabia, to the temperate subjectivism of Renaissance Humanists). It is also the case that when André Gide visited Hesse in Montagnola in about 1947, these two grand old egoists passed the time talking about cats. The recent craze for Hesse has had far more to do with his relaxing mysticism than with his passion for the real creatures, vulnerable in nature, or in humanity made opaque by the obdurate ego. That opacity is a matter he keeps coming back to, seldom without idealist premises (and escape-routes). It is a condition of despair, which renders personality incapable of transformation. It is a sort of eternally recurrent cultural insanity, a blockage in the lines down which a 'higher' energy should flow, to irradiate the human scene.

The study on two mountain scenes in Novalis was actually a byproduct of an immense work, now abandoned, on the cosmic mountain archetype from Sumer to the present. Hence the mass of footnotes. Once more the accent falls on a kind of archaeology of the creative mind, reaching now further back than the studies on Rilke and Mörike. The shafts sunk into the Sumerian and Assyrian cosmological views, into the medieval underworld, and into Novalis' own fabulous Thuringian landscape, present other aspects of the semiotic system of an ancient participatory consciousness.

The subsidence of the participatory universe, as Kafka's fictions were the first to show, probably destroyed the old spiritual foundation of symbolic thinking and imagining. History's ravages have, at least, modified that foundation in unconscionable ways. A glimpse of the difference may still come to us,

through certain works of art, certain heartbreaks too. Or is the whole conception a colossal projection of hindsight? The so-called original participation may have been the most decisive given of prehistoric or protohistoric man. Or else it was and remains a supreme, voluntary fiction. Either way, we seem now to know of it as a form of loss, or of resistance, which provokes a creative response now and then, because it is intrinsic to the actual workings of human perception and of imagination in the here and now.

Yet we are in the midst of a great death of imagination. I put this briefly and militantly. Young people are growing into old people within highly organized systems of ignorance. They find or lose themselves in a world of impenetrable obstacles, a clotted and contrived world. Old words, like 'Byzantium', connote for them only new or future obstacles, which no present revolutionary ideology or revised phraseology can render translucent as a field for real action, real projections. How in the present context can we respond to this suffocating situation?

One obvious response might be formulated as follows, even though it is subject to highly individual variations. There is the task of identifying and exposing (or exploding) all the poisonous *husks* of the participatory universe, namely authoritarian mystiques, in whatever disguise. It is those mystiques that choke the life-currents. In the field of action this means: reversal of present economic priorities, destruction of the profit-motive as a way of life. There is another task also: the task of renewing aesthetic sensibility, through new models of order, so that difference will shine for all the world through congruity, as the vital gist of coherence. One extreme model of the latter still is the kind of artwork projected by Marcel Duchamp, in which no two successive memory-imprints resemble one another. The poetic reality is, after all, a reality of first things, of the fresh roots of mind, the well-being of earth, the springtime of our suffering and passionate species.

7

So much by way of a proposal that these various writings have links and implications. The terms are broad, arguable and rather redundant, not without purpose, for I want to avoid suggesting either that the book is systematic, or that it propounds a theory. I am shamelessly more interested in surprises than exceptions. If those are not attended to, and if we lose the faculty for feeling in each moment the pressures of the past and the growing of the

future, if exceptions are not respected but ploughed under into schemata, then we are abandoning the poetic reality and opting for death (or for 'false totality'). Exceptions, which needle perception, are what provoke the impulse to make coherent the life of intangibles, in all their colours, rather than declaring a stance or believing something. The interaction of making and believing within the imaginative impulse, as dialectical factors in any fiction of concord or fiction of exceptions, is not the point at issue. What changes the set of the mind by enlarging its aperture, is the capacity for noticing exceptions and then attending to them, with lucidity and with love.

Lastly, the question as to what readers I have in mind. A good deal of bluff goes into such considerations, ordinarily, even if the bluff is supported by statistics. Who is this amalgam, 'the general reader'? Who is 'the student'? The writer meets with an exception, with something he finds to be singular, he decides to attend to it, and he writes up the results of his investigation, for the exception's sake. The reader is out of sight and out of mind. Or the writer writes as a non-intentional form of display, obeying, birdlike, some abstruse impulse. A bird's display, too, is not necessarily a series of movements executed only when other birds are present; nor is it meant for theatrical effect. The presence of onlooking birds, even of some who pretend not to be looking, is a matter of small importance. The bird does his display, regardless. I would like, then, to think that my reader will be that most concrete and exceptional person who is both 'nobody in particular' and 'somebody else', who was always present, in whose honour I give a special emphasis to the 'in particular'. Far better such a reader than some faceless 'one', in Heidegger's sense, the 'one' who figures in such general statements as that of the French waiter who protests, 'on ne commence pas, Madame, avec le dessert.' Above all, I hope that my reader will not find too many trivialities here, but true particulars that are alive in the fragile ongoing artifice of human concerns. May a care for particulars enable the reader to think for himself or herself more freely than I have been able to think for others.

1974-5

NOTE

TRANSLATIONS of German passages in the various texts will be found in Appendix 1. Some studies were so composed originally as to make such references minimal or unnecessary. The poems by Mon and Rilke are accompanied by translations. In Appendix 2 there is a line by line crib to Mörike's 'Auf eine Christblume' and there are also translations of the passages from Novalis discussed in the study on mountain symbolism.

As regards the Walser study, I must beg the reader's indulgence. Here I have not provided translations, because most of the passages cited only lose in translation the special qualities of structure which were being discussed. The reader without knowledge of German may still find the study helpful, I hope.

Abbreviations of journal titles in the notes are standard, e.g. *DVS=Deutsche Vierteljahrsschrift, EG=Etudes germaniques, Euph.=Euphorion, MLR=Modern Languages Review, MDU= Monatshefte für den deutschen Unterricht, OL=Orbis Literarum, PMLA=Publications of the Modern Languages Association.*

1

THE RISE OF PRIMITIVISM AND ITS RELEVANCE TO THE POETRY OF EXPRESSIONISM AND DADA

IT WOULD be bookish to affirm that the European cultural tradition has been continuously rational. The works of reason have, no doubt, assured a degree of continuity. Yet the socio-economic conditions have been such that what emerged was a complex of shifting tensions evolving through time and enjoying precious few moments of equilibrium. At such moments, reason and unreason entered a relationship which was fruitful. When split apart, each became the other's evil. The massive splitting in wars and revolutions during this century may even have destroyed Europe as a cultural continuum. The German literary tradition is certainly not one in which reason has always been sovereign. Yet it has been one in which Europe's peculiar tensions appear in sharp outline. There has been a rational decorum of sorts, with periodic bursts of unreason nourishing a literature that plies between manners and manias, folk modes and sublime ones, logic and music. Rationality even triumphed during the bourgeois epoch. Yet that epoch's most incandescent writers— Lessing, Büchner, Nietzsche—were men in whom reason fought some of its fiercest palace revolutions, ousting all sorts of deceptions and ossifacts. During the period of Expressionism and Dada, as the revolt against reason took new forms, Primitivism was one of the factors bedevilling aesthetic rationales. The tension was such that reason seems to have been hungering, or sickening, for primitive unreason in the first place: a tired Tithonus, praying to his Aurora. This primitivism has been both a vital and a deadly force in social and cultural life ever since its epiphany around 1900. Possibly its rise can be linked, though not causally, with the decline of humanitarian values. For Serenus Zeitblom, at least, in Thomas Mann's *Doktor Faustus*, there is a relation between primitivism in modern art and atavism in totalitarian politics, between 'Ästhetizismus' and 'Barbarei' as forces coalescing in a general brutalization of culture. Early in this century some of the sweetest reasoners among the artists were looking back, or inwards, to primitive modes in feeling or in art, as correctives to rationales which they believed to be unsound or unfit in an age of such internal uncertainty and external complexity. On the one hand, amazing advances in the physical sciences were seeming to assure at least secular progress; on the other,

the primitive in art came to be seen as an index to the formative powers of the unconscious, or as a prism refracting the light which dawns at the birth of culture. But this immense new intellectual horizon had terrors in store. The rage for simple essence in the arts differed from Rousseauism, to be sure; but its public sequel was no less subversive, because it became cruelly distorted. And never before had the sublimations of culture been so tellingly questioned, so eroded by doubt. No Greek or Latin poet (except perhaps Theocritus) aimed to purify his rhetoric, as poets early in this century did, by dosing it with supposedly primitive elements. Yet even primitivism, in its quest for the preconditions of culture, lost innocence amid crushing conflicts between dogma and spontaneity, in which mass killing became programmatic in the name of order, and global destruction itself could be got up to look rational.

Before outlining some of the stages by which the value 'primitive' became positive and desirable, I should declare a few preliminaries. The gist is epitomized in Harold Rosenberg's sentence: 'Before any poetic event can happen, the cultural clatter must be stopped.' (1) In general, primitivism was an active force in experiments which challenged the venerable view of art as a perspectival simulation of nature with a theory of art as visionary fact. The new theory was first formulated by Kandinsky in his *Über das Geistige in der Kunst* (published 1912). In particular, primitivism has many facets, ten of which I list at once:

1. 'Prelogical' or 'savage' art, without support from later ethnological findings.
2. 'Naive' European art (excluding folk art), e.g. Henri Rousseau.
3. Alogism in poetry: Russian Futurists, Hugo Ball, Hans Arp.
4. Infantilism, positive and negative. In Russia, Kruchenykh, as in his *Duck's Nest of Bad Words* (1913). Gregor Samsa's infantile eating in *Die Verwandlung* belongs here; so does the revaluation of children's art and the child's imagination, from *Zarathustra* to Morgenstern, *Der blaue Reiter*, and Paul Klee (1912).
5. Resuscitation of folk forms: again the Russian Futurists, pre-eminently Khlebnikov in his epics; also folk woodcuts, Bavarian glass-paintings and votive paintings, in *Der blaue Reiter*.
6. 'Anti-aestheticism' including the 'Ästhetik der Hässlichkeit' first mapped by Kandinsky in a footnote to *Über das*

Geistige in der Kunst (2nd edn., 1912, p. 71). Various versions of this in, for example, Rilke, Benn and Brecht.

7. Feigned illiteracy (chiefly in some Russian Futurist poems).
8. Exoticism in some cases: Gauguin, for example, whose colours inspired the *Fauves* and *Die Brücke*, or Klee's experience of colour in Tunisia in 1914. Descriptions of Africa and South America in popular journals (e.g. *Die Gartenlaube*, during the 1890s) might have nourished fantasies of primeval landscapes and primitive paradises as Europe took stock of its dominions.
9. 'Das Elementare', a crucial concept in Expressionism and Dada. Thus Hugo Ball: 'Das Elementare, Dämonische, springt dann zunächst hervor; die alten Namen und Worte fallen' (8 April 1916, in *Die Flucht aus der Zeit*). Later: Antonin Artaud's idea of primordial theatre.
10. Atavism: Jarry's *Ubu* (1896), Brecht's *Baal*, Jahnn's *Perrudja* (1929). Also Kokoschka's plays of the period 1907-18.

This list gives some notion of the word's semantic range. It also indicates how widespread and magnetic the phenomenon was. Even the most Socratic writers of the period were in some way touched by primitivism, if only in subject-matter. Mann's dreaming Aschenbach regresses, to experience his primitive Dionysiac vision. Kafka's Gregor regresses: often in Kafka, too, scenes with the angular flat stillness of 'naive' paintings occur. Hermann Broch noted this 'primitive' side in Kafka. Musil's Törless experiences the regressive unreason of sado-masochism; later, the Moosbrugger episodes in *Der Mann ohne Eigenschaften* are dialectical versions of the idea of the primitive. By then the idea had been demagnetized by a generation's thought. The turning-point towards irony in fiction might have come in 1924, with Thomas Mann's analytic treatment of atavism in the 'Schnee' chapter of *Der Zauberberg*. To mention the later Rilke's quiet priapism is not to blur the field. Here he meets, if only half-way, with D. H. Lawrence. One should certainly not equate primitivism with regression (infantile or archaizing) as an outcome of anxiety; but in some cases there are connections, within the psychology of post-Romantic nihilism. Less obvious connections exist between primitivism and poetic structure. German primitivism in poetry was not as conspicuous as it was at the same time in Russia. But the phenomenon is there, and the term is one which profiles several in-between areas that are not satisfactorily defined by the host of terms clustering around the concepts *Abstraktion* and *Ausdruck*.

Maurice Vlaminck has said that he took to Picasso in 1905 a Negro sculpture which he had found in a Paris *bistro*. Max Jacob has said that Picasso first saw a Negro sculpture in Matisse's studio. At all events, Vlaminck, Matisse and Derain are usually thought to have been the first modern European artists to admire African works of art. (2) Picasso's *Les Demoiselles d'Avignon* and *La Danseuse* (1907) are two paintings which show the first 'influence' of primitive art: Negro masks from the French Congo and Bakota statuettes, respectively. (3) The conventional 1905-7 dateline can be shifted ten years back if one listens for the first real stirrings. For Germany the ground was being prepared during the 1890s, as it had been prepared in France by exotic art (notably Japanese). In Berlin during the 1890s the first connections were being made between primitivism and 'soul' art. In February 1894 Stanislaw Przybyszewski, who was closely associated with Edvard Munch and Strindberg, wrote of Munch's paintings that they were visions of an inner world, direct expressions of psychic energy, without cerebral mediation. (4). Then towards the end of 1894 Strindberg met Gauguin in Paris. (5) On 31 January 1895 Strindberg visited Gauguin's studio yet again, in order to refresh his mind for his 'letter' which introduced the catalogue of Gauguin's 1895 exhibition. Here he concluded: 'Now I too begin to feel an irresistible drive to become a primitive and to create a new world.' (6) Within two years Strindberg had written his *Inferno*, an anti-Tahiti, to be sure, but a fiction which created a new psychological world by exploring forbidden psychic depths (Gauguin appears in it as 'one man who possessed genius, an untamed spirit' [7]). The narrator in *Inferno*, moreover, is impressed by a charcoal drawing by his sculptor friend, 'sketched from the floating weeds in the Lac des Suisses' at Versailles; and he exclaims: 'Here was a new art revealed, an art taken from Nature herself! Nature's clairvoyance . . . may the harmony of matter and spirit be born again.' (8) This constellation of new values was followed and developed by primitivism a decade later by the artists of *Die Brücke* and *Der blaue Reiter*. The equation was: primitive= psyche=pure energy=*natura naturans* (rather than *natura naturata*) as spontaneous creation of spirit. Twenty years later, Hans Arp is found studying, on the shores of an actual Swiss lake, the primal shapes of pebbles, lumps of wood and other organic flotsam. (9)

The date of Ernst Ludwig Kirchner's first visit to the Dresden

Ethnographic Museum is usually given as 1904. (10) The *Die Brücke* painters were inspired by precedents as various as Grünewald, El Greco, and masks and sculpture from Africa and Oceania: works whose expressive distortion and defined energy served them as landmarks, just as much as the moderns Gauguin and Van Gogh did. Gauguin had upgraded primitive art in terms which appealed strongly to artists, like those of *Die Brücke*, who believed that a new art pertained to a complete reform of western culture, to a rebuilding of its spiritual basis. Gauguin wrote: ' "Refined art" springs from sensuality and subserves nature. Primitive art springs from the spirit and uses nature.' (11) Kandinsky, in his *Über das Geistige in der Kunst*, also wrote with such radical reform in mind: 'Ebenso wie wir, suchten diese reinen Künstler [meaning primitive artists] nur das Innerlich-Wesentliche in ihren Werken zu bringen, wobei der Verzicht auf äusserliche Zufälligkeit von selbst entstand.' (12) Here also, for the first time, Kandinsky related primitive and abstract art: 'Je freier das Abstrakte der Form liegt, desto reiner und dabei primitiver klingt es.' (13) Yet Kandinsky firmly stressed the limitations of this sympathy between the finest modern artistic sensibility and the primitive. The moderns, he wrote, are plagued by doubt and by the 'nightmare of materialist ideas' (a hangover from the nineteenth century). Accordingly, there can be no more than a passing passion for the art of primitives. The primitive is like an ancient vase which has been dug up, but which has a crack in it. (14) Towards the end of his book, all the same, Kandinsky returned to the question: the new dance (Isadora Duncan) has also looked back to earlier times for a model, namely, to the Greeks, 'aus demselben Grunde . . . aus welchem die Maler bei den Primitiven Hilfe suchten.' (15) The primitive here is still *one* sacred fount in which 'das Innerlich-Wesentliche' dwells, and across whose surface 'feinere seelische Vibrationen' have played. It is, moreover, an object-lesson for artists who are exploring 'das Objektive der Form', who are working towards a systematic non-figurative 'Konstruktion zum Zweck der Composition'. (16)

The most dramatic result of sympathy with the primitive was *Der blaue Reiter* (1912). Here the spectrum included, besides Cézanne, Matisse, Gauguin, Van Gogh, Delaunay and other new painters, European 'naive' painting (Henri Rousseau), Russian and German folk art (woodcuts, carvings, votive paintings), children's drawings and primitive works (masks, wood carvings,

statuettes) from twelve different cultures. By now Wilhelm
Uhde's monograph on Henri Rousseau had appeared (1911).
Rousseau was being recognized as having been, since he first
exhibited in Paris in 1885, a 'native who turned up on the shore
when the exploratory voyages of modern art arrived in the new
world'. (17) Most striking was the range of the primitive *exotica*:
South Borneo (Dayak), South American (Yuri-Taboca), Easter
Islands, Cameroons, Mexico (Aztec), New Caledonia, Alaska,
Marquesas, Bali, Benin, Ceylon, Guatemala (the last not in the
original edition). (18) Here, too, the word 'primitiv' occurs in
some new contexts. Franz Marc, whose 'Animalisierung der
Kunst' has mystical features in any case, wrote of the new Ger-
man 'Wilde': 'Die Mystik erwachte in den Seelen und mit ihr uralte
Elemente der Kunst.' (19) David Burliuk, writing of Russian de-
velopments, advocated a militant barbarization of art. (20)
August Macke stressed the strength of form in primitive masks:
'Schaffen von Formen heisst: leben. Sind nicht Kinder Schaffen-
de, die direkt aus dem Geheimnis ihrer Empfindung schöpften,
mehr als Nachahmer griechischer Form? Sind nicht die Wilden
Künstler, die ihre eigene Form haben, stark wie die Form des
Donners?' (21) No sign here of the later ethnological view that
primitive works are 'expressions of deeply rooted art traditions
which dictated to a large extent the basic designs that the pro-
fessionally trained primitive artists were required to follow'. (22)
On the other hand, the absence of 'pictorial exactness', stark-
ness of form, form as the pulse of mind recording contact with
the elemental—these were primitive features which appealed to
Marc, Macke and Kandinsky, and which later inquiry endorsed.
The accent on untutored spontaneity was an intrusion from the
new myth about the primitive; hence the tendency at this time
to merge primitive art, children's art, and even mad art, which
prevailed for some time to come and was still troubling André
Malraux in the 1920s.

It is not hard to see how Kandinsky's concepts of 'innere
Einheitlichkeit' and 'Seelenvibration' codified his responses to
the primitive works that he knew. A model for his theory of ab-
stract art (in *Über das Geistige in der Kunst*) had been music.
His theory was anchored in concepts of psychic tone, immateri-
ality and dissonance. In *Der blaue Reiter*, too, music is a context
in which primitivism appears. N. Kulbin, writing on 'Free
Music', advocated the use of quarter-tones and eighth-tones, as
tones existing in nature (musical instruments might have to be

redesigned). At the time Delius, Mahler and Scriabin were among the composers to whom this vitalistic notion of music as the polyphony of nature had its appeal. It was perhaps the strongest source of inspiration for early twentieth-century music. But Kulbin's dream of plugging music in to nature did not match the more radical realities which were already on the scene: eruptive syncopated rhythms animating tonal structures of ravishingly intricate ambiguity. Bartok's *Allegro barbaro* is dated 1910. Stravinsky was writing his *Sacre du printemps* in 1911 and 1912; the ballet was first performed on 29 May 1913. (23) In his *Ragtime* (1919) primitive and jazz metres are combined in a highly sophisticated montage. Stravinsky's instrumental finesse dominates one end of the scale. At the other came the cardboard-box drumming to a simultaneous poem, first performed on 29 March 1916, by the Zürich Dadas (their version of 'musique bruitiste', invented in 1913 by the Italian Futurist Luigi Russolo). The same programme of 29 March included 'Chant nègre I et II', accompanied by small exotic drums to a quasi-African melody provided by Jan Ephraim, owner of the Cabaret Voltaire.

Kandinsky's essay 'Über die Formfrage' scanned the various themes in *Der blaue Reiter*: children's art, the coexistence, in a single image, of real and abstract elements, Cubism, the compositional genius of medieval and folk art, and the 'neue grosse Realistik' of Henri Rousseau, master of the mental image. 'Das rein Kompositionelle' was the common denominator which Kandinsky inferred for the new art of a new cultural epoch. (24) The transition was thus made from the emotional or 'romantic-symbolic' attitude to the primitive, which had still marked *Die Brücke*, to an analytic concern with structure. (25) By the time *Der blaue Reiter* appeared, with its momentous conception of structure as a graph of unspoiled psychic activity, primitivism was capturing many of the outstanding minds of the time. In his *Formprobleme der Gotik* (1912) Wilhelm Worringer struck the main nerve of modern interest with his theory of relations between primitive dread of a hostile incomprehensible world and the creation of 'absolute' abstract forms on plane surfaces (suppression of the 'tridimensionality of the actual world'). (26) 1912-13 was the year of Freud's *Totem and Taboo*; read or not, his *Traumdeutung* and *Psychopathologie* were being discussed by writers from about 1909 onward. Jung's *Die Psychologie des Unbewussten* (1912) suggested another perspective on archaic

patterns active in the modern psyche. (27) Morgenstern had already nominated the child as the 'deathless creator in man'. (28) Paul Klee discovered children's art in 1912. (29) In April 1914, 'possessed' by colour in Tunisia, he added a fresh nuance to the bond between the primitive and the exotic: 'Very fine belly dances. One doesn't see such things at home.' (30) Long before the First World War George Grosz discovered his form of primitive art: graffiti on public lavatory walls, also the crude paintings and panoramas of images without perspective which he had seen at circuses, all of which influenced his drawings during the period 1916-20. (31) The first analysis of African sculpture was Carl Einstein's *Negerplastik* (1915). (32) Einstein was already known as the author of the canonical early Expressionist fiction, *Bebuquin* (1909), in which the hero had found reason rocked by something like Worringer's 'metaphysical dread' and man doomed unless his consciousness could be transformed: 'Die Logik hat nicht eine Grundlage', 'die materielle Welt und unsere Vorstellungen decken sich nie', 'Herr . . . Ich bin geschaffen zu erkennen und zu schauen, aber Deine Welt ist hierzu nicht gemacht; sie entzieht sich uns; wir sind weltverlassen.' (33) In 1916 and 1917 Einstein also published in *Die Aktion* his seven translations of African Negro poems, which have some stylistic kinship with the compressed 'abstract' lyrics of August Stramm. (34) The purity of the paradisal vision was volatile. Even some of Stramm's poems show how, in poetry, a straining after the primordial could result in teutonic grunting, rather than in the spirited crystalline transparency envisaged by Kandinsky and Klee. By 1914 there are already signs of primitivism becoming a cliché. Yet one phrase by Klee, in his Tunisian diary, epitomizes the pre-1914 mood: 'When is the spirit at its purest? In the beginning.' (35) And at the end of 1915 Hugo Ball takes up the question in terms which anticipate a whole new extension of the idea into the constructive iconoclasm of early Dada:

> In einer Zeit wie der unsern, in der die Menschen von den ungeheuerlichsten Dingen bestürmt werden, ohne sich über die Eindrücke Rechenschaft geben zu können, in solcher Zeit wird das aesthetische Produzieren zur Diät. Alle lebendige Kunst aber wird irrational, primitiv und komplexhaft sein, eine Geheimsprache führen und Dokumente nicht der Erbauung, sondern der Paradoxie hinterlassen. (36)

The alliance of primitivism and abstraction is one of the most copiously documented facts of the period under question. Both

were ways of training imagination to pounce intuitively on the
unsuspecting essence. Both were ways of baring the nerve of
'primary sensations' and of seeing universal forms as 'impressions
of rhythm' (Malevich). As such, both were central to the deep
changes in sensibility pervading the arts by about 1913. (37)
Many writers have studied these changes in the visual arts. The
motives and forms of abstraction in German poetry have also
received much attention recently, R. N. Maier's treatment being
the most detailed and most acid (*Paradies der Weltlosigkeit*,
1964). Applied to poetry, the new value 'primitive' was clean
contrary to the languishing idioms of the time, from the ornate
sublime to the declamatory diffuse. It suggested a poetry of
stark pre-logical metaphor, word dislocation and new patternings
of sound. This meant not merely a sporadic walloping of en-
trenched norms. The primitive was not just an anti-world, it was
a world in itself. It promised a mode of imagining with its own
rhythms and with an immediacy of vision which might break the
spell of reason by reading it backwards. Here one might suspect
that abstraction and primitivism colluded only up to a certain
point. Abstraction was not always an end in itself, but was one
means of preparing language for primitive effects (as in Stramm,
and most notably in Carl Einstein's extraordinary poem 'Der
tödlicher Baum'). It is not, I think, anachronistic to refer here
to Hermann Broch's later evaluation of the primitive; it does
apply to features in the imagery of Heym and Trakl which the
fine terminology of abstraction seems to abuse:

> Die Welt wird wieder zum ersten Male gesehen, und zwar in
> einer Unmittelbarkeit wie sie sonst bloss dem Kinde und dem
> Primitiven ... zu eigen ist, und so wird auch der Weltausdruck
> zu dem des Kindes, des Primitiven, des Träumenden: er voll-
> zieht sich in einem Akt neuer Sprachschöpfung.... So ist dar-
> aus nun . . . etwas völlig Neues emporgeschossen, die Ur-
> Symbolik irrational-unmittelbarer Weltsicht. (38)

Primitivism was, at all events, an active force in the 'Umwortung
aller Worte', the disarming of bourgeois language, which Morgen-
stern had begun with his 'humour' (as a species of psychic erup-
tion) and his 'childlike' genius for breaking the sleep of words.
(39) The poem as a magical exposure of psychic happenings, a
meta-language, only lightly misted over by existing linguistic ra-
tionales: this was the mermaid left singing on the shore as
nineteenth-century rationalism ebbed away. An ambiguous mer-
maid—deprived of her element, the ordering insulations of art,

she could become a bloated demon bewitching all with new toxic illusions. Freud's *Gedanken über Krieg und Tod* (1915) showed, at least, how he inferred from the war that the savage agitating under a skin-deep civilization has traits which are not paradisal at all, but plain brutish.

Ten facets of primitivism were listed at the start of this essay, and that list is not by any means complete. It is also a historical fact that primitivism in the twentieth century is as much a question of individual stylistic nuance as realism was in the previous century. There is, moreover, a 'false primitivism', which arises when the primitive or archaic exerts a spell that paralyses critical and moral judgement (the Kridwiss circle in *Doktor Faustus*). Apart from motifs in poems, there are modulations in poetic structure which are an almost unexplored field among the cultural changes inspired by primitivism. (40) I propose now to plant some tentative markers in that field.

 First, there is the matter of perspective. My suggestion is that primitivism has to do with plane surfaces, in painting and in poetry. It has often been noticed that naive paintings and early abstract paintings suppress central perspective. Depth is reduced, and forms come to occupy a frontal plane. Kandinsky was concerned with this change in balance between plane surface (the canvas itself) and perspectivic modelling (depth of image): between 'flache Fläche' and 'ideelle Fläche'. The loss of 'possibilities' by flattening, he proposed, might be repaired by two methods: thinner or thicker lines with forms intersecting, and variable intensities of colour. Both methods could make the image psychically resonant, 'zu einem in der Luft schwebenden Wesen, was der malerischen Ausdehnung des Raumes gleichbedeutend ist'. Neither need relapse into illusionistic three-dimensional perspective, or into Cubism's 'impoverished plasticity'. (41) Worringer's view of primitive drawings also took up the problem: the savage artist is seen as a creator of absolute abstract forms on plane surfaces, who ignored the 'tridimensionality of the actual world'. (42) There is also a third factor: Nietzsche's critique of cognition and morals since the Renaissance, which culminates in *Der Wille zur Macht*. The 'world' is not identical with the world of our perspectives. These perspectives shape only its 'Scheinbarkeit'. But Nietzsche reverses idealism: he exclaims, 'Als ob eine Welt noch übrig bliebe, wenn man das Perspektivische abrechnet!' And he adds: 'Der Gegensatz

der scheinbaren Welt und der wahren Welt reduziert sich auf
den Gegensatz "Welt" und "Nichts".' (43) The existing 'per-
spektivische Welt' is a fiction fitted to the values of good and
evil which men with eroded instincts have mistakenly set on
things. The subversion of these values and of the opaque semei-
otic system which enshrines them is the task of independent and
creative minds, who dare to face the 'Nichts' without self-
deception, and to project new and future values into it. Now can
one correlate these four fields: Nietzsche's critique of mental
perspectivism, the plane-surface theory of primitive art, Kandin-
sky's advance into abstraction from the zero point of the canvas
as plane surface, and the converging of forms in flat frontal
planes in Henri Rousseau? I would speculate, first, that this is a
family of phenomena, though I cannot state how closely knit
the family is; and, secondly, that the family does have a none-
too-distant relation in a plane-surface factor to be found in the
poetic imagery of Trakl, Jakob van Hoddis and Lichtenstein.
Trakl's patterning of tenses in his poems of 1912-14 creates a
semblance of flat time, or simultaneity. Quasi-mythic events
occur in the present tense of the poem, which is not the 'eternal
present' of older lyric poems. (44) Trakl's present tenses are
often bracketed by preterites which profile the mythic present
without shifting it, or their own contexts, into a background.
Present and past contexts occupy luminously the same imagina-
tive time-plane. Time as succession is almost blotted out by time
as visionary momentum, a kind of open-textured omnipresence,
in which moments constellate in a planimetric time. This is the
case in 'Helian' and in 'Elis' (I and II). In 'De Profundis' the
time-plane also bends, without achieving anything like volume:
the 'sanfte Waise' is gleaning (still), while, in the next stanza,
shepherds *found* her corpse in the thorn-bush. In Jakob van
Hoddis's poem 'Weltende' and Alfred Lichtenstein's 'Die Däm-
merung' (to cite two well-known models of early Expressionist
poetry), simultaneity again results in a flattening of time-
perspective. In 'Die Dämmerung', additionally, the optics of the
imagery become flat through the reduction of emphasis on any
words denoting a presumptive or preformulated awareness. Thus
Lichtenstein tucks the adjective 'fetter' away behind the empha-
tic verb 'klebt' in the line 'An einem Fenster klebt ein fetter
Mann'. The montage here is of a kind which suppresses both
optic depth and temporal sequence. This is the case in many
poems of the time, in which simultaneity was the object, with

plasticity held to a minimum, in favour of graphic abruptness and rapid visionary sweep. These poets need not have thought this new way of seeing to be primitivistic; but their imagery manifests features which were thought to be primitivistic by men who were pioneering the new visual aesthetics of the time.

Secondly, a more conspicuous (and perhaps antithetic) fruit of primitivism: Hugo Ball's sound poems of June 1916. Abstraction here eliminated lexicality almost entirely. Only sound-patterns are there, and in four of the poems the sounds are from African languages, notably Bantu and Swahili. Ball put an African mask on the European lyric, as Picasso in 1907 had put African mask-faces on two of his ladies of Avignon. Ball's endeavour was to rescue the 'innerste Alchimie des Wortes' from journalism's ravages; (45) later he dissociated this endeavour from the rude onomatopoeic explosions of Marinetti, which he thought were all too naturalistic. (46) The African elements constitute a kind of transcultural pidgin: numerous Bantu and Swahili words do occur, but Ball could not have gone much further in rupturing their semantic relations, even if he had known (which seems unlikely) that they meant something. (47) The effect of such magical incantation, for a non-Bantu or non-Swahili speaker, is to extinguish all the lexical tensions which make and integrate 'meaning' symbolically. (48) On the other hand, as Goethe observed of the ballad, it all depends on the quality of the performance. Tonally and rhythmically, these poems oscillate between solemnity and fun, between incantation and irony. Their first performance was, for Ball, traumatic, in so far as a stratum of repressed childhood feeling was released in a discharge of mental images amid religious overtones. (49) But his catharsis included the moment of liberation which the ironic oscillation enshrines. This irony is, paradoxically, the mark of the 'truly primitive' in modern art. Without it, the critical distance shrinks and false primitivism, spell-binding and stupefying, raises its Medusa head. Irony controlled the inter-animation of meaning and unmeaning, or meaning and counter-meaning.

Thirdly, Hans Arp's word-fracturings. Arp's treatment of words exemplifies his own distinction between *Unsinn* and *Gegensinn* in *Unsern täglichen Traum* . . . There is much talk of the 'destruction of meaning' in Dada. Dada did mean the subversion of cliché, a form of violence implicit in poetry at most times, which now reached an intensity unthinkable before Rimbaud. But Dada also showed both that the unmaking of false meaning

admits new life into art, and that meaning is not so easily un-made. Creative shocks may shatter certain norms, vernacular or poetic, but they also induce fresh integrations. Or ghostly co-herences survive, in which the 'human substance' may not be so attenuated as conservative critics (like R. N. Maier) suppose. Arp makes not *Unsinn* but *Gegensinn*, in so far as strong traces of speech-norm survive as the frame in which a 'destruction' has been made. What determines the impact of the *Gegensinn* is often precisely the quality of the trace. 'Variante als Nr. 2', from *Behaarte Herzen*, contains the mild paronomasia, 'Das schiff ist unglücklich/schon seit kindesbeinen und -armen/fühlt es die kerne in seinem innern'. Another version of the middle line, in *Die gestiefelten Sterne*, reads 'schon seit kindesarmen'. (50) The se-mantic shift affects the phrase 'seit kindesbeinen'. In 'Variante als Nr. 2', the juxtaposition of norm and shift sharpens the point. In the other version, the pun is made much flatter. Michael Polanyi's terms 'focal awareness' and 'subsidiary awareness' shed light on this and similar shifts. (51) The norm 'von kindesbeinen' is one on which we bear with focal awareness ordinarily, and in which we would notice nothing of intrinsic interest. But our subsidiary awareness realizes the tacit meaning in the *parts* of such a norm. Arp invents (usually from nouns) by structuring his highly active subsidiary awareness and by feeling out the discrete properties of such parts. In 'von kindesbeinen und -armen' he is raising his subsidiary awareness to parity with the focal awareness. In 'von kindesarmen' he has allowed the subsi-diary awareness almost, but not quite, to replace the focal. The word 'heufische' in 'kaspar ist tot' is a more striking case of the shift. The norms *heu, haifisch, häufig, heuschrecke* become parts that are integrated in a neologism which has 'counter-meaning' and which then spins out its own web of phonic and semantic surprises. As subsidiary intrudes on focal awareness, so do parts and wholes change their relationships: *beileibe/beiseele, wagehalsig/wagenasig, katafalken/kataspatzen, spazierstock-dunkle frauenzimmer, zum beinspiel*. This redisposal of levels of linguistic awareness was a key to many secret chambers of the mind. Yet with dead-pan cadences, absence of punctuation marks and of capitals, and with many nuances of under-emphasis, it sounds 'on the level', as indeed it is. For everything is done to make the 'denaturing' of speech-norms introduce a new 'nature' on the level of the planimetric word-configuration which raises to focal positions the elements of *Gegensinn* submerged or tacit

in ordinary language. This is a German version of 'Zaum', or
'transrational language', as conceived at the time by Khlebnikov
and Kruchenykh. Benedict Livshits's account of his first response
to Khlebnikov's manuscripts is relevant: 'I saw before me lan-
guage come alive. The breath of the original word seared my
face . . . The baring of roots . . . was a real myth-making, an awa-
kening of meanings dormant in the word, as well as the birth of
new ones.' (52) In Arp the word reveals itself as a sparkling field
of perception the moment when silent supports of meaning
rush, dance, hop or creep out of hiding and become its positive
structure. His method added to the plane-surface element of
primitivism two further elements: childishness is regained on a
highly structured level of ironic intelligence, and we witness the
actual unfolding of processes which initiate language and so
shape our sense of a world. Primitivism had become a way to
realize meaning precisely where language seemed to be doing
nothing; or, to quote Klee: 'Die Genesis als formale Bewegung
ist das Wesentliche am Werk.' (53)

The structural features on which I have touched indicated new
modes of perception, a new creative sensibility. Public primiti-
vism during the first half of this century faced the other way: it
meant the recrudescence of archaic instincts in deadly modern
guise and with hideous instruments—aggressiveness, violence,
even supine collaboration with terror as 'fate', as 'the historical
dialectic', 'the white man's burden' and so forth. But there have
also been joyous effects, like the primitivism of 'negritude' in
body-based dance and song, which since 1963, at least in the
U.S.A., has been bending, if not breaching, the labyrinthine
racial barriers, unfreezing the 'soul' amid the ferment of 'Ameri-
ca's attempt to unite its Mind with its Body, to save its Soul'.
(54) Certainly in art and anti-art, primitivism now seems to have
sounded a positive note among the cacophonic desublimations
and the ecstasies of destruction. It sought to achieve the ingres-
sion of new salutary life-instincts into civilized man. It helped to
shatter 'illusionistic art' and those ideologies which such art
shields. It challenged, with its reversals of 'meaning', the pseudo-
nature imposed on people's senses by the repressive rationality
of unfree social systems. It was an early signal of the present
'Great Refusal': it promised liberation from those compulsions
which make men stupid, brutal and automatic. Yet now these
early primitivisms have mainly been absorbed. They are accepted

as art, safe in museums and books, overshadowed or neutered by what Herbert Marcuse has called 'the technical reaches of powers whose terrible imagination organizes the world in their own image and perpetuates, ever bigger and better, the mutilated experience'. (55) Heavy, indeed, are the odds against any eventual realization, in social terms, of the three forms of new sensibility outlined here. Specifically: (1) in plane-surface poetic imagery, a model for a balanced visionary optics of time, with psychological and historical tensions mastered without violence, without their doing violence to one another; (2) in the sound-poem, signs that even down among the translexical nerve-roots of language rhythm and song are facts of life (here, in my view, the irony in the structure is a token of intellectual joy in invention, liberation from the spell of regression); (3) in Arp's word-fracturings, a lucidity which denies that word and world can be stereotyped, which understands the silences embedded in language, and which announces that imagination's linguistic universe has an ordering as well as an analytic function in the transformation of the senses, and of their world.

'BOLSHEVISM IN ART': DADA AND POLITICS

MY TITLE is a quotation from Richard Huelsenbeck's pamphlet *En Avant Dada*, dated 1920. Probably he, too, was quoting the phrase, but from an English or American source, since he quotes it in English. In his pamphlet, Huelsenbeck sketched out a history of Dada till then. His aim was partly to show that the Dada of the Berlin Dadaists, of whom he was one, was the only true Dada. He denounced as false Dada the ideas and practices of Tristan Tzara and his friends in Paris. He did this by defining true Dada as a dynamic intellectual revolt which could not be fixed in any one attitude, least of all in the position of 'abstract art', to which Tzara had reduced Dada in Paris. Huelsenbeck then associated Dada with Bolshevism. He called Dada 'a Bolshevist affair'. The link was not an arbitrary one, since Bolshevism and Dada both plotted the abolition of middle-class values. Bolshevism did not, of course, envisage the creation of such things as Dada had proposed in 1919—proposals which Huelsenbeck reproduced in his pamphlet: progressive unemployment, the use of Dada simultaneous poems as state prayers, the setting up of a hundred and fifty Dada circuses for the enlightenment of the proletariat and so on. All the same, if Huelsenbeck did have his tongue in one cheek, he did not have it in the other. To him, the Dada writer was a rebel with a revolver in his pocket and Rimbaud's example at the front of his mind. Also, it might be added, he was a ferocious opponent of the forces which had, six years before, unleashed the most murderous war in history till then. (1)

Yet there are several uncertainties which blur our present picture of Dada politics. It is agreed that Dada's nihilism covered many other sectors of the moral, social and intellectual upheavals of its time: Dada, after all, did flourish in an epoch which revolutionized art, morals, social structures, science and ideas. But it is not agreed whether Dada had, like Surrealism afterwards, a social revolutionary side (I refer to Nadeau's study of Surrealism). Sometimes it is thought that modernist writers and artists during the period 1917-21 did concur with the Bolshevist version of social revolution; but their actual attitudes have never been demonstrated, and we do not even know what their version of Bolshevism might have been. Thus the generation now under thirty seldom realizes even that modernism as a whole was—somehow—politically involved. Since Dada entailed many tendencies of

modernism, but was a state of general intellectual emergency rather than an exclusively literary or artistic 'movement', its political ingredients are of special significance to the whole question of politics in modernism. In this paper, I shall investigate the varying degrees of political stress in the four phases of Dada, considering the subject primarily from this one side.

It has to be remembered that Dada did have its four distinctive phases. Each phase took shape individually, because different individuals and ideas, or different groups of individuals and ideas, were at work in each. It also has to be remembered that each of these four phases showed the imprint of the political and intellectual ambience prevailing in each of the four cities where Dada throve: Zürich 1916-19, Berlin 1917-20, Cologne 1919-20, Paris 1920-2. There is also a fifth phase which was studiously nonpolitical and which I shall not discuss: the phase in which Kurt Schwitters developed his own form of Dada, known as Merz. We first meet Schwitters in Berlin in 1918, banned from the Dada group by Huelsenbeck because he was nonpolitical, and because Huelsenbeck obviously enjoyed arrogating to himself the power to ban. In 1919 Schwitters in Hanover published his poems, *Anna Blume*, and the publisher Paul Steegemann began a series of Dada and near-Dada pamphlet publications. But Schwitters is best known for his magazine *Merz*, published during the period 1923-32: *Merz* began to appear, that is to say, at the moment when Dada's original impulse had died out.

Two other factors have to be borne in mind. The first is that Dada resists any attempt to split it into neat sectors for special scrutiny. Its lavish ambiguities—between pro-art and anti-art, between constructive anarchy and destructive nihilism—its sublime defiance of all systems, its rejection of all suave or sedentary attitudes, require us to keep the whole phenomenon in view all the time when we study any one aspect of it. A person who tries to follow Dada will know roughly how Aeolus must have felt when he was stuffing all those contrary winds into one bag. The second factor has to do with the sources. There are certain discrepancies between documents of the time relating to Dada politics and the memories of Dadaists published thirty and forty years later. The documents indicate that there was nothing political about Zürich Dada. But then, in 1947, Tristan Tzara—one of the original Zürich Dadaists—stated that the mood of revolt at the time did have a political side. (2) As for Berlin Dada, here

the documents do indicate a political side over a particular period, with Dada supporting the extreme left-wing Spartacists. Yet this is toned down somewhat in the memoirs of Raoul Hausmann, George Grosz and Richard Huelsenbeck. (3) Another Berlin Dadaist, Walter Mehring, when confronted with a *Times Literary Supplement* article (9 June 1961) suggesting that he and his friends in Berlin in 1919 had been on the Bolshevist bandwagon, wrote the editor of that journal a letter hotly denying that this had been the case. Today it is hard to gauge with any delicacy the degree of serious emphasis placed on such things in the past; a past, moreover, in which the political alignments of literary men were much less strict than might be expected. On the other hand, these discrepancies are fairly consistent in their pattern. Tzara espoused Communism a decade after Dada; thus he might well have seen a point in playing up, especially in 1947, the existence of a political strain in Zürich Dada to which he claimed copaternity. Huelsenbeck, Hausmann and Grosz might have chosen, contrariwise, to let the dead bury their dead. The pattern is somewhat elucidated by the memoirs of Wieland Herzfelde, *Immergrün* (Hamburg 1949 and 1950). Herzfelde is the only Dada author now living in east Germany. After Dada he continued to write, edit and publish in the German left-wing cause. And he does in his memoirs duly tell of his political adventures in Berlin during the Dada years. Yet I say no more than 'somewhat elucidate'. Wieland Herzfelde could hardly have been more noncommittal and modest in his account of his activities at the time, even though he spent five weeks in prison for publishing supposedly subversive literature in 1919, and was the accused in two court cases involving Dada in 1920.

Zürich in 1916 housed a large number of refugees from the east and north of Switzerland. Yet the country was hardly an oasis in the desert of war. It was rather the focus of the ideological conflicts which had generated the war. From a bird's-eye viewpoint one can pick out in Zürich alone four foreign groups, which either opposed or ignored each other. There were the experienced and mature man of letters, like Joyce, Wedekind, Rolland. There were the German Expressionist writers like Frank, Ehrenstein, Rubiner, who were pacifist Socialists. There were the Russian Socialist exiles, like Lenin and Zinoviev. And there were the young German and Roumanian expatriates, Ball and Huelsenbeck, Tzara and Janko, and the Alsatian Hans Arp, who in February 1916 became the Dadaists. These groupings

are devised arbitrarily. The viewpoint is deceptive. The men involved were highly individual characters; there were also strong differences within their particular circles, even within the Dada group which was relatively coherent. There was also much travelling back and forth between Zürich and other Swiss cities, like Berne, where Rubiner in 1917 published the political newspaper *Zeit-Echo*, and Geneva, where Trotsky was living. But over one brief period in 1916, conveniently enough, the fluid situation froze to form a symbolic milieu, in which the great dialectic of the age came to focus: the conflict between freedom and system, spontaneity and order, imagination and calculation. This was the Spiegelgasse, in the old sector of Zürich, one hundred paces from the river Limmat. At No. 1 Spiegelgasse was the little café where the Dada group established their Cabaret Voltaire in February 1916, with high-spirited intent to blast all bourgeois ideas of art and normalcy. At No. 12 Spiegelgasse lived Vladimir Ilyitch Lenin with his wife Kroupskaya. Lenin, the calculator, would sometimes play chess in the Café Terrasse, which, too, was at one time (until the waiters went on strike) a haunt of the Dadaists. Here it was that Arp, Serner and Tzara composed their first simultaneous poem. But there was, symptomatically, no contact between Lenin and these young writers and artists. As Georges Hugnet has put it: 'They ignored each other, cordially.' (4)

There is no sign in Dada publications between 1916 and 1918 of the Zürich Dadaists having even known of the congress of Russian and German Socialists at Zimmerwald in 1915, or of the 1916 congress at Kienthal. Hugo Ball, at this time (1916) the catalyst of Dada sensibility and ideas, made no mention in his journal of these two crucial political events. Yet before and after the entries relating to Dada between 1916 and 1917, Ball's journal bristles with social and political interest. Dada, in this phase, had rejected all conventions of order in literature and art; it was also ignoring, on the face of it, the efforts of men at the time to establish systematically new social orders.

Whether or not the Zürich Dadaists knew what was afoot, their festivals of anarchic aggressivity, first in the Cabaret Voltaire and soon in Zürich guild rooms, paralleled the nascent social revolution. Ball grasped this when he wrote in his journal that art was not naively an end in itself—meaning by art the new anarchic Dada art—but was a reflection and reverberation of its time. (5) A week after the first Dada publication, *Cabaret*

Voltaire, on 6 June 1916, Ball wrote in his journal the following notes on the Dadaist:

Now that the bankruptcy of ideas has stripped man's image down to its inmost layers, the background instincts are moving out pathologically into the open. Now that no form of art, politics, commitment, can contain the dam-burst, all that is left is the blague and the bloody pose . . . The Dadaist fights against the agony and death-throes of the age . . . He knows that the world of the systems has disintegrated, and that the age, pressing for cash payment, has opened a jumble sale of now profanized philosophy. Where terror and a bad conscience begin for the vendors, there for the Dadaist begin gales of laughter and a quiet sense of relief. (6)

Ball's attitude is ambivalent. 'The Dadaist fights against the agony and death-throes of the age.' In the Dada manifestations, this ambivalence—Dada as constructive anarchy and Dada as destructive nihilism—is evident in little more than the printed programmes, which mix mildness with a promise of fury. This is what was advertised for the 'Author's Evening' of 14 July 1916, at 8.30 in the Waag guild room: Part I—piano music by Hans Heusser, 'exotic dance rhythms'; prose and poems by the whimsical Emmy Hennings, read by herself; Hans Arp discussing his *papiers collés*; Hugo Ball reciting 'Gadji Beri Bimba' (a sound poem); Tzara's simultaneous poem 'La fièvre puerpérale' ('Puerperal Fever'), recited by Ball, Huelsenbeck, Janko and Tzara, with masks by Janko; two supposed Negro songs, the first 'performed' by Ball, the second sung by Huelsenbeck and Janko. Part II—Janko discussing his paintings; more music by Hans Heusser; a 'poème mouvementiste' by Huelsenbeck and Tzara, with masks by Janko; three Dada dances by Emmy Hennings, with masks by Janko and music by Hugo Ball; a poem called 'Mpala Tano' by Huelsenbeck; and a 'Cubist dance' devised by Ball and performed by Ball, Hennings, Huelsenbeck and Tzara. It looks demure enough, and genteel enough to entice the ladies in furs and men with little notebooks, and pocket-books—lovers of art. This was intended. These artists had to live. But Tzara has described the evening, perhaps with some *fureur de fumiste* as follows: (7)

Before a dense crowd, Tzara manifests, we want we want we want to piss in various colours, Huelsenbeck manifests, Ball manifests, Arp explanation, Janko my pictures, Heusser own compositions, the dogs howl and the dissection of

Panama on piano on piano and wharf—shouted poems, shouts in the hall, fighting, first row approves, second row declares itself incompetent the rest shout, who is stronger the big box is brought on, Huelsenbeck against 200, Flyyyyyyybuttons accentuated by the very big box and bell-ringing with the left foot, protests shouting smashing the windowpanes killing demolitions fighting the police interruption.

Hostilities resumed: cubist dance Janko costumes, each his big box on his head, noises, Negro music / *trabatgea bonooooooo oo ooooo* / 5 literary experiments, Tzara in tuxedo explains, at the curtain, dry, sober, for the animals, the new esthetic: gymnastic poem, concert of vowels, bruitist poem, static poem chemical arrangement of notions, Biribum biribum saust der Ochs im Kreis herum (Huelsenbeck), vowel poem *aaao, ieo, aii*, new interpretation of subjective madness of the arteries the heart's dance on the blazes and the public's acrobatics. More shouts, the big box, impotent piano and cannons, ripping of cardboard costumes the public flings itself into the Puerperal Fever stoppppppp. Discontented newspapers simultaneous poems for 4 voices plus simultaneous with 300 definitive idiocies.

I quote at such length because some current versions of these early Dada displays add to the confusion by telescoping events which occurred on two or three different occasions. It was not on 14 July 1916, for instance, but much later—at the ninth Dada evening, in the Kaufleuten guild room, on 9 April 1919, that Walter Serner made his celebrated (but unpreserved) address to a tailor's dummy. (8) I quote it also to illustrate the background of fury and agitation from which the graver arch-Dadaist Hugo Ball, shortly after this first July evening, retired into the Ticino for a rest, and on which he turned his back for ever in May 1917, to enter political journalism in September the same year. Ball's break with Tzara in May 1917 anticipates in some ways André Breton's in 1921: both Ball and Breton came to reject agitation and the anti-art cult as sterile activities if ends in themselves—dead ends into which intellectual rebels of the time often strayed. For all this, Tzara's manifesto of July 1918 must have seemed at the time like a war whoop against all systems and theories, philosophical, political and esthetic. Its content is not political, but it does express a disillusionment which is not puerile or bogus, and which does at points have political and

social overtones. Tzara said: 'Writers who teach morality and discuss or ameliorate the psychological basis [of actions] have, quite apart from a secret desire to make money, a ridiculous knowledge of life—they have classified, partitioned, canalized life. They try to watch the categories dance while they beat time . . .' And he continued: 'I destroy the pigeon-holes in the brain and those of social organization: to demoralize everywhere and fling my hands from heaven to hell, eyes from hell to heaven, re-establish the fecund whirl of a universal circus, in powers that are real and rooted in each individual's imagination.' (9)

These are still only political overtones. Considering that by this time the Bolshevik Party had been in control of Russia since October 1917, they would seem very mild overtones to anyone expecting to find something like an avowed political credo. It is not, in fact, to Tzara's publicly negative Dada that we have to turn for some evidence of a political side in Zürich Dada, but to certain other artists who had shared in the manifestations but had remained essentially constructive (without being more naive). Among these, many, like Ball, had always seen Dada not merely as an attack on official art, conducted with all the weapons of anti-art, but also as a constructive experiment. They had gone back to fundamentals. It was Hans Richter, who had spent some time in Zürich in 1916 and had been connected with the *Aktion* writers and artists in Berlin, who in April 1919 was instrumental in forming some of the Zürich artists into a group which endorsed the current social revolution. They were called 'radical Dadaists'. There was Richter himself, Viking Eggeling, Arthur Segal, Marcel Janko, Hans Arp, Augusto Giacometti, Walter Helbig, Fritz Baumeister and Otto Morach. This group published a manifesto which asserted that they stood for abstract art as a new 'brotherly' art with a positive role to play in the reforming of society. The group also had a name: *Bund revolutionärer Künstler*, in German, and in French, *Association d'Artistes Révolutionnaires*. It came into being briefly at the moment in April 1919, when the German Soviets, guided to some considerable extent by the intellectuals and writers Leviné, Landauer, Mühsam and Toller, were about to seize power in Munich, and when Bela Kun's Third Soviet International was in control of Hungary.

Yet this group dissolved within a few weeks. Inside a few days the Whites exterminated the Munich Reds. Tzara and

Serner, the systematic iconoclasts of Dada, had not approved of such an association in the first place: it did, after all, contradict their principle of disrule. Strictly nonpolitical artists like Arp must also have had doubts about its purpose. 'Every construction', Tzara had said in his 1918 manifesto, 'converges on perfection, which bores.' And again: 'How can one contemplate ordering the chaos which constitutes the infinite formless variation: man?' (10) All the same, the *B.R.K.* or *A.A.R.* was more than an overtone. Its brief formation coincides with the apparent Bolshevist alignment of the Dadaists in Berlin. Serner himself, who remains the mystery man of early Dada, though he did not actively participate till 1917, vanished without a trace in the U.S.S.R. sometime during the 1920s.

In February 1917 Richard Huelsenbeck had arrived in Berlin. Here he met Raoul Hausmann and Franz Jung. With Richard Oehring, Hausmann and Jung had between them been editing since 1916 the magazine *Die freie Strasse*. Jung and Hausmann were both adherents of the psychology of Otto Gross; and *Die freie Strasse* had been propagating Gross's ideas, as well as those which Jung and Hausmann had developed independently (for example, Hausmann's theory of 'the Clytemnaestra complex'). In 1913 Jung had published a collection of stories, *Das Trottelbuch*, one of the first absurdist books in German prose. During the Dada years in Berlin he also published two so-called 'proletarian' novels. Jung's ideas and Hausmann's were akin to those of the Zürich Dadaists in so far as they presupposed the existence of a middle-class system of convictions, challenged the validity and normalcy of this system's moral and social order, and plotted the demoralization of every aspect of that order. These men, moreover, put their ideas into action. One of their most extravagant and daring friends was the ex-architect Johannes Baader, about whom more will be said later.

By early 1918 a coherent Dada group had come into being. It published a manifesto, (11) and held a manifestation (March 1918) in a till then respectable art gallery. By the end of 1918 the group consisted of Hausmann, Huelsenbeck, Jung, George Grosz, Gerhard Preisz, Walter Mehring, Wieland Herzfelde, John Heartfield, Carl Einstein and some others. They were all highly gifted young men. And Berlin now, of course, was the heart of the collapsed German Empire. The city was rapidly filling with men whom war had mutilated and whose one hope was revolution, but it was already full of others who still knew no conscience.

The German navy mutinied at Kiel on 3 November 1918; on 5 and 6 November the revolutionary sailors seized Lübeck, Bremen and Altona (Hamburg). On 7 November the kings of Bavaria and Saxony fled from their capitals; and in Cologne, Frankfurt, Hamburg and Munich, workers' and soldiers' councils were set up. On 9 November the generals decided to call a cease-fire on all fronts. With the proclamation of a republic, Wilhelm II fled to Holland. But this was only the start. Fritz Ebert, who was elected president of the new republic, headed the Majority Socialists, the S.P.D. This party was not famed for integrity. It had betrayed the pacifist ideals of the international labour movement on 4 August 1914, when it voted for war credits. The Majority Socialists were now rivalled by a younger party, the U.S.P.D. (Independent Social-Democratic Party), but also by the extreme left-wing Spartacists. During the ensuing weeks the Independents failed to reconcile the S.P.D. plan for a middle-class republic and the Spartacist plan for a working-class republic. Gradually the workers' and soldiers' councils were winkled out of their positions of control. But a counter-movement followed. The Spartacists came out on to the streets. Shortly before Christmas there was street fighting in Berlin between the Spartacist groups and the security forces levied by Noske, Ebert's Minister of the Interior. The fighting was to continue, bloodily and in bursts, for several months into 1919. Other great cities suffered the same disturbances, especially Munich in April 1919. In Berlin on 15 January 1919 the two Spartacist leaders Karl Liebknecht and Rosa Luxemburg were seized by Noske's troops. Liebknecht was shot 'while trying to escape'. Rosa Luxemburg was shot while in custody, and her body was flung into a canal (it was recovered only months later). This was a critical turn in events; for to these two leaders had been entrusted the hope that revolution would not stop half-way and swing into reaction—as it eventually did. These things happened three weeks before the First National Assembly of the new regime opened in Weimar on 7 February 1919.

This is, very sketchily, the background of violence against which Berlin Dada has to be seen if it is to be understood at all. To exaggerate the political leanings of the group is a mistake. Raoul Hausmann censures the French Dada chronicler Georges Hugnet for doing this. But to minimize the political leanings is also a mistake. Hausmann himself does to some extent tone things down, though he quotes freely in his memoirs from his

own writings of the time. For instance, he wrote an article for the anarchist magazine *Der Einzige* (20 April 1919), in which he excoriated the German middle class for its teutonic placidity, its smug idealism, its genteel evasions into overblown art, its stingy restraints and its sedentary self-righteousness. He also said that Bolshevism would sweep away these corruptions and make way for fresh values, stemming from incorrupt levels of society—the masses, of course. In another invective of the same period, 'Dadaistiche Abrechnung', published in *Die junge Kunst*, 1919, Heft 1, he wrote: 'Life today, this cataract of insecurity and disintegration, has at last spat out this society [the middle class]; it's no use any more for that society to wall its horizon around with safety devices: the masses are on the march.' (12) Hausmann was in neither case speaking at a venture. He had been brooding now for over two years on the decay of the patriarchal and juridical order of the middle class. Carl Döhmann, though writing later (1920), expressed the same views when he described as a 'Dadatropism' an age's cognizance of its own disintegration. He refers to Spengler, of course, and continues: 'It is the analytic function of Dadaism to jettison a world's horribly ossified basic notions which have long since become a towering system of madness, to reduce them to zero, to dissolve them into that . . . shadowy sea of unsurveyable meaninglessness which can only be represented by metaphors, in the abstrusest absurdities and with ultimate idiocy.' (13) The rare pages of the Dada magazines which appeared early in 1919 are also illuminating: *Jedermann sein eigener Fussball*, *Der Dada*, *Die Pleite* and *Der blutige Ernst*. They show how strongly these young writers and artists felt about the atrocities being enacted on the Berlin streets and elsewhere. *Der Dada*, edited by Hausmann, contained a pasted-in manifesto entitled 'What is Dadaism and What Does It Want in Germany?' The first proposal sounds quite serious, less so some of the following ones. The first is for 'the international revolutionary association of all creative artists and intellectuals throughout the world on the basis of radical Communism.' (14) The same idea underlay the short-lived *B.R.K.* group in Zürich. There is also Grosz's cartoon in *Jedermann sein eigener Fussball* (the only issue was confiscated by the police), which follows the leading article's strong polemic against the First National Assembly. It shows a pope, with steaming pisspots left and right, dangling on strings a puppet labelled Erzberger (who was chief minister in Ebert's cabinet). The

puppet's right hand, extended, vanishes behind a canvas propped
on an easel. This canvas represents 'Der Bolshevismus', here
shown as a skull-headed killer with a belt stuffed with grenades
trampling over a city. From the puppet's left hand dangles an-
other puppet, labelled 'Viktor Naumann Pressechef' (Chief Press
Officer); little figures are rushing from the Bolshevist into the
already crammed gaping jaws of a big popish-mitred face on the
right. The last page of the magazine printed a warning to the
Bavarian revolutionaries: 'The revolution is in peril. Close ranks
round your flag and arm for the fight against the White Terror
of Berlin.' The magazine actually appeared on 15 February
1919, almost two months before this White Terror exterminated
the Munich Reds. It contained also a poem by Walter Mehring,
for which, according to him, (15) he and the publisher Wieland
Herzfelde stood trial. It is hard to tell if the offence was caused
by the antimilitarism or the obscenity of the poem. The poem is
also a satire on the frilly side of middle-class escapist theatre at
the time: it is called 'Der Coitus im Dreimäderlhaus'; the
Dreimäderlhaus, a popular operetta, had a gala one-thousandth
performance in Berlin on 12 November 1918, when the revolu-
tion was nine days old.

The question now is: to what extent were these outbursts
sustained within an actual political strategy? Were they only
brief episodes, an 'eczema of youthful heroism', as Walter
Mehring wrote in his autobiography? (16) Is there another side
to them, which gave Dada in Berlin, as Hausmann claimed in
his memoirs, a character which was by no means exhausted in
political gesticulation? Or can one legitimately speak of a group
of writers and artists which was pro-Bolshevist and anti-S.P.D.
even if it was not perhaps politically affiliated? The documents
continually lead us back to the individuals within the group.
And here there are divergences. We know that only one of the
group had a Communist party card: John Heartfield, the photo-
monteur. (17) We know that his brother, Wieland Herzfelde,
had Communist sympathies, and that he was imprisoned for some
weeks in March and April 1919 as the publisher of *Jedermann
sein eigener Fussball* and some unspecified pamphlets. (18) It is
possible, too, that Carl Einstein's left-wing sympathies date
from these years, or even earlier. But there were other writers
who published in the Dada magazines, John Höxter and Salomo
Friedländer (Mynona), for instance, who were not outspokenly
political. Huelsenbeck, for all his politically shaded aggressivity,

was an ironic man, viewable (at least by Hausmann) as a café-anarchist rather than as a genuine agitator. Huelsenbeck loved provocation at any price, and throve on creating a disturbance. We also know that George Grosz, though he was constitutionally a man with biting hatreds, at his best when hemmed in, as then, by adequate objects of hatred, was not now much inclined to deny his spirit of odium in paradox and to espouse a doctrine. And Grosz is a key figure: his cartoons are the backbone of the magazines *Jedermann sein eigener Fussball, Die Pleite* and *Der blutige Ernst*. The riddle of Grosz at this time and later is only partly explained by his conduct under trial in 1920; but this detail is significant. Soon after the 1920 Dada exhibition in Berlin, he and Wieland Herzfelde were accused of slandering the German military. At the exhibition, antimilitaristic cartoons by Grosz were on show, also a dummy with a pig's head, in military dress, was displayed hanging from the ceiling. At the trial, Grosz was inarticulate. He did not preserve an accusing silence; but his failure to utter a single sensible word could have been the work of fear, induced by the recognition that his inner antagonisms were being aired in public before a father-figure, the judge. Others might equally well say that his conduct pointed to the gulf between art-protest and genuine political action. (19)

Another key figure is Johannes Baader. He was an older man than most of the others, and a Swabian to boot—thus with a centuries-old tradition of quasi-religious eccentricity behind him. He had thrown up his profession to cultivate his eccentricities in a way which makes him seem cousin to the two other early twentieth-century eccentrics, Alfred Jarry and Jacques Vaché. Hausmann knew Baader well and has to be relied on as a source for details here. Four episodes can be briefly retold, since they illuminate certain other than political aspects of the Berlin Dadatropism. Two of these episodes are often mentioned: Baader was the man who rose up in the gallery of Berlin Cathedral and told the officiating priest that he (the priest) did not really care a hoot about God; Baader was also the man who, at the National Assembly in Weimar, showered the assembled delegates with leaflets proclaiming the reign of Dada and his own status as president of the universe. The two other episodes are as follows: one fine summer evening in 1918, Hausmann and Baader were strolling down the Rheinstrasse in Berlin when Baader said that it was the hundredth anniversary of Gottfried Keller's birth (if it *was* 1918, he was a year early). Baader

suggested that they should therefore read some Keller together. This happened to be possible, for Hausmann had a copy of Keller's novel *Der grüne Heinrich* in his pocket. The two men went into the middle of the street and stood under the street-lamp, shoulder to shoulder, and began to read the book in turns. But they read it by taking a phrase here and there, changing the tones and rhythms of their speech, and without any pause. 'It gave it a new meaning', Hausmann says in his memoirs, 'and marvellous combinations.' They ignored the people passing by: 'We were alone in the world, surrounded by the whole world which had vanished into the abyss of our poetic inspiration, absorbed as we were by our new inventions.' After this, the two men went to a bar and conversed for an hour in the psycho-analytical jargon which they had invented, and which contained no single 'normal or regular' word, speaking 'in a state of ecstasy coming from the unconscious which irradiates its mysteries through all things.' (20) The fourth episode, being parody-political, seems to be just as symptomatic of the Berlin Dada state of mind as the deadly earnest of Grosz's cartoons. Baader suggested to Hausmann one day towards the end of March 1919 that they should found a Dada republic at Nikolassee, a Berlin suburb. His aim was to prove that this could be done without violence: the only weapon needed was a typewriter. Hausmann immediately improvised a proclamation of the republic, and Baader scribbled it down in his notebook. All owners of villas were to be declared 'futile bourgeois', and imprisoned if they made a fuss. Baader's plan of campaign was to arrive at Nikolassee at 5.45 p.m. on 1 April, affix proclamations to walls and tree-trunks, then go to the burgomaster and tell him that an independent republic had been declared, and extract from him the borough cashbox and the promise to obey orders. The burgomaster was to be told that two thousand soldiers were ready outside, with rifles and grenades. 'We shall be quite alone', Baader told Hausmann, 'but you watch, it'll make an impression.' Then Baader made a mistake. He wanted to appoint another friend Chancellor of the Exchequer; this friend —he can't have been Dada—took fright and warned the burgomaster. The burgomaster can't have been Dada either, because he also took fright, and (as Hausmann later found out) had a contingent of two thousand soldiers waiting on 1 April to repel the invaders. (21)

When, in January and February 1920, Baader, Hausmann and

Huelsenbeck toured several German cities and Prague with a travelling Dada manifestation, they were not making Bolshevist propaganda, as Hugnet in his Dada chronicle seems to have believed. They were simply earning a living by being provocative; and provocation, by no means political only, was obviously the one role in which Berlin Dada excelled. Baader can be regarded as a not always amiable crank who was molested by the police from time to time because he was a fireball rushing towards dynamite. But in the Berlin setting, Baader's hallucinated behaviour also made him a symbolic figure, for he personified the violent disruptions of these years. In Dresden, Hausmann, Huelsenbeck and he were denounced from the audience as 'Communists'; these performances did, as Hausmann has said, inflame political passions. (22) But then at this time anyone with a little talent could earn the title of Communist or Bolshevist. Even Klaus Mann did. (23) What one must also grasp is this: these men were some of the first men in modern Europe to experience at first hand, and to rebel against, organization turned inhuman. They responded defiantly with a furore of youthful heroism, but also with absurdity and farce. The quality of this response was defensive. It preserved their independence. It was also a means of defying the devil by capping his nonsense. Plainly one reason why they kept their independence was that, to Dada, Communism, like every imaginable system, was necessarily corrupt. A Marxist would add that they could never have become Communists because they were not themselves enough emancipated from their class. They were, after all, middle-class intellectuals themselves. They had rejected their own class's system of convictions, but had espoused no alternative system, except Dada, the negator of systems. For Dada, as Tzara said, 'doubts everything'. The Marxist might see only negative qualities in the values which they did act out: spontaneity (a rare factor in the German mind), a nihilism floating between the sublimely impersonal and the defiantly egocentric, and what Breton was to extol grudgingly in 1922 as 'disponibilité parfaite': complete detachment.

One single publication of the Berlin period is serious and positive in its commitment to the Communist cause. This was Wieland Herzfelde's *Gesellschaft, Künstler und Kommunismus*. (24) This thirty-page pamphlet appeared in 1921, however, and this date makes it a late production, since this was the last year in which Berlin Dada was vigorous. Moreover, Herzfelde was

associated with the Dadaists as a publisher rather than as a crea-
tive artist or perpetrator of eccentric exploits. His pamphlet
dealt with the question of reforming society towards Commu-
nism, and especially treated the effects of this reformation on
bourgeois writers. It attacked the pulp literature and escape li-
terature which was fed to the working man for his miserable
solace (this was before TV and glossy cinema); but it also criti-
cized the tendency of political revolutionaries to misinterpret
the aims of genuine revolutionary artists. The socially 'super-
fluous' writer or artist, Herzfelde maintained, should be sup-
planted by the one who allies himself with the masses. His
function may be to expose the hideous insides behind the fa-
çades of the middle-class value system and power complex; and
to indicate how these deformities can be corrected. Yet art is
not propaganda and it need only be so misconstrued by artists
who refuse to come down from their clouds. Above all, the new
artist or writer is responsible for transforming Communism from
an objective political programme into a principle of living con-
sciousness. The pamphlet needs fuller treatment than can be given
it here. Some of Herzfelde's ideas sound like clichés today. The
Communist reaction against avant-garde experiment was an-
nounced only one year later, in 1922, in Avram Efros' doctrine
of 'Left Classicism', which soon became the official Socialist
Realism. On the other hand, Herzfelde's ideas do in part antici-
pate by several years Aragon's attack on vulgar literature in his
Traité du Style (1928), as well as Aragon's discussion of the di-
lemma of the modern *révolté* artist in the 1920s. In addition, it
is (as far as I am aware) the only discussion which envisages,
during this strenuous period, the creation of a literature which
has assimilated revolutionary ideology and still remains a free
creation of the human mind. And it shows us, once and for all,
how far even the eccentricities of Berlin Dada were removed
from the eccentric gestures of the pre-1914 Banquet Years in
Paris. What we have in Berlin, whether it is Hausmann, Baader,
Grosz, Huelsenbeck or Herzfelde, who is the protagonist, is not
a paroxysm of self-reflexiveness within the middle class, but an
articulate and at points active protest in favour of the working
class—the victims of the bourgeois social system as it then was
in Germany. Soon this trait became a principle of Piscator's
Agitprop theatre; it is a determining factor in Brecht's plays and
dramaturgy of the later 1920s. But it would be wrong to say
that this protest confined itself within a doctrine. The Dutch

Dadaist, Theo van Doesburg, wrote of Berlin Dada in 1923: 'the bourgeois have called Dada Bolshevist, the Communists have called it bourgeois. Dada laughs.' (25) But Dada did also hope. Hausmann, writing in 1921, formulated the hope as follows: 'Upon the period of revolution in art-forms follows the grandiose epoch of revolution in economics and all society, with its laws and institutions. Yet nothing ends without creating something new. We are living at the start of a new humanity, and of a new optics. Each happening in the world means a change in man.' (26) The aesthetic and social revolutions overlap in this formula. But one cannot say that this makes them compatible. Rather the formula suggests that by now, in 1921, for Hausmann at least, art is made for man and not for political convenience, even though it is inescapably a social fact. This was a reflection in retrospect. Four years later, also in retrospect, George Grosz wrote that Dada had only discovered, had not explored, the promised land in which art functioned as a revolutionary force in the class struggle. In *Die Kunst ist in Gefahr*, he wrote:

> our mistake was to have concerned ourselves seriously with art at all. Dadaism was a breakthrough, with much noise and scornful laughter, out of a narrow, self-important and overestimated milieu [i.e., art] which, floating in the air between the classes, knew no responsibility to the life of the mass of men . . . We saw then the insane end-products of the prevailing social order and burst out laughing. We did not see that a system underlay this insanity . . . In the void where we found ourselves after getting beyond the big words about art, some of us Dadaists disappeared . . . But we saw the great new task: tendentious art, in the service of the revolutionary cause. (27)

And later: 'The time is coming, when the artist will be no longer the spongy bohemian anarchist, but a lucid and healthy worker in the collective society.' (28) From the far side of Dada, it does seem that Berlin Dada could have been more political than it was.

Hausmann has called Dada an intellectual and practical attitude without equal in the twentieth century. He thought of Dada as being 'a combat for the realization of an inner, convergent and contradictory equilibrium.' (29) If Berlin Dada is seen as a whole, such an equilibrium can be discerned in it; the foregoing sketch of this phase at least indicates that Hausmann's distribution of emphasis is verifiable, and that it may be more

just than Hugnet's (1932 and 1957). Hausmann's record was, admittedly, written forty years later. But it is a documented record of an experience covering not only the period itself, but also the years on either side of it. Even if it does seem to tone down the political side, that record does attune it to other— nonpolitical or parody-political—aspects of Berlin Dada: it goes further than Hugnet in allowing for the complexity of the experience. But what about Huelsenbeck's assertion in 1920 that Dada in Berlin was a 'Bolshevist affair'? Was this more than a glimpse of the promised land? Or was it, as Hausmann says, hunger for leadership and provocation on Huelsenbeck's part? Had Huelsenbeck limited the full sense of Dada by calling it, however ironically perhaps, a 'Bolshevist affair'? It is natural that these viewpoints should seem to contradict each other. Dada was not something which was ever codified; its force lay in its power to provoke different minds to think differently about it. Yet can these viewpoints be reconciled by reference to a third and contemporaneous view of Berlin Dada? To some extent they can. The view is that of the Cologne Dadaists.

Hugnet testifies that the Cologne Dadaists, Max Ernst, Hans Arp and Johannes Baargeld, did find that the Berlin Dadaists were saddling Dada with propaganda by domesticating it inside a doctrine. It is no wild conjecture if one supposes that they came to think this at a particular moment, and that this moment may not have seemed so particular to Hausmann then or later. The moment was, I think, in the summer of 1919. By then, they would have seen the early 1919 Berlin Dada magazines, including the *Der Dada* Manifesto, which was to set the jazzily political tone of Huelsenbeck's *En Avant Dada*. These magazines and the manifesto probably showed them that Dada's coalescence with doctrine could only make for puerility in politics and impurity in art. There are certain grounds for supposing this. Baargeld and Ernst had themselves published a Communist paper in early 1919, *Der Ventilator*, which was sold at factory gates and on the streets until the British occupation authorities seized all unsold copies. But their second venture, the magazine *Die Schammade*, dated February 1920, was entirely unpolitical. The sharpness of the separation of Dada from politics at this point in Cologne is underscored by the fact that Johannes Baargeld had founded, early in 1919, the Rhineland Communist party, and had affiliated it with the Spartacists. (30) Yet he contributed to *Die Schammade* nothing even remotely connected with his

political role.

Hugnet points out that these men wanted complete creative autonomy for Dada. One might conjecture that Arp was the man whose foresight counted here. On the other hand, it would be naïve to suppose that the anti-art of Cologne Dada—of which the Cologne 1920 exhibition was a classic example—did not by now imply the kind of anti-bourgeois provocation which had become in Russia the official method of destroying the middle-class myth about itself. In Russia, Cubism and Futurism in art had been harnessed for precisely this purpose: the dislocation and destruction of the middle-class image of reality. Yet Cologne Dada does present a relatively early case of tension between two distinctively modern experiments: the one which cultivates the autonomy of art by rigorous technical refinement; and the other which affirms in practice that technique is nothing if not an expression of social mechanics.

Cologne Dada was short lived. But during this time, the collaboration of Max Ernst and Hans Arp resulted in the so-called *Fatagaga* collages; Ernst produced his *Fiat Modes* lithographs; and Arp's poems were published (*Die Wolkenpumpe*) by Paul Steegemann. Dada also continued its adventures in provocation through the 1920 exhibition. This has often been described. All accounts mention certain obscene poems which were recited by a girl dressed for First Communion standing in the narrow corridor which led from the next-door inn to the gentlemen's restroom. Can these poems, one wonders, have mixed obscenity with subversion as did Walter Mehring's 'Der Coitus im Dreimäderlhaus'? Was this one of the reasons which made the police intervene? Alas, no. The only writer who names an author for these poems is Marcel Jean, in his *History of Surrealist Painting*. Marcel Jean had it on Max Ernst's authority that the poems were by Jakob van Hoddis, the early German Expressionist poet who went mad in 1913. Some of van Hoddis's early poems, like the cycle 'Varieté', might have been thought obscene at the time. But he never wrote a political line in his life.

We do not know if any of the Berlin Dadaists were familiar with Bolshevist philosophy and political theory. It might be assumed that John Heartfield and Wieland Herzfelde were not unknowing. In Cologne, Baargeld's political activities presumably had some ideological basis. But for many of the Dadaists, even if they knew Marx, Bolshevism was probably something in the air, which promised to be viable, an aggressive alternative to the

hypocrite mentality of the middle class. For Hausmann, Buk-
harin's theory of the new collective man especially might have
seemed like a political parallel to his own psychology, which
rejected the distortions forced upon the self by the ego. The
German Dadaists in Berlin, generally, saw a blockage of vital
energies in the middle-class idolatry of the ego. Several writers
of the time, notably Leonhard Frank in his war novel *Der
Mensch ist gut* (1918), had diagnosed in the middle-class habit-
narrowed ego a source of uncontrollable malice and real evil.
To the Dadaists, its abolition would admit new sound waves
and light waves into consciousness: a new image of reality
would dawn. Bolshevism suggested a similar refreshment of the
sense of life on the social plane. This correspondence of Dada
psychology and the revolutionary ideology was to be explored
in 1921 by Franz Jung, in his abstruse book *Die Technik des
Glücks*. It is also echoed in the last sentence in Grosz's and
Herzfelde's *Die Kunst ist in Gefahr*: 'All the fuss about one's
own ego is quite pointless.' (31) But by 1925 there had emerged,
in France, the signs that serious *rapprochement* between revolu-
tion in the arts and revolution in politics was beset by problems;
a gulf seemed to yawn between the poetry of the collective
mind and the politics of the collective state.

It was in their strenuous quest for a new sense of life that
Berlin Dada and Paris Dada had common grounds. But Paris
Dada developed, between 1920 and 1922, in an ambience un-
like that of Berlin. In Paris Dada could safely leave politics to
the political, or to the anarchists, and thrive on the tradition
of scandal and buffoonery which had flourished in the arts be-
fore the war. There had been interchanges between Tzara in
Zürich and some young French writers in Paris during 1919.
The French issue of Tzara's *Anthologie Dada* (nos. 4 and 5 of
his magazine *Dada*), which appeared in May 1919, contained
work by Picabia, Cocteau, Reverdy, Soupault, Breton, Ribemont-
Dessaignes, Gabrielle Buffet and Pierre Albert-Birot (who had
edited the magazine *Sic*, 1916-19). Aragon, Breton and Soupault
founded in 1919 the magazine *Littérature*, and published work
by Tzara in it during the course of the year. In fact, the issue
for December 1919 contained both a Dada poem by Tzara and
some early pages of Breton's and Soupault's first Surrealist
work, *Les Champs Magnétiques*. *Anthologie Dada* itself appear-
ed one month after the failure of the leftist coup in Bavaria. But
there is nothing in the French issue that echoes the event. Nor

was there to be anything political in French Dada publications after this. Tzara arrived in Paris in January 1920. On 23 January there was held in the Palais des Fêtes the 'Premier Vendredi de *Littérature*', which is generally accounted the first Dada scandal in Paris. By claiming as their spiritual parents Apollinaire, and before him Rimbaud and Lautréamont, the French writers were linking themselves with the *avant-guerre* experiments. But their assent to Tzara's dazzling idiotisms inaugurated now the shock attack on literature, art and the bourgeois, which Paris Dada sustained for the next two years.

To Huelsenbeck in Berlin this looked like a falsification of Dada: Tzara had fixed it in one exclusive attitude, that of 'abstract art'. To some French journalists it looked like 'Bolshevism', (32) this now being, as in Germany, a term of indiscriminate abuse. To Tzara it looked like the practical demoralization for which Dada stood, and which he had announced in his July 1918 manifesto. In his preface to Francis Picabia's poem *Unique Eunuque* (February 1920), Tzara wrote: 'Only negative action is necessary.' (33) In his 'Manifeste de M. Aa l'Antiphilosophe' (5 February 1920), he said: 'And we are all idiots / and deeply suspected of a new form of intelligence and of a new logic in our own manner / which is not Dada at all.' (34) In his 'Manifeste sur l'amour faible' of December 1920, Tzara combined frontal and rear attack: 'Above action and above everything Dada places Doubt. Dada doubts everything . . . But the true Dadas are against Dada.' (35) And in the same manifesto he said: 'Dada works with all its strength for the establishment of idiocy everywhere.' (36) Tzara's cult of negative values had taken on. Paul Dermée, in the short-lived magazine (it was a folded leaflet) *Z* (March 1920), wrote: 'Dada destroys and stops that.' Aragon, in *Bulletin Dada* (February 1920) wrote not only 'no more painters, no more writers, no more composers, no more sculptors, no more religions', but also 'no more republicans, no more royalists, no more imperialists, no more anarchists, no more socialists, no more bolshevists, no more politics, no more proletarians, no more democrats' and so on, till his peroration: 'enough of all these imbecilities, no more anything, no more anything, nothing, NOTHING, NOTHING, NOTHING.' (37) None of the literary magazines shows political interest—*Littérature, Z, Projecteur, Cannibale, Proverbe, 391*—none even alludes to social revolution, except in one instance. This was the second issue of Picabia's *Cannibale* (25 May 1920). Here the first-page

photograph of Picabia and Tzara seated in an 85 HP·Mercer has the caption: 'Messieurs les révolutionnaires, vous avez les idées aussi étroites que celles d'un petit bourgeois de Besançon' ('Revolutionaries, your ideas are as narrow-minded as those of a *petit bourgeois* of Besançon'). (38) As late as March 1921, when *Littérature* published several pages of statistical tables showing which authors and other personalities, past and present, were liked and disliked by the Dadaist group, Lenin and Trotsky scored very badly indeed. Out of a possible maximum of plus 25 and a possible minimum of minus 25, Lenin scored -3.72 and Trotsky -3.63. Even Dante and Fatty (a Paris hotelier) did better: Dante scored -1.54 and Fatty 5.72. (39)

In Tzara's four manifestos of 1920, he tends to become more and more explicit in his statements about Dada. This reflects, I believe, the internal tensions of the group of writers who were nominally adherents of his schemes. By May 1921 the tensions were public: at the mock trial of Maurice Barrès, Breton virtually censured Tzara for actually being frivolous. What were these tensions? In his 'Manifeste sur l'amour faible', Tzara coined a phrase to describe Dada: 'Dada est une quantité de vie en transformation transparente et sans effort et giratoire' ('Dada is a quantity of life in transparent, effortless and giratory transformation'). (40) This is not only a splendid and apt phrase. It is also a striking example of Tzara's tactical skill within his group. The phrase sustains his own aggressively iconoclastic Dada, with its accent on spontaneity, its refusal to 'classify, partition, and canalize life'. It is also gauged to placate men like Breton who were starting to suspect that this 'sinistre farceur' was an impresario for sterile agitation, without any desire to 'change life' (in Rimbaud's words): Dada, he told these doubters, is 'a quantity of life in transparent transformation'. And it was also gauged to beguile those men who, like Paul Éluard, were anti-literary but still creative inheritors of the *simultaniste* poetry of the prewar years: 'transparent, effortless and giratory transformation' would have rung true to them. They would have recognized in it the symbol of the gyroscope which, as Roger Shattuck has shown, had been since Jarry the emblem of simultanism in modern poetry and art. (41) Yet Tzara's phrase sparkles up from the deep cleft which is now beginning to split the Dada writers in Paris. It was a question of the 'quantity of life': how far did Dada's demoralizing go beyond negative values, towards creating a new socially and aesthetically viable morality which

would revolutionize modern life? Breton had been identified by
Paul Dermée in May 1920 as the 'moraliste du mouvement
Dada'. (42) And it was Breton who first broke with Tzara's
Dada for the same reasons which were to make the relations be-
tween Surrealism and Communism so ambiguous later on. To
Breton, Dada's 'quantity of life' was not enough, because it was
self-negating. Tzara, also, was not being sincere: he had made
Dada's 'negative action' into just another way of sitting down.
(43)

Anti-art in the service of sterile agitation was the aspect of
Dada which Breton now judged to be remote from the actual re-
volutionary mood of the time as he understood it. For this
reason, he did not contribute to Tzara's Dada exhibition in the
Galerie Montaigne in June 1921. Soupault, Éluard, Ribemont-
Dessaignes, Péret and Aragon all wrote pieces for the catalogue,
and all contributed artefacts to the show. Yet in time these men,
too, were to abandon Dada for Surrealism, after the Congrès de
Paris in 1922. Was this split, as it gradually opened during the
years 1921 and 1922, motivated by political interests? Doubt-
less such interests were there. Malcolm Cowley, who knew most
of the Paris Dadaists, and who followed (with reservations)
Edmund Wilson's view of Dada as a negative end-phase of the
Romantic 'religion of art', wrote in 1934 that 'Dada manifesta-
tions were ineffectual in spite of their violence, because they
were directed against no social class and supported by no social
class.' (44) His retrospect's Marxist terms cannot be wholly dis-
sociated from what he saw in retrospect: he also wrote of the
'fierce moral convictions' among the writers whom he knew;
(45) and he alluded to his own political excitements of the time
as if these were an infection from Dada. (46) There might be
reason enough to suspect that the grapplings between Surrealist
writers and Communism in 1925 do date back at least to 1922,
when nonpolitical Dada lost its hold on so many of its adherents.

Yet this is made unlikely by the existing documents. Cowley
did not see how Dada, in its origins and as a whole, marked a re-
vival of another Romantic theme: art as the spontaneous utter-
ance of life itself. If one overlooks this, and conjectures that
Breton rejected Dada because it was not political enough, the
way in which he stated his rejection makes no sense at all. On
1 September 1922 Breton included in the fourth and last issue
of the new series of *Littérature* a translated extract from Huel-
senbeck's 1920 pamphlet *En Avant Dada*. It was the passage

which denounced Tzara for fixing Dada within the exclusive scope of abstract art, and thus for betraying the true aim of Dada, which was to tolerate no fixation, position or attitude whatever in its immediate revolutionary relation to modern life. Dada had set out to catch reality red-handed; but Tzara had cloistered it back into art and literature; and these, Huelsenbeck believed (Breton agreed), are highly suspect things. In his remarks on this extract, Breton did not refer to what Huelsenbeck had said about Bolshevism elsewhere in the pamphlet. And he made no statement that was suggestive of some political view. Breton was evidently determined to unmask Tzara from inside Dada itself: Dada, that is, not as doctrine, aesthetic or political, but Dada as violent intellectual revolt against the 'consoling myths' which, in art or politics, block the free exploratory play of imagination. Huelsenbeck's remarks suited his purpose very well. And it would be altogether naïve to conjecture that Breton had political motives on the grounds that he chose not to mention them. What he said was that Dada in Paris had given its lesson in 'disponibilité parfaite', and that thereafter each man must press on by himself, finding his own way, and not stopping where Dada now had landed him. (47)

What this investigation shows is not, I hope, a pedantic attempt to prove the self-evident. Uncertainties have surrounded this topic for some time, which has been natural, considering Dada's intrinsic ambiguities as well as the rarity of the documents. From this reconstruction, on the basis of the documents, one can conclude that Dada's political horizon was such that it should be neither generally assumed nor generally ignored. To adapt Huelsenbeck's phrase: Bolshevism in Dada was primarily a German affair. But only for the few months between January and April 1919 did Dada's political horizon so contract that Bolshevism thrust across into the foreground. And even then it was endorsed without unanimity. In each phase of Dada, there were factors which strained against political engagement or ideological commitment in any accepted sense. Bolshevism's appeal consisted probably in its promise to blast and destroy accepted values. The new kind of human being which its project for society envisaged was also a matter of interest. Yet a wry reflection on this promise is the fact that Dada's decline should have roughly coincided with the first epiphany of totalitarian Communism at the tenth Congress in 1921.

Because the documents need not give the complete picture,

some uncertainties remain. But this reconstruction shows too that in Dada were prefigured the schisms and tensions within Surrealism's espousal of the consoling myth of social revolution. Dada's negation of all consoling myths no doubt accelerated its own decay. It could not abolish the will-to-utopia. Yet its work was done. Before Dada, men of insight had seen through the modern consoling myths, in art or politics, as evasions of a deep fear that unmeaning dogs human experience: Alfred Döblin, for instance, in his novel *Die drei Sprünge des Wang-Lun* (written 1912-13). Dada acted ruthlessly on this insight. At its purest, as in Arp's reliefs, sculptures and poems, it affirmed unmeaning as a tenacious factor in human experience, and as a source for new ideas of order. In doing so, it devised, like the hypothetical buffoon in Dostoevsky's *Letters from the Underworld*, all kinds of enormities, 'purposely becoming idiotic', and insisted by this that men are not 'the keyboards of pianos' —nature's automata or lubricants in some colossal self-cancelling civilization machine. For an instant, after Dada, the consoling myths of the 1920s and the 1930s could be picked out on the horizon, sharply and unmistakably, as fictions which intelligence may create out of its frustration, and to which it may submit in its fear of freedom.

DADA VERSUS EXPRESSIONISM, OR
THE RED KING'S DREAM

THE PATINA now forming on Dada and Expressionism makes them congenial to the antiquarian. But Dada's quarrel with Expressionism during the years 1916-20 raised issues which are still hotly debated. Two of these issues claim particular attention, for they are typical of twentieth-century antagonisms. They are: the relation between intellectual revolt and social revolution, and the question of modernity in the style of contemporary literature and art. As it took shape, the quarrel defined its own area; but even within this area it was not so nugatory as to be not worth recovering from apparent oblivion.

The earliest testimony to friction between Dadaists and certain Expressionists and Activists was the arrangement of clients in the Café Odeon in Zürich early in 1917. Hans Arp tells that the two groups sat at separate tables, (1) and he gives names which correspond to those in Hugo Ball's contemporary account. (2) In one group sat the Dadaists: Arp, Ball, Huelsenbeck, Hennings, Janco and Tzara; and in the other group sat Ehrenstein, Frank, Rubiner, Schickele, Strasser and Werfel. Ball jocularly defined their differences: the Dadaists represented 'die ästhetische veranlagte Spezies', while the others were 'die Moraliker'.

The Dadaist Ball, however, was friendly with Schickele and Frank. Also, prior to his coming to Zürich in 1915, he had been a contributor to Franz Pfemfert's radical left-wing and avantgarde magazine *Die Aktion*. In addition, he had had much to do with Kandinsky in Munich, where he had tried to establish an Expressionist theatre. So in 1917 the differences might have seemed less obvious than they soon became. Yet in Zürich in 1917 an important crisis did occur. It occurred on the evening of 19 May 1917. On this day, the first issue of Ludwig Rubiner's Activist *Zeit-Echo* had appeared in Bern; and in the evening Ferdinand Hardekopf, till then associated with the Expressionist and Activist group, read some work at a Dadaist meeting. Ball reported (in the letter already cited) that this caused a furore. It made matters worse when only a few days later, just before Whitsun 1917, he himself suddenly left Zürich for Magadino. To the Dadaists in Zürich this looked like desertion into the other camp.

But in fact there were three sound reasons for Ball's flight. Tristan Tzara, with whom he had founded the Dada Gallery in

March, had loaded him with all the paper-work and he was tired out; he was also under pressure to earn money—Emmy Hennings and her ten-year-old daughter were dependent on him; and Dada had, in addition, brought him in his intellectual life to an impasse out of which he had to break in his own particular way. He had reached the impasse, however, to a greater extent as the result of his private quarrel with the Expressionists and Activists. This had been going on for more than a year before the May 1917 crisis. Among the Dadaists, Ball is marked as a special case by two factors: he was by far the most widely read of his confederates; and his earlier involvement in Expressionism in Berlin and Munich had kept him closely in touch with precisely those political questions with which the 'Moraliker', Rubiner and Frank, were concerned. His unpublished Heidelberg thesis had been on Nietzsche—'und die Erneuerung Deutschlands', and he had also brought with him to Zürich a selection from Bakunin which remains in manuscript to this day. After meeting Rubiner and talking with him on a May evening in Zürich in 1915, Ball thus wrote in his journal: 'Perhaps we shall be friends.' (3)

Yet Rubiner is not mentioned again in the journal until September 1916. A writer whom Ball did see often after April 1916 and whose name recurs frequently until December 1916, was Leonhard Frank. (4) In Frank, Ball was faced with the type of the Expressionist 'Schrei' writer: he noted how Frank had the idea of 'living the absolute' in his own person. But, he remarked, neither bohemians nor Expressionist writers are suitable exemplars in this adventure [121, 7 November 1916]. For Ball this was an acute problem, not least because of his religious and psychiatric interests. But it is also a problem which recurs throughout Dada's quarrel with Expressionism and Activism. The antagonism can be gathered by contrasting two typical statements, one from either side: the Activist Kurt Hiller says, 'Wir wollen, bei lebendigem Leibe, ins Paradies'; (5) but the Dadaist Ball says, 'Wir leben ja nicht in freien Zuständen, sondern in der Hölle, mein Kind.' (6) This contrast is in some ways the pivot of the whole debate as Ball saw it in its origins and as it later developed in Berlin. The Activist, as Utopian pilgrim of the absolute, with his grandiose abstractions and his middle-class 'Gemüt' is viewed by the Dadaist as a pedant, an anachronism and a hypocrite. Thus Ball viewed Frank's novel *Jürgen Irrsinn* (which he helped to type) as mere literary 'Schöntuerei' [122].

Early in 1916 (26 February), poems by Werfel, Morgenstern and Lichtenstein had been read in the Cabaret Voltaire, less than three weeks after the opening night, on which poems by Kandinsky and Lasker-Schüler had been read [71, 72]. And in his journal entry relating to the miscellany *Cabaret Voltaire* (June 1916) Ball wrote with some pride that all avant-garde groups, including Expressionism, were represented in it [91]. It is doubtful if Werfel, for one, would have been admitted once the friction between Dada and Expressionism had reached the pitch of 1917. But to the Expressionist Kandinsky Ball returns very often for orientation in his thinking about the new freedoms in German avant-garde art and literature, of which Expressionism had been till now the spearhead. Before 1915, as the 'Vorspiel' chapter of his journal shows, Ball had seen in Kandinsky not only a supreme artist but also a creator of a new world [8]. Kandinsky's vision was, to Ball, 'die Wiedergeburt der Gesellschaft aus der Vereinigung aller artistischen Mittel und Mächte'; and this laid upon the artist a special responsibility—'die Konvention zu durchbrechen und zu erweisen, die Welt sei noch immer so jung wie am ersten Tag' [10]. Here there is an evident link with the 'paradise' notions of the Activists, with their Utopian 'passéisme à reculons' (to adapt Marinetti's phrase). But Ball insisted that Kandinsky's theories, and others, should be applied not only to art but also to man as a concretely existing person: 'Um den Menschen geht es, nicht um die Kunst, wenigstens nicht in erster Linie um die Kunst' [76, 5 March 1916].

Common to these reflections on Kandinsky is the existential accent. Moreover, Ball had every reason to connect Kandinsky's art and theory with what Worringer had in 1911 defined as 'transcendentalism' in art: abstraction not as a logical or rhetorical mutation of reality, but as a function of man's instinctive need for redemption. (7) In fact, three notions are involved: (I) modern society must be reformed; (II) modern art has a role to play in this reformation, a role that is at once iconoclastic and constructive; and (III) man, existing concretely, with his inalienable 'Erlösungsbedürfnis', is the measure of reform. By 1916, however, fresh dilemmas have arisen. The anthropocentric image of reality no longer holds good, since man is no longer assured of unity of consciousness, and accordingly his revolt against the obtaining orders is undermined by doubt about his freedom in both moral and aesthetic spheres. The three notions

appear singly or together in varying forms in all later Dada invectives against Expressionism and Activism; but almost invariably they are qualified by the new dilemmas. Even in 1916, at least to Ball, it seemed that Kandinsky's original vision had been obscured, that too much was being taken for granted, and that false accents had entered the social and political thought, as well as the literary style, of many Expressionists and Activists. Two symptoms of this were their sententious meliorism and their sentimental individualism.

Ball's own crisis seems to have come to a head through his lecture on Kandinsky, given in Zürich on 7 April 1917. (8) This summarized his own findings in the sphere of modern painting: its characteristic fragmented image of reality recording the irregular rhythms of the modern creative mind and its loss of stable perspectives. But the next day, Ball noted in his journal: 'Ist die Zeichensprache die eigentliche Paradiesessprache?' [148]. And in May his doubt—as well as his metaphysical frustration—switched to Kandinsky's art itself. He asks then: Kandinskys dekorative Kurven—: sind sie vielleicht nur gemalte Teppiche (auf denen man sitzen sollte, und wir hängen sie an die Wand)?' [161]. His feeling now is that abstract art—the authentically modern art—is bereft of any vital relation to archetypes and can therefore result in 'mere' ornament. The year before, in August 1916, Ball had written that 'Logos' should not be confused with either logic or phantasy—but that we do happen to live in a 'phantastic age' [102]. By May 1917, however, the compromise had become intolerable. Ball then wrote in his journal (11 May 1917), that the new art is deceiving and diabolic in so far as it is not founded in 'revelation and tradition'. (9) It is art which makes only false pretensions to visionary plasticity. It is art which does not meet the existential needs of man confronted with chaos in history and in himself. The modern experiment in the arts had been an attempt to make do without revealed or traditional values in the face of chaos and in the cause of social revolution. To Ball, abstract art and Utopian politics are equally evasions of this central question, and they do nothing to solve the new dilemmas, nothing to reconstitute the crumbling fabric of society and art.

As Ball came to doubt genuine abstraction in painting, he also came to doubt false forms of it in language. A hostility to abstraction in language took shape in some of the Dada experiments in poetry in early 1916. On 18 June 1916, Ball noted in

his journal that the Dadaists had taken the 'Plastizität des Worts' about as far as it could go [95]. Sometimes it is supposed that the Dadaists were ultra-abstractionists: that by sacrificing logical sense and by admitting chance in their simultaneous and sound poems they aimed at abstraction, a direction predetermined by iconoclastic and cathartic impulses. But it must be borne in mind that this 'plasticity of the word' was arrived at by the emancipation of words from the old rhythmic moulds, from normal syntax and from commonly corrupted usage; and that Ball inclined, under Arp's considerable influence, to view this as the establishment of a verbal counterpart to the new 'concrete' art, or at least of the rudiments of a purified language for the logic of imagination.

The common usage of the Activists, on the other hand, throve on abstract jargon of the 'superlative' and 'gesticulating' kinds, to which Ball strongly objected—'Wie kann man sich schützen?' he exclaimed in November 1916 [111]: how can one shield oneself from the melodramatizing habit of mind which was not only current among the pamphleteers of the day, but was also ingrained in writers as far back as Kleist, Wagner and Nietzsche. Ball related this habit to abstraction, and later even traced it in Kant's 'Verhaspelung der Vernunft in der Reflexion' [202]. In March 1916 he had deplored the dislocation of levels in culture when he noted, with something like a sigh, that it was unthinkable to sing a folksong in the shadow of Thomas or Heinrich Mann [76]. A remark in December 1916 seems to sum up his hostility, as a Dadaist, to the superlative and abstractive tendencies which flourish in such dislocation, as well as to the moralizing tendency which went with them: 'Ich bin nur ein Künstler im Kleinen, ein Kabarettist. Was wäre es, wenn ich Moral predigen wollte?' [134]. Long before this, in 1915, he had suspected that the meliorism of the Activists betrayed their frustration as poets [53] rather than any grasp of essentials as moralists. His knowledge of his own strict limits as a poet showed him this ingredient of Activism from the inside.

What Ball exacted as a Dadaist was magic in the creative process, uttered in notations of the concrete absurd. As a social revolutionary he again exacted concreteness of utterance—for the sense of fact, not least as a corrective against the psychological imbalance of other conspirators. What the Activist practised, in his poetry as in his pamphlets, was quite the reverse: 'gesticulation' (Rubiner), 'Ratio' (Hiller) and abstraction, all in aid of an

indefinite 'Humanitätspropaganda'. (10) Yet even the new art in the Dada experiments gave Ball small satisfaction. By April 1917 he is asking if the purism of 'absolute' dance, poetry and visual art is not symptomatic of some malaise [152-3]. The slightest external stimulus sets off the greatest psychic resonance; but the resonance manifest as imagination in art has no more to show than 'Fiktionen und Bilder' which, being not objective but wholly medial, merely distract 'mit den erstaunlichsten Lügen und Vorwänden' from the wounds which experience inflicts. Rightly or wrongly, Ball concluded that these explosions of absolute imagery mark a disintegration of the western creative mind as hitherto conceived [156].

His doubt concerned both Expressionism and Dada. Yet against this negative evaluation of the 'spiritus phantasticus' in the new art must be weighed the fact that Ball believed Dada to be both a requiem mass for a perished age and the primitive ushering-in of a new age: 'Die Dadaisten sind . . . Wickelkinder einer neuen Zeit' [93]. Despite his anti-Expressionism, despite his critique even of Dada experiments, Ball was not turning traitor to Dada when he went to Magadino in May 1917. As late as 1926, after his researches under de Sanctis in Rome (1924-5), he is still reflecting on Dada, though he does not name it, when he defines in his essay 'Der Künstler und die Zeitkrankheit' the therapeutic nature of modern experiments in religious and psychiatric terms, and tries to redefine Dada as an authentically modern style. (11) What he feared, however, as early as 1917 was that this new art in either Expressionism or Dada was a symptom of an age sick unto death, and not objective art, thus not authentically visionary art. For him, a deadlock had been reached. Dada had asserted itself precisely as a voice and not as an echo, not as a reflex action of social chaos, but as an initiatory and concrete utterance of the autonomous logic of imagination. Dada was an attempt to reinterpret those reserves of mind which constitute all art and literature, no longer now through traditional canons, but in spontaneous lyrical terms and by the game with chance. Yet it had come to seem like little more than an exclusive and hubristic form of autotherapy.

But in May 1917, sceptical enough to doubt his own misgivings, Ball defended himself against the Activist Rubiner, when the latter accused him of 'making propaganda against art' [160]. He knew well enough that the 'Literat' who negated, for political reasons, any exclusively aesthetic approach to art or

literature, would not have understood his own doubts. Yet on
the surface it might seem that Ball had come close to the Activist
position. For had not Rubiner glorified the 'Literat' as the new
type of committed writer, who is no longer the insulated
'Dichter', but the intellectual whose creative work is a social
therapy for the 'wounds', a means to the reformation of the
human community? However, there is a clear distinction be-
tween Ball, the tired Dadaist, and the meliorist and Activist
Rubiner. Rubiner had written in 1913: 'Die heu-
tige Dichtung wird wieder eine Dichtung der Werte.
Sie wird auch schon, in einem erneuten Sinn, politisch.' (12)
Against this political accent of the new 'Dichtung der Werte'—
itself a reaction against the sacerdotal formalism of the 'Hof-
prediger' Stefan George—Dada had reacted with a poetry of
'Ohne-Sinn ... was nicht Unsinn bedeutet.' (13) And Zürich Dada
stood apart from the struggle for power. To the political gesticula-
tion it preferred the psychological gesture of donning the mask,
and it cultivated an atmosphere which Francis Picabia, in his poem
Télégraphie sans Fils, called 'l'atmosphère énigmatique et mas-
quée'. (14) 'Zwischen Sozialismus und Kunst kann ich keinen
Ausgleich finden', Ball noted in March 1917 [142]. And then
on 20 June 1917, he elaborated this in terms which define, once
and for all, the gulf between Dada and Activism:

> Es ist ein Bestreben, den innersten Rahmen, das letzte Ge-
> fängnis der geistigen Person zu erfassen. Die Entwürfe rühren
> an jene prophetische Linie, die den Wahn begrenzt. Zwischen
> dieser Sphäre und der greisenhaften Gegenwart liegt eine
> ganze (soziale, politische, kulturelle und sentimentale) Welt,
> auf deren Vorstellungen der Künstler verzichtet. Der Kampf ge-
> gen die daher rührenden Phantasmen ist seine Askese [166].(15)

Yet why is Ball found in Bern in September 1917, writing poli-
tical leaders for *Die freie Zeitung*? He needed money, of course.
But his presence there also meant that he was carrying his struggle
for the right style straight into the Activist camp. As already
suggested, his motives for doing this reveal that the friction be-
tween Dada and Activism—or the Activist wing of Expressionism
—was just as much a question of style and tone as one of con-
flicting ideas about the relation of poetry to the social revolution.
To overlook this ingredient of the quarrel is to misjudge the
proportions of it, as is the case in Wilhelm Emrich's recent
thoughts on Dada. (16) Emrich alleges that Dada exploded the
'Absoluta' which Expressionism had set up in reaction against

nineteenth-century relativization of values. Yet both Ball and Huelsenbeck (later in Berlin) were repulsed in equal degree by absolutist thinking and by the lofty phrase-making on which it throve. Ball's reflections on Kandinsky show how he was correlating reform in art and society. But of the romanticism in any such correlation he was critical. He had noted in November 1915: 'Den Jargon des Abstrakten vermeiden' [67]. On 6 April 1916, he vowed: 'Den Sinn schärfen für die einzigartige Spezialität einer Sache. Die Nebensätze vermeiden. Immer geradezu und direkt vordringen' [83]. Between these two statements had come his recognition that Hans Arp, too, whom he viewed as the prototype of the Dada artist, had rejected the inflations of the Expressionists and was paring imagination down to its core [74]. (17) Stark analytic prose was Ball's imperative. The Activist, on the other hand, had the bombastic tendency applauded in 1913 by Stefan Zweig in his essay in *Das neue Pathos*: 'Nicht für leise Stimmen ist es geschrieben [das neue Gedicht], sondern für laute, hallende Worte [*sic*] . . . Und dieses neue Pathos . . . ist vor allem Lust, Kraft und Wille, Ekstase zu erzeugen.' (18) Even Rubiner did not avoid this tendency, though he was the least pretentious and the most clear-headed of the Activists. But even before he went to Bern, Ball had defined the central stylistic problem of the politico-literary ambience of the time. He was one of the many writers of the time whose belief in social revolution began with the experience of intellectual revolt. But he was one of the few who dispensed with rhetoric, and whose social thinking was not blunted by the prevalent metaphysical frustration. For him, realistic discussion of social and political questions was impossible without abandonment of 'literary' politics. A style had to be found which would cut off the supply of melioristic gas which spreads from the sick modern psyche into the modern political brain and prevents men from acting in the knowledge that 'we are living in hell'. This kind of realism is one aspect of Dada which is seldom noticed. The Berlin Dadaists were also realistic, though with different motives; for the Berlin Dadaist resembles Wyndham Lewis's 'Panurgic-pessimist, drunken with the laughing gas of the Abyss'. (19)

What we find then between 1916 and 1917 is a conflict of ideas which also assumes the form of a quarrel about style. Comparison between Ernst Stadler's poem *Kinder vor einem Londoner Armenspeisehaus* and Rubiner's *Dieser Nachmittag* shows the decisive stylistic change which made it possible for

this conflict to develop—but only after 1914. The fine observation and level voice of Stadler's pre-1914 poem enshrine profound compassion for a few starved children queuing up for a meal before bed. But *Dieser Nachmittag*, published in 1916, amplifies every detail of a near-plagiarized scene to such an extent that the queue stretches right round the world and the hungry oppressed masses forming it contrive to enter the Millennium. (20) Now Dada may well have had little in common with the later phase of Expressionism in which it began; but it is sometimes thought to have had something in common with the early phase before 1914: with Lichtenstein, Hoddis and possibly Stramm. Certainly Dada did canalize the strong absurdist element of early Expressionist poetry into the mainstream of modern poetic experiment, which flows into French Surrealism as the idea of a non-literary literature. But even the link with early Expressionism is made dubious by two factors. In the first place, a mutation had entered the language of poetry with Dada's outleaping not only of logical sense and verisimilitude, but also of the associative, 'visceral' and 'neural' modes in image and sound which early Expressionism had first developed, and which became ingredients of Walden's post-1914 'Wortkunst' theory ('Neuro-Mantik'). Prior canons of *self*-expression were discarded as being no longer commensurate to the Dada mood, with its sensitivity to the new tempi of life under pressure from chaos in the psyche and in the external world. This dissatisfaction had first been propagated in the Futurist imperatives of anti-art and anti-poetry, of 'audacity and revolt', which first found constructive expression in the Dada poetry of the Zürich period: Arp's *Wolkenpumpe* poems (written 1917), Huelsenbeck's *Phantastische Gebete* (1916) and Tzara's *Vingt-cinq poèmes* (1916). The second factor was the political mutation within the Left, which resulted for the Zürich Dadaists in a disillusionment not undergone by the early Expressionists, and for the Berlin Dadaists in a state of mind which carried antipathy to Expressionism as a whole even further—well beyond the sense of the particular.

On 4 August 1914, the Social Democratic Party had voted for war credits; and this had been widely viewed as a betrayal of the whole anti-militaristic policy of the international labour movement up to that date. The intellectuals, among them the Expressionists and Activists, divided now between Marxist Centre and Marxist Left, were ideologically at sea; but their disillusionment was not complete, and they maintained the

humanitarian front in the form of abstract and Utopian schemes for mankind's eventual betterment. The Zürich Dadaists, on the other hand, had been more radically sceptical. With them, political disputes took second place to fervour for the new freedoms in art. Yet, as Ball's journal shows, these new freedoms formed only a thin skin insulating their constructive experiments from the destructive political vacuum of war then consuming the world around. Also the destructive element in anti-art itself, bared with such nihilistic glee by Tzara in his manifesto in the Zunfthaus Meise on 23 July 1918, made for another tension which became increasingly less fertile. But it is likely that for German Dada at least the taboo on politics had been broken even before Tzara's manifesto. For probably prior to the Berlin Dadaists' first appearance in March 1918 (one year after the outbreak of the Russian Revolution, and six months after the Bolshevik group took control in Moscow), they had adopted Communism as a convenient weapon against Expressionism and all that it represented. Communism appealed, of course, to the aggressive and anarchic instincts of many intellectuals at the time. But this was the first occasion on which it became the political credo attaching to avant-garde literature and art—a role which it was to play throughout the 1920s and 1930s.

It is in Berlin during the months of violence after November 1918 that Dada's quarrel with Expressionism reaches a head for the second time. The voice of protest is now no longer that of Ball's soliloquy in his journal. It is the loud voice of Bolshevik Dada, with Richard Huelsenbeck as the chief spokesman. The relevant writings here are mainly his 'Erste Dada-Rede in Deutschland' (1918), his complementary pamphlets *En Avant Dada* and *Dada siegt* (both 1920), and certain sections of his article 'Die dadaistiche Bewegung' (1920). (21) Yet when ideological conflicts are being settled in the streets and cafés, there are usually events which momentarily focus the situation more sharply than the shouting of combatants. There is one particular set of coincidences in Berlin in March 1919, which is revealing of the situation there and then. On the evening of 7 March, at about 6 o'clock, soldiers arrested the Dadaist writer and publisher Wieland Herzfelde. (22) With his brother John Heartfield, Herzfelde had founded the Verlag Neue Jugend in 1916; and he was now director of the Malik Verlag. The soldiers confiscated certain books, also the Dada magazine *Jedermann sein eigener*

Fussball (the sole issue of which is dated 15 February 1919).
Herzfelde spent three punishing weeks in prison, without being
specifically charged; and he was released eventually without
a trial. He had been arrested as a fresh wave of street-fighting
broke in Berlin. Between 7 and 10 March Noske's troops in-
flicted heavy casualties on the Spartacist-inspired groups of
working men rising against the new middle-class Socialist regime
of Ebert and Scheidemann, which had convened its first Assem-
bly at Weimar in February, one month after its soldiers had ar-
rested and shot the Communist leaders Rosa Luxemburg and
Karl Liebknecht. But then, on 25 March, only two weeks after
the rising had been crushed, and five days after Herzfelde's re-
lease, there was held in the Blüthnersaal an official reading of
Expressionist 'revolutionary' poems. The poems read were by
Kurt Erich Meurer, Zech, Becher, Hasenclever and Werfel—poets
subscribing to the Activist slogan 'Der Mensch ist gut'. The hall
was only half-filled, but the audience heard Meurer solemnly
pronounce: 'Den Künstler, der berufen ist, das Geist- und Ge-
fühlsniveau des Volkes zu heben, betrachte der Staat als Beamten
der Menschheit und besolde ihn als solchen', and then proceed:
'Das wirschaftliche Moment bleibt ohne Ethos ungestützt. Ethos
ohne die ästhetische Durchleuchtung ist wie ein mineralischer
Körper, dem das Od entzogen ist.' (23)

It is putting it mildly to say that diametrically opposed inter-
pretations of the social revolution are at the root of the conflict
between Dada and Expressionism in Berlin. To some extent,
fluctuations of opinion within Expressionism, including Acti-
vism, are geared to fluctuations between Centre and Left within
the Independent Social-Democratic Party (U.S.P.D.). (24) But
the Dadaists sided with the radical left wing, which militantly
opposed the drift towards a middle-class, and not a working-class,
republic. Even though only one of them, John Heartfield, had a
Communist Party card, (25) the others all avowed hatred of the
middle class, with its compromising left-wing parties, the S.P.D.
and the U.S.P.D.; and all interpreted Expressionism as the art of
this class, with its teutonism, its moribund 'Gemüt' and its
policeman Noske.

Nevertheless, their 'Bolshevism in art' slogan does not denote
strict Communist alignment. On the contrary, the flurry of
short-lived Dada magazines after 1918 indicated their indepen-
dence; (26) for this flurry followed the exclusively Communist
alignment of Pfemfert's *Die Aktion* in 1918. Before this, the

Berlin writers Hausmann, Jung, Herzfelde, upon whose mood the magic word Dada, brought by Huelsenbeck from Zürich in January 1917, had worked as a catalyst, had all been contributors to *Die Aktion*. (27) Even before 1918, these writers had not been primarily political. *Die freie Strasse*, edited by Richard Oehring and Franz Jung, 1916-17, and by Raoul Hausmann, 1918-19, had published texts of psychoanalytic provenance, based on the theories of Otto Gross. Franz Jung's pre-Dada *Das Trottelbuch* typifies the seminal experience of these writers as being an awareness (emotional rather than intellectual) that the world is irremediably absurd, an awareness excluding any belief that social revolution might lessen its absurdity or correct the sense of alienation inherent in the absurdist experience. (28) Even the Marxist element in the vocabulary of Huelsenbeck's 1920 pamphlets (for example, 'ideologischer Überbau', 'Phalanx') is in fact a jargon varnishing a host of notions that are incompatible with Marxist categories. Needless to say, in the 1918-20 situation, the seminal experience does get caught up into political quarrels. And Berlin Dada foreshadows in some ways the subsequent failure of left-wing intellectuals during the 1920s (for example, the French Surrealists) firmly to unmix the motives of revolt and those of revolution. But that the Dadaists should now have clung to their independence from actual Communist ideology reflects not only the likely party view of their conduct (a new twist to the phrase 'Proktatur des Diletariats'), it also reflects their instinctive suspicion that, in practice, the spheres of revolt and revolution collide more often than they collude.

Once this independence has been recognized, one can see that the quarrel between Dada and Expressionism is actually a quarrel between declassed bourgeois intellectuals. This clash of temperaments and ideas within the middle class itself gives reason to suppose that, with few exceptions, both sides tended towards parlour revolution rather than that of the laboratory. Yet the Dadaists tried hard to stand outside the middle class; and their invectives were hurled against the Expressionists as etiolated creatures of a dying economic system and 'Kulturideologie' from which they fondly believed themselves to have escaped. The 'Erste Dada-Rede', a tirade delivered in the name of the new 'Club Dada' at the the first Dada manifestation in Berlin, March 1918, sets the tone for the attack on Expressionism which is to be sustained for the next two years. In this manifesto,

Huelsenbeck attacked Expressionism for its evasive attitude in the face of the cultural collapse of the west. He widened the front later; but basically the argument remains the same: Expressionism comprises a set of false attitudes to the question of modernity in art and to the new rhythm of society; but Dada has dispensed with attitudes altogether, and is the first movement in ideas to reject aesthetic 'solutions' altogether.

Huelsenbeck was very sharp in his attack on the middle-class idolatry of art and the artist. In *En Avant Dada* he named Däubler, Hiller and Edschmid as panderers to a public which wanted art as compensation and obscure idealism as distraction from the immediate. (29) Raoul Hausmann has also told how his friends had been earlier infuriated when Herwarth Walden had published, under the 'Sturm' imprint, a Prussian Song of Songs. (30) In such prevarication, Huelsenbeck found an 'Abkehr von jeder Gegenständlichkeit' and 'Verinnerlichung, Abstraktion'—terms which assume in his argument a purely pejorative sense. This tendency he interprets as a symptom of fatigue and pusillanimity among the bourgeoisie [*En Avant Dada*, 27]. But he claims that the new techniques evolved in Dada art—simultanism and bruitism in poetry, and the new materials in visual art—positively affirm the concrete. He protests: 'Unter dem Vorwand, die Seele zu propagieren, haben sie [die Expressionisten] sich im Kampf gegen den Naturalismus zu den abstrakt-pathetischen Gesten zurückgefunden, die ein inhaltloses, bequemes und unbewegtes Leben zur Voraussetzung haben' [*En Avant Dada*, 28]. He goes on: 'Der Expressionismus, der im Ausland gefunden, in Deutschland nach beliebter Manier eine fette Idylle und Erwartung guter Pension geworden ist, hat mit dem Streben tätiger Menschen nichts mehr zu tun' [*En Avant Dada*, 29]. (31) Expressionism, Huelsenbeck asserts, is the latest vehicle of the system-loving middle-class 'Kulturideologie'; and the Dadaist, who rejects all systems, knows that the time has come 'nun mit allen Mitteln der Satire, des Bluffs, der Ironie, am Ende auch mit Gewalt gegen diese Kultur vorzugehen. Und zwar in gemeinsamer gewaltiger Aktion. Dada ist eine deutsche bolschewistische Angelegenheit' [*En Avant Dada*, 35].

Several authors have remarked on Dadaist nihilism—with its mentality that has pleasure in arousing hate; but few have distinguished this from another ingredient—the enjoyment of a sense of power in desecrating things already dead. And it is no small irony that Huelsenbeck's attack should have come at a

time when, in retrospect at least, Expressionism as a coherent literary movement was a corpse. There seems, at least, to have been no riposte from Expressionism to these attacks upon it. It is, however, less as a literary movement that Huelsenbeck attacks Expressionism than as a symbol of the forces of repression and oppression which emanated from the middle class. And against this enemy he, Hausmann and Johannes Baader ('Oberdada und Präsident des Weltalls') did actually go on a campaign during the months of February and March 1920. They performed in Leipzig, Teplitz-Schönau, Prague (where Baader ran off with the scripts just before the performance) and Karlsbad. Their aim was not to 'generate ecstasy' in the Expressionist manner; far from it, they aimed to provoke and release anarchic, aggressive drives in the good bourgeois audience—by way of primitive therapy, much as the Italian Futurists had done up to 1914. (32) But the element of farce in this, and in Huelsenbeck's heroics (which are no less ostentatious in 'Die dadaistische Bewegung'), should not obscure the real issues involved in such forays.

Huelsenbeck's invectives are aimed against two images of the poet, which seemed to have overlapped in later Expressionism: the older image of the poet as maker of harmonious forms, and its successor—the image of the poet as eruptively vociferous seer. Expressionists like Edschmid had played the second off against the first; but to Huelsenbeck the first was still active as long as writers still decimated implacable reality on the Procrustes bed of aesthetic effect. Certainly, neither image seemed right to the Dadaist in an age of street-fighting and systematic violence. In 'Die dadaistische Bewegung' he wrote: 'We are not living in Attica, but in Germany' [NR, 972]; and he asserted that Dada was strictly of the present, rejecting any abstraction or ideal which evades the multiplicity of the present. This multiplicity Dada embraces—'die ungeheuere Phantasmagorie des Jetzt mit seinen tausend Tiefen und Untiefen, die menschliche Existenz insgesamt mit Mord, Jammern und Kalbsbraten' [NR, 973]. The 'Kalbsbraten' at this point suggest that Huelsenbeck's embrace of violence is defensive; but he does assert, doubtless against the naive pacifism of Hiller and Werfel, that violence is a reality to be mastered; and he concedes nothing to those civilized bourgeois who unpacked their Goethes at the front for spiritual refreshment [NR, 977.] (33) Expressionism, which treats art as a restrictive and compensatory phenomenon, fosters such humbug and is 'ein Fliehen vor der harten Kantigkeit der Dinge'

[*NR*, 977]. Activism, too, which pretends that men exist to be bettered, is blind to the duplicities of the psychic domain as disclosed in modern psychoanalysis [*Dada siegt*, 39-40]. Therefore the Dadaist requires a liberated art which is at once multidimensional and militant: 'Die höchste Kunst wird diejenige sein, die in ihren Bewusstseinsinhalten die tausendfachen Probleme der Zeit präsentiert, der man anmerkt, dass sie sich vor den Explosionen der letzten Woche werfen liess . . .' [*NR*, 977]. This meant, however, that art shed its aesthetic categories and became 'nur Propagationsmittel für eine revolutionäre Idee' [*NR*, 978]. (34) Thus in some measure the opposition to bourgeois ideas and forms of art—Expressionism—is a vote of no confidence in any form of art whatever. Yet it is hard to disengage from the ironies and ambiguities of Huelsenbeck's anti-art theories some rule indicating how far he is prepared to go. It is likely, after all, that he and his fellow-Dadaists would all have ascribed to Emmanuel Mounier's dictum: 'Art is made for man, for everything which serves to fulfil him and his true inner freedom, against all that enslaves or diminishes him.' (35)

As for Activist meliorism, Huelsenbeck's view was that precisely such credos as this diminish man by blotting out certain areas of his inner and outer landscapes. Here he goes all the way, also in his Parthian shot at the intellectual pretensions of Activism—as exemplified, one might add, in such prevaricatory writings as Hiller's 'Ortsbestimmung des Aktivismus'. (36) He writes in 'Die dadaistische Bewegung': '. . . für uns [lag] der Geist keineswegs nur in der artistischen Leistung des Dichters, es war für uns eine Absurdität, die Menschen geistiger und besser (Meliorismus!) machen zu wollen, da nach unserer Ansicht der metaphysische Wert eines "Geistigen" und, um ein beliebiges [!] Beispiel heranzuziehen, einer Giesskanne durch keine intellektuelle Manipulation zu differenzieren war' [*NR*, 978]. As earlier suggested, the absurdism of Dada, in Zürich and Berlin, overlaid a tougher realism than can be found in most Expressionist and Activist writings of the time.

But apart from the old iconoclasm and the old hostility to abstraction, what remains here of the old constructive aims of Zürich Dada? Huelsenbeck wrote in retrospect on the 1920 campaign: 'Wir wollten sie auf ein neues primitives Leben hinweisen . . .' [*NR*, 979]. This sounds rather tame. But read in context it is less so. For the 1920 campaign was meant to shock the narrow mind into recognition of its cultural malaise; to

debunk 'official' art, including official Expressionism; and to show people 'dass ihre Vorstellung von Kunst und Geist nur ein ideologischer Überbau war, den sie sich hier für Geld zu erwerben suchten, um dadurch ihre alltäglichen Schiebergeschäfte zu rechtfertigen' [*NR*, 979]. Now our present view of such aims cannot avoid a certain bias. The word *primitiv* is one of the many which the last forty years have robbed of innocence; and we argue that primitivity, for all its sound and fury, signifies nothing. Moralists, too, disparage Dada as one of the periodic modern outbreaks of intellectual savagery which, by bedevilling intellect, violated the 'dusky body' of the instinctual self. And they argue that Dada misjudged the malevolence active in the new consciousness emerging in Europe as the old consciousness was sloughed. Yet in Dada usage the word *primitiv* did correlate two positive notions: first, the notion of creative spontaneity, which underlay every Dada criticism of teutonism, of routine man and of 'fabrication' in art; second, the notion of 'Weltbewusstsein', as distinct from self-gratifying intellectualism, and with its faintly mystical tinge. (37)

Both these notions lent themselves to distortion, the first into permissive violence, and the second into submissive fears of freedom. It is assuming too much to suppose that the original notions are causally related to the distortions of them. Yet this essay's subtitle is not entirely specious. This altercation in the no man's land between literary and social history is often reminiscent of the quarrel between Tweedledum and Tweedledee in *Alice through the Looking-Glass*. Sometimes Expressionism resembles Dee, who says 'CONTRARIWISE'; and then Dada resembles Dum, who says 'NOHOW'. The quarrel concerns, too, amongst other things, their 'nice new rattle'—the motives of revolt, and the new freedoms in literature and art. Yet sometimes Dum and Dee resemble Activism and Expressionism respectively, and then Dada is like Alice, who can get neither of them to show her the way out of the Dark Wood. At all times all three seem, as did the three in Alice, like figments of the Red King's Dream—the Red King in this case being Lenin, and his dream the abolition of the middle class. Finally, the Black Crow who frightened them away is the shadow of terror which thickened as counter-revolution drifted into Nazism. The analogy holds at several points, focusing the episode, and by no means trivializing it.

THE ART OF UNREASON

THE PAST ten years have seen the formation in England of a climate of opinion which is generally hostile to the various isms associated with art and poetry in the immediate past. This might have been expected. But it is one thing to dismiss the isms as meaningless catch-phrases relating to groups of now fossilized mannerisms, and quite another thing to dismiss as absurd the impulses and creative thought from which the isms variously derived.

This second tendency flourishes most in a situation like the present, in which 'reason' and 'intelligibility' are thought to be desirable in poetry; and in which it is forgotten that the darker divagations of the pioneers sprang from definite psychic needs in a definite historical situation. Dada in particular, having found no adherents in this country (though it became otherwise international), has never met here with any truly reconstructive criticism. And there has been much more a tendency to belittle Dada as just another bohemian jamboree, and to ignore its significance as a state of intellectual emergency, spontaneously born (not fabricated) in a period of complete social and cultural disruption.

The gradualness of the English social revolution underlies in good measure the comparative indifference, as well as the logical consistency, of English opinion regarding foreign social, psychological and aesthetic cataclysms—Dada perhaps more than any other. F. S. Flint's punctual brochure, *The Younger French Poets*, (1920) makes much the same appeal to sanity, against any cult of unreason, as later statements. Yet there is a revealing difference between Flint's views and current ones. He was sympathetically measuring the French Dada poets against a stylistic norm of clarity. He objected therefore to the degree of deliberate unreason in them: Tristan Tzara 'dumps his personality in front of the world without reserve or arrangement: he shoots it as a scavanger shoots rubbish; and his style is strictly adequate'. But of the poems in general, being little concerned with the motives of unreason, Flint wrote: 'They fling a new confusion into the general anarchy and merely add to our hopelessness.' Later writers, on the other hand, are less explicitly orthodox; and they are less concerned with style. They tend to view Dada as an art-movement; to give detailed and savoury accounts of

Dadaist anti-art stunts; but then to conclude by wagging the stern finger of restraint and asserting that Dada is dead.

It is legitimate to say that Dada, as an art-movement, is dead. But it is an error to consider it exclusively as an art-movement. Like Futurism, from which it inherited several ideas including that of public provocation, Dada was from the start not primarily a new set of aesthetic principles (as Cubism was); it was a mood, which became a state of mind, a state of intellectual emergency, which spontaneously took on a subversive character as it affected poets and artists and entered the world of daily life. Are later critics involuntarily holding their nose against the odour of sub-version which the corpse of Dada gives off? Are they, perhaps reluctantly, resisting the lure of the spirits of unrule and obeying the pull of conformity which insidiously commands the present? Do critics now seek to bury the energies of revolt underlying past pioneering movements by fitting them into their unex-amined schemes of dread?

If this is the case, the habit is partly due to the fact that till now, in official histories and in Dadaist hand-outs (like the one which Tzara wrote for *Vanity Fair* in 1927), the accent has lain on destructive Dada stunts and anti-art agitation. This icono-clastic aspect of Dada was primarily exploited by the Paris Dadaists under Tzara's stimulus; and the point of these antics has now been lost. But there are other factors in Dada which make it a richer phenomenon than this. The origins in Zürich in 1916; its constructive role in the arts, which is inseparable from its role as a destroyer of dead weight; the Bolshevism of the Berlin Dadaists during the German Revolution (1918-20); and not least Dada's assertion of spontaneity within the given his-torical context—all these are aspects which have implications for us today.

The German Dada writers are the primary sources here. The reissue of texts and manifestos, as well as the appearance of memoirs, the Hans Bolliger bibliography (which is comprehensive but omits the work by F. S. Flint), a complete chronology, and fresh comment by former Dadaists, now make a new approach possible. Of course much of Dada has been buried by assimilation, into advertisement typography, into the cinema, into jazz and so on. Of course, too, Dada is not alive unless the psychic needs which gave it life are still present. But much of Dada, as a state of mind, is relevant both to the existing restoration of 'reason'

and to the existing avantgardiste stagnation which mutually
feature in the present nomadic intellectual scene.

The Dada state of mind crystallized in Zürich early in 1916,
after initial stirrings in Munich, Berlin and New York. It is too
often believed that Zürich Dada was a deliberate imitation of
the physical battle raging outside. This it was not, though it
could hardly avoid being a reverberation of it. The
time had set up, as Willy Verkauf writes in his
Dada, 'an almost insuperable impasse between civilized
existence and the artistic consciousness of these artists'. The
reverberation takes on a new quality, moreover, in the light of
Hugo Ball's views on the 'mood' to which he gave conscious
direction. In this light Dada crystallized in one of the periodic
crises of western society, when the old disagreement between
official art and living art comes to a head. At such times, the
whole cultural façade of society ceases to coincide with the
concrete situation of artists and men as living individuals. As
Ball saw it, particularly in Arp's graphic work and sculptures
then, Dada was an attempt to tap the pure sources in living con-
sciousness from which the creative impulses spring; and to re-
cover the spontaneity of the individual self not only for art's
sake but also for the sake of human survival.

The catharsis called for a wholesale rejection of the disinte-
grating system of convictions which supported the civilized
middle-class societies then reverting to barbarism in the surroun-
ding war. From here one can see how culture-worship under-
went a violent change into its *Doppelgänger*, iconoclasm. But
one can also see how wrongly the belief arose that Dada is purely
anti-art, or that its iconoclasm excludes all opposing elements.
This belief is wrong because it makes no allowance for the in-
herent ambiguity of every Dada thought and act. It also over-
looks the oscillation in Dada psychology (as in such finished ex-
perimental works as *The Waste Land* and *Ulysses*) between
iconoclastic parody and constructive spontaneity. During the
first months in Zürich, at all events, the mood was one of what
Kandinsky had called 'constructive anarchy'. And it was towards
a recovery of spontaneity that Dada in 1916, and in all its fol-
lowing phases, directed the 'great freedom' which Kandinsky
had named as the tenor of all modern experiment.

Yet in some ways this was a case of the drunken butler following

Caliban's 'hey-day freedom!' call—'O brave monster! lead the way'. And it was fifteen months after the first evening in the Cabaret Voltaire that Hugo Ball began to suspect that the content of the new freedoms, manifested in the sound-poems, simultaneous poems and other primitive displays, was not 'pure' at all, but diabolic. That both he and Huelsenbeck knew that some of the regression-tactics tried in the cabaret were bogus, is a minor point. His real doubts concerned the whole value of any poetry of revolt. Images without root in revelation were merely fresh objects of idolatry, he thought: the Dada experiment cannot produce, it can only reproduce, for there can be no creation from a point beyond parodic antithesis to what already exists in consciousness. Huelsenbeck later wrote that the Dadaist rejects art because it seems to him to be nothing but a moral safety-valve for the convenience of the middle classes. Three years before this Ball began to doubt the foundations even of the new iconoclastic art, whose non-figurative forms had been arrived at in experiments designed to eliminate every narcissistic factor and, incidentally, to reassert the positive autonomy of the creative mind.

Ball knew Rimbaud and Nietzsche well. He now found his own experience confirming theirs. Particularly one saying of Nietzsche's must have rung in his mind—that the realm of modern invention has no original substance, but is a 'carnival in the grand style, the transcendent heights of the height of nonsense', in which the artists are 'parodists of world-history'. Likewise, in Lautréamont, he would have found even earlier proof of the inverse (to Ball diabolic) egotism at the root of the poetry of revolt, the self-worshipping 'gongorisme métaphysique des auto-parodistes de mon temps héroico-burlesque'.

Other Dadaists recognized this. Huelsenbeck's *Phantastische Gebete* (1916 and 1920) are poems which bristle with the qualities which Lautréamont had so acidly defined. But at this stage only Ball's thought moves decisively into line with Kierkegaard's. Anti-literary as the Dadaist mind now was, Ball's scepticism about even the purist experiment gave it a fresh turn which he alone was able to follow. He had founded, with Tzara, the Dada Gallery in March 1917; but soon he fled for the second time to the Ticino (partly, it is true, because Tzara had loaded him with all the work). Then in September he moved to Berne. Here he was at last able to earn a living as a leader-writer; and

gradually he amassed the 'mountain of fire and steel', his *Kritik der deutschen Intelligenz* (1919), which he was to fling into the scales of the German Revolution, only to find himself once more alone, for the book was too radical. Even among Dadaists, whether they were dandies or revolutionaries, Ball seems to have experienced uniquely what responsibilities attend upon spontaneity; and how, as Ortega y Gasset later said, in the sunset of revolution men submit to slavery rather than feel 'the terror of facing single-handed, in their own persons, the ferocious assaults of existence'.

The fusing of the vanguard groups after 1918 did not mean that the centre shifted at once, with Tzara, to Paris. Marcel Janco and Hans Arp were among the artists who remained in Switzerland. The 'New Life' group, of which they were adherents, held in January 1919 an important exhibition in Zürich. These were abstract artists who had been through the Dada catharsis. Marcel Janco introduced their work as meaning a return to 'life', and a constructive use of the new materials: 'We are fighting the lack of system, for it destroys forces. It is our highest aim to bring about a spiritual basis of understanding for all mankind.'

This is a far cry from the strident iconoclastic terror which struck Paris one year later and established the role in which Dada has generally been considered since. The accent on 'life' is consistent with the older Dada dream of admitting new lightwaves and sound-waves into consciousness by abolishing the ego-barrier. But it also brings the aims of the 'New Life' group closer to those of the Berlin Dadaists of 1919, with the important difference that in Berlin, at the axis of the revolution then in progress, it was Bolshevism and not abstract art which held the promise of a 'basis of understanding'. Here art and anti-art had crowded over into concrete life, the life in the streets, whose marvels Futurism had glorified. In Berlin particularly, with officially inflated Expressionist poets now in high esteem, and with Noske's troops shooting down the proletariat in the name of morality, Dada the life-bringer had work to do. Yet by January 1920, the original gospel of spontaneity, now variously spreading from Berlin, Zürich, Cologne and Paris, had created the schism which has persisted ever since. This was the Huelsenbeck-Tzara schism. The first symptoms of it went back to Zürich; but it came into the open when, in the name of 'life', from Berlin in 1920, Huelsenbeck, in Berlin since early 1917, denounced

Tzara's heresy of abstract art.

It easy to say that Dada's doings in Berlin seem idiotic in the light of later political developments: all that shouting in church, and in the National Assembly, all the daft clambering of amateur incendiaries on to the Bolshevik bandwagon. But the Dadaists could not know that they were assisting at the birth of systematic terror. And it was a desperate time, at least for men of genuine principle. Wieland Herzfelde, associated with Dada as cofounder of the Malik Verlag and publisher of Huelsenbeck and Grosz, as well as of the magazines *Neue Jugend* (1916-17) and *Jedermann sein eigener Fussball* (1919), was actually arrested on 7 March 1919, and spent three brutal weeks in prison.

It is wrong of Walter Mehring to omit this fact from his account, *Berlin Dada*. It is also confusing, because Herr Mehring tells that a trial was held in which he and Herzfelde were the accused. Herzfelde, in his pamphlet *Schutzhaft* (end of March 1919) states expressly that he was discharged without a trial; but Herr Mehring now alleges that there was a trial in which the damaging evidence was an 'obscene and seditious' poem of his which had appeared in *Jedermann sein eigener Fussball*. Undeniably a trial could have taken place after Wieland Herzfelde had published his pamphlet, though he says nothing about one in his recent memoirs, *Immergrün* (1949 and 1950). Moreover, if it did, it is understandable that the Dadaists of this time should have found everywhere evidence that their cult of the absurd was a contagion from the very heart of contemporary life. For the poem ('Der Coitus in Dreimäderlhaus', which Herr Mehring does not reproduce), though it is barely intelligible, is obscene and seditious only on a schoolboy level; and though the courts had a mass of graver cases to examine, Gottfried Benn was called as an expert, it is now alleged, and saved the day by lecturing the jury on the links between psychopathic sexuality and literary satire.

It would help to clarify this affair if some report of it had appeared in the papers or current journals; but no trace is to be found. Herr Mehring complicates the issue by saying that the cortège (with a genuine funeral band) arranged to advertise the magazine (the date of publication was 15 February 1919) passed down streets whose houses were scarred by bullets from Spartacist fighting and from the Kapp *Putsch*. Since the Kapp *Putsch* did not take place until 1920, one wonders what else besides has been imperfectly remembered. Herr Mehring also tends to

melodramatize his account of the psychopathic Johannes
Baader's intrusion into the National Assembly. This was in June
1919, though Herr Mehring sticks to his old assertion (in his
The Lost Library, 1951), that it was at the first convening—in
February 1919. The headlines on the next day, moreover, did
not blaze abroad the news that Dadaists had interrupted the
'first National Assembly'. They did not mention it at all, either
in February or in June. It is hard now to laugh about Dada's
doings in Berlin. But it is disloyal, even to Dada's ghost, either
to belittle or cheaply to melodramatize them. What motives
made these men behave as they did? What can these motives tell
us about Dada?

The simplest answer to the first question is that they believed
Bolshevism to be the channel through which the new spontane-
ous life would flow into society. This was not a fond belief. In
February 1919, the Russian Revolution was still only two years
old. Moreover, it seemed like a signal to engage, falling as it did
between Dada's beginnings in February 1916, and its second
epiphany now in Berlin. Seldom, however, did the Berlin Dada-
ists show signs of having understood, say, Bukharin's theory of
the mass-man (though they might have masochistically adopted
it). They would not have been so faithless or foolish as to con-
done Abram Efros's call, in 1922, for a new 'harmonious' classi-
cism—'left classicism', and for the rejection of western modern-
isms as having been outgrown now that the destructive phase of
the revolution, which they had so devoutly served, was past.
And only one brochure, Wieland Herzfelde's very sober and
direct *Gesellschaft, Künstler und Kommunismus* (1921), made
any practical suggestions about what writers should do for the
working-class cause.

The proposals made by Richard Huelsenbeck in his *En Avant
Dada* (1920) are only mock-serious, mostly parodic. For Huel-
senbeck, as much by what he says as by how he says it, asserts
the true Dadaist freedom from all isms and all systems. Huel-
senbeck's mood, again the mood of parody, is more typical than
Herzfelde's of the spirit in which Berlin Dada, as bullets flew, re-
plied to Tzara's call for abstract art with a call for crazy-heroic
action against the forces of middle-class repression. Events had
forced Dada into attitudes of nightmare contortion. But this
was not just the mood of grim nihilism sometimes attributed to
Berlin Dada.

There is no simple answer to the second question—what can these motives tell us about Dada?—for it involves the host of unsolved questions which still dog us. The key to the question seems to be the bond between spontaneity and responsibility in behaviour, thought or art. By severing this bond in a critical period of transition Dada compels us to reexamine the nature of it in a period of illusory stabilization.

In *Civilization and Its Discontents* Freud wrote: 'The crucial problem for humanity seems to me to be whether and to what extent human cultural development will succeed in overcoming the disturbance of social life which results from the instinct for aggression and self-destruction.' This, in a nutshell, is still the problem with which Dada confronts us, whether it is today a question of poetic idioms of unreason, or of those forms of social and political unreason which are the monsters of crisis. Unreason is commonly regarded as an evil, because it is thought to be a mark of man's alienation from his authentic self. But Dada, in its time, or when its time comes, vindicates Dostoevsky's saying that the 'futile and fantastical element' forms part of man's very composition, compels him to resist reason, and to introduce chaos and disruption into everything for the sole purpose of asserting that men are men, not 'the keyboards of pianos'.

Unreason, Dada shows, has a positive part to play in the demolition of systems of conviction which crush man and man's spontaneity. These systems may be obvious, like those which the Dadaists attacked in Zürich and Berlin; or they may be insidious, like ours which impose conformity subterraneously through mass-media. On the other hand the Dadaists then shirked admitting to themselves that their iconoclasm was often the monstrous creature of a conscienceless and not of an heroic imagination. Since, to them, both conscience and intelligence had been compromised, they had little choice. *Prenons garde d'entrer dans l'avenir à reculons.*

Dada shows that unreason has a positive part to play in the making of works of art. Most artists have always known this instinctively. The difference for artists and writers today is that the Dada experiment showed how, given the structure of the modern creative mind, its dynamism and its responsibility, unreason is only a start. The Dada experiment shows too, however, that 'intelligibility' also is only a start: that 'intelligibility' bears only a contingent relation to a poem's poetic sense and to a

painting's painterly sense. In poetry especially Dada tells. Current versions of the experiment, in some of the *New Departures* poems and displays, and in those of some Beats, fail simply because the exponents have talent not as poets at all but only as impotent puppets of the systems which they excoriate, and as victims of the temptation to create without toil.

Toil and severity, neither of these concepts excludes the spontaneity for which Dada stood. All three concepts are names for the creative life in which they are interfused. Their combined functioning gives the creative life direction. Dada shows that if any one should break away and seek to function independently, then it is because all three enjoy only the freedom of a sick civilization.

Hans Arp, Richard Huelsenbeck and Tristan Tzara, *Dada*, Zürich, Arche.

Richard Huelsenbeck, *Phantastische Gebete*, Zürich, Arche.

Walter Mehring, *Berlin Dada*, Zürich, Arche.

Hugo Ball, *Briefe, 1911-1927*, Zürich, Benziger Verlag.

Emmy Ball-Hennings, *Ruf und Echo*, Zürich, Benziger Verlag.

THE ALIENATED SELF
(*Franz Jung's Memoirs*)

IT CAN hardly be said that Franz Jung, as a writer, has been forgotten. There never was a time when his production was sustained enough to attract a public. Yet a few connoisseurs do now inquire after his several novels, play, stories and essays—all slim books in small editions. And for a long time he himself has been, like the Austrian Walter Serner, one of the mystery men of modern German literature. Both were desperadoes, both unpardonably intelligent. It was Walter Serner, in the Café des Westens, wearing a grandiose fur overcoat, but nothing else, who furnished Franz Jung, then a bedraggled deserter from the German army after the battle of Tannenberg, with a forged medical certificate. What might these two men not have done had they ever collaborated in a literary way.

Jung's memoirs (written from Daly City, San Francisco, where even his telephone has now been disconnected) present a gamut of literary, political, business and underworld adventures, of a specifically *mitteleuropäisch* kind, during the deadly epoch 1910-45. They also commemorate a life of incorrigible isolation, bitterness and maladjustment during that epoch. *Der Weg nach unten* is the work of a writer who once had it in him to become a German Communist Louis-Ferdinand Céline. Jung's first story, 'The Experiences of Emma Schnalke', in *Das Trottelbuch* (1912), is one of the few strictly honest and intelligently written tales of erotic frenzy in the German language. But his political disillusionment, after his second working spell in the new Russia (1921-4), brought with it a state of exhaustion which made it impossible thereafter for him to take writing seriously. For a few years after 1925 Jung revived as an ingenious but undevoted playwright; but years of worse frustration followed (if a broken man can be frustrated), and there are few enough moments in his memoirs which break free from *jemenfoutiste* journalese. This bitter decline is only one aspect of Jung's whole bitter story.

One of the key sentences in these memoirs can be paraphrased as follows: 'the single, isolated individual suffers because he is fated to do so; he exists unprotected, wholly unable to defend himself and so dazed that he cannot possibly establish the resistances from which a sense of community springs'. This sentence comes at a point about three-quarters of the way through

the book; it sums up Jung's reflections on his experience of isolation and of attempting to overcome it.

Up to 1917 he was one of the many Munich and Berlin café-rebels, living by their wits and without much sense of cause. After that he worked hard as a freelance Spartacist agent and orator during the revolution months in Berlin (and even captured a telegraph office); in 1921 he went to organize the Mansfeld riots in the same capacity. In 1920, together with a professional agent, Jung captured a ship off Hamburg and sailed it to Murmansk, appearing as a delegate of the communist oppositional groups (later K.A.P.D.) at an extremely testing Moscow congress. And in the late summer of 1921 he returned to Russia, via two Dutch prisons and under the alias of Larsz, to work there for three years. First he worked for the international labour-aid organization in the Comintern, which sent him among the famine-stricken Volga Germans. Then he was put in charge of an agricultural project (with Harold Ware's troupe of tractors); and thereafter—Buckarin interceded for him when the project collapsed—he became manager of two successive factories, the Solnze match-factory at Shudova and the Ressora machine and tool factory.

Jung's record of this work should be valuable for its insight into the economic and industrial chaos in Russia at that time. But no less valuable is his first-hand account of men and motives involved in the German Communist circles of the 1920s. In both cases it is a picture of disruption exacerbated by ideology. Yet Jung still clung to his impulse, fortified by what had welcomed him as he had sailed his captured ship into Murmansk: the sound of men singing, and in their song a glimpse of longed-for home: the *Menschenheimat*.

Jung cannot in any case be viewed just as a sentimental messianist, or as one of the lonely intellectuals who adored abstractly a god which failed. Yet his active commitment was never total. He was not a professional politician when he first went to Moscow; nor was he a trained manager when he made his second visit. His problem was that he remained 'only half with it' ('nur halb dabei'). The half of him who was not with it did not, moreover, consist of a detachable self held in reserve in case of calamity. This was his other problem: smuggled out of Leningrad in an anchor-locker in 1924, he made his way back to Berlin, only to find that he had no reserves left whatever, not even sufficient to advise others of the radical left that they were now disillusioned

for several wrong reasons.

Outwardly, Jung's case may not seem exceptional. But the effect of his experience on his mind and character, and the way in which he now recalls this experience, make the case a classic instance of modern intellectual and social frustration. It presents, not fortuitously, an almost grotesque version of the Faust experience in Goethe's poem; and Faust is the prototype of the modern isolated, inwardly rent *homo intellectualis*, without tradition and without a social context. Faust's existence is a series of triadic moves: full engagement, alienation from the objects engaged with, and self-regeneration. Jung, in his violable isolation, has half-engagement ('ich war nur halb dabei'), half-alienation from the objects half-engaged with, and then bare survival, a mere exasperated going-through-the-motions.

Alienation is not understood here as estrangement from some normative ideal self or from God. It is understood as a loss of any sense of identification with any external sphere of constructive interest. The sphere once engaged with becomes a dead one, irrelevant to the real needs of the existing self, or it can react destructively on the existing self, crushing it. So this parallel may also serve to illustrate the seeming vacuousness of Jung's business occupations. He worked as financial and business editor for many papers over many years; in his memoirs, again and again, he can be seen as a wasted figure manipulating thousands of insubstantial bits of paper.

There were times in Berlin, Vienna and Budapest when the agencies in which he worked were fronts for left-wing political activity. In Berlin he was involved with such dark characters as Schönherr and Beye, as well as with the resistance organizers Gärtner and Schwab. In Vienna he worked for the *Wirtschafts-Woche*, in its economic offensive against the 'German cobra' in Balkan countries. New insights into obscurer regions of German resistance to Nazism are to be found in these pages. Yet Jung's wasted figure terminates all things with a shrug of the shoulders. Nothing was effectual, not even his 'last attempt to be articulate' in opposition—the magazine *Der Gegner*. No society, in his view, whose members consisted exclusively of the eaters and the eaten, in which even the isolated intellectuals were parasites, could have resisted the illusion of substance engineered through mass-hysteria.

Two figures in these memoirs stand out from the ruck of compromised and crooked souls. The first is the 'uncle' who

was a lodger in Jung's parents' house in Neisse. To this uncle Jung looked for help and confidence. He could tell him everything, and the uncle understood. His parents, of the middle class, non-Jewish artisans, had no such understanding to give. The uncle died, and the boy Jung went on a lonely tramp into the mountains, imagining that his uncle was there with him. Not long after his return home his elder sister died and thereafter his mother was emotionally lost to him. From that point his life entered its course of violence, alcohol and cunning.

The second figure is Lotte Lenya. Jung was connected, as finance agent, with Ernst-Josef Aufricht's enterprise which supported Brecht's *Aufstieg und Fall der Stadt Mahagonny*; he was also part-owner of a nightclub where the cast used to meet. One evening a young Jewish working-man came hurtling into the bar pursued by a group of S.A. brownshirts. Lotte Lenya pulled the fugitive down beside her, stood up and told the leader of the S.A. group to clear his men out of the bar, leave her guest alone, and, if he wished, to take a drink himself. For the next fifteen minutes, Jung writes, not one of us dared even to clear his throat. But the lady won, the offer was accepted, and, with the brownshirts gone, the fugitive was released through the back door. This is the only incident in the book which Jung directly calls an act of courage—and, he adds, of supreme theatrical talent.

Yet even this eulogism comes to seem more like an accusation when Jung himself reflects on the millions who found no such back door; and who must be forgotten, he adds (with or without sarcasm?), in the name of progress. It is at such points that the reader can hardly tell any more if the writer's pessimism is devilish, or if it is the tone of a superlatively embittered but incorrupt witness.

He makes no pretence to reliability, and could never fairly do so, given his expression of unbelief and that self-condemning *Existenzangst* of his which springs from such a deep splitting of identity. Jung might have been one of the most defiantly insecure of aliens in his time: those whose alienation from existing society was the sole form of life that their selves could assume. Yet his aloneness in his isolation—changed by none of his practical or intellectual attempts to overcome it—led not to inviolability but to indifference. He is himself the first to confess this.

It is an agonized indifference. He is not like Meursault, the 'stranger' in Camus's novel, who sees only sporadically his image

in society's eyes (the law's). Jung saw this social image of him-
self much more continuously; and the sight of it exasperated
him, for, failing to assert the alienated self constructively, he
could do no more than drift from one catastrophe to the next.
This was less a life of controlled experiment than a life put out
of control by the epoch's play of inhuman power.

The development of a new rhythm in economic and social
life was the main theme of Jung's Communist writings between
1917 and 1921. In his time the new rhythm was ruptured; the
doctrinaire and authoritarian phase began. Jung's story shows
that this phase did not redirect or even harness the normally
ambivalent, at worst self-destructive, energies of the distressed,
isolated individual. On the contrary, these ambivalent energies
were gradually atrophied. His story shows too that even earnest
practical work for the cause could reduce the energies to zero
in such an atmosphere of malice and suspicion. The bewilder-
ment which ensued was experienced by Jung in a measure
which makes his witness one of a paradoxical kind. In the con-
fession of defeat there is a triumph of comprehension, but in
the self-condemnation there is pity for none.

Franz Jung, *Der Weg nach unten*, Neuwied am Rhein, Luchterhand.

2

THE PICTURE OF NOBODY:
SOME REMARKS ON ROBERT WALSER,
(WITH A NOTE ON WALSER AND KAFKA)

*His doubt is healed, although he may
discover still another doubt.*
Kierkegaard

CRITICS ARE seldom aware of the unconscious criteria which
motivate their judgements. Were they quicker to grapple with
these criteria, the history of critical opinion might be less marked
by errors of omission. For some reason modern opinion seems to
be drawn to writing which is charged pre-eminently with ideas.
A corollary of this is the presence in some post-analytical criti-
cism of an interest in ideas about literature, its peculiar logic, or
in approaches to literature, which threatens to eclipse genuine
interest in the books themselves. But even where a certain rare-
faction of this kind is not in evidence, it is the socratic imagina-
tion which nowadays electrifies critics. They require authors to
question, even to illuminate, the whole structure of experience;
and their statements imply that this cannot be done by any in-
telligence which is not 'logomorphic' and in which ideas do not
flourish. The great socratic novelists of the past half-century
have indeed prompted critics to take this attitude. Plunged in
the prolix forests of meaning which their prose embodies, the
critics have hardly noticed other figures, marginal figures who
have sought to do other things with words, who have worked
mostly in the dark, receiving for their pains, like the little man
in Kafka's smallest fable, a resounding blow on the head. Robert
Walser is one of these figures. He seems to be a stranger to the
realm of ideas. A pre-eminently non-ideational intelligence, he
is reluctant to emerge from the shadows. He protests: 'In der
Tat mache ich mich mit Vorliebe so wenig breit wie möglich,
weil ich der Ansicht bin, dass genügende Menschen existieren,
die gern gross sind und das unfeine Bedürfnis haben, wichtig
aufzutreten' (*Seeland*, pp. 60-1). (1) And when finally he does
emerge, he cuts a curious figure: blithe Ariel, Buffoon and baf-
fled Hamlet, all in one. He might even seem a Swiss Prince
Myshkin, were it not for the picaresque in him, the rogue, but
also the devil that Keller equated with the power to create from
the centres of things. (2) 'Ihnen Gelegenheit geben, mich zu se-
hen,' he threatens, 'hiesse, Sie mit einem Menschen bekannt

machen, der seinen Filzhüten den Rand mit der Schere halb ab-
schneidet, um ihnen ein wüsteres Aussehen zu verleihen' (*Kleine
Dichtungen*, p. 9). Doffing his darkness still more, he brandishes
another hat of his invention, 'einen armen, dummen, weichen,
verdrückten, formvollendeten, freilich ein wenig wunderlich
runden Hut, eine Art verbogenen rostigen Kochtopf, ein Unge-
heuer von Hut, der mit tiefer, hoher, phantastischer, unförm-
licher, greulicher Bratpfanne mehr Ähnlichkeit hat, als schein-
bar absolut notwendig ist' (*Seeland*, p. 16). Indeed Walser's wri-
tings do not constitute, like the novels of Broch, Mann and Musil,
watersheds of the modern intellect. He does not bring us intel-
lect, nor massive volumes of ideas at all. He brings a new world
of sensibility, an unmediated vision of experience, an image of
reality seen without the interference of a concept. This discloses
the sovereign wit in his work which Christian Morgenstern dis-
cerned in his first novel, *Geschwister Tanner*, and which he called
'das Sehen der Welt als eines immerwährenden Wunders'. (3)
But it reflects also the form of Walser's bizarre and courageous
life, a life lived nakedly, outside the unprotecting sphere of glass
of which Eugen Gottlob Winkler spoke (*Briefe*, Bad Salzig,
Rauch, 1949, p. 226). (4)

The name Walser occurs in sixteenth-century documents re-
lating to the district of Trogen, Wald and Heiden in Canton
Appenzell, east Switzerland, and at the end of the seventeenth
century a branch of his family settled at Teufen in that Canton.
Here Robert Walser's grandfather, Johann Ulrich Walser (1798-
1866), was born. The son of a wealthy, cultivated and poly-
philoprogenitive doctor, Johann Ulrich became a clergyman,
but left his living at Grub in 1832 and moved to Liestal in Basel-
land, where he distinguished himself as an outspoken Radical
pamphleteer and publisher. His son Adolf was trained as a book-
binder, even serving an apprenticeship in Paris. But in 1864 he
opened a stationery and toy shop in Biel, Canton Berne, of
which he was still proprietor when Robert Walser was born.
Adolf's wife, Elise Marti, whom he married in 1868, was the
daughter of a blacksmith. She came from Schangau in the Em-
menthal. Robert Walser writes of her as a majestic but severe
woman, whose gentleness might be suddenly darkened by storms
of temperament. She died of a cerebral thrombosis in 1894.
Adolf, whose image in his son's writings is that of a robust, jo-
vial, eccentric, but rather disappointed old gentleman, sur-
vived her twenty years. Born on 15 April 1878, Robert Walser

was the seventh of eight children, of whom one died before he was born, and another, his brother Ernst, in the same year as his mother. Of his brothers and sisters, Karl and Lisa stood closest to him. Karl (1877-1943) earned considerable distinction as a painter, as a scenic artist for Max Reinhardt, and as a book-illustrator. Lisa, who died in 1944, the elder daughter of the family, took charge of the household when her mother died and often looked after the errant Robert during later years. She was a schoolteacher and for thirty years taught languages at Bellelay in the Jura.

The family was poor and Robert Walser had to leave the Progymnasium at Biel in 1892, when he was fourteen. He then spent three years training as a clerk in the Biel Cantonal Bank. In the spring of 1895 he left Biel to work for three months in the bank of Speyr & Co. in Basel. Then, on his brother Karl's suggestion, he obtained a clerical post in the Union publishing house and booksellers (Deutsche Verlags-Anstalt) in Stuttgart. But in the autumn of 1896 he came to Zürich. Here he was first employed as an insurance clerk, then as a bank clerk. He lived in various quarters of the town: Trittligasse, Spiegelgasse, Schipfe, Aussersihl and the Zürichberg. In the Trittligasse he wrote his first prose pieces, and on the Zürichberg his forty poems. Some of these early writings appeared in J. V. Widmann's periodical *Der Bund* and others in *Die Insel* (for Franz Biel was interested in Walser). Collected they became *Fritz Kochers Afsätze* (1904) and *Gedichte* (1909). Now as later Walser usually took employment on a short-term basis, and he would give up work in order to write. It was presumably for a few weeks in the early spring of 1903 that he worked in an elastic factory in Winterthur, an episode to which he refers in his novel *Der Gehülfe*. (5) But the scene of *Der Gehülfe* is Wädenswil on the Lake of Zürich. Here it was that Walser worked as clerk to an amateur inventor from the summer of 1903 to January 1904. The previous years in Zürich itself, which included a period as manservant in the household of a wealthy Jewish lady, provided material for the novel *Geschwister Tanner*. During these years Walser also worked in a transport firm, a machine factory, and an office where unemployed persons were employed to address envelopes. Perhaps it was after 1904 that he worked in a brewery in Thoune. Little public attention was attracted by his earlier work. *Fritz Kochers Aufsätze* was quickly remaindered. Unlike Thomas Mann and Hermann Hesse, Walser had no sense of what the

public wanted to read.

Between 1904 and 1905 comes a blank period: the sources are vague, or silent. Presumably he took work in other towns in central and east Switzerland. Then in 1905, summoned again by his brother Karl, Walser went to Berlin. Here for a time he shared two rooms with Karl, then he lived alone. And here he wrote, prompted by Bruno Cassirer, his three extant novels: *Geschwister Tanner* (1907), *Der Gehülfe* (1908) and *Jakob von Gunten* (1909). When Cassirer found that his patronage was not paying, Walser was given up. But long before this he had accepted poverty as his proper context, and he could live on a minimum. He wrote *Geschwister Tanner* on a diet of sprats. The period in Berlin included a month in a school for servants. Thereafter Walser went to work as a kind of butler in the household of a nobleman in Upper Silesia. The school for servants provided material for the novel *Jakob von Gunten*; and the nobleman's household provided material for the story 'Tobold' in *Kleine Prosa* (1917). Some time, possibly only a few weeks, was also spent, during this period, in Munich, where Walser met Wedekind and Kubin. From Munich he took one of his frequent mercurial walks. He wanted to see Max Dauthendey in Würzburg, and he covered the distance of some eighty kilometres in just over ten hours. Shortly before he finally left Berlin he also travelled from Bitterfeld (between Dessau and Leipzig) to the Baltic coast, this time by balloon, in company with Paul Cassirer and a good stock of cold cutlets and liquor. During the last two years in Berlin he enjoyed the patronage of an unnamed wealthy lady, but when she died he returned to Biel, in 1913. Some of his Berlin impressions are contained in *Aufsätze* (Leipzig, 1913); and his rediscovery of the central Swiss scene finds expression in *Kleine Dichtungen* (Leipzig, 1914).

For the next seven lean years, from 1913 to 1920, Walser lived in Biel with interruptions for military service in the Landwehr. He worked in a bank and also did some amateur acting (his passion for the theatre is shown in many of his short prose pieces, including a number in *Aufsätze*). These were fertile years. In 1917 three books appeared: *Prosastücke*, *Kleine Prosa* and *Der Spaziergang*; in 1918 *Poetenleben*; in 1919 *Seeland* and *Komödie* (the latter a collection of four dramolets, three of them in verse); (6) and in 1920 appeared 'Das Christkind, ein kleines Versspiel' (*Die Neue Rundschau*, XXXI, 12), though this may be an earlier work. But by 1920, as Walser later told Carl

Seelig, who befriended him in later years, he was written out, had exhausted all the new themes which the rediscovery of the central Swiss scene had offered him. The language of some of the writing of the time shows signs of this enervation.

In 1920 he moved to Berne. He took the usual humble and temporary posts in banks, and lived for some time in the attic of a *hôtel garni*. His novel *Theodor*, completed in 1924, was lost by the Grethlein Verlag. Two extracts from it, as well as a remarkable story, 'Ophelia', were published by Max Rychner in vol. XVII (1923-4) of his *Wissen und Leben, Neue Schweizer Rundschau*. Walser's ninth and last book of short prose pieces, *Die Rose*, appeared in 1925. Many (but by no means all) of the prose pieces which appeared at the time in various newspapers and periodicals (particularly the Prager Presse and the Berliner Tageblatt), are now collected in *Unveröffentlichte Prosadichtungen* (Geneva, 1954). These writings show Walser exploring new realms: new themes, and some new styles. This is especially true of a remarkable piece called 'Ein Flaubert-Prosastück' in the selection *Grosse Kleine Welt* (Erlenbach-Leipzig, 1937), which also contains much else from the last period. But the writings of these years also reflect the onset of the mental disease which Walser was now vainly resisting by recourse to alcohol. The last manuscripts display an uncanny calligraphic grace, but are written in no known language. In Seelig's account (op. cit., pp. 21 and 25), these years are haunted by gruesome dreams, horrific visions, fabulously long walks by day and night, and some unsuccessful attempts at suicide. In 1929 Walser voluntarily entered a mental hospital. He was transferred in 1933 to the sanatorium at Herisau in Appenzell, the canton of his ancestors. Seelig's account of the last twenty years of his life shows that, whatever the clinical reports may show, and despite the emotional condition peculiar to schizophrenics, Walser's great energy of body and mind, and the strange magic attaching to his person, were not diminished during this period. He could walk for miles, on roads or over rough country, quote at length works not read for twenty or thirty years, and converse with outspoken pungency. He wrote no more. He said that he wished to live as his fellow patients lived, since he was no longer a free man. After lunch on Christmas Day 1956 he went for a walk. In the middle of the afternoon some children with sledges found that the dark shape prostrated on a snow hill, which had roused the curiosity of their father's dog and also their own, was the

body of an old man facing the sky with his right hand laid to his heart. Thus died Robert Walser.

It would appear that Walser's work falls into four periods: the seven years in Zürich, the seven in Berlin, the seven in Biel, and the last years in Berne. But to isolate four such periods is wrong unless they are considered less as distinct phases in a gradual progression than as four segments of a sphere. Statements about his work must allow for this. Their lodestar should be not an image of unbroken linear progression from one work to the next (because Walser's work does not develop that way), but an image of a configuration of intersecting stylistic and thematic cycles. In discussing briefly his novels, I hope to describe at least one orbit of this sphere, and to suggest some perspectives in which his work as a whole may be viewed.

Walser's first novel, *Geschwister Tanner*, was written in three to four weeks in Berlin (Seelig, p. 48). It is quasi-autobiographical, set for the most part in Zürich, with an interlude in the Bernese village of Täuffelen (Seelig, p. 92). But neither of these places is named; and the time-sense embodied in the novel is likewise etherealized, for seasonal change, not clock time, evokes response here. The experience of the protagonist, Simon Tanner, is construed episodically. And one can count seven episodes, each of which serves to unsheathe a little more of Simon's temperament. For Simon is, like Dedalus, Malte, Meaulnes and Törless, the modern fictional self-analyst, the seeker of his true self. He is also the spokesman of his family, a family of wistful insubordinates in revolt against the turgid society in which they are implicated. Simon is the underdog, the *eiron* of Greek comedy. He is the ironic outsider, who wants not insulation from raw existence but exposure to it: 'ich liebe das Gefährliche, das Abgründige', he says (p. 244). But neither he nor his brother Kaspar, a painter, nor his sister Hedwig are heroic in stature. On the contrary, they are humble, unassuming people, fugitives not aggressors, at sea in a negative world, phenotypes of a dissolving society. Neither demons against God, nor minds against nature, nor seekers of an earthly paradise, they are airy aliens with 'zu sehr Springlust' (p. 293) in a realm of gravity, convention and 'the agony of Habit'. (7)

The episodic structure does not display the kind of mounting and declining tensions of a story in traditional canon. The secret here is that, given such a protagonist as Simon, the reader simply cannot anticipate what is likely to happen next. And this

suspense of unknowing is sustained throughout the seven episodes: despite the fact that the episodic structure, being an open, porous structure, involves digressions, monologues and apparent irrelevancies, and despite the fact that the things that happen to Simon are mostly commonplace. He works in a bookshop; he lives with his brother for free in the house of a friendly lady, Klara Agappaia, whose formidable husband sometimes fires a pistol into the night, because he likes the sharp sound it makes, against the emptiness; he visits his brother, then his sister, in the country; he works as a servant for a lady in the city whose small son is a cripple; he dreams of Paris; he befriends a male nurse; he eats in a restaurant for working-men; and so on. But it is just this immersion in the minimal and Simon's interpretation of the minimal that occasion 'das Sehen der Welt als eines immerwährenden Wunders'. This unique personalization of the given reality, here as in the other two novels, makes Walser's prose existential in a way which was later to attract Franz Kafka's attention. 'Im Alltäglichen', Walser later wrote in *Jakob von Gunten*, 'im Alltäglichen ruhen die wahren Wahrheiten' (*Jakob von Gunten*, p. 113).

It is first and last Walser's language, embodying as it does his peculiar sense of existence as rhythm, which gives *Geschwister Tanner* its specific energy. His language, too, estranges its world, as far as the wistful insubordinacy of its characters is concerned, from the world of the stock lyrical Bohemian. The earlier collection of short pieces, *Fritz Kochers Aufsätze*, had explored the world of the insubordinate: the schoolboy and the 'Kommis'. The language of *Fritz Kochers Aufsätze* delights with its *naïveté*, its capricious pleasure in the insignificant, its miniaturistic mannerism. But *Geschwister Tanner* shows for the first time a stylistic mode which is later to dominate Walser's writings: a style in which ethereal and graphic statements mix and alternate in a spirit of play. This is found here, for example, in the account of Simon's nocturnal walk (pp. 96-102), with its dovetailing of graphic detail and the alternations of rhythm which register both Simon's changing moods and his changing pace. It is as if improvised, but unerring in its emotional precision: the language not of reflective description but of stereoscopic presentation. Then there is the account of the coming of spring (pp. 147-9), or the account of Simon's dream of Paris (pp. 206-15), which again show Walser's skill in truing language to matter, in making things speak for themselves. In such passages the perspective is

mobile, detail and contour are opalescent. But the truing of lan-
guage to matter is equally in evidence when the perspective is
static, as in the account of Simon's thoughts as a servant in the
city lady's household, where the stereoscopic effect is achieved
by anaphora:

> 'dann der Herrschaft melden, dass der Tisch gedeckt sei, und
> dann die Speisen auftragen und dann zur Tür hinausgehen,
> um wieder hineinzugehen, wenn geklingelt wurde, zusehen,
> wie gegessen wurde und Freude dabei empfinden, sich zu
> sagen, dass es hübscher sei, zu sehen, wie gegessen wurde, als
> selber zu essen, dann der Tisch wieder abräumen, das Ge-
> schirr hinaustragen, einen Rest Braten in den Mund stecken
> und dabei eine frohlockende Miene machen, als wäre es et-
> was, um dabei eine frohlockende Miene machen zu müssen,
> dann selber essen und finden, dass man jetzt wirklich ver-
> diene, selber etwas zu essen: das alles musste Simon. Er
> musste nicht alles, zum Beispiel musste er nicht gefrohlockt
> haben, wenn er stahl, aber es war sein erster, zarter Diebstahl,
> und deswegen musste er frohlocken; denn es erinnerte ihn
> lebhaft an die Kindheit, wo man stiehlt, irgend etwas aus dem
> Speiseschrank, und dabei frohlockt' (pp. 187-8).

Referring in later years to his novels Walser said: 'Um die
künstlerische Gesetzmässigkeit mich foutierend, habe ich ein-
fach drauflosmusiziert' (Seelig, p. 14). This applies most closely
to the improvised, candid, semi-crystalline language of *Ge-
schwister Tanner*. The expression 'künstlerische Gesetzmässig-
keit', on the other hand, would surely apply to the laws and
logic of fiction proper, as opposed to the laws and logic of any
other form of imaginative statement. Now Walser's next novel,
Der Gehülfe, does approach fiction proper. But if it can be said
that, of the three novels, *Der Gehülfe* alone does not appear to
break with the common epic canon, even here the finite and ty-
pical qualities of the given situation coincide at points, to dis-
close by nuance the symbolic character of this situation. Rather
than question Walser's capacity for writing fiction proper, one
should therefore observe how he transforms the com-
mon features of the genre and extends its potential range of
statement.

Der Gehülfe was written in six weeks, again in Berlin (Seelig,
p. 92). The protagonist Joseph Marti is again the *eiron*, the cri-
tical underdog, but he is now lodged in a bourgeois attic. The

novel is based on Walser's months as a clerk to the amateur inventor of Wädenswil; and the theme is the division against itself of a provincial household, induced by the inventor's inordinate capacity for believing the lies he tells himself about himself. Characters are now seen less as objects than as autonomous subjects. Foremost there is the inventor himself, Tobler, whose ungovernedness, in magnanimity or wrath, plunges his house into discord and petty friction. And there is his wife, ostensibly a sensitive woman, whose frustration finds a malignant form in her agonizing of her younger and nervously enuretic daughter, Silvi. Both characters are 'alive', because complex: they are moreover complex because the moral vision embodied in the narrative is complex, caustic and at once compassionate, obtained from a position of unshakeable and therefore totally unassuming moral strength. Then there are the details of the fabric: the railway official's wife who is so proud of her four words of French (p. 56); the barrenness of small beer-gardens; the glass ball weighing between eighty and ninety pounds, which Joseph has to carry into the garden when the sun shines and into the house when the rain falls (Tobler magnificently requires it so); and the mood-suffused images of lake and lakeside, reflecting the turning of the year, an inviolable world on the margins of the abject human shallows. Tobler's inventions are all the more vacuously grotesque for being juxtaposed to this inviolable world; for example the slot-machine for cartridges with an interior turntable displaying a fresh advertisement each time the lever is pulled, or the clock with wings that shoot out sideways displaying, again, advertisements. Here too Walser uses graphic imagery to express, by nuance, discreet states of mind, the ego's underworlds. 'Kein Auge sieht in das Auge der Tiefe', Joseph meditates, 'das Wasser verliert sich, der gläserne Abgrund tut sich auf, und das Schiff scheint jetzt unter dem Wasser ruhig und musizierend und sicher fortzuschwimmen' (p. 55). But into the glassy abyss there is an access: at least one instance is found where Walser introduces into a situation, by means of imagery alone, a Kafkaesque dimension of dramatic pregnancy. Thus Joseph's submerged attraction to Tobler's wife is implied when, having just by accident glimpsed her in négligé through the open door of her room, he ascends to the attic to find his attention inexplicably riveted by Tobler's kneeboots (p. 202).

The symbolic pregnancy of Joseph's situation as a whole becomes evident only towards the end of the book, with his

apparently casual recognition that all that has come to pass
in the 'Villa zum Abendstern' is 'ein Bild des zwanzigsten
Jahrhunderts' (p. 267). This nuance puts a new shape on every
issue involved. One realizes that the limiting of the perspective
to Joseph's personal vision, as far as the narrative is concerned,
and the limiting of the duration and location of the events thus
narrated, has resulted in just such a synoptic image of the given
time in the given place; and that this synoptic image has been
given inevitability and conclusiveness by the simplicity of
phrase, closeness of texture and transparent plasticity of Walser's
language. This tendency to structural concentration distinguishes
Der Gehülfe from *Geschwister Tanner*. It distinguishes it also
from the expansive naturalism of Thomas Mann's *Buddenbrooks*
and from the mawkish preciosity of Hermann Hesse's roughly
contemporary *Peter Camenzind* (1904). At the end of *Der Ge-
hülfe*, Joseph Marti has to turn his back on a world in which, as
an outsider perforce, he had hoped to find at last the centre of a
clear life, a focus of affection, 'den Mittelpunkt eines Paradieses'.
His progressive disillusionment, of which the novel is a state-
ment, was to have a decisive effect on Walser's narrative tech-
nique. In *Jakob von Gunten*, he abandons the quasi-fictive third
person narrative, and speaks in the first person singular through
the persona of his eponymous hero. The autonomy of his eccen-
tric vision of things is made by this complete.

Jakob von Gunten is called 'ein Tagebuch', but the autobio-
graphical material (Walser's brief period in the Berlin school for
servants) is transformed beyond recognition. Jakob's experience
in the enigmatic Institut Benjamenta, of which his journal tells,
is presented as being pluri-significant. Jakob himself is not sure
why he is there, nor what the institute is. And the presentation
of events in the immediate language of the journal does not al-
low the reader to know any more than the baffled Jakob him-
self. (8) Jakob is once more the *eiron*, the insubordinate under-
dog. But the insubordinacy of this particular subordinate marks
an extreme elaboration of the smaller schoolboy world of Fritz
Kocher. Indeed, at points *Jakob von Gunten* reads like a brilliant
parody of the first chapter of Novalis' *Die Lehrlinge zu Sais*.
Yet here Walser has entered the climate of the absurd, in which
no single event has a single meaning, and in which, as is evinced
from Kafka's subsequent exploration of the absurd, no degree
of acumen on the part of the protagonist can clarify the opa-
city of immediate experience. *Jakob von Gunten* is, indeed, not

the subjective construct of a kind of dwarf-complex. It distils the mentality of the age as Hofmannsthal had defined this: 'Das Wesen unserer Epoche ist Vieldeutigkeit und Unbestimmtheit... Ein leiser chronischer Schwindel vibriert in ihr'. (9) But this does not mean that Walser here indulges in evasive and implausible symbolism, as his contemporary and countryman Albert Steffen does. (10) On the contrary, there is no slipping the yoke of fact, however pluri-significant the facts may be. *Jakob von Gunten* is the one book by Walser which we know Kafka to have read and admired. (11) And it is plainly Walser's direct vision of the absurdity of fact which attracted Kafka, as well as his discrimination of the symbolic pregnancy of commonplace events by what astronomers call 'averted vision'—vision by which faint stars can sometimes be seen 'not by looking straight at them but by catching the light in the corner of the eye'. (12) As examples of the direct vision of the absurdity of fact (showing Walser's technique of isolating and scrutinizing detail), there is the image of the schoolmaster, Herr Wälchli, in the common-room chair, fast asleep, but still smoking his pipe (p. 62); or there are the many occasions on which, after interviews with the principal, Herr Benjamenta, Jakob flies from the room to glue his ear to the keyhole of Benjamenta's door. There is the special instance when, after Benjamenta had a moment before tried to strangle him, Jakob rushes out, listens, and hears Benjamenta softly chuckling (p. 154). Or again there is the lightning image of the boy Schilinski with his electric tiepin and his passion for striking wax matches (p. 25). Or the punning imagery of the city might here be cited: 'Und die Sonne blitzt noch auf dem allem. Dem einen beglänzt sie die Nase, dem anderen die Fussspitze. Spitzen treten an Röcken zum glitzernden und sinnverwirrenden Vorschein. Hündchen fahren in Wagen, auf dem Schoss alter, vornehmer Frauen, spazieren' (p. 41).

Such isolation of detail can produce surpassing clownery, and also grotesque verbal comedy, as when Jakob writes:

Unsere Schülernasen haben die grösste geistige Ähnlichkeit miteinander, sie scheinen alle mehr oder weniger nach der Höhe zu streben, wo die Einsicht in die Wirrnisse des Lebens leuchtend schwebt. Nasen von Zöglingen sollen stumpf und gestülpt erscheinen, so verlangen es die Vorschriften, die an alles denken, und in der Tat, unsere, unsere sämtlichen Riechwerkzeuge sind demütig und schamhaft gebogen. (p. 59)

Or likewise grotesque situations may thus arise, as is shown in

this detail from an interview with Herr Benjamenta:

> Da nahm ich wieder den Faden auf und sagte: 'Gott selbst gebietet mir, ins Leben hinaus zu treten. Doch was ist Gott? Sie sind mein Gott, Herr Vorsteher, wenn Sie mir erlauben, Geld und Achtung verdienen zu gehen'.—Er schwieg eine Weile, dann sagte er: 'Du machst jetzt, dass du zum Konto hinauskommst. Augenblicklich'.—Das ärgerte mich furchtbar. Ich rief laut aus: 'Ich erblicke in Ihnen einen hervorragenden Menschen, aber ich irre mich, Sie sind gewöhnlich wie das Zeitalter, in dem Sie leben. Ich werde auf die Strasse gehen und dort irgend einen Menschen anhalten. Man zwingt mich, zum Verbrecher zu werden'.—Ich erkannte die Gefahr, in der ich schwebte. Zugleich mit den Worten, die ich aussprach, war ich zur Türe gesprungen, und jetzt schrie ich wütend: 'Adieu, Herr Vorsteher', und drückte mich mit wunderbarer Geschmeidigkeit zur Türe hinaus. Im Korridor blieb ich stehen und lauschte am Schlüsselloch. Es blieb alles ganz mäuschenstill drinnen im Bureau. Ich ging ins Schulzimmer und vertiefte mich in die Lektüre des Buches: 'Was bezweckt die Knabenschule?' (pp. 66-7). (13)

The technique of averted vision can hardly be shown by citing specific examples, though there are some: particular moments, as when Jakob sees the (erotic) sword and helmet over the doorway to the inaccessible 'inner chambers' of the institute (p. 37), or the initiation scene (p. 105 ff.) with its Kafkaesque interlacing of the traumatic and the actual, of comedy and earnest. But here it is more a question of the unseizable meaning of all that happens in the given context, and also of a complex cumulative effect, which may involve a deliberate comic anticlimax. For instance, Jakob supposes that the 'inner chambers' lead into a world of romance: he expects to find a spiral staircase, a chapel, a park, three old ladies, candles ablaze, a princess and (strange to say) an Englishman. But in fact he only finds a bowl of goldfish. The averted vision, suggesting symbolic pregnancy (or 'faint stars') of meaning, consists here in Jakob's having already been initiated, by a dream, before the ostensible initiation begins. He knows the mysteries to exist, so the bowl of goldfish tells us, in his mind alone. Hence also the mysteries are never 'explained'. But they are embodied in Jakob's experience as this unfolds in the journal: the meaning is there, but always just out of reach.

It follows that, while Jakob's progress in self-knowledge should lead him towards a knowledge of what the institute is, the climate of the absurd only increases the pluri-significance of all things. One by one, Jakob discards his illusions: but this only makes him more and more poignantly aware of the polarity, or plurality of his own nature. He notes: 'Stets begegnet dem selbstbewussten Menschen etwas Bewusstseinfeindliches.' (p. 100); and again: 'Man muss mich nackt auf die kalte Strasse werfen, dann stelle ich mir vielleicht vor, ich sei der allumfassende Herrgott' (p. 119). The climax of this polarity, or plurality, in all things comes when Herr Benjamenta tries to strangle Jakob (p. 153), though a moment before he had suddenly become so friendly. And in such a climate it is not surprising to find Jakob indulging in megalomaniacal fantasies and simultaneously recognizing that he is the lowliest of creatures: his surname may indeed even be a pun, arrived at by his definition of his status at the institute, where he starts, as he says, 'von unten, von ganz unten' (p. 126). So at points Jakob may appear as a caricature of pride, as contrasted with his friend Kraus, who is the perfect servant, while at other points Jakob is plainly the Parzifal, whose task it is to penetrate the pluri-significant absurdity of fact and to arrive at a true vision of the meaning of his experience. And this is what the end of the book promises, for here Herr Benjamenta, the prisoner of the absurd, who exists in a state of disillusionment and despair (p. 172), implores Jakob to become his companion, so that they may abandon the institute together (p.161). At this point we are on the equator of Walser's world. There is much here of Kafka's double vision of wonder and despair, but without Kafka's inscrutable logic of doubt. It is the point at which the candid innocent, the Holy Fool, and the dark inquisitor of doubt conjoin in the exuberant visionary of joy. And this point is not reached by a simplification of experience, for the very burden of *Jakob von Gunten* is that no single interpretation of things is the right one. It is reached by Walser's uncanny power of seeing things without the interference of a limiting concept. And this, perhaps one of the flukes which plot the unerring course of genius, gave him to write what seems to be the first novel of the century to explore existentially the domain of the absurd. Moreover he created for this domain a style which was later, through the medium of Kafka, to become fertile ground for future writers: a style in which the pluri-significance of experience is recreated without becoming

implausible, a level-minded style, a style in which the variability of semantic contour does not involve diminishment of graphic verve, but rather extends graphic verve towards the indefinable frontiers of symbolism. These are some of the qualities of *Jakob von Gunten* which may have attracted Kafka. It might be added that Kafka must also have found here, besides the grotesque (often Chaplinesque) comedy so dear to his imagination, an in-clusive and autonomous first person singular world akin to that which was later to provide the basis for his own mono-per-spectivist narratives.

A convenient point of departure for any account of Walser's shorter prose pieces is the review of his book *Geschichten* which Robert Musil wrote when this collection appeared in 1914. (14) Kafka's *Betrachtung* was reviewed in the same article, and Musil was quick to appreciate certain kinships between the two books. But he found that Walser failed to make moral contact with what he represented in his writings. He strictures the story 'Der Theaterbrand' in which the burning of a crowded theatre is described, Musil felt, as if it were an occasion for delight. But Musil's concern with moral responses caused him to simplify. Walser does not call the conflagration delightful at all. His atti-tude in the story is critical and ironic. The story is set in an age (presumably the Renaissance) in which 'die Persönlichkeit galt alles' (*Geschichten*, p. 77), in which the arts flourished along with personal brutality, and in which people, being unprotected from the elemental, were in need of the arts as redeeming in-fluences. (15) And the storyteller's concern here is to show how people, regardless of the splendours of art, succumb to inhuman conduct when driven by the imhuman force of the elements. Musil was also too absorbed by the particular problem this story offered him to appreciate the way in which the situation de-scribed in 'Der Theaterbrand' is reversed in another story in *Ge-schichten*, called 'Seltsame Stadt'. The setting here is an age in which propriety so suffuses and civilizes the inhabitants of a certain city that poets and artists do not exist there. The irony here is that this city does not exist, 'hat keine Wirklichkeit' (pp. 52-3). That Walser could envisage these two opposite situ-ations shows that he is concerned with 'moral responses', for all that Musil thought, and also that he is fully capable of such res-ponses himself. It is not that Musil was misled by the deceptive-ly cosy quality of the narrative in 'Der Theaterbrand', a quality perhaps which prompted him to call Walser a 'phantastischer

Biefermann', but rather his remarks reflect his own prepossessions and they simplify Walser's. This is shown by the subsequent development of Musil's own thought. For in *Der Mann ohne Eigenschaften* Ulrich's thoughts on morality proceed by spirals towards an intuition of an immorality, a kind of pure spontaneity, in things themselves, which is remarkably close to Walser's sense of the absoluteness of the elements. Thus in Book I, chapter 40, Ulrich meditates: 'Die Dinge schienen nicht aus Holz und Stein, sondern aus einer grandiosen und unendlich zarten Immoralität zu bestehen, die in dem Augenblick, wo sie sich mit ihm berührte, zu tiefer moralischer Erschütterung wurde' (*Der Mann ohne Eigenschaften*, Hamburg, Rowohlt, 1952, p. 160). It may be objected that this intuition is subsequently modified (Moosbrugger intervening), but Ulrich's meditations advance in the last chapters of the novel to a point where he envisages the paradisal state of a trans-human sphere of objects, and conceives of objects as images in God's unqualifiable dreams rather than as food for man's moral considerations. 'Unsere Wirklichkeit ist . . . zum grössern Teil nur eine Meinungsäusserung', Ulrich postulates, 'obwohl wir ihr wunder was für eine Gewichtigkeit andichten' (*Der Mann ohne Eigenschaften*, cit., p. 1275). But here it is essential to notice that Walser's image of reality is conceivable in terms that are different from Musil's. With Musil its final meaning transcends the myriad possible senses in which experience can be understood, and the intellect in detached reflection moves cautiously towards the frontiers of the 'Weltbild der Ekstase'. But Walser, with his clairvoyant intuition, plies continuously to and fro across this frontier, so that he can even voice a final meaning in terms of a personal vision, a personal ecstasy: 'Das reine Sein wurde mir zu einem Glück, wofür ich weder Worte noch Gedanken fand' (*Seeland*, p. 84).

This indelible vision of an absolute purity in creation underlies the stylistic peculiarities of many of Walser's shorter prose writings. Given this vision, any form of representationalism *per se* is out of order: for language is not meant to reproduce the actual. So when Walser is found masquerading, as he frequently does, as a 'Berichterstatter', this must be understood as one of his various ironies. In one of his rare abstractive moments he writes: 'Leben und Kunst spielen wie freie Wellen nebeneinander' (*Seeland*, p. 24). (16) The persona of the 'Berichterstatter' in *Der Spaziergang*, for example, allows his imagination just that freedom of focus that it requires in order to create, out of the

most quotidian encounters with beings and things, unique images of personal reality, hilarious or horrifying, but always authentic. And this freedom of imagination does not mean that phantasmata flood the field of expression. Phantasmata, like the ogre Tomzack in *Der Spaziergang*, are rare in his work; and even when they do occur they lie within the bounds of possible experience. Likewise, as Musil noted in his review of *Geschichten*, Walser's verbal games relate always in the end to realities. And if the sphere of objective reference in his work is limited, it is limited to minimal and unobtrusive phenomena which by virtue of their unobtrusiveness impinge upon the inmost quick of consciousness. Such a limitation is the ultimate test of an artist's skill, for the unique personal vision thus created is not to be splintered or dulled by the interference of a spurious subjectivity, and is not to be flattened by any form of rhetoric. The peculiarly personal image of reality and its limitation to the minimal is implied when Walser writes in *Aufsätze*: 'Gott ist das Gegenteil von Rodin' (*AKD*, p. 93).

Another sentence in *Seeland* describes the tenor of Walser's anti-rhetorical style: 'Unnützes Getue, überflüssiges, windiges, fahles, schales, kahles, faules, müssiges, exzellentes, hochachtungsvolles Gerede kann mir jederzeit gestohlen sein; ich frage dem Zeug wenig oder absolut nichts nach' (*Seeland*, pp. 42-3). Yet to appreciate his work, especially the shorter prose pieces, one must discard prejudices against mannerism. I suggested earlier that the style which dominates his writings is one in which graphic and ethereal statements mix and alternate in a spirit of play. This produces the musical lucidity of his prose, with its sudden swirls of irony and comedy. There is, too, a capricious lusoriness in much of his work, with multiple verbal games, ironic inflections transfiguring the apparently commonplace, packs of adjectives chasing disproportionate nouns, and lightning arabesque flights off at a tangent. The vague term 'Jugendstil' has sometimes been used thus to chasten such prose, but the term is too vague to be just. What is hard to explain, on the other hand, is the lapse into 'Kitsch', the stylistic enervation which affects some of his work during the Biel period (1913-20). 'Friedreich lagen und standen schöne, ehrbare Häuser und freundliche Gärten da. Auf allen Gegenständen lag reizende Altertümlichkeit. Hans ergab sich einem Träumen, das ihm vorspiegelte, dass er wieder ein kleiner Knabe sei, der neben Vater und Mutter und seinen Geschwistern im Sonntagsabendlichte

zart einherspazierte' (*Seeland*, pp. 222-3): here the conscious control of such diction by parody, a parodic control which elsewhere electrifies his writings, has deserted him. Clichés culled during random reading in popular literature are no longer transfigured by contact with his imagination: they are echoed. Likewise one can find here echoes of phrases, rhythms and images he had earlier coined himself. There comes also in *Seeland* an automatic tabulation of impressions without original imprint. This is just the opposite of the kind of parodic tabulation found in the story 'Tobold', in which one sentence covers three pages and finally, by the concluding parodic curve it receives, magnificently cancels itself out (*Kleine Prosa*, pp. 188-91). A remark in *Seeland* hints in its last four words of the predicament in which his imagination finds itself when deprived of its formative energies and confronted with impotence: 'Inzwischen tut es mir in tiefster Seele gut, hier aufs Wasser zu schauen und im Bewusstsein, dass dies göttlich schön sei, Stunden hinbringen zu können' (*Seeland*, p. 245).

When Walser's style is found at its usual intensity, its formations evade easy definition. The contrast with Kafka may offer a key, for, if Kafka's prose has a glacial purity, Walser's is anything but glacial. There come hypotactical constructions which scrutinize and interpret a subject simultaneously, viewing this subject in as great a variety of perspectives and with as much simultaneity as normal syntax will allow, but with a temperamental airiness that distinguishes such constructions from those produced by the tight, logical hypotaxis that Kafka used. There is a continual alternation of temperature, because there is a continual play of temperament. Thus there is also a delight in the sheer sounds of words arranged in musical patterns: 'Am Gestade plauderte einsilbig der wundrige Wellenplunder' ('Ophelia', *Wissen und Leben*, XVII, p. 1519); or delight in rhythmical patterns, as in the outset of the story 'Dorfgeschichte':

> Ungern genug setze ich mich an den Schreibtisch, um Klavier zu spielen, das heisst anzufangen von der Kartoffelnot zu sprechen, die vor Jahren ein Dorf heimsuchte, das an einem zirka zweihundert Meter hohen Hügel lag. Mühsam ringe ich mir eine von nichts Wichtigerem als von einer Magd berichtende Geschichte ab. Erstere wusste sich je länger um so weniger mehr zu helfen, (*UP*, p. 178)

Such patterns of sound and rhythm can make for statements which are volatile in the extreme, checked by swift ironic

interventions which mark, even in the middle of a sentence, a switch in perspective, to multiply the precise impressions that such synergies of sound and sense create. There comes, too, sustained interplay between the narrative (Mann's 'Geist der Erzählung'), the narrator and the likely responses of the reader. This may sound reminiscent of Jean Paul, for there is no question here of the narrator being unobtrusive. But there is a difference. In Walser the narrator (and sometimes the reader also) is drawn into the vortex of the narrative. The 'aside' becomes a structural element within the whole created statement and is assimilated into the irony in which the whole statement is framed. This happens in 'Schwendimann': 'Er suchte nicht viel, aber er suchte das Rechte. Mit der Zeit hoffte er das Rechte zu finden. "Das wird sich finden", murmelte er in seinen zersausten schwarzen Bart. Schwendimanns Bart war ganz struppig. So, so? Struppig? Sessa! Voilà! Ausgezeichnet. In der Tat! Hochinteressant! Mit eins und so stand er vor dem Rathaus' (*Prosastücke*, p. 45). Likewise in 'Der Affe', the monkey is told to go into the kitchen and prepare a meal, and the narrator reports: 'Er tat, was ihm befohlen wurde, ging in die Küche, konnte sie aber nicht finden. Ging er denn hinein, ohne dass sie ihm zu Gesicht kam? Hier schlich sich ein Schreibfehler ein' (*Die Rose*, p. 66).

This form of arabesque discourse can explore dimensions of verbal comedy which are inaccessible to any prose of a representational nature. Often what is said may be out of all proportion to what it is said about, but in such a way that the statement creates its own proportions, its own world of imaginative forms. One of these forms in Walser is caricature. It is not the malicious caricature of the deceived imagination. It is the caricature of the imagination that grasps intrepidly the nettle of the absurd, having seen through the complacencies of the self-evident. Here is Professor Meili in *Der Spaziergang*, complete with unbendable scientific walking-stick:

Professor Meilis Nase war eine strenge, gebieterische, scharfe Adler- oder Habichtsnase, und der Mund was juristisch zugeklemmt und zugekniffen. Der berühmten Gelehrten Gangart glich einem ehernen Gesetz; Weltgeschichte und Abglanz von längst vorübergegangenen heroischen Taten blitzten aus Herrn Professor Meilis harten, hinter buschigen Augenbrauen verborgenen Augen hervor. Sein Hut glich einem unabsetzbaren Herrscher. (*Der Spaziergang*, p. 6)

The oblique scrutiny of isolated detail which results in caricature

may also be carried one step further, to become hallucination, but hallucination in the broad day of vulgar pun: 'Mit einmal büsste ich nämlich meine bisherige flotte kecke, schlanke Gestalt zu meiner Verwunderung ein. Irgendeine unbekannte Macht verwandelte mich in einen Ball; ich wurde kugelrund und rollte statt zu Fuss zu gehen und kugelte herum' (UP, p. 118).

Perhaps Walser's capacity in this sphere is best shown in his longer portraits, as the interior speech of the 'good citizen' in 'Basta' (Kleine Prosa), or the clerk Helbling in 'Helblings Geschichte' (Kleine Dichtungen, AKD), or in the portrait of the enormous and awe-inspiring actress, Frau Birch-Pfeiffer (Aufsätze, AKD). (17) But it is shown also in some of his neologisms, like the portmanteau 'spazifizotteln' (Die Rose, p. 108), or 'schritthüpfen' (viz. 'zu den Likörtischen', AKD, p. 99), and in puns like 'die Mutter geizte im Zeigen körperlicher Fülle' (Die Rose, p. 52). And here are caricature jungles: 'beschlingpflanzte, beleopardete, affenbeherbergende Urwälder' (Die Rose, p. 49). And the adjective-string also can enter this sphere. Here is one of the longest:

> eine Art himmelblaues, schwanenfederweisses, nach Veilchen und Rosen duftendes, tapetentürenhaftes, intimes, freches, nettes, graziöses, Diskretion und Lebensart voraussetzendes, Spitzen und Bänder in Erinnerung bringendes, spitzbübisches, sittlich sehr wahrscheinlich fragliches, dafür aber sicher um so anmutigeres Boudoir- und Antichambrestückchen. (UP, pp. 172-3)

A kind of inverted form of caricature as word-play is the deliberate ironic elaboration of the obvious. This may be found in a direct form. 'Der Winter hat lange Nächte, kurze Tage und kahle Bäume. Kein grünes Blatt kommt mehr vor. Dagegen kommt vor, dass Seen und Flüsse gefrieren, was etwas sehr Angenehmes nach sich zieht, nämlich den Schlittschuhsport' and so on (UP, p. 190). The quasi-naive is handled with less sardony in other tales which are written as fairy-tales, as 'Der Mann mit dem Kürbiskopf' (Aufsätze, AKD) or 'Mehlmann' (Geschichten). And Walser's 'Absicht, mit Worten zu tanzen' (UP, p. 41) makes for the märchen-like quality of so much of his work: its levitation. Here the obvious and the extraordinary may be juxtaposed in images or in compound words to evoke anything but stock responses in the reader. In the middle of one story a general appears, 'for local colour only', as the narrator explains (UP, p. 130);

or there is the hero Odysseus—caught reading a newspaper (*UP*, p. 281); or at dinner, for no reason at all and none offered, one of the guests is found to be literally frozen stiff (*UP*, p. 202). Such curves in discourse, such flying arabesques often radiate from a single nuclear construction in a sentence or paragraph. The nuclear construction in the following sentence is the explosive compound adjective: 'Um die Zeit, als der russische General Gortschakow eine anerkanntermassen beinah allmächtige europäische Persönlichkeit war, gab es innerhalb der grösseren und geringfügigeren Bürgerlichkeit dienerinnenhändeinbewegungsetzende Mieder oder Korsets' (*UP*, p. 129). And this curve of discourse, the exploitation of comic anti-climax, the interrupted arabesque, come again in the clownish sigh, here the sigh over a former beloved:

> Sie war sehr graziös, lebhaft und ungemein klug. Sie pflegte öfters mit Kastagnetten als verführerische Spanierin in ihrer Stube umherzutanzen. Auch als Schauspielerin würde sie sehr wahrscheinlich Erfolg gefunden haben. Noch lieber dachte ich sie mir als Hirtin, Schäferin oder Jägerin im Wald oder auf grüner Wiese im flatternden Phantasiekostüm. Sie besass Witz, Anmut und Schelmerei und mahnte mit diesen Gaben an das Rokoko. Sie heiratete immerhin später einen Lehrer. (*Kleine Prosa*, pp. 111-12)

When caricature informs the language itself the result is, of course, parody. Many of the stylistic peculiarities mentioned so far enter the kind of high-spirited parody in which Walser is so adroit. In the piece called 'Büren' (*UP*) comes a parody of travelogue style with interlaced parodies of officialese:

> Indem ich erwidern zu dürfen glaubte, dass ich nichts so heftig suche und so schleunig zu finden hoffe, als etwas zu trinken, machte ich die Bemerkung, dass ja einzig Durstlöschen vorläufig äusserst dringend sei und prompter Erledigung bedürfe, während alles übrige momentan als unwichtig betrachtet werden und folglich warten könne. (*UP*, p. 171) (18)

Then too the story 'Verkrüppelter Shakespeare' begins with an astonishing parody of the first plunge of narrative *in medias res*, such as that which Tolstoy admired in Pushkin and Kafka practised:

> Nacht wars, als ein Einsamer, dem der Name Mackensen nicht unbekannt sein konnte, der überdies wusste, was man unter dem Begriff MacMahon sogleich oder doch wenigstens schon

nach fünf bis zehn Minuten zu verstehen habe, der drittens mit der Gestalt eines gewissen Generals Mack infolge Lektüre von Geschichtsbüchern vertraut war, wegen eines, man kann sagen, krachenden Lachens erwachte. (*UP*, p. 268)

But in 'Ein Flaubert-Prosastück' comes one of the most breathtaking sentences of all: one asks, is this parody, of Flaubert or Henry James, or is it a completely original and positive structure, elaborate, but with the spontaneity of a windharp:

Er führte in der Tat aus, auf was es ihn hingerissen hatte anzuspielen, und sie duldete seine Jetztzeitbräuche nicht in Betracht ziehende Bildungswandlungen, Erfahrungen usw, teilweise oder vollständig übersehende Überwältigtheit mit dem Zagen einer sich auf ihrem Antlitz abspiegelnden Befürchtung, dass er zu weit gehen könnte, was aber nicht der Fall war, indem er es bei der Herausformung seines Entzückens bewenden liess, aus dem heraus er zu ihr sprach: 'Sie haben recht . . .'. (*Grosse kleine Welt*, pp. 52-3)

The piece entitled 'Dorfgeschichte', which also belongs among the later writings, shows again what new and vivid unities can result from the technique of parodic caricàture when this is conjoined with the technique of interrupted arabesque. And at this point it would seem that we arrive in the sphere of quite different forms of narrative, where such pieces as 'Die kleine Berlinerin' (*Aufsätze, AKD*) and 'Brentano' (*UP*) transcend dreamlike discontinuity and display the full stereoscopic and coherent vision of things, with its richness of colour and roundedness of contour. At this point it is but one step from the parody of illusion-puncturing ridicule to the anti-parodic creation of a positive sphere of original imaginative discourse, free as air, and filled with vivid personal truth.

The limited scope of this paper prohibits any discussion of affinities between aspects of Walser's work and other modern developments, Dada for instance, in some of the later writings, though hardly Expressionism. An affinity with the painters Klee, Chagall and Kandinsky might also be found. But whatever affinities exist, they seem at length accidental. Central to Walser's work is an independence from influences, movements and vogues, an insulation which reflects his outstanding originality of character and, paradoxically, his openness of character. 'I raise my hat to this age', he wrote, 'but not too high' (*UP*, p. 155). This remoteness from contemporary currents is eminently Swiss. But there is something here which does not accord with

prevalent notions about Swiss literature. It will be objected that
such an etherial parodist and self-reliant critic of bourgeois so-
ciety does not belong to the same world as Haller, Pestalozzi
and Gotthelf, and that even Keller might have looked askance at
him. (19) Where is the political dimension, the humanitarian re-
solve, the Republican sense of structure? It could be answered
that as a spokesman of the lowly commons (for Walser often
sees himself as such) this wholly authentic poet ridicules the
denizens of the bourgeois world only when their absurd unwit-
ting postures and, linguistically, their platitudes, put all authen-
ticity in question. 'Fraud', as Kierkegaard remarked in another
context, 'is not tolerated in the world of the spirit'. But, more
generally, the political dimension in the Swiss intellectual tradi-
tion obtrudes to us or to German readers only because we do
not recognize its role in the structure of Swiss civilization. In
this civilization, politics enter the household at every aperture,
even the poet's household if he has one. This means that in
Switzerland the political dimension is not felt to obtrude. It is
assimilated as a structural element in the common life, and con-
sequently the focus of the common life, and of literature, is not
in politics at all, but something of which politics is but one
among many other manifestations, namely the small circle of
individuals united by a common responsibility. And into this
small and indissoluble circle, with its unlimited elasticity, its un-
limited capacity for assimilating the incongruous, Walser fits as
the *genius loci* itself. He may be a poltergeist in the household
of 'Helvetia Mediatrix', but he is a vital member of the vital
group, whose knowledge of his country and of his countrymen
is as rich as his love for them, despite the grave formalism which
can so heavily overlay their vitality. He is, in fact, a poet in
whom the Swiss *anima* assumes a real, existent form. As the rau-
cous Trinculo said when he heard Ariel flute forth to perfection
the melody he botched himself: 'This is the tune of our catch,
played by the picture of nobody'.

Perhaps another objection may be raised. In an age when li-
terature, as Walser himself said in later years, has become intel-
lectually imperialistic (Seelig, p. 106), does not the absence
from his work of a strictly socratic or discursive element not
only reflect his lack of 'higher education', or of all that 'Bildung'
implies, but also stigmatize him as a child of the provinces,
clownishly out of step with the times. This second objection can
only arise if Walser's work is misconstrued. Because he is gay,

critics who care only to confront works whose discursiveness
springs from profound *ennui* and melancholy should not call
him irresponsible; for his gaiety is a conquest of the vacuum, a
conquest which could not have been made were not the healing
of doubt the sign that doubt has been understood. Because he is
a miniaturist, critics who laud Leviathan should not call him tri-
vial; for that would be to commit the old error under which
Stifter's assailant once laboured, the error of allowing ideas of
mass to interfere with awareness of value, a confusion which is
driven clean out of doors by Yeats's remark: 'Is it not certain
that the Creator yawns in earthquake and thunder and other po-
pular displays, but toils in rounding the delicate spiral of a shell?'
(20) And to call Walser either irresponsible or trivial also is to
ignore the anthropological enigma which underlies his whole
mentality, an enigma to which a saying attributed to Matthias
Claudius refers: 'Leben Sie wohl, und wisst, dass alles Quark ist,
ausser einem fröhlichen Herzen, das seiner bei aller Gelegenheit
mächtig ist.' (21) But this second objection also may spring from
erroneous notions about the tenor of Swiss literature and
thought. One of the hallmarks of Swiss intellectual life and of
Swiss literature in the German language is their recurrent con-
trariness to simultaneous German developments. Often the great
figures are diametrically opposed to their great German con-
temporaries. Pestalozzi, the unassuming active philanthropist,
stands in a contrary relation to the pensive archangels of Weimar.
Amiel, Bachofen and Burckhardt explore the substrata of ex-
perience, the dark nerves filled with figures, the symbols of the
psyche, the discreet motives of history, while their German con-
temporaries follow the course of enlightened Liberalism, Posi-
tivism and the centralization of political power. In our day, Wal-
ser, the rejected, daring, capricious Ariel of modern German
prose stands in just such a contrary relation to his monumentally
informed and systematic contemporaries. Once more the uncon-
scious motives governing tradition have asserted themselves,
though few heard Walser play the tune of their catch, or knew
his vision of the world as a continual wonder.

A NOTE ON WALSER AND KAFKA

In a letter first published in Carl Seelig's article 'Robert Walser
als Dichter der Armut' in *Volksrecht* (Zürich), 3 Jan. 1957, Kaf-
ka wrote that he had read *Jacob von Gunten*. This letter must

be dated 1909, not 1908 as Seelig (following presumably Max
Brod's dating) unjustifiably asserts, because *Jakob von Gunten*
was only published in 1909. But apart from the mention in the
Volksrecht letter and a passing mention of *Der Gehülfe* in
Richard und Samuel, no individual work by Walser is mentioned
in Kafka's published writings (also: *Richard und Samuel*, writ-
ten by Kafka and Brod together in 1911, betrays at this point
[*Erzählungen und kleine Prosa*, Berlin, 1935, p. 273] the stamp
of Brod's style, not that of Kafka's). Walser's name occurs only
once in Kafka's *Journals, Tagebücher*, 1910-23 (Frankfurt,
1954), p. 536: 'Walsers Zusammenhang mit ihm [Dickens] in
der verschwimmenden Anwendung von abstrakten Metaphern'
(*c.* 1917, and perhaps a pregnant reference, in view of Kafka's
concern with the language of metaphor). I can find four refer-
ences in writings about Kafka: 1) M. Brod, *F.K., eine Biogra-
phie* (Prag, 1937), p. 83, where Walser is mentioned as being
among writers in whom Kafka was interested (*c.* 1908-10), from
which it may be inferred that the book concerned might be
Jakob von Gunten (cf. *Volksrecht* letter: 'die anderen Bücher
habe ich nicht gelesen'; 2) G. Janouch, *Gespräche mit K.* (Frank-
furt, 1951), pp. 56-8, an account of a reading by Ludwig Hardt,
at the Prague Mozarteanum in 1919, which included some Wal-
ser, for example the prose piece 'Gebirgshallen' (*AKD*, pp. 54
ff.), as may be inferred from 3) Hardt's own account of this in
The Kafka Problem (New York, 1946), p. 34; and 4) Seelig,
Wanderungen mit Robert Walser, cit., as quoted below. Internal
evidence of the relation is a problem in itself. The first published
work by Kafka which could show Walser's influence would be
Betrachtung (Leipzig, 1913 [January]). Yet it is notable that
Kafka's short prose pieces here, though some are reminiscent of
Walser (especially 'Der plötzliche Spaziergang', 'Der Ausflug ins
Gebirge' and 'Der Kaufmann'), cannot reflect influence from
Walser's short prose pieces as such unless Kafka read in periodi-
cals some of the pieces later collected in *Aufsätze* (1913) and *Ge-
schichten* (1914). This is quite possibly what may have occurred:
cf. Seelig, p. 107: 'Ich erzähle ihm [Walser], . . . Kafka habe
auch oft mit Enthusiasmus vom *Jakob von Gunten* gesprochen
und Max Brod seine [Walser's] Prosastücke aus Berlin vorge-
lesen'. This, however, does not exclude the possibility that Kafka
read the Berlin prose pieces at a later date (*Betrachtung* was a
collection of odd and occasionally earlier pieces in any case).
Though it may be more than a coincidence that both Walser and

Kafka cultivate the short 'Prosastück', Walser's reply to Seelig's statement given above may be both typical ('Robert bemerkt aber nur trocken, in Prag gebe es doch Aufregenderes zu lesen als Walsereien') and indicative: pointing away from the sub-aesthetic domain of 'influences' and towards the more rich and illuminating phenomenon of certain parallel stylistic (and thematic) developments on independent lines. This may be followed, for instance, in Walser's 'Fritz' or 'Basta' (*Kleine Prosa*, 1917) and Kafka's 'Josefine, die Sängerin'. In all three stories sentences and paragraphs are built up as it were choreographically around a recurring pivot-word which, each time it occurs, receives a new semantic or grammatical inflection.

That Walser knew nothing at all of Kafka's work is to be inferred from Seelig, p. 55.

APPENDIX: CHRONOLOGY OF ROBERT WALSER'S LIFE

1878: Born 15 April, in Biel, central Switzerland (youngest of eight children).

1888-92: Progymnasium schooling in Biel.

1892-5: Apprentice clerk in the Biel branch of the Bern Cantonal Bank. Then (1895) to Basel, employed as bank clerk by Speyr & Co., and on to Stuttgart, where his brother Karl (born 1877) was apprentice to a scene painter. R. W. worked in Stuttgart first in the advertisement office of the Deutsche Verlags-Anstalt, then in Cotta Verlag (publishing houses). Interview with Josef Kainz: R. W. thinks of becoming an actor.

1896: Arrives on 30 September in Zürich, where he stayed until 1905, although during this time he also took some jobs and made visits in other places. Jobs: clerk in factories, to a lawyer, in a bank, an insurance firm and a sewing-machine factory, house-boy to a wealthy Jewish lady, addressing envelopes in a 'Schreibstube für Stellenlose' (where unemployed people were paid for minor clerical work). R. W. is now writing poems, while living the life of the 'Kommis' or clerk (*Fritz Kochers Aufsätze*, 1904, *Helblings Geschichte*, many other later prose pieces).

1897: To Germany, probably Berlin, for one month.

1898: First poems published in J. V. Widmann's periodical, *Der Bund* (Bern). R. W. meets in Zürich the elegant, epicurean writer and editor, Franz Blei.

During the period 1896-1905, R. W. also took jobs in Thun and in Solothurn (1899). 1899 also: possibly a trip to Munich. Either then or in 1901 he met the writers who were launching the periodical *Die Insel*, A. W. Heymel, O. J. Bierbaum, R. A. Schröder. Four poems by R. W. appeared in the first issue, October 1899, thereafter several short verse plays (*Komödie*, 1919).

1901: Authenticated trip on foot to Würzburg from Munich (80 kilometres in 10 hours). In Würzburg he met the writer Max Dauthendey. M. D. gave him 20 marks to help him on the way to Berlin, where Karl W. was now working as a scene painter. R. W. visited K. there in January 1902.

1902-3: Visits to his sister Lisa, who was now teaching at Täuffelen on Lake Biel (cf. *Geschwister Tanner*, 1906).

Spring 1903: Works in an elastic factory at Winterthur.

Summer 1903: Military training in Bern.

July 1903: Assistant to an inventor, Karl Dubler-Grässle, in Wädenswil, near Zürich (*Der Gehülfe*, 1908).

Jan. 1904: Leaves Wädenswil and returns to Zürich.

1904: Publication of the short prose pieces, *Fritz Kochers Aufsätze*.

Spring 1905: To Berlin. R. W. lived periodically with Karl in the latter's Charlottenburg apartment. K. was by now a successful scene painter, stage designer and book illustrator, working for Max Reinhardt (illustrations to Cervantes, Kleist, Hauff, Hoffmann, Gautier, Morgenstern, Hesse, Hofmannsthal, Eduard von Keyserling and others).

For some time during 1905, R. W. attended a Berlin school for domestic servants, after which he was employed as a man servant at Schloss Dambrau in Upper Silesia (cf. *Jakob von Gunten*, 1909). *Fritz Kochers Aufsätze* was remaindered; the popular book of 1904-5 was Hermann Hesse's *Peter Camenzind*. (Winter 1905-6 was the period when Rilke worked as amanuensis to Rodin.)

New Year 1906: Back to Berlin. R. W. writes his novel, *Geschwister Tanner* in four weeks, staying at Karl's apartment. Christian Morgenstern was the publisher's reader who recommended it to Bruno Cassirer ('he gazes upon the world as a continuous marvel'). Morgenstern also wrote to R. W. scolding him for careless punctuation, syntax and other inconsistencies. The book was published in 1906 and sold a thousand copies in the first year; it was favourably reviewed by

J. V. Widman, Franz Blei, Felix Poppenberg.
At about this time, Max Brod in Prague discovers Walser. It remains uncertain whether Brod or Kafka read him first.

1908: R. W. leaves Karl's apartment. Was back there again in 1910. Left again in 1912. The brothers were notorious for their mischievous pranks in Berlin literary society.

1908-13: For a while during this period, R. W. was a secretary to the Neue Sezession art gallery of Paul Cassirer. A very productive period. The novels *Der Gehülfe* and *Jakob von Gunten* appeared (1908, 1909), many short prose pieces were appearing in periodicals: *Aufsätze* (1913), *Geschichten* (1914) were published by the most advanced publisher of the time, Kurt Wolff (Leipzig). Before Bruno Cassirer dropped R. W. he gave him a large cheque for a journey to India. Walter Rathenau—later foreign minister under the Weimar Republic, assassinated in 1924—offered him a job on Samoa (R. L. Stevenson's island). R. W. declined both the cheque and the job: 'Does Nature travel abroad? Do trees go on journeys, in order to obtain greener foliage somewhere else?' (*Geschwister Tanner*).

R. W. did, however, take a balloon trip from Berlin to Königsberg, in company with Paul Cassirer. Exact date not established.

1909: *Gedichte* (poems), a 'Luxusausgabe' with illustrations by Karl W.

At a party during this period R. W. met Hugo von Hofmannsthal; he is reputed to have said to him, 'Couldn't you forget for a moment that you are famous?'

Following the withdrawal of Bruno Cassirer's interest, R. W. had serious financial difficulties. The Berlin period ends with his return to Biel in 1913.

1913 f.: Various lodgings in Biel. Poverty during the war. Publications: 1914: *Kleine Dichtungen* (special edition for a book society; general edition 1915). 1917: *Kleine Prosa* (Zürich, Rascher Verlag). 1917: *Prosastücke* (Rascher). 1917: *Der Spaziergang* (Frauenfeld, Huber Verlag). 1918: *Poetenleben* (Frauenfeld, Huber Verlag). 1920: *Seeland* (Zürich, Rascher Verlag).

1914: Intermittent military service in the Swiss territorial army.

1919: His novel, *Tobold*, rejected by Rascher Verlag, was subsequently lost or destroyed. During this Biel period, R. W. concentrated on short prose pieces, to the exclusion of longer

fiction.

1916: Death of a brother, Ernst (schizophrenia).

1919: Death of a brother, Hermann (severe neurosis).

Nov. 1920: R. W. goes to Zürich to give a reading. He reads at rehearsals so strangely that the literary editor of the *Neue Züricher Zeitung* is asked to read instead of him. R. W. sits in the front row at the reading, after it has been announced that he is unable to be present.

1921: R. W. moves to Bern. Job (which he abandons after six months) as Sub-Librarian in the Bern State Archives.

Early 1920s: Short prose pieces appear in *Neue Züricher Zeitung*, *Der Bund*, *Basler National-Zeitung*, *Frankfurter Zeitung*, *Pro Helvetia*, *Wissen und Leben*, *Weltbühne*, *Tagebuch*, *Der neue Merkur*, *Prager Tageblatt*. (Until mid-1920s.)

R. W. consistently keeps aloof from literary circles, Swiss or German, even at the risk of losing his livelihood, such as it is.

1921-2: Novel, *Theodor*, lost or destroyed except for three extracts published in periodicals.

1925: *Die Rose* (Berlin, Rowohlt) appears, R. W.'s last short prose collection to be published during his lifetime, except for the Seelig selection, *Grosse kleine Welt* (1937).

Late January 1929: R. W. voluntarily enters the insane asylum at Waldau, Bern. In June 1933 he is moved to the asylum at Herisau in Canton Appenzell. During the next years he is visited by Carl Seelig (*Wanderungen mit Robert Walser*, 1957).

25 December 1956: R. W. dies while out walking in the snow.

PARAGRAPHS ON TRANSLATION

OVER A score of modern German writers have appeared in English translation during the past fifteen years. This is a fair average in comparison with figures for translations over the past century and a half. It means that during these fifteen years readers without knowledge of German will have been given access to the newly collected poetry of Rilke, to the poems of George, Brecht and Hofmannsthal (who is still in the press), to Musil's *Der Mann ohne Eigenschaften*, Broch's *Der Tod des Vergil*, to Thomas Mann's later fiction and to certain plays by Brecht, to prose and verse by Gottfried Benn (1960), and to a gallery of lesser-known writers, such as Robert Walser and Wolfgang Borchert, and of living ones, such as Aichinger, Böll, Frisch, Gaiser, Goes and Roehler. Plays by Dürrenmatt and Hochwälder have also been performed, as well as radio plays by Eich, Weyrauch, Lavant and Bachmann. An American firm (Dell) has even risked a paperback of German short stories which includes as many as six stories by living writers. All in all the inference might be made that modern translations are readable and marketable, and that the willing reader can get a fair idea of 'modern German literature' without knowing any German.

This inference would be wrong. For one thing living authors usually get selected and translated under commercial conditions which leave wise selection and valid translation to chance, and which foster the anomaly that published translations are discussed by reviewers who have neither the knowledge nor the time to assess their validity. Scarcely one theatre critic, for instance, noted that Dürrenmatt's *The Visit* was a truncated travesty of the original text. Also no reader of a foreign literature can pretend to any knowledge of it unless he is familiar with what is currently believed untranslatable or unimportant (thus commercially useless). This is particularly the case at a time when publishers are hard put to recognize any but commercial values. It might be noted that writers of magnitude usually have in any case to die, like Enoch, before they get translated.

Even when we think that we have assimilated a foreign writer, we find on closer inspection that somewhere along the line there has been a fault or a series of faults to spoil everything. Take two recent translations of Rilke's poem 'Requiem auf den Tod eines Knaben', one by Mr J. B. Leishman (1957) and the

other by Mr Randall Jarrell (in the Doubleday Anchor book of
German verse, 1960). The first line of the original reads: 'Was
hab ich mir für Namen eingeprägt', which means 'The names
that I imprinted on my mind!'—or, to keep it more on the speech
level of the original, that of an eight-year-old boy, 'How many
names, I got them all by heart.' For this line Mr Leishman gives:
'What names I printed in myself'. This is wrong because 'what'
here can only mean 'what sort of', whereas the sighed 'was . . .
für' in the original context also has the sense of 'what a lot of';
and it is also wrong because 'print' is incorrect and unnatural
English, with no oddity for counterpart in the original. For the
same line Mr Jarrell gives: 'Why did I print upon myself the
names.' This is wrong, because the original is not interrogative
but exclamatory, and again because 'print' is impossible. Did
theses translators drop the 'im-' prefix of 'imprint' for fear of
missing the right rhythm? If so, they did not try very hard to
hit it. Neither version is accurate, neither is English, and neither
is in keeping with the speech-level of the original.

Of course, this is only one line, and the poem is quite long. But
there is little improvement in what follows. Mr Leishman inserts
meanings which do not appear in the original: often he sacrifices
sense to engineer a rhyme (which is the least tolerable of vices
in a verse-translator). For example, the original 'mähnig, sehnig,/
vierbeinig', which means 'maney, sinewy, / four-legged', becomes
'maney, shiny, / sinewy, fourlegged', so that 'shiny', may rhyme
with 'tiny', two lines above. In Mr Jarrell's version of the same
phrase we find that he too has 'shiny', but that he omits 'sinewy'
altogether—which shows (to put it mildly) how misleading Mr
Leishman can be. Mr Jarrell also copies Mr Leishman in writing
'He promises' for the original 'Er verspricht', which has the
sense of 'he is [a] promising [lad] '. 'He promises' is meaningless
without some such addition as 'well' or 'much', the absence of
which is not overcome by Mr Leishman's tortuous addition of
'a trace' (to rhyme with 'face' two lines above). And this is the
witness of a translator who is widely esteemed, and of a poet of
some high repute.

It is no use saying that faults like these do not prejudice the
'whole effect' of a translation. Indeed, they show that exactly
philological failure in matters of detail induces stylistic faults
which invalidate the whole translation. If he does not know

what an original text says and how it says it, how shall a translator create some 'whole effect' that is even remotely akin, let alone validly analogous, to that of his original? This is not the old quarrel between literal and free translation. The point here is that, in translations of verse and prose alike, there is a general failure of communication and style as soon as there is any disproportion between translation and original, any mistaking or dropping of the original tone and tempo and level of utterance, and any failure to spot multiple levels of meaning or peculiar syntactical patterns of feeling, not to mention cruder faults in perception as well as in understanding. The *Gestalt* theory of translation, which says that an original must be totally apprehended before it can be adequately re-created, is all too often aired to shield misjudgement of detail.

Surely this is one reason why translations have seldom been thought worthy of serious discussion. The margin of error is so wide that, even if his original is part of the translator's own culture-complex, the best that can be hoped for is a provisional approximation, for whose constancy there can be no sound criteria. This question of the provisionality of translations is closely linked with the question of style, since style also moves.

Older translators, as is known, were usually interested in classical writings; and our immediate forebears in the eighteenth century, believing as true mechanists that images *adorned* ideas, were content like Pope to bring originals over into current language by force if necessary, even if it meant shedding some images in the process. They never thought that the reverse procedure— bringing their current language over toward the style of the original—might have more adequate results. Thus, in 1791, Tytler could applaud Pope's excision, on the grounds of taste, of Homer's reference to the 'well-girt nurse' (*Iliad* vi. 467). Not until the stylistic upheaval of the German *Goethezeit* and the European Romanticism which it precipitated, did it become obvious that excisions of this kind are faults, since originals are unique images of their particular cultures, in which well-girt nurses may be more decorous than in Pope's Twickenham. Not until this was recognized did it become clear that the modernization of a text to which the translator can only penetrate through a time-barrier must be aligned with the fact that modernity too, in matters of taste and language, is always on the move.

There is still no reason why modern-dress translations should not get made today. But the reaction against them, exemplified in William Arrowsmith's super-Petronius, compels translators of older or of modern writing nowadays to recognize primarily that their material is language (which is by no means so self-evident); that in fact, as Jean Paul said in his *Vorschule der Äs-thetik* (1813), language is their whole affair, and that they have always to allow for a language being a vehicle of those values which are the dynamics of a particular culture. Translators of Villon may still fail to catch his tone and his tempo (the ges-tures of his culture), even though they catch his sense and his sentiment. Translators of modern Greek, where a different kind of barrier exists, may meet with just as elusive gestures. But translators of modern German verse, prose or plays do at least have access to the modern German culture-complex. And though many of its gestures may remain hidden from them, or alien to their medium, they are in a position to match their own lan-guage to the styles of original German works.

This approach does subordinate the question of provisionality to the far more pressing one of intrinsic consistency or of what Coleridge, speaking of verse-translation, called 'brilliancy' in the language of translation. It is just this brilliancy, combining pre-cision and style, which has always given good translations, from Golding's Ovid and Hölderlin's Sophocles to Untermeyer's Broch and Friar's Kazantzakis, a sort of dual (but not hybrid) nationality, in which the style of the original blends not so much into any rigid requirements of the language of translation as into those energies which the translator lures into focus out of such requirements as may exist. The Kaiser-Wilkins Musil may lack the sheer impact and intricacy of the Kazantzakis *Odyssey* in Friar's version; but it does go a long way toward Musil; these translators have also admirably caught the glitter and *presto* of Benn's essay-style. This is not to legitimize any torture of the language of translation, such as is often found in Mr Leishman's Rilke, or in hurried commodity translations. Nor does it legitimize the notion that the translator is intellectually and imaginatively the creator's equal.

Yet not all translations derive from the impulse to imitation, this 'elemental need of man' whose gratification 'has nothing to do with art' as Worringer so disparagingly alleged. Most trans-lations are, indeed, made by men and women working desperately

to strict schedule, not because the work gratifies them at all but because they have to live. There are many other translator-types. One of the more familiar ones is the 'literary' poet, whose original work too springs not from life's nothings so much as from some impulse fired by a ready-made model. A type who seems rather rare in this country is the genuine translator-poet, whose work has both precision and style and who usually has a very close-grained mind—Nerval, for instance, or Baudelaire, rather than Pound, for in Pound the style is so often achieved upon forfeit of precision.

The present writer's narrow experience in translating modern German verse has shown him one thing: that verse translation, provided it is done with headstrong paradoxical faith in the result, can teach a poet things about the potentialities of his own language which are different from those which he learns by working in his own language alone. There is also a kind of disinterested fascination in such work, which is not felt by the scholar who simply 'studies', or by the poet who simply 'uses'.

 Benn's syntactical strangeness and his lightning exchanges of levels of diction; Brecht's 'gestic' simplicity; Celan's exploration of meanings that are at once concrete and metaphysical; Fried's analogous but crisper poetry in which images that are rooted in ordinary speech suddenly assume an autonomous life; and Andreas Okopenko's poem 'Grüne Melodie', with its most un-Germanic rush of negative capability enabling the poet to speak in the role of the colour green—these test the translator, alert his ear to a wide variety of cadences, teach him what every schoolboy has forgotten, namely, that the words for which the biggest dictionaries are most needed are the ones you thought you knew best, and provide him with a special kind of discipline. It is that discipline of language and of temperament which Hölderlin advocated in his remark—one that no translator can disregard—about 'going out into what is alien', without which exodus there can be no real 'homecoming' to one's own laral domain.

FRAGMENTS ON METAMORPHOSIS
AND TANGENTS
(*from a notebook*)

1

SANTA FE, 16 May 1971. There are ceremonies, probably ancient ones, which repeat words, rhythms, actions, dance-movements, interminably. A slight variation, after so much repetition, a heavier drumbeat, say, or a new word, marks a shift in the relation between the people participating in the ceremony, and thus too in the relation between those 'forces', the presence of which is the concern of the ceremony. Example: the Navajo Corn Dance. Ritual origin of repetition as a principle in sacred language, words or gestures.

Rhyme and 'regular' rhythm in poetry are survivals of this. The odd thing is, how infrequently semantic repetition appears in poetry. Music repeats melody, with variations and inversions; poetry seldom repeats its *words*, except in the chorus of a song.

With rhyme and 'regular' rhythm now almost irrelevant to the kind of meaning-making or presence-invoking ritual that a poem is about, semantic repetition might come to loom as large and potent as melody-variation in music (changing of relations between identical elements in a pitch-series). It is, besides, often boring the way a poem goes on and on without repeating, though with variation. More *quasi*-musical elements in a poem's structure would, if there were semantic repetition, become explicit pattern. The reader or listener wouldn't be so intent on 'getting' what comes next. Anxious anticipation, the straining of wits, would be eliminated. A clearer focus, an ordering kind of concentration on the *presence* (as opposed to what comes next) of certain phrasings, sounds, patterns of sound and 'sense'.

The repetition/variation structure would also be appropriate for any poem whose subject-matter is the most ancient of all, in poetry or ceremony: metamorphosis (not just change, as currently understood or misunderstood).

Navajo sandpainting presents an image of closed space (bounded on all sides) and within that space a multiple pattern of relations, elements in binary opposition, paired opposites, matched by other sets. Magic focus, like the interanimation of sounds in a poem—Khlebnikov, Mayakovski, Rilke, Mallarmé, Mörike sometimes.

2: Boston, 14 March 1972

Dream: down a side street, then I come to a boulevard and see on the other side of it a shopfront, burnished bronze and olive green, an oldfashioned window in several sections, with wooden frame and crossings. I tell myself that this is how shops used to look, and remark the solidity and beauty of it. Perhaps there were wooden (Corinthian?) columns on each side of the shop front. It looked like an old apothecary shop.

Now I know that this is Munich. I have crossed to the same side of the boulevard as the shop, and am moving up the boulevard to the right (as from the juncture of side street and boulevard). But I'm walking on all fours. I think: how comfortable this is, amazing how well I can move in this way, loping on all fours. A very tall girl approaches, elongated like a figure in an El Greco or a Leonora Fini. (On waking I think she may have been like the girl called Uschi whom I met in Munich in 1949.) She is peering at me, with small head atop a long gowned or thickly overcoated body. I crane my head as she passes, and notice the amused smile on her face.

Now I am moving up a side street to the left, narrow and uphill, and here I find a small junkshop, with some exquisite porcelain flower vases on a shelf inside. One has several separate funnels, and is painted in bright colours, perhaps red and blue. White porcelain. (A tiny porcelain heart with exposed valves?)

München/Mönchen: monk/monkey. The antiquity of the scene: perhaps a faint memory, colouring the dream, of readings in (and about) the eccentric Alfred Schuler (ed. Luwig Klages, 1940), who regarded Munich as a Roman city, and whose ideas about the presences of the spirits of the dead, alongside the living, at Roman banquets, certainly come through in one or two of Rilke's *Sonnets to Orpheus*. While moving like a chimpanzee, I was so limber. Can't quite recall if I was conscious of walking on my knees, it didn't feel that hard or comfortable under me. Yet my body was not arched as it should have been if I was on feet and hands. Very flexible wrists.

3: Austin (Texas), 13 November 1972

In car at intersection of Nueces and 24th street, facing north. A tree, sycamore, immense canopy of yellowing leaves, like an umbrella; then a girl walking, in the foreground, between me and the tree. She wears a cape of yellow colour, mixed with black, a faint black pattern. With this cape she has the shape

and colour of the tree: a tree is walking, I think, but yellow, the tree is flame, I recall Breton's *chevelure/flamme* image, while still looking at the girl, or tree, walking, and for a moment, a briefest moment, as she stops walking, for some reason, there rises vertically from her head a wavering sheaf of hair, stands there upright, for a briefest moment, then sinks back into place. A flame! Had I put it there? Had the wind, a gust of wind, anything to do with it?

Certainly there are moments when apparently random thoughts coincide with, are synchronized with, apparently random events, in such a way as to dissolve the (common) barrier between subject and object, without any diminution of the sensory scene. A special kind of attentiveness is all it takes, to make such a moment happen, or to make it recognizable, indeed possible (Aristotelian Thomist sense). The 'communicating vases' metaphor fits such moments, or the quality of that kind of attentiveness. Imagination 'seems' to project an event, much as in a dream, although the actuality of the event, as one factor in the coincidence, is not thrown in doubt. Ideally, the surrealist poem is a sustained stereoscopic score which enables the reader to conduct this kind of performance, with the reality inside his own head as the orchestra. Such a poem enacts, symbolically (which is really), the drama of such coincidences, such moments of participatory animation.

The poem (ideally) also urges the reader's imagination to conceive of externals as a scenario waiting to be created, not fixed but transmutable, the world—waiting to be wrenched from its literal fixity in a frame of utilitarian purposes (or blank apathy). A transposition of contexts occurs, such as structures the mental space of a poem of this kind. The 'world' is freed from its habitual frame, and the reader's frontal awareness is freed from its automatism (cf. V. B. Shklovsky on Sterne and Tolstoy). Vision suddenly is interiorized, phenomena fill with light, while, correspondingly, 'I' can look upon those images, sensations, desires and terrors, which the moment chances to make apparent in the depths of me. Sustain this moment, and you have Machado's time: 'the psychical character of ultimate reality.'

There are also moments in which this kind of participatory attentiveness is so intense, that the person might find himself convinced that his 'I' is a creature—plaything or extinguisher—of an imagination which is other than his, or his as he knew it up to that moment. An imagination like an *anima mundi*, such as

the alchemists detected in the life pervading mind and matter; the mental landscape of which is the supra-individual; the topography of which can, however, be explored in experience, since it does have a kind of consistency. This imagination is the 'world' to which Don Juan the Yaqui introduced Carlos Castaneda. The language of folk myth is like an atlas of that world. Traditional metaphysics (Hindu, Chinese), an astronomy of its celestial space. 'The mar of murmury mermers to the mind's ear, uncharted rock, evasive weed . . .' (Joyce, *Finnegans Wake*, p. 254).

Pound, Canto 76:
Cythera potens, Κύθηρα δεινά
no cloud, but the crystal body
the tangent formed in the hand's cup
as live wind in the beech grove
as strong air amid cypress.

—the mythic figures, gods, demons, are like incarnations of the psycho-sensory qualities of such chance moments when 'mind' and 'matter' communicate: the stronger the imagination, the more coherently the god or demon combines visible and invisible properties (identical with neither—errors of asceticism, errors of idolatry), definition and suggestion.

The more complex kind of moment, sustained, explored, its 'time' crystallizing into form—need not acquire, as language, extreme complexity at all. Nor need its language be richly auditory. Some of Breton's later poems, like 'The House of Yves Tanguy', have a starkness quite different from the luxurious earlier ones of the 1920s. W. C. Williams: 'the writer of imagination would attain closest to the condition of music not when his words are dissociated from natural objects and specified meanings but when they are liberated from the usual quality of that meaning by transposition into another medium, the imagination' (*Spring and All*).

Kafka and the *Grenzsituationen* (limit-situations): the modern enterprise modified frontiers, or limits, of perception, in such a way as to warp, smash, push back or pull inwards, those limits, with a view to changing the position of the centre (bourgeoisie).

4: 'If man could think without the aid of the first person singular, the mortal sins would vanish from the earth' (V. S. Yanovsky, from his novel, *Of Light and Sounding Brass*, Vanguard, 1972, quoted in the *New York Times Book Review*, 17 Dec. 1972).

There is a certain kind of largeness which implies a vacuum: the late Hapsburg buildings in Vienna, Wilhelmine buildings and barracks in Berlin, Texan city churches and banks (barely distinguishable), Nazi parades and ideals. They are out of all proportion to the human body, for one thing, and are so intended— as tools with which to intimidate and mystify people. Likewise there is a smallness which seems to come from timidity: English pettiness. No open horizon calling you, not even the sea any more. The language of advertising, especially in the U.S.A.: the trivial dressed up as something momentous (everything 'new' or 'very'). English advertisers write with pursed lips and smirks.

An unfakeable largeness: Siegfried Klapper in Mormoiron— the miniscule paintings of fruits, vases, bottles, surfaces alive with tiny details, enormous ('mad') energetic attentiveness to minute particulars, without loss of 'the whole', the clear delicate imprint of the whole creative intelligence. He seems to think that the world is so rotten, only a constructive diminution to the pinpoint can offer a foothold for the sacred.

On the one hand, 'the paved path that leads to the church', on the other the traveller, his feet 'moving in measure, on and on, for love of life' (end of Hölderlin's 'Griechenland'). There is no transformation without transgression. True largeness (Mozart) might consist in a relation, felt and known, between the intricately modelled, fascinating 'exterior' (a face, not a front), and the interior, effortless, occult energy, which seems akin to stars, electrons, birds. It is not a question of 'size', but of measure.

Largeness also depends on your having a supra-individual theme, even if that theme is known to be an elaborate illusion, or fiction (as most of them turn out to be in the long view of history). Gombrovich: 'There is no shelter from face except in face, and we can escape from men only by taking refuge in other men . . . I fled, with my face in my hands' (end of *Ferdydurke*).

Largeness also depends on order, some degree of dramatic organization, 'self-interfering system', like a knot (Buckminster Fuller). Clutter, large or small, is life, not largeness. Since largeness is, conceivably, a grand fiction, its own theme, then the starlight, filtered through immense intervals of time, bestows its terror, or its blessing, on our eyes, though we flee, with our faces in our hands.

Magnitude of the keyhole: 'One thing is dominant in me, the ardent attraction of the abstract. The expression of human feelings, of the passions, interests me no doubt, but I am less

inclined to express these movements of the soul than to make visible, so to speak, the inner flashes of illumination which we cannot explain, which have something divine about them, and which, translated by the marvellous effects of pure plastic art, open up magical perspectives' (Gustave Moreau).

5: 17 January 1973
In dreams, objects appear, which are endowed with a power of enchantment. A wooden finger-ring, intricately carved with figures; a slender ancient bottle, found in the cutting of a roadside, filled with dark red liquid, which looks delicious; an old coin, a magical cake, a book of thirty or three hundred years ago, but freshly printed, since the dream occurs that long ago, perhaps it was in Leipzig.

Dreaming of such objects, you think: Somehow, this time, I shall try to transfer this one to the other world. But you wake up empty-handed. Such objects are no more transferable than certain objects, or scenes, sets of sounds, syntactical patterns, of a poem.

In the dream one is enchanted by the object, or by the profusion of such objects. And often the object or rain of objects will not hold still. One is so enchanted that one does not bring to bear on the object the will to penetrate it, which can be brought to bear on objects in waking life. This one doesn't do because, or so it feels, the object itself is what is penetrating oneself, or its magic is pervading one's whole being: the object holds you within its ambient shimmering horizon.

Perhaps it is here, inside the dream, that there is a threshold that could be crossed. The object cannot be transferred into the waking world, but possibly the dreamer could force the object to hold still just long enough for his intelligence to explore every detail of its appearance and so to transport his intelligence into the heart of the object.

What then? Would the object undergo a transformation, so giving a sign that it resists inspection, or that its appearance is illusory? If so, would its transformed appearance bear any similarity to its first? And would, if subjected to similar intent scrutiny and holding up under it, the transformed appearance itself undergo another transformation, and so on, until the dreamer came to some transformed ultimate, not the impossible, but, having penetrated the various shells, would he behold and at the same time come to participate in some dance of those neural

energies, which were the shapers of the object in the first place?

In dreams of imaginary music there might be something of this, only you are there *at once*, without passing through successive stages of penetration and transformation. I dreamed, years ago, of a music that was swooping and soaring in a mountain sky, incarnate in a richly robed woman, like a goddess, attended by a mass or halo of other, smaller figures, song and instruments. That music filled the world (of the dream), it was sharp as grief and sweet as milk. Mörike in a letter records a dream of enchanted music played as dancers trod on the pedals of a raised circular dais, also out in the open air, or perhaps in a forest (the music was the dance, the dance the music).

The motility of such dream objects might signify that their matrix, if that is the word, is a fluctuating dance of energies which can articulate itself either as music or as a thing (or series of things). It would depend on whereabouts, along the slide from particle to appearance, the articulation occurred.

At all events, instead of trying to transfer such objects to the waking world, motivated by possessiveness, one should try to transfer, into the dream world, the faculty of attentiveness available, but seldom realized, in the waking world. Would such attentiveness inevitably break the spell and destroy the object, instead of putting it through a series of transformations? Or, would that attentiveness never hold the object still long enough for the exploration of its intrinsic particulars to be completed?

There might be a dream in which a dreamer, who succeeds in exploring an object, and even in penetrating to the heart of it, finds inside the object the waking world (though he would not be awake) filled with self-transforming objects and in each of these objects utter nothingness.

The objects are presences, not just phenomena, presences fathered by desire generated in the neural energy matrix. They are not willed, they appear. Appearing as they do, in their immediacy, it can probably not be said that a dreamer chooses them or gives them voluntarily the forms they assume. And often, or usually, they are 'to hand': he touches them as he sees them. They are neither distant, nor intangible. So they seem to span a distance which, in the waking world, is seldom bridged: between the furthest reaches of desire, the deepest unconscious motives of desire, and the actual palms of the hands, and the fingertips. The dreamer's idea is that he can grasp (in oldfashioned terms a 'lower' sensation) that which is merely visible (the eye

as a 'higher' organ of sense). He does not know the incorporeal dreamwork of desire, because, beholding such an object, he is himself a function of that dreamwork and (or is he?) disembodied 'pure mind'. That may be going too far; but at least this kind of dream experience might be analogous to states of being that approximate to pure mind; the flaw in the diamond being the wish to grasp (and to possess) the object. Or perhaps the flaw is not the wish to grasp, but the dreamer's ignorance of what it is he wishes to grasp. Yet without that ignorance the object would not even appear, because the dreamwork of desire depends on ignorance, to some extent. Not entirely, however: because the dreamer's wish to transfer the object to the waking world is a sign that he is not ignorant of being asleep, even if he is ignorant of what forces are shaping the figuration of his dream.

Rid the dreaming mind of its wish to possess, and the image of the object rises in purity as the dream horizon sinks: a distance is implanted in the relation between dreamer and object, without loss of presence, without reduction of enchantment. Only an image, the dreamer thinks, or he thinks: Bless my soul, of all things, an image. Not a fraud, but a dwelling place of desire, or rather—the architect of conception.

6: (Conception dated winter 1969, in Vienna)
A man is walking down a dark alley in Prague, down another alley, turning the corner, down yet another dark alley he goes, carrying a cello case. Streetlamps, and it is a warm night. Cello music sounds through the night.

The man is in an upstairs room. He opens the case, takes out a cello, and plays. The room is empty, except for the man, sitting on a wooden chair, playing his cello. The music stops. There is a sound of hooves, galloping, far off. The man plays again, fervently. More hoofbeats, as of many horses.

The man stops playing, puts the cello back into its case, he leaves the room, closing the door carefully, he walks down the stairs and out into an alley. No sound at all.

Suddenly a loud sound of many hooves. In a dark alley, nobody else to be seen, the man opens the case, extracts a horse, mounts the horse and rides away into the hills of Moravia.

For Robert Sylvester (Plot for a short film)

7: 30 January 1973: more about the dream objects

Dreamed I was walking down a narrow open-air corridor, not a lane, in a large city, and found soon that the centre of this corridor, or arcade, was taken up by a long table—couldn't see the end of it—on which, gradually it seemed, but the gradualness was sudden, a succession of objects appeared, like small idols, figurines, standing statuettes. I looked until I found one that I liked. It had a round head, the size of a golfball, minutely carved with strange curves and figures, and the body likewise; but, as far as I could see, all the figures, including this one, had been covered with a thin coat of green paint (like the fake patina on bronzes in the Roman flea market). Thought that this would be removable. Looked at other figurines, but did not pick them up, for I now noticed that the sides of the corridor were cases with sliding glass doors, with other objects in them. Saw a blue object, like lapis or azurat, two finely polished plates, about the size of postage stamps, somehow held apart and each firmly fixed to a slender chain. I put my finger, left hand, through the opening in the glass and was pulling this object out when I dislodged a larger ornament, with a longer chain, and the two objects were entangled.

All the objects were there for the taking. Then there were people coming up behind me, and they too had begun to notice the objects. Actually I first saw the objects after finding two things made of wood. One of these was a long cane, perhaps two feet long, with a dozen or more protuberances, all smooth. Thought at first it was, like a piece of driftwood, not an artefact, but (again suddenly/gradually) it was distinctly carved: a wand, in the form of a single human figure, but with all these knobs, thumb-sized; the shape had the unity of a totem pole. Then came the long table stretching into the distance.

I did not think of taking these objects 'back' with me. But one thing I do now notice: as I looked at them, I could perceive the whole surface of each object, all around, in a flash, and *all at once*. No question: there would be no need to dwell on an object or turn it to see another side of it. The objects had surfaces, but these visible surfaces already showed their 'typical extensions': normally hidden surfaces were visible (as when one looks at a box and sees not six sides but three). So the dream object doesn't hide its physical 'implications' and probably its psychic implications are no less revealed. It means, to the dreamer, what it is, in its wholeness, perceived in a flash, with

no segregation of internal and external aspects.

The dream might have epitomized a thought I had when seeing the film about Lawrence of Arabia: Lawrence, as he raised the Arab revolt, was able to re-enact the visions, dreams and imaginings he may have had while exploring Crusader castles. Suddenly the antique was actuality, and he was doing it.

Maybe these dream objects were also telling me something about the notion of magical signs in Hermetic tradition: 'real characters', as Bacon and Leibniz called them, which are 'believed to be in actual contact with reality', and which signify 'some profoundly unifying experience'. I had been thinking about this statement (found in Frances Yates's review of Peter French's book on John Dee, *New York Review of Books*), in relation to language in poetry: 'He wants to establish . . . that the creative imagination of the poet is allied to the magical activity of the magus, stimulating the creation of vital poetic images. French is here trying to grapple with the core of the problem of the mental image . . .' (*New York Review of Books*, 25 January 1973). Mantras: the Sanskrit concept of 'seedsounds'.

If the dream was a precipitate of these prepossessions of the day before, what was it telling me? That the mental image, dream object, only seems to point to a meaning beyond itself (symbol), because the total meaning it reveals (all sides of the object simultaneously visible) is concentrated in itself so compactly that conceptual thinking cannot exhaust it, but must infer (therefore) that there is something external to it that it 'means' (points to). A different kind of mental activity, poetic, not conceptual, which the poem of 'real characters' might engender and guide, or liberate, *can* comprehend that whole concentrated meaning ('profoundly unifying experience'). Kant's 'aesthetic ideas' belong in this area, so does Pound's definition of the image as 'an intellectual and emotional complex presented in an instant of time'.

8: *Banalities*: early February 1974

There are legendary Englishmen—Philip Sidney, T. E. Lawrence —whose quality transcends the causes for which they fought: Protestant Europe, the Arabs. Yet they did need a cause to fight for. Sidney had a difficult choice to make, because he admired many Catholic intellectuals, men like Campion, and, having witnessed the Saint Bartholomew massacre in Paris, he knew to what atrocities religious fanatics can stoop. Lawrence also had

to cling to his cause as to a raft in a storm, once he had made his choice.

A cause is public. Sidney's conviction was that the end of education is to equip a man for virtuous action in the public field. If you live for a cause, you take on a supra-individual responsibility—of which Kafka said that you can neither identify it, nor live without it—which braces and crystallizes you. Philip Sidney had his melancholia, Kafka's Josef K. had no cause, only a 'case': both are characters who have to overcome their self-centredness, have to surpass their 'nature', in order to become lucid (Josef K. has flashes only, sporadic flashes, which deepen the darkness). Philip Sidney's education and upbringing must have helped him—the example of his splendid father, who reminds one of a great Iroquois chief.

By having a cause you can put on a little immortality, you think. A great historical movement may take centuries to achieve anything like a structure, to bring forth fruit. So they fight and die for a cause, these gentlemen, which in due time takes on a character they had not conceived of, the great mutations flow from the Uncontrollable Incognito, the cause is no longer what they thought they were fighting for, and only because the cause crystallized the man does the man achieve legendary stature, his cause perhaps forgotten, or only vaguely connected with a name. The actions vacuous? No, they did produce a man. 'If Caesar and Pompey had thought like Cato, others would have thought like Caesar and Pompey, and the Republic, destined to perish, would have been dragged to the precipice by other hands . . .' (Montesquieu).

For a poet, the cause may be the tradition with which he identifies. But all that survives of him is his performance. The product is not exhausted like equipment after use, but remains to testify to a struggle, a commitment to the grandest of supra-individual majesties—language. Yet even here the legend can hide the reality. What a poet is supposed to have written excites the imaginations of others, who abide by their suppositions and hardly glance at the testimony itself: hence, the classic.

Yet, again, the classic is precisely the writer who produces a coherent vision of reality which can be shared and which is valuable for human beings. Not a writer who jots down something for himself, from moment to moment, extemporizing, but a writer who provides (explicitly or not) a way of understanding, a style of mind, a landmark in the wilderness. He is consistent,

however fragile or doubting he may be, with all his self-torment. By creating the valid, consistent vision (inclusive of absurdity, that midwife to myth, and thus to language-creation), he disappears into the apple that others can eat.

Cause and bandwagon: poet apes climb on the poetry bandwagon, fluting and drumming. They enter the vacuum, which is worse than the vacuum of historical action: the vacuum of soliloquy fondly believed to be communication, but actually verbal wish-wash (the 'scene', the 'network', etc.).

Sidney's letter to Walsingham, 24 March 1586, contains this notable passage (written from Utrecht): 'For I think I see the great work indeed in hand against the abusers of the world, wherein it is no greater fault to have confidence in man's power than it is too hastily to despair of God's work. I think a wise and constant man ought never to grieve while he doth play, as a man may say, his own part truly, though others be out.' (His friend, William of Orange, had been assassinated in 1585.) He goes on: '. . . but if himself leave his hold because other mariners will be idle he will hardly forgive himself his own fault.' (What noblesse, considering the meanness shown toward the whole enterprise by Queen Elizabeth, who probably, like any bureaucrat, feared Sidney's charisma and intellectual brilliance.) According to Fulke Greville, Sidney had never engaged in worldly affairs without being conscious of their unreality. Finally his left thigh was shattered by a bullet, and on his death bed in the Netherlands he wrote a lyric called 'La Cuisse Rompue', which was set to music and sung to him.

9: 13 February 1973

Don't forget the Todas, people in north India, shown in Louis Malle's film, *Phantom India*. Eight hundred of them, no laws, no rulers, disputes (if any) are settled by a specially appointed council of elders, which is dissolved when things are settled (as the person called 'Imperator', in the Roman Republic, was appointed to get things started again when they became snarled up, and who would disappear, once the job was done). Little boys improvise dance-poems to re-enact local events, such as the arrival of the camera team. A crisp and chirping language. Men with wondrous coherent faces, Greek profiles, powerful brows and noses: it has been said that they're descended from part of Alexander's army. Girls are deflowered at the age of thirteen by men who understand all about it. They have no

word for sex—their word means 'food', or 'fruit'. Free love: one wife for several brothers, due to shortage of women. The older brother is responsible for the children. The men dance in a circle, robed in gowns of woven stuff, red, blue, white, deep colours. The dance steps are similar to Macedonian folkdances of today. They dance to frame, define or accent an action, such as the arrival and presence of the Ministry of Agriculture bus, with propaganda officials announcing the takeover of much of their land for the planting of forests to produce turpentine. Not an agricultural but a pastoral economy. Water buffaloes. Two old men, side by side but a yard apart, rolling long sticks between their palms, were churning buffalo milk into butter or curds. Not sure if they eat buffalo, but have the impression that the animal is sacred ('unclean'). Their origin-legend: buffalo rose from the river, one by one, and holding on to the tail of the last buffalo was the first Toda.

Their houses are made of wood. Beautifully balanced forms, like Navajo hogans, but larger, with Dutch-barn shaped roofs, log or plank walls, and a small front door, very low down, for crawling through. Very solid, like artefacts. Mountain and hill country, bushes, green, slopes, dells. One Toda (female) was tattooed. And don't forget the Bondos either, aboriginals, ugly, poor, diseased, with elaborate fore-arm ornaments and neck-rings of aluminium, no longer the old bronze neckrings. They buy the aluminium ones in the nearest market. To us each ring looks like any other, but the Bondo women spend hours study-ing their particular merits. Only three hundred Bondos are left. They make broom-heads out of reeds. Awful sadness on the round face of a bent old woman. And they weave miniskirts, with which the women conceal the lower parts of their buttocks. Mud houses, well patted, with wooden crossbeams. Free love, and a special house for young people to try one another out in. Easy divorce: a husband leaving his wife donates goats to his in-laws. They are swindled by the market middlemen.

10: Athens, 25 July 1973
At noon one meets X for lunch, and there is conversation, of a serious kind, continuing afterward in his room, with its freshly sanded and turpentined wooden floor. This is the second of two meetings. One is coming to know him somewhat. He says, among other things, that poems seldom are about people, be-cause entering into a relationship with a person takes time and

entails numerous variable circumstances. What makes a relation real is the swarm of details surrounding it. In a poem, that kind of slow evolution, also the arbitrary but crucial detail, is not the thing.

Fourteen or fifteen hours later, night has passed, one wakes up convinced that another person of one's acquaintance resembles X closely. Yet one cannot place or identify this other person, Y. A similar build, though perhaps more wiry, similar hair, a similar way of holding the head forward when talking. A similar, if bushier, moustache. X was wearing blue cotton trousers, whereas Y is remembered in green ones. Both faces have a kind of uncertain sweetness, a look of eager strain in the cheeks. But who is Y? Where has one met him? Perhaps he does not exist. Perhaps one has unwittingly visualized X's double, or his shadow. The identity of Y cannot be ascertained also because it is not at present possible to visualize a particular physical surrounding world in which his image belongs. A café? A room? A bus? And when could one have met Y? How long ago? How well does one know him? All this is uncertain still.

Then, still drowsy from the hot night and the ouzo, one begins to doubt the existence of Y altogether. Further, if Y does not exist, might not X also be a figment? Yesterday's lunch, in the grimy little eating-house, the aubergines and the maccaroni —were they figments too? If X did actually say what he is thought to have said about the slow growth of a relation between persons, even if he did not actually exist, that remark might have been, in the framework of a conversation that failed to occur, a reminder of the fact, if it is a fact, that identity can only be defined by fictions, and that it is not, despite the suppositions induced by lazymindedness, continuous, coherent, unitary and solid.

Suddenly one has identified Y. He does exist. The resemblances are real, and so are the ways in which X and Y rhyme with one another. Y is discovered, he has a name, he inhabits a real place; suddenly, too, the variable details are falling into place around him. What a relief, to know that others do exist.

11: Athens, 25 July 1973
Last night in the tiny restaurant on the little street and opposite the thick-walled whitewashed little one-storey house with the red tiled roof—

In the smoky, glowing, dim light, some light thrown across

the street from the doorway of the restaurant, some coming from the open door and window of the little house (we are eating squid and drinking retsina at a table outside)—

And outside the window of the little house there is a bench, or perhaps it is a group of boxes, and on this bench or these boxes a little girl in her panties is embracing a boy who is somewhat older than herself, she is perhaps eleven, he about thirteen. They keep looking into the house through the window. There is a room in there, directly off the street, and beyond that room another, in which the two bigger girls who occupy the house receive the young men of the neighbourhood, at intervals. For the house is a small whore-house, and properly bathed in this ancient light, the colour of terra cotta.

The children are looking intently through the window, trying various kinds of embrace, breast to breast, her head pressing gently against his breast, touching one another, as far as one can see, their bodies silhouetted in the light that fills the frame of the window.

From where we are sitting, at a table loaded with squid and retsina bottles, one cannot see into the room beyond the first room. But from the tender and tentative embraces of the girl and boy one might infer that the bigger girls are pleasant whores.

A LETTER TO THE NATIONAL ASSOCIATION
FOR HUMANITIES EDUCATION

20 February 1973

Dr George T. Prigmore, Chairman
and Members of the Committee on the Preparation
 of Humanities Teachers
National Association for Humanities Education
P.O.Box 628, Kirksville, Missouri 63501

Dear Mr Chairman, Ladies and Gentlemen,

I write on the understanding that you welcome comments on your Guidelines leaflet. I shall say in advance that my comments are not favourable. Being neither a schoolteacher nor an educationalist, I am not versed in the ways of your world. But I have been studying and teaching language and literature for twenty years—German literature—in the Universities of Zürich, London and Texas. I am the author of several books of poems published here and in England, also of various articles and translations. And I am English. I offer these introductory details in order to assure you that my criticism of the leaflet is sincere, though my hostility may startle you.

First, the language of the leaflet. It is a mixture of behaviouristic jargon and committee-protocol bureaucratese. Bad grammar, vaporous wording, cant and obfuscation abound in it. Examples: 1. 'Utilize the processes of decision-making and problem-solving' (paragraph 1). Obfuscation: how does one set about 'utilizing' a process? What are these processes? Do you mean anything definite? People make decisions; but to speak here of processes being 'utilized' gives the impression, an unenlightened one, that a general drift decides all. Also 'utilize' means 'use': but how does one 'use a process'? Is this jargon meant to mystify readers? cf. paragraph 2: again the word 'process', but apparently meaning something different ('processes by which ideas and values are determined and expressed'), though nothing more definite. 2. 'Prime among objectives' (paragraph 4). Does this mean 'the first objective'? If not, the passage should read 'Among the principal objectives.' 'Prime' in your use indicates that the writer(s) never knew Latin; and nobody has decided which are the main objectives. 3. Preparation, section 10: 'Students should have experience in, and the teaching of, the techniques of analysis ...' The grammar

here is bad, the meaning a blur. A student cannot 'have ... the teaching of' anything, let alone of 'techniques of analysis'. And what are these 'techniques'? Are they ready-made, to be 'utilized'? Rules of thumb? Doesn't one patiently acquire personal ability in the arduous field of analytic thought? The grammar mystifies, because it makes the proposition imply that you can 'use' a technique like a chisel, or that techniques can be conferred, like medals or degrees.

4. Learning Behaviour, section 1: 'Demonstrate an understanding of and a competency in the study of human behavior ...' Is it the study of behaviour, or behaviour itself, that are to be understood? If you do mean here that the teacher must be a competent behaviourist, then why not say so? If you do not mean this, then the requirement is a strange one, indeed. 'Demonstrate an understanding of human behavior ...'—first the teacher would have to have understood, then he would have to demonstrate understanding. Evidently you abuse the word 'understanding' here. And who could judge the supposedly demonstrated supposed understanding?

5. Parts of speech in your language: example, paragraph 3, of 'Philosophy'. This paragraph contains the following verbs: 'is', 'encompasses', 'stresses', 'must assure', 'exist', 'should lead'—a total of six verbs out of one hundred and fifty words: a four and one half per cent miniscule deference to mental or other activity, even allowing for the mandatory character of the language in question. Briefly: the life of verbs is suppressed by noun phrases and participial phrases; the verbs that do appear could hardly be deader.

I ask myself how the study of Humanities may fare, if the linguistic blundering of your pamphlet sets the style. It is one thing to work for the increase of humane intelligence, quite another to reduce enlightenment to ashes. The traditional medium of the Humanities is the word, not mumbo-jumbo.

Next, although the notion of Humanities as an 'integrative' discipline is a reasonable one, the kind of integration proposed in the leaflet is both unfeasible and inflationary. Your scheme is replete with what Fred Schroeder calls 'shotgun superficiality', 'the distorting of history', and 'the distorting of esthetic concepts'—three of his five possible 'abuses' (see *Joining the Human Race*, 1972, page 38). The staggering spread of attention required of the teacher being trained and of the student being taught could have only one result: obliteration of any personal

mode for the discrimination of values. Yet Humanities is histo-
rically a questioning search for values. The persons undertaking
that quest, in the past, have been often agonized and turbulent,
sometimes lucid, creative and heroic. But to have undergone the
preparations listed under your seventeen paragraphs would de-
molish the substance of a saint, let alone that of a modest teacher
or scholar, unless that person were in any case fortified by two
convenient intellectual defects, (1) honest-to-goodness insensiti-
vity to value and its questions, (2) inability to appreciate the
otherness of other things. Let me enlarge somewhat on this
second defect.

There is much to be said for the efforts of Humanities teachers
who try to make apparently remote matters 'relevant'. But here
there is a serious problem. By reducing the otherness of other
things, and those things may be texts, pictures, ideas, moral
systems, for the sake of relevance, the teacher merely indulges
existing egomorphic 'behavioral patterns'. The object of study,
once its otherness is denied or ignored, is merely cut to fit the
student's condition of mind, his existing frame of reference. No
real intellectual transformation, no real structuring refinement
of sensibility, no cultivation of instinct, can occur without exer-
tion toward the other, which is the living nerve of both educa-
tional and spiritual disciplines. That is, at least, the story from
Plato to Wittgenstein. If objects of study are no longer tended
for what they are, as intrinsically interesting structures of mean-
ing that can be shared, then they cease to radiate their interior
life. The norms of teacher and student remain untransformed
and eclipse all features other than those which suit the criteria
offered by those norms. If those criteria are such as fail to iden-
tify what they cannot measure, and so fail to achieve intelligent
contact with the *other reality*, then those criteria are wrong for
the educational process.

The problem in teaching is to nourish intelligence, by bringing
a person to attend to what, being uniquely itself, is other than
himself. A teacher tries to help other people to think for them-
selves about other human situations, creations and ideas, and to
think at all requires personal knowledge, personal understanding
(see the work of Michael Polanyi). No thought is given to this
fundamental problem either in Schroeder's book, or in the
NAHE leaflet. Instead, the whole multi-significant variety of
human cultural enterprise is shrunk to a set of classroom 'ex-
periences', 'realizations', 'appreciations', within the context of

the North American WASP *status quo*. But if anything like a genuine humanistic enterprise is to occur, that context, as you should know, must be *prevented* from grinding the real meat of other cultures and of the U.S.A. into midwestern meatloaf, with preservatives added (see your Philosophy, paragraph 3).

Your leaflet presents yet another feature of this selfdeceptive stereotyping and devaluing tendency. Teacher and student are asked to believe that 'philosophy, science, literature, and the arts are manifestations of the prevailing view of reality'. Can this really mean what it says? This statement is untrue, whichever way one reads the sense of 'manifestation'. The statement is also historically and ideologically biased in a most unreflective way. Do the writers of the leaflet not even know that many works of art, quite apart from scientific theorems, are creations of persons of genius who, by the intensity of their dissent, transfigured the 'views of reality' that prevailed in their times? Do they honestly suppose that primitive Christianity manifested Roman imperialism? That Luther manifested the Pope? That *Guernica* manifests Fascism? Do they believe that Socrates, Leonardo, Goethe, Flaubert—to name only a few solitary men whose lives were not altogether catastrophic—blithely manifested prevailing views of reality?

If the writers of the leaflet think such things, even while burying sense under such an obfuscatory word as 'manifestation', then they are deceiving teachers and students in advance; they are falsifying reality to suit their book. The ignorance of history, and of social questions, implied in such a statement is shocking. No less shocking is the exclusion of 'otherness' from the programme. That exclusion might be sociologically conditioned, to be sure: the mushroom Humanities, now sicklied o'er with the weird boglight of valuelessness, overgrows and suffocates that sense of the sacred, the authentic 'other', which happens to have fostered authentic creative work (as opposed to useful productive work) since Aurignacian times. There are two other quite concrete points at which I detect this disregard for the other: (1) Performance, paragraph 9: 'Demonstrate an understanding of the creative process by participating in the creation of original works' and (2) the absence of any remarks about languages (even English).

As for (1): the creative gifts of many happy and unhungry children are beyond dispute, and the shame of American schooling is its tendency to crush such spontaneous display once the

'serious business' of vocational training and adjustment has begun. However, it will not help to send a teacher into a studio, or poetry workshop, in the vague hope that he or she will pick up a few hints. Precisely such picked-up hints have already spread a miasma of misunderstanding through some American classrooms. It is only possible to write a paragraph like Performance 9, if you have no conception of what, in the adult world, is real, difficult and intangible ('other' again) about making meaning, writing poems or painting pictures. You yourselves would have everything conveniently explained. The experience of artists and of perceptive critics points the other way (though not necessarily toward utter mystery). It also seems that teacher and student alike are to be subjected to a barrage of secondhand information. Although paragraph 9 tries to suggest that the 'real thing' should be known about, this suggestion is not supported anywhere else in the programme. Nor does the question arise as to what original thinking, or original creation, might mean or be—as opposed to processed (mediated) information and ready-made 'techniques'. If you do intend to set up, against anti-culture, an omnipresent artificial environment for 'cultural appreciation', in order to make a better America, then this matter should be considered in a careful way by well-read and civilized sociologists and ethnologists, working together with practising artists.

(Note: among the 'Demonstrate . . .' paragraphs, I found myself, with some distress, expecting one which would say, 'Demonstrate an understanding of imagination'. To my surprise, or relief, I could not find the word 'imagination' anywhere in the programme. Nor could I find the word 'think' as a plain verb, though 'challenging thinking' and 'critical thinking' are there—the positive and personal action of the verb frozen to death in the gerund form.)

As for (2): I note that Fred Schroeder also regards the learning of a foreign language as being practically unmentionable: for him it would be unnecessarily 'time-consuming'. Precisely: it does take time to learn about the other—another language, or a work of art, a philosophical method, or a social question from another time and place. Schroeder allows no time for what Freud called 'the procrastinating factor of thought'. But with what are people trying to catch up? Schroeder says that almost everything has been translated into English (mercifully it has not). But here he misses the point entirely. Exclude the original information and you admit fakery; you admit the cliché-mongering

which requires students to be 'exposed to' matters they might
be trained to think about. Once again the main faultline appears:
Studied avoidance of the original thing (based on a fond belief
that 'translation' equals 'original'), and a bland overlooking of
the other, in this instance the original linguistic sources where
real study of the Humanities begins.

Of course, many students do find languages difficult; provin-
cialism, stupefaction, distraction, and some other more benign
factors, bend their minds against the whole exercise. The main
source of difficulty, however, possibly the least benign imagin-
able, is that to many students language itself, including their
own, is a matter of indifference. The white middle class is in the
midst of a massive troubled withdrawal from the main line of
communication, by which alone a human being can figure the
world in its intricacy, and feel his way to himself. This last feature,
axiomatic for the humanist language experience, is pulverized
by your term 'self-acceptance'. Your failure even to mention
this issue in the leaflet, and Schroeder's breezy goodbye to lan-
guages, persuade me that the Humanities programme of the
leaflet is (wittingly or not) more likely to pulverize minds than
to liberate and nourish anyone's ability to imagine and to think
articulately. Indeed, prevailing aphasia may be directly caused
by language such as that of the leaflet. Indeed, your scheme
might very well facilitate control of intelligence within the exist-
ing socio-economic network, the system of success, and within a
spiritless parochialism against which humane North American
thinkers and writers have consistently militated.

You are substituting for the agora a pseudo-cultural super-
market, or a tourist arcade. Your buyers will be precisely those
stuffed busybodies who understand nothing about life, thought,
or literature, and who buzz in and out of museums during sum-
mers in Europe, providing a silly spectacle and some dollars for
the no less stuffed and busy souvenir traffickers. Many of the
paragraphs in the leaflet seem to me to consist of well-intended
banalities dressed up in pretentious jargon. That is not the right
language for persons facing an historic crisis of truth.

My last two points are these:

1. The leaflet exhibits an alarming and puzzling bias against the
word. Yet the word is the time-honoured medium of human
knowledge, no—it *is* that knowledge. The word is not dead, it is
people who are indifferent, as others and yourselves are indiffer-
ent to the learning of foreign words. The bias in question appears

in the language of the leaflet, marking a curious (and unexplained) turn in the history of humanistic study. The word, here, has been first jumbled and then, like the other, marginalized out of existence.

2. The kind of thinking that informs the leaflet has a false premiss: the premiss that an awareness of something equals an understanding of it. You do not differentiate or define your terms (knowledge, awareness, appreciation, etc.), because, so it seems, you do not know what intellectual values are enshrined in them. Possibly the staggering spread of attention required of the teacher being trained is another byproduct of a devastation of values which I read in your lines and between them. It is made to seem that nothing, not even understanding, matters in itself, for what it is. Yet not only works of art are incomparable and unique creations. One possible value on which your case rests is this: the idea that the contents of knowledge can be directly transferred. But then your scheme indicates that those contents are *produce*—stripped of personal quality, origin and intent—to be acquired by direct and quick transaction, as one might acquire some bacon.

Here I am not saying that direct transferability is impossible or undesirable, nor am I saying that learning and teaching are absurd enterprises. I am saying simply that there is no trace of lucid and self-critical thinking about Humanities or education in your leaflet. You have, briefly, projected a commercial thought-model upon a field of meanings where that model is irrelevant—or ruinous. My analysis tells me that few, if any, of the skills and contents in question have for you any intrinsic value within their own frames of reference. All have been extracted from those frames, cheapened, reduced to tokens. This might be due to the way in which the mechanico-commercial model pervades most spheres of political and mental life today. But you might have given thought to that pervasion before building it into the leaflet.

Believe me, my earlier allusion to 'the sacred' does not stamp me as an opponent of democracy and enlightenment; but to my way of thinking the authors of the leaflet betray both the old and the new ideals of education, by letting the model of commerce bewitch their *directio voluntatis*. We do live in an age in which works of art are technically reproducible. In consequence, the creations of human minds as well as the horizons of those minds lose that aura which was part of the older modes of

aesthetic and spiritual experience. But we can take judicious advantage of electronic gadgets, as long as we understand that our own historical conditions are such as they are, as long as we refrain from imposing our models on other conditions, either by Humanities or by violence. What you have done is obey uncritically the momentum of the 'process'. You have not made any choice about its goods or its evils.

Hence, with the best intentions, you have quite happily enabled yourselves to apply to the activities of teacher and student an inappropriate thought-model, and an early nineteenth-century model at that: its malignancy was diagnosed by John Stuart Mill. Hence also you may require 'deductive thinking'; but why not inductive thinking? Does the latter encourage a sense of the particular, sensitivity to discrete textural detail, to the unique? Hence, too, under your programme, a young person who chooses to think and to discriminate between original and mediated information, would have to spend about five years, even after graduation, cracking shells, none of them containing a language or even a literature valued for its own sake, in order to be 'prepared'. A less thoughtful person would doubtless be able to demonstrate certain requisite awarenesses sooner. But both achievements would be improperly evaluated; for no person of honest understanding could even 'demonstrate' all that you propose, let alone preside in judgement over demonstration by others.

Yours sincerely,

Christopher Middleton

REMARKS AT THE QUÉBEC INTERNATIONAL
MEETING OF WRITERS, OCTOBER 1974

[*Note*: a French version of the following was addressed to writers participating in the annual conference (1974) organized by the magazine *Liberté* in conjunction with the Arts Council of Canada. I had written the English text in advance, basing it on questions proposed in the *Liberté* brochure. Several of the issues raised in the talk had come under discussion during meetings held prior to the talk. The gist of the discussion was this: To what extent is writing (*littérature*) liable to be neutralized (*récuperable*), and how can a radical kind of writing (*l'écriture*) avoid various ideological and commercial traps, upholding a free critical vision *vis-à-vis* society in present times. The terms *intégration* and *fausse totalité* also figured in the (rather woolly) statement of themes. French-Canadian writers at this meeting, aged between thirty and fifty, insisted vigorously on their personal, linguistic and cultural independence from both English and North American influences. Writing and speaking French in Canada is a definite political act, an act of dissent. The French writers tended to wrap many issues in the Byzantine phraseology of Vincennes, certain forms of which complicated the syntax and shortened the practical horizon of the French Canadians. Much of the talk reminded me of Cavafy's poem, 'Waiting for the Barbarians', where the senators and orators keep going to the battlements of the city with their fine robes and elaborate speeches, though finally the barbarians do not arrive, perhaps they never will, which is difficult, so the poem says, because the barbarians 'were some kind of solution'. Be that as it may, the French writers were more than formally sympathetic to many of the French-Canadian statements: a number of shared interests were identified, also mutual adversaries in the sphere of monopoly-capitalist exploitative *planification*. Oddly enough, no one even mentioned during actual meetings the bid of I.T.T. to buy up millions of Canadian trees for the manufacture of Xerox paper. A brilliant concluding talk by the Algerian writer Rachid Boudjedra put in some doubt the tendency of some French-Canadian writers to identify their problems with those of third world minority populations. All the talks appeared in Jean-Guy Pilon's magazine, *Liberté* (early 1975).]

ON PAPER it looks as if our discussions might revive an old theme. Writing one month before we meet, I wonder if we shall be putting through various phraseological mutations the tiresome old arguments about art versus propaganda. I need not remind you that these arguments have raised many tempers since that theme first began to plough its crooked furrow through social and artistic problems posed by the modern totalitarian state.

One slight directional change might be implied in paragraph two of the *Liberté* text. There it is suggested that some writing —*l'anti-écriture*—may be propaganda without the writer's knowing it. His writing may reflect 'exterior models', in such a way as to commend, rather than criticize, the socio-economic power-nexus. I wonder about this.

True, a writer may become entrapped in the system of mental habits, or conformities, which, in his particular society and his particular language, radiate false consciousness and false totality. But consider the other side of the suggestion. A writer whose writing conforms only to certain 'internal laws' of *l'écriture*, is likely to become entrapped in solipsism, and in a closed phraseology, lacking external objects, rather than to expose, critically and imaginatively, the false exteriors which are the masks of power. I shall expand on this a little, in terms of language.

If you reject all exterior models and make your writing conform only to its internal laws, then you may find yourself paralysed, your language vaporous, because you are contradicting a fundamental law of language, which even Mallarmé could not abolish. This law requires that, for much of the time, words have to represent something external to themselves. Further, this representational function of language, at its purest in poetic writing of the highest energy, cannot be wholly controlled, either by reference to internal laws, or by the commands of the writer's conscious mind. For a language is a system of variable representations. A language carries in its most inconspicuous elements, and in its deeper structures, a whole ongoing history of meanings. The internal laws of a particular text are a microcosm of that history, a semantically variable microcosm. Exterior models and internal laws, both are essential to the functions of language; their interplay helps the poetic imagination to project spacious, inhabitable, but self-referring structures. Whatever we have to decide, as writers, we should not dismiss exterior models lightly, nor should we put them down

in order to raise internal laws up.

Another consideration. We are talking about writing as an art. Now even extreme apostasy in language, the breath-taking idiosyncrasy of great poets, is a profoundly social gesture. Likewise most writing, whatever its pretensions to freedom and purity, call it art or call it *l'écriture*, tends not to give shape to original perceptions, but to perpetuate clichés. We should not be deceiving ourselves about this. It is complacent to declare that certain social and political pressures are being resisted by a type of writing, *l'écriture*, which operates according to its own internal laws, even though one may admit that this type of writing shows a special sensitivity, social, moral and aesthetic. A type as such never resisted anything. Also what bothers me here is the claim to exclusiveness that is made on behalf of *l'écriture*. I'd be the first to agree that poetic writing sometimes differs from other kinds of writing. But the difference comes from its being wide open to reality, not a closed shop. The poetry of Osip Mandelstam has precisely this openness, even though it is often densely metaphoric and, as Russian, intensely *eigengesetzlich*.

Consider now the mere fact that poetic creation is anomalous. Any truly creative act is an act of resistance to norms, habits of mind, social pressures and general ideas. Dada said so. Valéry and Chestov have said so. Polish poetry in the 1960s was saying so. Such a creative act works a violent transformation in the history of the language in which it appears, in the picture of reality enshrined in that language. But such acts are rare, extremely rare. You cannot make them less rare by giving a new generic name to the same old collection of clichés and artistic postures. I would add that such acts are rare because they are seldom willed. Rather, they come about as or in an ecstasy of imagination. That strange polyphony, the voice of the writer who is disciplined to his bones and has assimilated certain experiences, comes to speak in a fit of clairvoyance, as a medium, an oracle. Not knowing, and not willing, these may be preconditions of the inspiration. There is a qualitative leap between this kind of speech and the usual labour, fuss, imprecision and caprice of writing.

Now for the question of totality, false or true. We should not deceive ourselves as we confront this question of totality. After all, the word has lost its grip on the heart of life, and there are few people nowadays who respect the little revealing it can do. Yet it is precisely as an art that writing is most receptive to

ideas of totality. Wholeness, integration, communion, these
have been deep motives in art, as incarnate imagination, for a
very long time indeed. In older poetry, the feeling of wholeness,
sometimes near-mystical, a cosmic participation in some ages,
in others the cohesion of the tribe: all this had roots in sacred
language. The European novel, from Balzac to Joyce, was an
epitome of the whole mind of an epoch, a compendium, how-
ever differentiated the novel might be, and however divided the
mind. Great plays are evolving panoptika of the one life-spirit.
In Greek ceremonial structures, or in Hopi rituals, or in a play
like Brecht's *Caucasian Chalk Circle*, the central actor is not
visible, for it is the one life-spirit feeling and speaking its way
towards human experiences. Consider, on the side, a painting by
Giorgione, or one by Cézanne: it is an epiphany of the 'one that
is differentiated in and for itself' (Heraclitus).

These are not academic sounds I am making. These are cru-
cial matters for us. Certainly the writer today has to be on guard
against totalitarian urges and influences, in so far as he feels
them to be deadly falsifications of human reality. He has to dis-
tinguish very sharply between true and false conceptions of
totality. His best energies may be articulated in archipelagos of
fragments (René Char).

Is any true totality even faintly conceivable to us? If not,
then how can we concretely and actually identify what is meant
by the cliché 'false totality'?

In our bones we know what it means. We can see it every day
in the bulging trouser-bottoms of American executives; we see it
in the scowls on the faces of Greek plainclothes policemen; we
see it in the hecatombs of children, the economically motivated
massive destruction of human lives in Vietnam; we see it in the
slaughter of Indian populations in Brazil, and in the torturing of
political dissidents there and elsewhere. I doubt if we go wrong
if we call it terror, which is dead magic. But to so many people
it brings a sense of ease, because a reality is provided, because
you do not have to create a reality out of questions and spon-
taneous desires. What about true totality? It is an aspect of
what Paul Celan called 'the majesty of the absurd', that some
writers can still live and swear by the living magic of suggestion,
as the only open gateway to true totality in linguistic structures.
A few fine details, but they point a way into the interior, from
which flows a light that is inextinguishable. Who is ever admit-
ted? Nobody is in there all the time.

Even then, even when you have made your text foolproof, excluding every faintest trace of false totality, modelling your exteriors with zest and most discriminatingly, along comes an ideologue and entraps your work in general ideas. Even professors do this. If the rebel writer is not put up against a wall, or into a lunatic asylum, he is positioned, so as to become harmless, in a marketplace. Thus Solzhenitsyn becomes a good old-fashioned fighting liberal chauvinist, for the North American ideologue. This writer's Slavophil opinions, dated or not, are seen by the ideologue to match certain, perhaps finer, North American articles of faith—churchgoing, life around the local soda fountain, strong property fences, free enterprise. So Solzhenitsyn is made to look like a hokey pro-Kansas cold warrior. In the marketplace, the messages need not get lost, and the bullets need not sing, but somehow all the labels have got mixed up.

So what are we doing, as writers who would rather write, perhaps in misery and isolation, perhaps quite comfortably, rather than join the manipulated multitudes? I'd like to remind you of Cézanne's famous remark about the carrot: 'The day will come when a single original carrot shall be pregnant with revolution'. The pure finesse of structure in a work of art, an original work bristling with questions and iridescent with emotions, that kind of finesse repels general ideas. And that purity strikes a blow at the conformities, at the mystifications and banalities that spread like stains, or bad prose, from the people in power. There is also the thematic form of resistance: protest letters, pamphlets, manifestos (yet most of these seem to have to do with rescuing other writers). All these are additions to reality, which may do nothing to change reality. At least not immediately. Already it may be too late. Why then should we be so impatient? Here at least we can guard against category-mistakes which are made all too easily in this very volatile field. Distinguish between the two ontological phases, direct action and poetic creation, distinguish thus too, quite properly, between acts of will and acts of imagination.

I do not believe, as some German experimental writers were proposing in the fifties and sixties, that you can change the mind of a society if you expose bad historical habits embedded in that society's language, and then work to decompose the syntactical and semantic structures of false consciousness. That hope went high, but it missed the general agony of habit and

seems to have landed in the museum of modernisms.

Obviously, though, something can be done by us as writers, who are still alive, and whose concern is language. We confront power on the ground of language. For power has its language too, expressing itself not only in statistics but also in clichés (the term *power* itself is a cliché, so we should watch it). Power infiltrates its zones of interest with zombies made of language—that is what clichés look like, the zombie shocktroops of power. A writer can function as a kind of trickster, or as a sorcerer (though not in the manner of the Romantic magus), to subvert the clichés, and to rend the linguistic web in which society is entrapped and made subservient to the brute interests of power (not all its interests are brutal, either in motive or in effect). A writer's living language can show up the zombies for what they are. Even many people who speak or write zombie believe that these dead bits of language are alive. If our words could ever reach those people, they might take a more searching look.

It is obvious, too, that, without being escapist, a writer can give his reader a taste of the life that is not politicized. A life of precise and vivid perceptions, a life with real pains and real clowns. The unmediated life, open and colourful, of the lost world we long to rediscover, a world such as is given to us in some music, our world as we dream it might have been long before our time. The trickster-sorcerer role has mythological models, African and American Indian. The role of He-Who-Reminds-Us is more purely historical. Either role can excite, inform and even create intelligence.

We may not be able immediately to change life, or to change established semiotic systems. But we can write to inspire people with visions, visions of a whole life other than that which is given, and visions of particulars—make them notice inconspicuous faces, the cruelty, unconscious often, of manipulators, the ugliness of certain fantasies, the smells of drains and of fresh cut orange peel, the way light falls on a bottle, the concrete implications of certain ordinary words—all these elemental realities of daily experience, the psychic infrastructures of objects. We can dismantle the grey cardboard world devised by the phrase-makers. We can offer, in the precision and zest of our writing, correctives to the language-rot which is killing the spoken and written word in most public areas, writing itself included. If we do not help people to become articulate for themselves, understanding language as an instigation to lucidity, then their

whole reality will become derivative, manipulated, mediated. More precisely: they will have no reality.

We cannot hope to purge the guts of power by flushing out the clichés. If we did that, the very bones of society might crumble. At least we can write in the knowledge that clichés are among the most pernicious weapons of false-totality social engineering. We should seek ways to undo the mass cretinization which such weapons are inflicting upon society through agencies political and commercial. Loss of reality used to be a writers' neurosis fifty years ago. Now it has become endemic. If we have been made immune, by experience or history, then we might work some cures—demesmerize our readers sitting before the TV screens.

As writers, we can work to create anew the signs of resistance manifest in our various traditions. We can make new signs, which may point in small directions, or in big ones. We can make signs which tell of imagination, not as luxury, but as an essential creative faculty, far more common than most adults think. Without making unconscious propaganda for a conservative bourgeoisie, we can tell of mind as a drop of dark brilliance that contains the sea of creation. We can cancel the signs that pretend, in political or behaviouristic disguise, to explain mind as a neural machine waiting to be pushed around by environmental controls. But foremost, I think, we should centre our signs in the living human presence, a tragic presence, however humble. I do not mean the writer's own presence, although the mystery is that we can't do without subjective vision.

Can we do more? Does avoidance of big words condemn writing to idleness? For me, the truths that writing looks for are inconspicuous ones, like the truths of madmen and archaeologists. That is why I doubt declarative statements, most of all in poems. Yet, here is my mad dream. Because of my words, young and beautiful people go down into the streets, full of the joys of life; out there, other people are going to kill them, but those people hear my words, and they decide to join them.

3

ON TRANSLATING A TEXT BY FRANZ MON

grundriss

war sichtbar
ist genau sichtbar
es ist sichtbarer
 als jetzt
alles ist sichtbar

hautflügler
 hexagon
 später die glasur reflexe ein
haargeflecht

die kleine gläserne kugel der angler schleppt die
 schnur mit der beute zum sterben zu klein
 flach übers wasser
 hauch
 hautrelief
heliotrop
von den kindern gottes gebaren die töchter
der menschen söhne
kahl und sanft
stiegen sie beide ins gleiche wellen
tal hoben die köpfe
 beobachteten einander
 zuweilen noch
 grundriss und
 hohlkehle
hefe
heft
 'welches mass an strafe kann einen mann treffen
 dessen anteil an der tat so ungeklärt ist'

biegen den hinterleib
 dich an dieser stelle zu treffen
 (auge den rücken nach vorn)
 mund lief ein tier für zwei
 für drei
 bist du tot

groundplan

was visible
is clearly visible
is more visible
 than now
everything is visible

hymenoptera
 hexagon
 later the glaze reflexes a
hairplait

the small glass globe the angler draws in the
 line with his catch to die too small
 flat across the water
 exhale
 skin-basrelief
heliotrope
of the children of god the daughters
bore sons of men
bald and meek
both went into the same wave
glade lifted their heads
 looked at each other
 still now and then
 ground plan and
 fluting hollow
leaven
leaf
 'what punishment can be meted out for a deed
 if a man's part in it has not been clarified'

hindquarters bend
 to meet you in this place
 (eye back to front)
 mouth ran/animal for two
 for three
 are you dead

er ist tot
alle vögel sind schon da
alle vögel
alle

I PROPOSE to describe some difficulties which I had when try-
ing to translate a text by Franz Mon. When I was working on
the translation in December 1965, I knew only a few facts about
Franz Mon: that he was born in 1926, that he lived in Frankfurt,
that his name was a pseudonym, that he had been a co-editor of
the experimental miscellany *movens* published by Limes Verlag
in 1960. I knew that he had published four books: *artikulationen*
(1959), *protokoll an der kette* (1960), *verläufe* (1962), *seh-
gänge* (1964). I had copies of only the first and the last of these,
but had not read the theoretical sections in the first. In *The
Times Literary Supplement* of 3 September 1964, I had seen
two of his so-called 'Bildtexte'; also I had read there a short
article by him called 'Letters as Picture and Language'. I did not
know his introduction to the 1963 (Typos Verlag) catalogue of
the exhibition *Schrift und Bild* held in Baden-Baden in 1963.
This essay, 'Umsprung der Schrift', is a theoretical survey of
aesthetic interactions between lettering and images since the in-
vention of printing. In it I would have found some confirmation
of my idea, which evolved as I translated the text 'grundriss',
that Mon was familiar with the fifteenth-century alphabet-sym-
bolism of the Cabalists.

Translating the text 'grundriss' was a matter of giving it a go,
in order to see what would come out. I did not particularly like
the text, and I did not understand it. Yet I wanted to include
something by Mon in the book of new German writing which I
was editing; Mon is one of the pioneers in the international con-
crete and kinetic poetry movement which has swept the world
from Brazil to Czechoslovakia since about 1952. 'Grundriss' look-
ed like a text which might present an aspect of that movement.

I forget if I started by studying the poem closely or by plung-
ing straight in. I probably read it four or five times. But it wasn't
until I began to write things down that I noticed the three series
of alliterating words which occur at fairly regular intervals in the
text: *hautflügler/hexagon/haargeflecht; hauch/hautrelief/helio-
trop; hohlkehle/hefe/heft*. These could obviously not be kept
completely intact. This was not an encouraging start: because I
couldn't find any relations between these words other than the

he is dead
now all birds are here
all birds
all

phonic relations. These phonic relations, too, were more com-
plicated than the straight pattern of nine initial *h*'s. Other con-
sonants and vowels were involved. I began, though, to wonder
now if the poem was organized on a phonic basis rather than on
a semantic one. (Later a more referential pattern did materialize:
two spheres of reference are involved, the first being geometric/
architectural, the second organic/vegetable.)

The phonic difficulties were as follows: In the first two series
of *h*-alliterations, the relation of *hautflügler* to *hautrelief* could
not be recreated in English. *Hautflügler*=hymenopteron, or hy-
menoptera (the order of bees, wasps, ants)—this word has a con-
venient initial *h* in English. But *hautrelief* is a French-sounding
and actually French loanword, in which the *haut* part puns on
the *haut* part of *hautflügler*. It means 'high-relief', but to trans-
late it this way would only make a horrendous pun with *hy*men-
opteron. The German pun cunningly relates the architectural re-
ference here to the organic references elsewhere in the three
series, for example *haargeflecht, hefe*: German *haut* meaning
skin.

There was one other slight problem here: Should I use the
singular *hymenopteron* or the plural *hymenoptera*? To designate
an order in nature, here an order of insects, English normally
would use a plural. All Mon's other alliterating words were
singular forms, the word *hautflügler* probably singular too,
though the word on its own could be either singular or plural.
I still felt tempted to use the plural form, *hymenoptera*, in order
to avoid the inept repetition of *-on* endings for *hymenopteron*
and *hexagon*, there being no such repetitions in the German.
Finally I did opt for the plural ending, for reasons of ear, sup-
ported by the suspicion that few English readers would recog-
nize a Greek plural ending when they saw one anyway.

Another difficulty: not only would *skin-relief* for *hautrelief*
miss out the *h*-alliteration, it would also miss the French con-
nection, *hautrelief*, and, worse, it would intrude an accidental
association with Helena Rubinstein, Max Factor or some other
firm. The German obviously denotes an elevated design on a
plane surface, while, via the pun, it suggests *skin*: *skin-relief* was

vitiated by the jargon of advertising, *skin-hautrelief* was clumsy beyond words, *skin-basrelief* would be a mistranslation botching the *h*-alliteration.

With the second series, things were almost as bad. *Hauch* could not be rendered in English with an initial *h*, since it means *breath*, but it could be rendered as *exhalation*. The *h* in *exhalation* would latch in, even if it wasn't in an initial position. The *x* in *exhalation* would also form a mirror-image phonic link with the *sk* in *skin* if I were to use the mistranslation *skin-basrelief*. This *x/sk* arrangement would give a phonic chiasmus in the alliterative spirit of the three series, even if it was not loyal to the letter. But what a desperate situation.

With series 3, I was again in trouble. Yet there were possibilities. The long *o* was a secondary phonic link between *heliotrop* of series 2 and *hohlkehle* of series 3. This could be caught if I rendered *hohlkehle* rather freely as *fluting hollow*. As a technical term in architecture, *hohlkehle* does nevertheless mean either *fluting*, or *hollow*, not both. My rather free translation would also catch the quite literal and non-technical sub-sense of *hohlkehle* as *hollow throat (Kehle=throat)*. It was a pity that the long *o* of *hollow* had to be in a nonstressed position. The intrusion here of a slight musical pun—*fluting*—did not seem out of place. It could provide a semantic link with the phrases about birds at the end of the poem (*alle vögel sind schon da*), phrases which gradually rise out of the *-flügler* element of *hautflügler* (*Flügel=wing*).

The three series were now coming out as follows:

 hymenoptera
 hexagon . . .
 hairplait
 exhale
 skin-basrelief
 heliotrope . . .
 fluting hollow . . .

I still had to cope with the last two members of series 3. Here, moreover, the translation would have to integrate the last member, *heft*, with another sound-sequence a little farther on. There are phonic relations, which cannot be accidental, between *heft*, *strafe*, and *treffen*. I shall now discuss how I worked on this.

The latter part of the poem contains the two phrases which involve the verb *treffen*: *welches mass an strafe kann einen mann treffen / dessen anteil an der tat so ungeklärt ist*, and then

after a short intervening phrase, *dich an dieser stelle zu treffen/ (auge den rücken nach vorn).* The first phrase was printed between quotation marks. I couldn't identify the quotation; in fact, I preferred not to, for fear that some standard English legal phrase might exist to match it, and that a standard phrase might dislocate the sound pattern I wanted to work out. The main snag here was the verb *treffen.* The first phrase involves a normal sense of *treffen* in such a context: *what punishment should befall a man* or *be meted out to a man.* The second *treffen* could mean either *meet (encounter)* or *hit.* The intervening phrase was *biegen den hinterleib*: if the second *treffen* did mean *hit*, I was landed here with an idiotic picture of someone hitting someone on the backside. However: did *hinterleib* here mean an insect's tail rather than a human backside? Did it refer back to the hymenoptera? It *is* the word used for the extremities of insect bodies, which curl (*biegen*) with joy when they sit on rocks in the sun, or when they get ready to sting. In any case, the bending-over backside didn't seem to belong in the poem at all. If the second *treffen* did mean *meet*, then at least this would assonate and pun on the *meted out* possibility for the phrase preceding. Even so, what a cheap pun. The relation between the two *treffens* in the German is a kind of pun-relation, but a deadpan pun is what you have there, not a clever-clever one.

I was still doubtful about the hindquarters bending or the insect's tail curling. Then it occurred to me that if this phrase did denote a curved backside, it would relate to the earlier phrase about the glass globe (*die kleine gläserne kugel*) and to the following phrase about the back-to-front eye—rotundity being common to the globe, the backside and the eyeball (if not to the curling insect's tail). *Auge den rücken nach vorn* involved an odd accusative absolute, but this was no problem: *eye back to front.* I decided not to overstrain things here by risking to translate *auge* as *eyeball. Eyeball* would have given a stronger visual effect, but by now I was feeling that Mon avoids any words and sound patterns which might present things plastically as recognizable images. My feeling about this was confirmed later when I found in one of the prose sections of *artikulationen* the following sentence: 'The requirement that a text's supreme quality should be plasticity is one of the imperishable voids in human thought.'

The logical relation of the hindquarters and the eye to what immediately precedes them was beyond my comprehension.

Perhaps there was no such relation. The relation to what follows was also obscure—to the phrase *mouth ran / animal for two / for three / are you dead.* . . The only detectable link here was the *ie* sound common to *lief* and *tier*, inverted in *zwei* and *drei*. (At the time I did not know that *für zwei, für drei* sounds rather like a children's counting game in German; and that *bist du tot*, like the phrases about birds, comes from German folk song. Such echoes can hardly be translated in this case.)

Having got this far with puzzling the poem out, I felt fairly certain that it was a montage constructed on two principles: it consists of semantic disjunctions and phonic relations. This isn't a sound-poem, but even then the main relations did seem to be ones made by vowel sounds and consonant sounds. At this point I read another poem by Mon, called 'verzögerte biographie'. Here, too, I found that he was getting semantic disjunctions at certain points, somewhat in the manner of the early Expressionist poet August Stramm. Here he had pared down to a minimum such 'normal' aids to sense as prepositions, articles and inflected endings, and he was juxtaposing nouns, verbs and adjectives in clusters without syntactical integration. For instance: the last three lines of 'verzögerte biographie' read *drall / gefängnis / meine freiheit*. In the context it is an open question whether *drall* is an adjective or an adverb here. You can't tell if it is or is not related to the word *gefängnis*. But if you translate these words into English, then connections are immediately suggested, because English adverbial forms have to differ from adjectival ones. *Buxom / gaol / my freedom* inevitably relates *buxom* to *gaol* more closely than *drall* and *gefängnis* in German.

There remained one or two more details concerning the third alliterative series and its connection with the later part of the text. Series 3 could not be kept intact. My *fluting hollow* for *hohlkehle* retained the *h*, even though this *h* comes late in the consonant series of the phrase. But the main difficulty here was the alliteration of *hefe* (yeast or leaven) and *heft* (booklet, copybook or issue of a magazine). The phrase about punishment seemed to evolve out of some purely phonic, but unstated, association between *heft* and *haft* (arrest). It also seemed that here these letter patterns, with *a, e, f* and *t*, evolved out of *heft* to give the phonically related words *strafe* and *treffen*.

Eventually I settled, in series 3, for *fluting hollow / leaven / leaf*. This meant switching from *h* to initial *l*, but I could sustain this *l*-alliteration through to the last word of the English punishment

phrase, *clarified (geklärt)*. And I hoped that a fine ear would be able to pick this out. I also hoped that my whole series—*leaven/ leaf/meted out/meet/clarified*—had sufficient phonic fibre, or timbre, to fulfil the original function of *hefe/heft/strafe/ treffen*. The *l*'s were already present, by the way, in the middle positions in the German series 1 and 2.

Even so, *leaf* was rather a far cry from *heft*. Also I found it impossible to capture the vowel link between *hohlkehle* and *hefe*. And my *u*-sound in *fluting hollow* didn't relate to any other sound in the three series or in the punishment phrase. It was some compensation to catch, in the middle sector of the translation, something of the phonic spirit, if not the letter, of the phrase *stiegen sie beide ins gleiche wellen/tal hoben die köpfe*, which came out as *both went into the same wave/glade lifted their heads* (I realize that German *Wellental* means merely *trough*, between waves). The clear phonic relation between *kahl* (in the phrase *kahl und sanft*) and *tal* had to be redistributed. For *kahl* I used *bald*, which assonated with *bore* from the second line of this section; *bald* could also function as a sort of supersonic chiastic eye rhyme with *glade*. I could have used *glabrous* for *kahl*, which shares the long high *a (eh)* with glade, but decided it was the wrong kind of word, too recherché. The middle sector of the poem, I now began to notice, was the only section in which the syntax was *relatively* undisturbed.

Now it was not until I began to write down discursively the notes I made while translating the poem, not until I began to think about the thoughts I had had about the text while translating it, that I began to get an inkling of what this montage of phonically related phrases comes to mean. The relatively undisturbed syntax of the middle section prompted this inkling. The presence of all these phonic relations also began to make new sense once I had begun to rethink the doubts and thoughts entertained while in the act of translating. I had been assuming that the poem was a semantic near-vacuum: an organized assemblage of sounds which evolve into words and cross-pollinate with each other. But I now began to see that it made a kind of sense, and I was beginning to grasp the mode in which this sense had been made.

To make this clear, let me scan the text for a moment. The text begins with some flat statements about things being visible. It continues by naming visible things in an alliterative series. The first series, consisting of phonically related words, imports into

the very act of reading a further sense to that of sight—the sense of sound. The sound-sense is articulated in letters only: there is nothing emotive or 'expressive' in the phrasing, and even semantic connections between these words are, as it were, beyond their horizon at this point—that is, they emerge only in retrospect from later points in the text, and even then these connections are rather vestigial (the geometric/architectural and organic/vegetable references). At the start, then, a number of visible entities are named and phonically related, but these phonic relations are not symbolic, they are alphabetical only. It's as if the language is being handled as a sort of code. If we knew this code which is embedded in the matrix of the alphabet, we could become relators and integrators of things which aren't ordinarily related at all.

Next comes a scattering of words denoting more physically visible things: the *gläserne kugel* phrases and the second *h*-series. After this comes the undisturbed, or rather, relatively undisturbed syntax of the middle section. The figures in this middle section are not visible entities, they are imaginary—the wording points to vague primal beings, sons born of the children of God and the daughters of man. We have not seen them, we only imagine them: yet they saw each other, 'looked at each other'. They are 'still now and then/groundplan . . .': as if they constitute at least part of an archetypal basis of being. As earlier, the reader *participates* in the poetic act of constructing this vision of the imaginary archetypal figures, less by taking the words in his mouth and hearing them with his ears as at the start of the text, than by responding to the relatively coherent flow of the syntax. The reader gets a clear view of the figures only if he responds to the fact that here, but not elsewhere, the syntax allows such a view. All the same, the syntax here is mounted on audible vowel harmonies which belong in this primal world of undisturbed syntax: *kahl und sanft/stiegen sie beide ins gleiche wellen/tal hoben die köpfe*. The phonic and syntactical *peace* of this section is different from the crumblings and probings toward coherence elsewhere in the text.

Then comes the third *h*-series of visible entities, related again only by a vowel (*e*) and two consonants (*h* and *f*), not related in fact and not related by syntax. At this point there is a jump in the text's curious logic: a jump across the quotation about punishment, to the phrase about the hindquarters and the phrase about the eye. I had found this perplexing. My inkling now

suggested to me that 'grundriss' could mean two things: ground plan and fundamental fracture (*Riss*=rent, fracture, division). Or at least: the poet as montageur seemed to be playing on its ambiguity. The fact that these later phrases were *not* related apparently to what precedes them now seemed to be the thing to watch. Because of a fracture, a *grund-riss*, the paradise world of the primal beings is cut off, somewhere else, not present in the visible world. *Grundriss* is what has made the visible world into a place of punishment, or at least into a place where certain rules for punishment are made and questioned. The body bending, or tail curling, to receive punishment—if that is what *biegen den hinterleib* means—is implicitly 'like' a turned-about eyeball. That back-to-front eye sees only the ineluctable modality of the visible, it doesn't see the invisible paradise world of the undisturbed syntax section which is, in the text, just behind it, irretrievably behind it.

The visible/punishment/fracture axis of reference includes one more fact: death. First this enters as a question, though without a question mark; it could also not be a question, since the German 'bist du . . .' could be construed as the natural inversion of the first words in a main clause which follows a subordinate clause. However, it seems to be a question as soon as you reach the next phrase, which is like an answer: *he is dead*. Death is for him, whoever he may be. The folk-song echoes here anchor this in the world of *naïveté*, folk wisdom, children's voices: the folk song goes, 'Schiesst der Jäger, bist du tot.'* The birds carry on, all the same, and the poem as a venture toward articulation peters out in the phrases *alles ist sichtbar, alle vögel sind schon da*, while just 'behind' these phrases again stands the sombre and blunt *er ist tot*. The individual death is here an extension from the image of the eye back-to-front, a tortured image, certainly, of the inadequacy of sight in the face of the chaos of the visible world.

So if I were offering an interpretation of the text, I would base it on the question of the relation between the central part of it, with its comparative lack of syntactical disturbance, and the other parts which have a greater degree of syntactical disturbance. Something on these lines: 'Grundriss' means both ground plan and fundamental fracture, for the purposes of this

*'Alle Vögel sind schon da,/alle Vögel alle!' is a quotation from a German children's song also (a text of it was established by Hoffman von Fallersleben). I am grateful to my colleague George Schulz-Behrend for catching this, and to Miss Harriet Watts for finding von Fallersleben's text.

text. The text is not merely 'about' loss of coherence in the visible world, it enacts this loss of coherence in language and lures the reader toward experiencing it at first hand in the very act of reading, while simultaneously putting him in a position to see around the edge of chaos into a dimension of harmony and order—perhaps I should say: to *hear* around the edge of chaos. The loss of coherence has a history which starts with the loss of paradise. By implication, this loss actually began the moment beings first 'looked at each other', that is: became conscious of the visibility of other beings, other things, conscious thus also of the otherness of these others. Consciousness of 'God' having been evacuated from mind, all that is left of paradise is a few scattered sounds are embedded in language: certain sounds brought together by the text, in an attempt to recompose the primal harmony of being—of human and divine being as the ground of meaning. Language, so the text suggests, is an essay in recomposing a primal coherence in the midst of a devastating and uncontrollable explosion, called death-in-life. The fundamental fracture has brought not only linguistic disjunction and incoherence into being, it has also brought punishment and death as facts of the visible world: *alles ist sichtbar/er ist tot.*

There was some kinship, I later began to think, between Mon's procedure here and that of Cabalists in and after the Middle Ages: they had invented transpositions and permutations of letters in existing words in Hebrew, with a view to revealing secret meanings in these words and plotting secret relationships between letters and mystical truths. (See Kurt Seligmann's *History of Magic*, New York, Pantheon Books, 1948, pp. 346 f.; also Mon's essay in the *Schrift und Bild* catalogue.)

I could have read too much into this montage of disconnected signals. Yet my experience with this text was such that it made me most anxious to find at least some coherence in it. I don't think that I could have ventured an interpretation at all if I hadn't first tried to translate the text. I also stress the fact that thinking about the difficulties of translation prompted me to hazard these guesses as to the text's 'meaning'. I translated it without understanding it, normally not a commendable procedure. But if I had not translated it without understanding it, I would have missed the chance of using that failure as an aid to interpretation. Interpreting it became, in turn, an act of further translation, for the terms into which I have translated its signals in the interpretation given are rather more metaphysical than

the signals themselves. The poem itself has only the faintest vestiges of that kind of language.

In conclusion, here are three paragraphs of prose from Mon's *artikulationen*. They strike a slightly more positive note *vis-à-vis* language and its delights than the scattering of notes embedded in the 'grundriss' text. But they do confirm certain details in my figuring out of it. Also they mark a connection between Mon's concerns and those of some other poets who seem in most ways worlds apart. Robert Duncan speaks with their voice when he writes of

> a call we heard and answer
> in the lateness of the world
> primordial bellowings
> from which the youngest world might spring.
> <div align="right">(The Opening of a Field, p. 50)</div>

"The requirement that a text's supreme quality should be plasticity is one of the imperishable voids in human thought. certainly language achieves the image, but only in hard consciousness, for an instant, and ineluctably as the boulder of Sisyphus the inconspicuous mobility of what is said—the spans and gradients of articulation—rolls down and away and along its own grooves. babbling and scribbling are utterances in which the organs proceed tentatively, below the level of what can be envisioned, under the skin: not toward some random goal, but often enough in a vacuum. the monotonous untwisting babble can find, with the sureness of the somnambulist, the threshold of articulation, where a gesture excitingly occurs. at root one only succeeds in entwining and untwining from down below, from understanding, the dense pregnant sequence of sounds which remains unforgettable and repeatable, as the trace of a progression, and is thus 'language' because it proceeds gestically.

On the very threshold of articulation, perceptible in the precise masticating motion of the speech organs, lies the level of 'nucleus words' which get under our skin prior to becoming plastic in images. erotic and pre-erotic elements are concrete in them, words are stimulant forms of a reality which we can often only attain with their help, frightening, gay, savage, and what not—not 'internal', not external but, like dreaming, sustained equally by bodiliness and imagination, and therefore supremely real, but, unlike dreaming, there for our free

use. out of the concrete forms of the courses taken by voca-
bles and gestures of articulation the world as our own world
constructs itself. speech at the very axis of articulation is a
dance of the lips, tongue, teeth; articulated thus pregnant
motion; vocables the basic figures of the dance, carry with
them certainly the meanings, relations, shadows of images,
but slurred into a motional character which supplies itself
with its own directions.

Speech which converts itself into poetry is an attempt to
take hold of what most obviously happens but is forgotten
among the complex and wearing tasks of language. poetry
doesn't vanish into the process, it seeks it, it uses the primitive
material—experience. it cannot escape from what is elemen-
tal, for earlier than speech the lips, tongue, teeth practised
the activities of assimilating, destroying, loving, delight. they
are occupied by these experiences when they shape them-
selves to speak; unavoidably the speech gestures will blend
with the characters of those activities, cross with them,
learn from them and thereby intensify themselves. they will
make more subtle experiments in tearing things apart; they
consume, for this purpose, the most fugitive food, air, they
crush, propel, suck it, in order to investigate the elemental
gestics of which the world is full. here we are dog, pig, bull
and rooster; we mingle with their characters whenever
language has to do with them, tear apart the familiar sights
we see and come up against pliant, sombre, shining pervious
texture, tumescences, sonant dilations, rattling skeletal
forms, animals that exist nowhere else."

RILKE'S BIRTH OF VENUS

(text and translation appear on pages 174-7)

GEBURT DER VENUS

An diesem Morgen nach der Nacht, die bang
vergangen war mit Rufen, Unruh, Aufruhr,—
brach alles Meer noch einmal auf und schrie.
Und als der Schrei sich langsam wieder schloss
und von der Himmel blassem Tag und Anfang
herabfiel in der stummen Fische Abgrund—:
gebar das Meer.

Von erster Sonne schimmerte der Haarschaum
der weiten Wogenscham, an deren Rand
das Mädchen aufstand, weiss, verwirrt und feucht.
So wie ein junges grünes Blatt sich rührt,
sich reckt und Eingerolltes langsam aufschlägt,
entfaltete ihr Leib sich in die Kühle
hinein und in den unberührten Frühwind.

Wie Monde stiegen klar die Kniee auf
und tauchten in der Schenkel Wolkenränder;
der Waden schmaler Schatten wich zurück,
die Füsse spannten sich und wurden licht,
und die Gelenke lebten wie die Kehlen
von Trinkenden.

Und in dem Kelch des Beckens lag der Leib
wie eine junge Frucht in eines Kindes Hand.
In seines Nabels engem Becher war
das ganze Dunkel dieses hellen Lebens.
Darunter hob sich licht die kleine Welle
und floss beständig über nach den Lenden,
wo dann und wann ein stilles Rieseln war.
Durchschienen aber und noch ohne Schatten,
wie ein Bestand von Birken im April,
warm, leer und unverborgen, lag die Scham.

Jetzt stand der Schultern rege Waage schon
im Gleichgewichte auf dem graden Körper,
der aus dem Becken wie ein Springbrunn aufstieg
und zögernd in den langen Armen abfiel
und rascher in dem vollen Fall des Haars.

BIRTH OF VENUS

On this morning, after the night which had passed in fear with outcry, turbulence, uproar,—all the sea broke open once more and screamed. And when the scream slowly closed again and fell from the skies' pale day and beginning, down into the abyss of the dumb fishes—: the sea gave birth.

With first sun shimmered the hair-foam of the wide sea-sex at whose edge the girl stood, white, confused, and moist. As a young green leaf moves, stretches, and slowly opens what was involuted, her body unfolded into the coolness and into the untouched dawn wind.

Like moons the knees clear ascended and dipped into the cloud-rims of the thighs; the calves' narrow shadow receded, the feet stretched taut and became light, and her ankles were live like the throats of people drinking.

And in the chalice of the pelvis lay the upper body, like a young fruit in a child's hand. In the small beaker of its navel was all the darkness of this bright life. Below this, the little ripple lightly swelled and kept flowing across to the loins, where now and then there was a quiet purling. But translucent and still shadowless, like a stand of birch trees in April, warm, empty and unhidden, lay the sex.

Now the lively balance of the shoulders stood in equilibrium on the straight body, which rose from the pelvis like a fountain and descended hesitating in the long arms and more quickly in the full cascade of the hair.

Dann ging sehr langsam das Gesicht vorbei:
aus dem verkürzten Dunkel seiner Neigung
in klares, waagrechtes Erhobensein.
Und hinter ihm verschloss sich steil das Kinn.

Jetzt, da der Hals gestreckt war wie ein Strahl
und wie ein Blumenstiel, darin der Saft steigt,
streckten sich auch die Arme aus wie Hälse
von Schwänen, wenn sie nach dem Ufer suchen.

Dann kam in dieses Leibes dunkle Frühe
wie Morgenwind der erste Atemzug.
Im zartesten Geäst der Aderbäume
entstand ein Flüstern, und das Blut begann
zu rauschen über seinen tiefen Stellen.
Und dieser Wind wuchs an: nun warf er sich
mit allem Atem in die neuen Brüste
und füllte sie und drückte sich in sie,—
dass sie wie Segel, von der Ferne voll,
das leichte Mädchen nach dem Strande drängten.

So landete die Göttin.

Hinter ihr,
die rasch dahinschritt durch die jungen Ufer,
erhoben sich den ganzen Vormittag
die Blumen und die Halme, warm, verwirrt,
wie aus Umarmung. Und sie ging und lief.

Am Mittag aber, in der schwersten Stunde,
hob sich das Meer noch einmal auf und warf
einen Delphin an jene selbe Stelle.
Tot, rot und offen.

Then very slowly the face passed by: from the shortened darkness of its incline into clear horizontal elevation. And behind it the chin steeply closed.

Now, as the neck extended like a ray [or jet] and like a flower stem in which the sap is rising, the arms too stretched out, like necks of swans when they seek the shore.

Then into the dark dawn of this body came like a morning breeze the first breath. In the most delicate branches of the vein-trees a whispering arose, and the blood began to rustle over its deep places. And this wind increased: now it flung itself with all its breath into the new breasts and filled them and pressed into them,—so that, like sails, full of distance, they impelled the light girl to the beach.

Thus the goddess landed.

Behind her, as quickly she walked over the young shores, all the forenoon the flowers and grasses rose up, warm, confused, as from an embrace. And she walked and ran.

But at noon, at the heaviest hour, the sea rose once more and flung out a dolphin, at that same place. Dead, red and open.

MY INTENTION here is to suggest a new reading of Rilke's
poem 'Geburt der Venus'. I am not able to follow H. Berend's
line of argument when he contends that the poem is not really
about the theophany itself, but about 'the process of birth sur-
rounded by peril of death', the cosmic myth announced in the
title being merely coincidental. (1) On the contrary, the poem
does bear witness to the theophany in language of singular pre-
cision and detail. The visual and the phonetic energy of the lan-
guage is such that the girl-goddess becomes presence. Moreover,
the Venus Anadyomene iconography is insistent in the poem in
ways which Berend overlooks. To be sure, there are the moments
which recall Botticelli's painting; but there are also moments
when another source informs both the imagery and the rhythms
—not a painting, but a sculpture, which Berend does not mention.
'Geburt der Venus' does belong among those poems on Greek
subjects, written during 1904, which lead thematically to the
end of the first part of *Neue Gedichte*. It does have to do with
Rilke's themes of birth and death, with equilibrium in being.
But to strip away its mythic figuration as mere 'foreground' is
to misconstrue the poem. The text does not elaborate on ideas;
it enacts a vision.

For all its pictorial qualities, the poem presents an image
which is not so much 'picturesque' as sculptural. At least, the
gradual assembling of Venus out of the foam into a manifest,
compact and animate body, occupying a specific marine sur-
round, occurs without recourse to colour adjectives. The rele-
vant phrasings recall, much more, the play of shade and light
over the surfaces of a sculpture. The poem contains only two
colour adjectives: 'So wie ein junges grünes Blatt sich rührt'
(line 11), and 'Tot, rot und offen' (last line). (2) The first occurs
in a simile defining the movement with which the girl's body
'unfolds', but it does not refer directly to her body. The second
refers to the torn body of the dolphin washed ashore at noon
after Venus has vanished inland. Here are the phrases which
give the sculptural effect:

blassen Tag (line 5); *von erster Sonne schimmerte* (line 8);
das Mädchen . . . weiss (line 10); *wie Monde stiegen klar*
(line 15); *der Waden schmaler Schatten* (line 17); *die Füsse
. . . wurden licht* (line 18); *das ganze Dunkel* (line 24); *hob
sich licht die kleine Welle* (line 25); *Durchschienen . . . und
noch ohne Schatten* (line 28); *aus dem verkürzten Dunkel
seiner Neigung* (line 37); *gestreckt . . . wie ein Strahl* (line

40); *von Schwänen* (line 43); *ihres Leibes dunkle Frühe* (line 44).

The first two do not refer to the body, but to the surroundings; in other ways too, as I shall show, this body and its surroundings exchange qualities.

The vivid and detailed visualization of the mythic event could certainly have been helped by Rilke's attentive gazing at sculptures, notably Rodin's. The accent on the surface play of shade and light, also the accent on the balancedness of the form contained and articulated in surfaces, accords with Rilke's ideas about Rodin:

. . . this beauty . . . stems from the feeling of equilibrium, the balancing of all these lively surfaces in their interrelations, from the realization that all these moments of animation [*Erregungsmomente*] vibrate to a finish inside the thing itself . . . (3)

They allowed him to glimpse into a secret geometry of space, which enabled him to realize that the contours of a thing must be composed as a number of planes inclined toward one another, so that this thing [the sculpture] can really be accepted by space, recognized by space, as it were, in its cosmic independence. (4)

Yet verbal image and sculpture are different. The poem does something that is foreign to sculpture: it presents a motional image of a body that is coming to be, not as a final form that is fixedly and ineluctably there. (5) One could also go back to Lessing's distinction between poetry's presenting of actions which succeed one another in time, and sculpture's presenting of shapes juxtaposed in space. The poem exemplifies Lessing's distinction. As Lessing pointed out that Homer describes the shield of Achilles in the making (not as a finished artefact), so does Rilke present Venus in the making. There are, however, some other details in which a quasi-sculptural effect is continuously produced, so that, to some extent, the two different kinds of aesthetic illusion do shade into each other here. The body of Venus comes to be in some of those minute and ephemeral gestures which Rodin's sculptures fixed, and which made his work, in Rilke's opinion, distinctively modern:

They are not like those movements which are preserved in the old works of art, gestures in which only the initial and terminal points were important. Between these two simple moments, countless transitions have intruded, and it became

evident that it was precisely in these in-between states [*Zwi-schen-Zuständen*] that modern man's life ran its course, his actions and his inability to act. Grasping things had become different, waving, letting go, and holding on . . . (6)

It is the collaboration between such ephemeral gestures, count-less transitions between the 'simple moments', and a quasi-archaic posture which makes Rilke's girl-goddess at once antique and modern, vital, yet ageless. As the poem proceeds, the girl-goddess appears not only frontally. Stanzas 2-4 give an anterior view, but thereafter the optics change: she is seen from all around, and at one point, possibly, from overhead. The poem takes a walk around her, as one takes a walk around a sculpture. This too seems to be a source of the poem's quasi-sculptural effect.

Volume in sculpture is actual, but in poetry it can only be virtual. I am not sure about using the word *volume* in relation to Rilke's imagery here; yet there is a kind of volume in the visual scene of the poem, and this is structured by the numerous meta-phors. Metaphor sets the body, as it comes to be, in a family of related objects and events; and it defines the nuances of feeling with which the theophany is envisaged. (These metaphors are not illustrations or ornaments; they illuminate the body in a configuration of kindred sights and events.) Metaphor here has a function which is analogous to the modelling of surfaces as arti-culations of volume in Rodin: see above—'dass die Konturen eines Dinges in der Richtung einiger gegeneinander geneigten Ebenen sich ordnen müssen, damit dieses Ding vom Raume wirklich aufgenommen, gleichsam von ihm anerkannt sei in seiner kosmischen Selbständigkeit.' Metaphor here is the agent which 'inclines the surfaces toward one another', composing them in such a way that space 'acknowledges the thing in its cosmic in-dependence'. Or, at least: the metaphors serve to generate a sense of vibrant space all around the motional image of the nas-cent Aphrodite, doubling this effect with another one: the body acquires virtual volume in the process. As will be shown, this illusion of volume is structured also by the sound patterns in which the vision of the theophany voices itself. Rilke also, in his Rodin essay, observed how exposed to the air his sculptures were:

If it was Rodin's aim to bring the air as close as possible to the surface of his things, here it is as if he had actually dissolved the stone in air: the marble seems to be no more than the firm, fruitful kernel, and its last gentlest contour is vibrant air. (7)

There are three kinds of metaphor in the poem: *wie*-similes, genitive metaphors and analogies. The first seven lines and the last four contain none of the first two kinds. In between there are twelve *wie*-similes and seven genitive metaphors. It would be tedious to list all these, and I shall not deal with the analogies. There are, however, some features here which call for close attention. The physical sources of the terms of comparison are as follows: the *wie*-similes relate, broadly, to organic nature— vegetation, anatomy, for example, leaf, moon, throat, fruit, trees, fountain, jet (or ray), flower stem, swan necks, sails and an embrace. The genitive metaphors enlarge this spectrum by introducing three artefacts: chalice, cup, balances. Beauty as delicacy of balance, as transparency, as shapeliness, is an idea common to both these types of metaphor. Many of the figures contain one fixed substantive element and one motional element, for example (numerals designate the stanzas)

(2) So wie ein junges grünes Blatt sich rührt

(3) Wie Monde stiegen klar die Kniee auf
 . . . die Gelenke lebten wie die Kehlen
 von Trinkenden.

(5) [der] Körper,
 der aus dem Becken wie ein Springbrunn aufstieg

(7) Jetzt, da der Hals gestreckt war wie ein Strahl
 und wie ein Blumenstiel, darin der Saft steigt

This quite natural polarity in the metaphors has an important function. The metaphors of all kinds set the *nascent* body in a context of *finished* forms (leaf, moon, tree, etc.). At the same time, they present the finished forms as forms involved in motions. Hence the peculiar visual dynamics of the poem. The image of the goddess has both dynamic and static (sculptural) qualities; this ambiguity communicates itself to the total visual context in which the body of the goddess is gradually being assembled. It is the dialogue between activity and tranquillity, between becoming and being, which gives the imagery its vibrance. There is, throughout, an interanimation of *Werden* and *Sein*, of motion and rest. The smallest details reflect an intuition which is central to Rilke's conception of the poetic work: the work exists as a metaphor in which transformations of being are composed in such a way that being becomes transparent. (8)

The visualization of theophany is only a part of the work. The scene is also heard. Throughout the poem, sounds are recorded. It begins with the clamour of the sea as it is about to

give birth: 'Rufen', 'Schrei' (stanza 1). Stanza 2 has no explicit
sound but the phonetics of the sea are interiorized: into the lan-
guage, viz., into the liquids in the simile of the unfolding leaf:
'sich reckt und eingerolltes langsam aufschlägt.' Stanza 3 again
has implicit sound of another kind: 'lebten wie die Kehlen / von
Trinkenden', where not only motion is involved. Stanzas 4 and
5 contain one allusion each: 'wie ein Springbrunn' and 'Fall des
Haars' (here again the sounds are only just this side of silence).
Stanzas 6 and 7 contain no sound allusions, but by stanza 8 this
silence proves to have been a pregnant one; for stanza 8 presents
the sounds of the zephyrs as they begin to animate the body of
the goddess, first from within, as her own breath: 'erster Atem-
zug', 'Flüstern', 'rauschen', 'Wind'. As will be shown, stanzas 6
and 7 are also comparatively reticent in terms of verbal sound—
preparing for the orchestration of vowels and consonants in
stanza 8. After stanza 8 all sounds disappear until the last heave
and lunge of the sea, as it disgorges the dolphin: 'hob sich das
Meer noch einmal auf und warf . . .'

These auditory details are lifeless fractions if contemplated
outside their context of motional imagery. Inside that context,
they are all animating details which make concrete the simulta-
neous visualizing and hearing of the theophany. The poem is
animate also with verbs of motion. Every single stanza has its
verbs of motion. Some verbs occur in the metaphors, the majo-
rity outside them—enacting, describing and defining the move-
ments of the nascent body in its 'space' of felt kinships. Some
examples:

(1) brach alles Meer noch einmal auf
 Schrei . . . herabfiel
(2) das Mädchen aufstand / sich rührt [*in the simile*] / sich
 reckt / entfaltete ihr Leib sich
(3) stiegen die Kniee / tauchten / wich zurück
(4) Darunter hob sich/und floss [*here the verbs of motion
 in mid-stanza are set off by nonmotion verbs which
 bracket them, e.g.,* lag/war/lag]
(5) aufstieg / abfiel
(6) ging vorbei
(7) darin der Saft steigt [*in the simile*] / streckten sich auch
 die Arme aus [*also the swans in the simile are moving*]
(8) kam/der Wind warf sich/und drückte sich in sie/wie
 Segel . . . das Mädchen drängten [*transitive*]
(9) landete

(10) dahinschritt / erhoben sich / ging und lief
(11) hob sich das Meer / und warf

All but two of these verbs are intransitive (the exceptions being 'drängten' and 'warf'). The motions involved thus acquire their quality of floating balance. They are motions directed toward no goals. The verbs present motion and growth for their own sake, there is no goal, purpose or object exterior to the process. The theophany is presented as an event which is too primal and ultimate to involve motions directed toward external ends. Its contours are all 'inclined toward one another'. The intransitive, objectless motion verbs are essential to the visualization of the divine, balanced body as it comes to be in the action of the poem. There is possibly an analogy to sculpture here, for the verbs of motion seem to function like the confluences of surfaces which Rilke admired in Rodin's work. The 'beauty' arises 'from the feeling of equilibrium, the balancing of all these lively surfaces in their interrelations, from the realization that all these moments of animation [*Erregungsmomente*] vibrate to a finish inside the thing itself.' (Compare the imagery of contained energy in 'Archaischer Torso Apollos'.)

So far I have followed the forms of perception, mainly sight and sound, in which the witnessing of the theophany is articulated. Next I want to map (generally without phonetic transcription) the major patterns of vowels and consonants. These patterns authenticate the act of witnessing and the truth of the witness; they make imagination vocally concrete.

Stanza 1 opens with *a* and *u* sounds, both long and short; and it closes with the same sounds:

. . . nach der Nacht, die bang
vergangen war mit Rufen, Unruh, Aufruhr,—
. . .
und von der Himmel blassem Tag und Anfang
herabfiel in der stummen Fische Abgrund—:
gebar das Meer.

The vowel pattern here can be described as a one-track pattern. In stanza 2, there is a distinct two-track pattern, this time in the consonants. The sibilants *sch, s* and the soft guttural *ch* dominate the start—sounds of waters swishing as the girl's body begins to crystallize out of the foam. Thereafter, lines 4-7 of the stanza are dominated by rolling liquids, *r* and *l*, soft exfoliations (the leaf simile) as the 'Mädchen' begins to be. Throughout this stanza, the *a* and *u* of stanza 1 are modulated to become thinner

and swifter *ä* and *ü*: the sea's tumult subsides into the first ten-
tative feeling towards form.

The girl has now appeared, as 'das Mädchen'. Through stanzas
2-4, the view of her as anterior: an up-and-down vertical mo-
tion of the perspective in stanza 3 beholds knees, thighs, calves,
feet, ankles, in that order. In this stanza 3, the vowels and con-
sonants have much more differentiated patterns than in stanzas
1 and 2. After the moment of origination in stanza 2 ('das Mäd-
chen aufstand'), follow now the moments of particularized be-
coming. One might speak here of a multitrack pattern. All the
vowels are there; and the five forms of consonant—labial, guttu-
ral, fricative, dental, sibilant. Lines 1-2 are dominated by *k* (plus
ch) interwoven with *ō*, *ie* and *ŏ*. Lines 3-4 have the *a/u* series of
stanza 1, including *i* as a sub-pattern: *ā, ā, a, (i), ū-ü / ü, a, (i), ū*
(=*ur*). Lines 5-6 have a succession of *es*, long and short: *ĕ, ĕ, ĕ,
ē, ē / ĕ-ĕ* (*ə*). The emergence of the *ĕ/ē* series at this point cer-
tainly opens a new phase in the coming-to-be of the goddess: till
now there has been no such series, and the sounds here do mime
the felt delicacy of the ankles as the goddess begins to move:
'Und die Gelenke lebten wie die Kehlen / von Trinkenden.' (At
the base of this simile is the fact that the curve from the boss of
the anklebone to the foot sole is similar to the curve from the
point of the chin down the upper throat to the Adam's apple: it
is not one of Rilke's precious or silly similes.)

Stanza 4 weaves this new *ĕ/ē* series into the *ă/ā* side of the
initial *a/u* series. The circulation of these vowels through the
next ten lines voices a new perspective at this juncture. Here the
view is a rotating one, as the eye explores the area of pelvis, na-
vel, groin muscle and sex. (9) I figure this interweaving as follows:
*Kelch, Beckens, Hand / Nabels engem Becher / ganze . . . hellen
Lebens / Welle . . . beständig . . . nach . . . Lenden / Schatten, Be-
stand, warm, Scham.* Into this pattern other sounds come with-
out interfering with it: the diphthongs *ie* and *ei*, short *u* and *i*,
with one long and one short *o* (*hob, floss*). The main strand of
consonants is liquids, *r* and *l*, which pervade every line. The
stanza has a complex phonic structure, but this does not depend
on alliteration, as it so often does in Rilke. In fact, there is no
alliteration until the end of the stanza. The profuse but rather
paltry ornamental alliterations of *Das Stundenbuch* (the third
part of which was finished only in 1903) have receded. Instead,
there is a structure which grips the insides of words. There is an
orchestration of vowels voicing a further differentiation of the

divine body as it materializes. The alliteration which does close the stanza is functional, not ornamental. It vocalizes the unity to which this differentiation has proceeded up to this point: 'Durchschienen . . . Schatten / Bestand von Birken / Scham.'

The a/u series, distributed in the vocalic melody of stanza 1 and sustained with modulations through stanzas 2-4, maintains its predominance in stanza 5. Here the main track of vowels is long a, interwoven with u, \ddot{o} and the diphthongs ie and ei. The dominant consonants are, once more, liquids. The main vowel and consonant series is thus preserved, but here the optics change, for the view now is not only anterior. The 'rege Waage' of the shoulders could be seen from anterior or posterior positions, also the body now rising like a fountain out of the pelvis. But the 'fall of hair' suggests either a lateral or a posterior view: the witness now is beginning to take his walk, to explore other views of the quasi-sculptural figure. Stanza 6 then sustains the long a, multiplies the ei diphthong with which it consorted in stanza 5 (one ei in 5, four eis in 6), and, after presenting the apparition of the face, closes with the line of rather pinched sounds voicing the closure of the chin (for example, 'hinter' and 'Kinn', two of the five chin movements which you make if you speak the line): 'Und hinter ihm verschloss sich steil das Kinn.' (10)

The viewpoint here is difficult to place; it is possible to make out that the visualization falters at this moment, especially in the highly mannered adverb *steil*, which seems to come in for phonetic reasons only (this is not the only stretched use of it in *Neue Gedichte I*). Yet 'hinter ihm' could indicate that the face at this point is being visualized from above, the head tilted back as the face rises 'in klares, waagrechtes Erhobensein', to reveal the jointing of the just-formed chin. The features are not described. This is consistent with the classical procedure, which demands that the features of a nude should be as little individual as possible. When Manet's 'Olympia' was first shown, in her classic pose, people were shocked by the face with its highly individual features, rather than by the chunky angularity of the body. Behind their negative surprise lurked centuries of prejudice based on originally sound classical procedure. (11) An impersonal simplicity of features is essential to the fine classical nude. Stanza 7 recapitulates, with a couple of modified as (\breve{a}), the a/u series in the following sequence: \bar{a}, \breve{a}, \bar{a}, \bar{a}/\bar{u}, \bar{a}, \breve{a}/\bar{a}, \breve{a}/\breve{a}, \bar{a}, \bar{u}, \bar{u}.

The vowel patterns of stanzas 6-7 are comparatively simple. Stanza 8 has a much more opulent orchestration, in vowels as well as consonants. In retrospect from here, stanzas 6-7 sound like voicings of the body as it arrives, trembling and breathless, at the brink of complete articulation. And stanza 8 does voice the animation, for the first time, of the whole corporeal form. There is every vowel and diphthong (except long *o*), and every consonant form in initial positions. This *tutti* of the alphabet mimes most aptly that moment of animation, when the fully formed body, the goddess incarnate, sails to the shore. Lines 6 and 7 enact this literal animation with onomatopoeia which might be rather facile if it did not contain the nuclear *a/u*: 'Und dieser Wind wuchs an: nun warf er sich / mit allem Atem . . .' (One pictorial source is evident here: the entwined male and female zephyrs in their lateral embrace in Botticelli's 'Birth of Venus', blowing the goddess inshore.) The *a/u* series persists in stanza 10, as the goddess runs ashore and nature responds to her (flowers and grass blades, the poem's counterparts to the female figure in the floral robe on the right in Botticelli). And *a/u* echoes and dies in line 1 of the last stanza: 'Am Mittag aber, in der schwersten Stunde . . .' After this comes the sequence of *e*s in line 3—*Delphin . . . jene selbe Stelle*—and the close with its three *o*s, two long, one short. The startling *o*-phrase (adjectives) defines the torn dead dolphin in its relation to the theophany. It is now cast up as a thing which belonged down among the torment of this birth process, belonged in the tumult prior to this morning: excluded from the process of vital integration, still it is not to be forgotten in the witnessing of the total process. (12)

This insistence of the *a/u* series throughout the poem is remarkable. It is the series with which the poem begins and with which it moves toward its end. But it is not the only insistent sound. There are thirty-three occurrences of the consonant *m* in the poem, even excluding declined endings, and these include many initial *m*s. The *a/u/m* constellation finally crystallizes into the climax-word *Umarmung*, five lines from the end:

 die Blumen und die Halme, warm, verwirrt,
 wie aus Umarmung.

Intended or not, design or magical coincidence, this persistent pattern of sounds is like a matrix from which the poem is born. Can it be that the theophany happens here in such a way as to articulate the (German) sounds of the word which, in Sanskrit,

is the sound of the universal breath of life, the primal word of cosmogenesis? At all events, it is AUM which is the nuclear sound pattern in the poem, and it is most aptly lexicalized in the word *Umarmung* following the *a*s, *u*s and *m*s of the line preceding it. One could extend this sound symbolism to include the role of *a* as alpha and *u* as omega in the pitch-series of German vowels: the first and last things in the universe of sounds. With *m* as its axis, the poem would then voice the equilibrium attained by the magical universe of the alphabet at the moment of Aphrodite's birth.

In conclusion I would like to deal with one or two points relating to the Venus iconography. The outstretched arms of stanza 7 are unusual for Venus. She does not appear thus in the Botticelli, one of Rilke's favourite paintings, and widely believed to be the picture which Rilke 'had in mind' when writing this poem. Nor are the outstretched arms found in known sculptures of the centuries following Praxiteles (*c*. 350 B.C.). The gesture is, none the less, not entirely Rilke's invention. From Rodin he learned not only how to look at surfaces and explore their relation to volumes: he had also acquired a predilection for archaic Greek sculptures (the absorption in Gothic came only in 1905-6). In a letter written soon after his arrival in Paris in 1902, he told his wife that the Venus de Milo was 'far too modern' for him, and that he preferred the Nike of Samothrace. (13) The Venus de Milo has the sloping shoulders which characterize all Venus sculptures since Praxiteles' Knidian Aphrodite. The Nike of Samothrace has straight shoulders. But that is a minor detail. The posture with straight shoulders which Rilke's Venus assumes goes back behind the fourth century B.C., behind the Medici Venus, the Venus de Milo, the Capitoline Venus and the Knidian Aphrodite. It goes back to the early fifth-century Ionian Aphrodite of the so-called Ludovici Throne. Rilke admired this relief, as is shown by his letters from Rome, 3 and 5 November 1903, to Lou Andreas-Salomé and A. Holitscher. The figure, lightly draped, seen only from the waist up, being raised by two flanking (headless) female figures, is now sometimes identified as Persephone. (14) But the series of reliefs in which it belongs is still called the Throne of Aphrodite; and that is what it was called when Rilke saw it in Rome.

The Ludovici Throne Aphrodite has shoulders which are gently tilted upward, in so far as the two flanking figures are supporting her arms as she rises out of the invisibility beneath

her waist. This slight upward tilt could have offered Rilke the
image of the shoulders as a 'rege Waage' (which sounds, other-
wise, somewhat mannered). From the same source, too, he could
have taken the details of the hair cascading (also stanza 5) and
of the upper body ascending like a fountain from the pelvis.
Stanza 5 has, as it were, an unbroken sinuous line running from
the contours of the upper body to the cascading of the hair. In
the relief, this sinuous line is accented by the drapery. In the
poem it is articulated in the run-on lines:

> der aus dem Becken wie ein Springbrunn aufstieg
> und zögernd in den langen Armen abfiel
> und rascher in dem vollen Fall des Haars.

Here, too, the detail shows how Rilke assimilated sculptural
form into poetic form. The Ludovici Aphrodite has raised arms:
one sees this from the position of the shoulders, even though
the arms themselves are not seen. In Rilke's stanza 5, Aphrodite's
arms are lowered: the line of the body ascends, and then, after
hesitating, 'descends in the long arms' and, 'more quickly' (be-
cause the distance is shorter), in the 'full cascade of hair'. Not
until stanza 7 does this Aphrodite raise her arms like the Ludo-
vici Aphrodite: 'streckten sich auch die Arme aus wie Hälse'.
These arms, extended to the side, not to the front, are wholly
alien to the Venus Pudica figures which began with the generous-
ly modest gesture of the Knidian Aphrodite, who draws her
right arm and hand down, to shelter her sex. Thereafter, this be-
came the classic gesture of self-concealment with both hands (as
in the Capitoline Venus, also in Botticelli's Venus). Rilke's
Aphrodite is not so disposed. She is candour incarnate, the
Ionian goddess, the unashamed original herself.

I would therefore argue that the Ludovici Throne Aphrodite
possessed Rilke's imagination with more intensity than has been
till now supposed. H. Schwerte mentioned her as one source,
besides Botticelli. (15) But he did not explore the detail of her
reincarnation in the imagery of the poem. Schwerte contended,
moreover, that the entire middle section of the poem is Botti-
cellian in spirit, reminiscent of the earlier (*Mädchenlieder*) Rilke,
as opposed to the Rilke of *Neue Gedichte*. (16) Yet not only
the position of the shoulders, but also the raising of the arms,
indicates that this Aphrodite of Rilke's is more archaic than
Botticelli's. Rilke's 'Greek experience' also had here more pro-
found and far-reaching effects on his art than those thematic
effects which are noted by Schwerte: the violent imagery,

agony and death at the start and finish of the poem, the antici-
pation of his 1905 statement, 'ein "heiteres" Griechenland hat
nie existiert.' These profounder effects can be judged from the
emergence here of the functional sound patterns of the middle
of the poem. These place it, stylistically, closer to the tightly
structured poems of the *Neue Gedichte*; and they remove it en-
tirely from the orbit of the earlier mode, with its pre-Raphaelite
ornateness. I would say, moreover, that this poem, even with its
suave euphony, is more achieved, more substantial, more (in
Rilke's sense) *Wirklichkeit*, than many of the *Neue Gedichte*
written between spring and July 1906 (the so-called 'Menschen-
bilder').

Here and in the other two poems begun in Rome in 1904,
'Hetären-Gräber' and 'Orpheus.Eurydike.Hermes', there was a
stylistic breakthrough. It is as if Rilke has created, after the
gropings and sketchings and languors of the longer descriptive
and narrative poems in *Das Buch der Bilder (Zweites Buch,
erster Teil)*, a language which can vocally enact events as 'reali-
ties' which are simultaneously plastic and acoustic. His language
had learned how to present an image with structured immediacy
and internal resonance; how to activate the whole human sen-
sorium and harmonize it as an instrument of wonder. He had
created his Orphic mode, a mode that was by no means always
at his command after this; for creation and capture do not
coincide, and such creations can be taken away as well as given.
This was a pregnant moment. It brought a new kind of life into
the tradition of oral poetry—a universe with which, as David
Masson has warned, we may be losing all intelligent contact.

MÖRIKE'S MOONCHILD: A READING OF
THE POEM 'AUF EINE CHRISTBLUME'

AUF EINE CHRISTBLUME

I

Tochter des Walds, du Lilienverwandte,
So lang' von mir gesuchte, unbekannte,
Im fremden Kirchhof, öd' und winterlich,
Zum erstenmal, o schöne, find'-ich dich!

Von welcher Hand gepflegt du hier erblühtest,
Ich weiss es nicht, noch wessen Grab du hütest;
Ist es ein Jüngling, so geschah ihm Heil,
Ist's eine Jungfrau, lieblich fiel ihr Teil.

Im nächt'gen Hain, von Schneelicht überbreitet,
Wo fromm das Reh an dir vorüberweidet,
Bei der Kapelle, am krystallnen Teich,
Dort sucht' ich deiner Heimat Zauberreich.

Schön bist du, Kind des Mondes, nicht der Sonne;
Dir wäre tödlich andrer Blumen Wonne,
Dich nährt, den keuschen Leib voll Reif und Duft,
Himmlischer Kälte balsamsüsse Luft.

In deines Busens goldner Fülle gründet
Ein Wohlgeruch, der sich nur kaum verkündet;
So duftete, berührt von Engelshand,
Der benedeiten Mutter Brautgewand.

Dich würden, mahnend an das heil'ge Leiden,
Fünf Purpurtrofen schön und einzig kleiden:
Doch kindlich zierst du, um die Weihnachtzeit,
Lichtgrün mit einem Hauch dein weisses Kleid.

Der Elfe, der in mitternächt'ger Stunde
Zum Tanze geht im lichterhellen Grunde,
Vor deiner mystischen Glorie steht er scheu
Neugierig still von fern und huscht vorbei.

II
Im Winterboden schläft, ein Blumenkeim,
Der Schmetterling, der einst um Busch und Hügel
In Frühlingsnächten wiegt den samtnen Flügel;
Nie soll er kosten deinen Honigseim.

Wer aber weiss, ob nicht sein zarter Geist,
Wenn jede Zier des Sommers hingesunken,
Dereinst, von deinem leisen Dufte trunken,
Mir unsichtbar, dich blühende umkreist.

IN THIS paper an attempt is made to investigate some of the baffling features of the poem 'Auf eine Christblume' which do not seem to have been noticed in the critical literature. (1) Perhaps an outline of the description of it by Gerhard Storz (2) will provide something like a firm initial foothold before I venture my own precarious steps through the poem.

Storz observes from the start that the character of the poem is primarily musical, not descriptive. He also considers (as Benno von Wiese does) that the poem is actually two poems, not one poem in two parts. In what he calls the first poem he notes the four five-beat iambic lines which make each stanza, also the way in which occasional dactyls vary the iambic pattern, giving oscillating cadences. He observes the paired parallel rhymes of each stanza, the first pair feminine and the second masculine, also the way in which these rhymes make for the peculiarly restrained sonority of the poem. The *ei* sound, he notes, dominates with its tone of delicacy and light ('Richtung des Hellen und Zarten'). He then shows that the sequence of the stanzas is more logical than might be thought at first. Stanzas 1 and 2 belong together. Stanza 3 stands alone. Stanzas 4 and 5 belong again together, and so do stanzas 6 and 7. Between these phases of the poem come slight pauses 'der Nachdenklichkeit oder des Ergriffenseins'. Elaborating this scheme, Storz notes that stanzas 1 and 2 disclose the poet's actual state of mind and his whereabouts in the barren hibernal churchyard. Stanza 3 then discloses a dream landscape of snowy light, and is dominated by the *ei* sound. In stanza 4 the 'seraphic stranger' is described, and so the full-faced image of the Christmas Rose makes its appearance. Then in stanza 5 there is a transition from this natural realm to the sacred realm through the phrase beginning 'so duftete'. Here as in the last stanza of all the word 'Duft' resolves all antinomies

of earthly and unearthly natures. According to Storz, stanza 6
makes a kind of fresh start: 'freudig scheint sich der Dichter von
der Meditation wieder zur Anschauung zu wenden'. In stanza 6
the sacred imagery is sustained in the first two lines, but then in
the next two lines the emblems of divine suffering (stated con-
ditionally) cede to actual observation of the childlike luminous
green which suffuses the flower and may call a Christmas Tree
to mind. Thus stanza 6 leads into the concluding imagery of
stanza 7, where the fairy realm of stanza 3 returns, now seen in
action: the elf shyly skirts the aloof sphere of mystic radiance,
the midnight flower. What Storz calls the second poem is then
described as a variation on this last phase of the first. The rhythm
is now more level. Though the stress is still varied, the iambs
close ranks and only one dactyl enters ('Wer aber . . .'). Also
now the rhymes are differently knit, with masculine endings to
the first and fourth lines of each of the two stanzas bracketing
the feminine endings of the middle lines. The elf, Storz proposes,
is now transformed into the butterfly dormant underground.
And an invisible hovering communion between butterfly-spirit
and flower may yet take place, regardless of the severance of the
seasons, in the intoxicating fragrance which the flower gives off.
Storz is aware of the dual earth and air aspect which distinguishes
the butterfly image from that of the elf, for he notes that the
appositive 'Blumenkeim' emphasizes its earth aspect. The butter-
fly alone, he suggests, can draw the flower back from its far-off
magical solitude into the terrestrial realm. This final transfigura-
tion comes in language of great delicacy and grace. The poem as
a whole exhibits what Storz describes as 'die Ergriffenheit, so
vom Geheimnis des Schönen wie vom Geheimnis der Natur, ein
Ergriffensein, das Zeichen der Liebe und der Leidenschaft an-
nimmt'.

Towards the end of his account, Storz suggests that the poem
is at points reminiscent of the 'Peregrina' cycle. He appears to
mean by this that the 'feeling' of 'Auf eine Christblume' has an
impassioned clarity which is akin to that of 'Peregrina'; but he
does not specify any relationships between images in the two
poems. I propose now to suggest that specific relations do exist,
and also that there are correspondences between 'Auf eine
Christblume' and other poems written both before and after the
early winter of 1841 when Mörike discovered his Christmas Rose
in the Neuenstadt churchyard. These correspondences will be
found to illuminate the meanings insistent in the imagery of

'Auf eine Christblume'. Subsequently there will be an account of certain differences between this and later poems which are commonly called Mörike's 'Dinggedichte'—poems in which he delineates and interprets isolated objects as things of beauty in art or nature, or both. The examination of these correspondences and differences may show how 'Auf eine Christblume' stands at the mid-point of Mörike's poetry in more than a chronological sense: it may show that here the configuration of echoes carried across from previous work marks also a unique climax in his later objective poetry. (3) Throughout I shall be taking it that Mörike is using words, as poets do, with their senses fresh and undiminished by common use, that he means exactly what he says, and that in order to grasp the meanings he brings out of words we must first discover what they, and the images they compose, meant to him.

The earliest adumbration of 'Auf eine Christblume' is the undated and rather derivative poem 'Nannys Traum'. This appeared in the 1838 edition of the poems, but was omitted from the two later collections. The poem is spoken by a child who tells how, as winter is approaching, she walks through the dusk into a churchyard and sees an angel beside a fresh grave. The angel conjures a white rose, 'die weisse Totenrose', out of the grave. The child is about to pick it when the angel stops her, makes her equally white cheeks turn rosy, and tells her to return to her mother with fresh rosy cheeks as a token. The imagery is fanciful and stylized, not real and imaginatively illuminated like the imagery of 'Auf eine Christblume'. The difference is made all the more clear when one considers that churchyard angels work miracles in fancy alone, whereas Christmas Roses are often cultivated on graves, being among the few flowers that bloom in winter. In 'Auf eine Christblume' also we are in that realm of discourse where, as in many of his later poems, Mörike treats tiny actual unobtrusive things, like the fossil seaweed in 'Göttliche Reminiszenz' and the orange in *Mozart*, as lenses through which vast recesses of meaning can be seen. (4) But the detail which does link 'Nannys Traum' with the broader range of imagery culminating in 'Auf eine Christblume' is its nocturnal setting. It has not been sufficiently noticed that the nocturnal setting of the latter poem has a special significance at this juncture of Mörike's work. The poet seeks the flower's realm not in the barren churchyard only, but 'im nächt'gen Hain'; he calls

the flower 'Kind des Mondes'; and later the elf too goes to his dance 'in mitternächt'ger Stunde'. A closer inspection of the elements of the descriptive locution 'Kind des Mondes' (which is attributive, defining 'Schön bist du . . .'), shows in them connections with the imagery of 'Peregrina'. If these connections are considered chronologically, it will be noticed that in 'Auf eine Christblume' the moon takes on a pregnant sense for the first time in Mörike since 'Peregrina'. Moreover, though the moon as such appears only on rare occasions in Mörike's poems about night, in both 'Peregrina' and 'Auf eine Christblume' it appears in conjunction with a lily image. The second poem in 'Peregrina' has 'Wo der Mondstrahl um Lilien zuckte'; and in 'Auf eine Christblume' the flower is called both 'lilienverwandt' and 'Kind des Mondes'. Thus over and above the fact that the initial 'lilienverwandt' of 'Auf eine Christblume' can also be taken as a quasi-botanical observation, in both poems there is a kind of bifocal vision of doubly pure whiteness where these images are concerned. (5) In 'Peregrina' the double vision is compacted; in 'Auf eine Christblume' it is distributed. But there is also a difference at this point. For it is not the same moon in the two poems. In neither case is there the full dramatic aspect of night such as is found in 'Gesang zu Zweien'. In the latter poem, night is magical, elemental music and enchantment. And in 'Peregrina' the connotation of 'moon' is erotic magic conjunct with its opposite, the purity symbolized in the lily. But in 'Auf eine Christblume' the moon image in 'Kind des Mondes' (and subsequently in the elaboration of this phrase) has an exactly opposite connotation, that of absolute purity and aloofness. In this respect, the moon image here is also distinct from the two earlier personifications of night in 'Gesang zu Zweien' and 'Um Mitternacht'. Night also, in 'Auf eine Christblume', is not the demonic setting which is found often in Brentano and Eichendorff; nor is the moon here, whose child the flower is, the pallid vampire moon of Droste-Hülshoff. In 'Auf eine Christblume' the night is sanctified. It is pure in the same way as that in which, as Adolf Beck has argued so convincingly, the day's onset is pure in 'An einem Wintermorgen, vor Sonnenaufgang'. This night is a sphere of purity that is antinomic to the sphere of the Romantic night which, delineated in the 'Peregrina' imagery, catches the breath in dread. (6)

The quasi-divine remoteness of the nocturnal flower also has a parallel in another poem: the poem 'Im Weinberg'. Here too

there is a lily, and here too a butterfly. The poet exhorts the butterfly, 'Eile zur Lilie du'; and the butterfly is to fertilize the lily with that divinity which it has drunk from the living Word of the poet's Bible. But again there is a difference. In the imagery of 'Im Weinberg' there is a merging of sacred and sensual elements which is alien to the imagery of 'Auf eine Christblume'; or, if this cannot be called a merging in 'Im Weinberg', then it is certainly an oscillation, characteristic of Mörike, between the two extremes. In 'Auf eine Christblume' on the other hand, there is no such merging, nor oscillation. There is an adherence to the one extreme of remoteness. This is rare in Mörike, who has been so aptly described by Alfred Mohrhenn as a poet of vibrance from a centre, as a poet of oscillating heterogeneous feelings held in a delicate, and often precarious, balance. (7) The inference of these observations may be gathered by passing now to two other poems written in the early 1840s. The poem 'An Wilhelm Hartlaub', dated 1842 (I, 174), states a decisive contrariety between the *remote* moon and the *immediate* starlit night. Then in 'Margareta', dated 1845, the concept of remoteness returns, detached from the moon context, but in another context which is no less relevant. The poet states his wish to show the soul itself, mirrored in an alien analogue:

> Könnt ich, o Seele, wie du bist,
> Dich in den reinsten Spiegel fassen,
> Was all dir einzig eigen ist,
> Als Fremdes dir begegnen lassen. (I, 184-5)

If 'Auf eine Christblume' is now read with these close correspondences in mind, it appears in a new light. True, the poem crystallizes the vision in which the poet has seen, as Benno von Wiese writes, 'das Göttliche als Gegenwart einer Blume'. (8) But it would appear that the poem is also a consummate form of Goethe's type of nature poem: in which nature and spirit are mutual analogues, each a mirror of the other. In 'Auf eine Christblume' the flower might then be an analogue of the 'soul' of the poet as he confronts the flower, rapt in wonder and awe.

It may be argued that this suggestion is irrelevant to the actual poem under discussion. But its validity may be tested against further correspondences between this and other poems. Again it will be found that Mörike is using words in an intensive way. In its pure remoteness, Mörike's flower with its emblems of divine love and suffering is akin to 'das Wort am Anfang' of

the poem 'Göttliche Reminiszenz'. The pristine freshness of the flower is stated, of course, in the locution already cited, 'Kind des Mondes'. But now it may be recalled that Orplid is called 'Kind' in the 'Gesang Weylas' (I, 92); and that Christ, in 'Göttliche Reminiszenz' (I, 191), is called 'das schöne Kind', and, though 'nicht allzu kindlich', still 'ein spielend Erdenkind'. In each case, 'Kind' is used in a pregnant sense to designate any being which is close to the root and origin of life, as Peregrina too is called 'das seltsame Kind' (I, 118). 'Kind des Mondes' is also not the only use of this pregnant sense in 'Auf eine Christblume'. The expression is taken up again in the subsequent emphatic 'kindlich zierst du' of stanza 6. Moreover, both these phrases in 'Auf eine Christblume' seem to have crystallized out of the notion of the flower's 'early bloom', which Mörike found in Pastor Müller's description of 'Elleborus, Niesswurtz' in his *Deliciae Hortenses* (Stuttgart, 1676), and which he described, in his letter to Wilhelm Hartlaub written shortly after finding the flower and reading Pastor Müller's account of it, as a very beautiful notion. (9) Likewise, in stanza 2, he is asking implicitly: what root, what origin has this new-found flower? And here his question coincides with another complex of associations: the associations of pristine earliness and origins which are found in such diverse poems as 'Früh im Wagen', 'Das verlassene Mägdlein' and 'An einem Wintermorgen', and have found explicators in Staiger and Ernst Trümpler. (10) 'An einem Wintermorgen' is especially relevant here, for in this poem the 'soul' of the poet actually *shares* the crystalline purity of day's first light. Not the least important *sense*-association here is that of coldness. In 'Auf eine Christblume' this appears in the 'Schneelicht', in the deliberate contrasting of 'moon' to 'sun', and in the 'himmlischer Kälte'. In another poem, 'Der Frau Generalin von Varnbüler', dated 1853, the Virgin herself even lets fall 'aus eisiger Nacht die tauende Rose' (I, 228).

But the child-flower, the moonchild of the snows is here an analogue of the soul only if it can be agreed that the term 'soul' is adequately defined by such terms as 'earliness', 'origin', 'beginning' and 'source of life'. It may be held that such inferences are too vague to have much force in the present case. Less vague are the inferences to be drawn from further correspondences with other poems, poems which display like 'Auf eine Christblume', the image of the circle. For the circle is a firm traditional symbol of the soul in a condition of perfection, and is in no

way, like the attributes mentioned already, an all too common and even entropic sign for it. In the letter of 29 October 1841, to Wilhelm Hartlaub, Mörike wrote: 'Die Pflanze hat einige Ähnlichkeit mit der Wasserrose'. What can this kinship have meant to him? It will be recalled that in the poem 'Vom Sieben-Nixen-Chor' (I, 156-9) the Sieben-Nixen sit between green walls of water holding water-lilies in their hands and staring upward to the light. This is no analogy in itself. But when it is also recalled that the Sieben-Nixen capture the King's son, and that he is later found with seven red wounds, there does seem to be an adumbration here of the 'fünf Purpurtropfen' which would be, as the poet suggests in 'Auf eine Christblume', the sole apt vestures of the Christmas Rose: the wounds of another 'King's son'. This parallel might be called fortuitous were it not for the fact that fortuity is plainly not an adequate concept with which to define the procedures which transform Mörike's mental images into verbal ones. More likely, in both poems, it is a question of a configuration of images in which Christian and faery elements intermingle, lying beneath the threshold of the poet's consciousness till roused to the surface, at a particular angle, by some exterior stimulus, in the present case by the Christmas Rose. In the first poem or first part of 'Auf eine Christblume' the Christian and faery elements are juxtaposed. The flower transcends the faery world (stanza 7) by virtue of its kinship, stated emblematically, with the divine world (the Virgin's robe and Christ's wounds). But it embraces both worlds. It is a kind of ubiquitous centre of both worlds, however aloof it may stand. It is akin to the symbolic rosarium of the alchemists. This symbolic flower, it is worth noting, is also called 'golden flower', or 'chrysanthos'. Mörike has seen this in the very nature of things, for he writes 'In deines Busens goldner Fülle'. The embrace as such cannot be called complete in the first seven stanzas of the poem. 'Huscht vorbei' of stanza 7 expresses a decisive linear rather than circular motion. It is not until the end of the so-called second poem (which may therefore not be a second poem at all, but a second part, or conclusion, of the poem), that the final 'umkreist' denotes the ultimate invisible motion of the butterfly circling the flower. The circle of perfection is here fully drawn. The *temenos* of the holy is marked out. With firmly articulated grace the language rounds off the image of the flower as an analogue of the living soul, that 'mysterious pulsation of the intuitive life of the mind', of which Mörike wrote in his letter to Luise Rau

dated 2 December 1829.

The circle image is indeed not at all uncommon in Mörike's poems, where it often again has unearthly connotations. In the last of the 'Schiffer- und Nixen-märchen', 'Der Zauberleucht-turm', there is 'eine Kugel klar, In Lüften gehangen' (I, 161). Here the destroyer broods over the waters. This earlier image is informed by dread. But the circle image in 'Auf eine Christ-blume' is informed by wonder, wonder at the radiant body of holiness: the theophany. For here is the moment of liberated vision of which Ulmon speaks in 'Der letzte König von Orplid' when he says of time:

Sie wirft die Larve ab und steht auf einmal

Als Ewigkeit vor mir, dem Staunenden. (II, 137)

Another most clear-cut image of such a magic circle appears in 'Die schöne Buche', written in the year after 'Auf eine Christ-blume'. Here the poet is standing in his favourite shady seclu-sion, enclosed by a magic circumference of sunbeams ('Zauber-gürtel', I, 94). His 'inner ear' listens to the 'dämonische Stille'. This image of the dark circle with a circumference of light (sun-beams) is reminiscent of the sunflower image in the early poem 'Im Frühling': 'Der Sonnenblume gleich steht mein Gemüte offen' (I, 48). Here it might be noted that, though the latter image seems to be drawn deliberately from nature, the sunflower is a symbol akin to the alchemical chrysanthos in the mystical language of Mörike's Pietist fellow-Swabians. (11) The relation of the circle image in 'Die schöne Buche' to the circle of dread in 'Der Zauberleuchtturm' and to the circle of holiness in 'Auf eine Christblume' can only be established by a correct reading of the complex word 'dämonisch' in this context. But it would appear that, in 'Die schöne Buche', 'dämonisch' denotes not a threat (as in 'Der Zauberleuchtturm') from some incalculable cosmic maleficence, but some unalterable law inherent in the cosmos which is perceptible at moments of total stillness. Per-ceived as 'der Schönheit Götterstille', as in the poem 'Nachts' (I, 322), it brings a vision which is hard to bear, but which must be borne, and which is most often presented in Mörike, as Zemp and others have suggested, 'nur in gleichsam "abgeblendeter" Form'. (12) And this is surely the case with the vision of 'Auf eine Christblume'. Here the circle image mirrors the vision *into* things in a way which does not reduce, though it may minia-turize, the content of the vision. This process is particularly noticeable in the two stanzas which conclude the poem as a

whole, and in which the vision actually penetrates through things and beyond them. In the early poem 'Rotkäppchen und Wolf' (I, 317-19), there appears an aspect of the circle image which is relevant to Storz's reading of these last two stanzas. Here the circle, or circuit, is formed when dead Red Riding Hood is resurrected as an elf. But in 'Auf eine Christblume', is the butterfly-*spirit*, as Storz proposes, a resurrected elf, circling the fragrant flower?

The wording of the second part of the poem does not seem to provide any grounds for Storz's proposal. These two stanzas do, however, permit another interpretation. Both concern the butterfly, the first designating it as 'Blumenkeim' and the second designating it as 'zarter Geist'. These words are placed symmetrically, in commanding positions, at the end of the first line of each stanza. 'Blumenkeim' is an elliptic simile: the butterfly, a seed, sleeps in the winter soil. 'Geist' can be read in turn not as 'spirit', but as 'ghost', this being antithetic to 'Blumenkeim'. The aspects involved therefore designate the butterfly first as a being which has not yet come to be; and secondly as a being which has ceased to be. Either being resides invisibly in the churchyard, from winter to winter, in an unbroken condition of earliness, throughout the cycle of the year. (13) The churchyard is seen then not as a place of death, but as a place of invisible presence. Whereas stanzas 1-7 culminate in the image of the flower as a 'mystical' presence, these last two stanzas go further and describe this presence in terms of absence. It is not, moreover, surprising to find that the so-called 'second poem' cannot be read and understood in isolation from stanzas 1-7. 'Presence' and 'absence', being and not-being, coalesce in a single sphere of meaning. And a sphere it is, for the cycle of being is thus completed in a vision of nature which mirrors the vision of divine being in stanzas 5-6: the life-cycle of Christ, from Annunciation to Crucifixion. The subtlety of the meanings here is such that every word has to be taken into account before the future projection of 'dereinst' and the fullness of tense and image in the final 'umkreist' can be appreciated. This tense equilibrium, between future and present (the imaginary present of the future projections), is surely the purest possible grammatical closure of the image of the circle. That this multiform circle image, as found in 'Auf eine Christblume', is one to which Mörike often returned, is suggested also by its appearance in the two later poems which again concern beauty and perfection: 'Corinna'

and 'Auf eine Lampe'. In 'Corinna', the girl whose soul is 'Ganz eines mit der sichtbaren Gestalt', is seen dancing the round of the revolving year, 'des Jahres Kreis' (I, 291). In 'Auf eine Lampe', the 'sanfter Geist des Ernstes' is 'ergossen *um* die ganze Form' (I, 105; my italics).

There are then meanings insistent in the imagery of 'Auf eine Christblume' which are related to meanings in other poems, and the relations between these meanings and images open windows into the monad which is Mörike's special poetic world. It might be wrong to suppose the Mörike has a consistent topology of his own. But in respect of imagery and meaning alike, 'Auf eine Christblume' occupies a position in his work which is not only chronologically central, but also thematically pivotal. If my investigation has passed at points almost out of the picture, this has not been for want of trying to follow Johannes Hoffmeister's warning against considering images as 'hintergründig' or 'verschlüsselt' when they are simply not made that way: 'Der Deutende muss schon Kategorien, Deutungsbegriffe verwenden, doch diese Begriffe müssen am Bilde gewonnen sein, sich gleichsam aus dem Bild selber ergeben und wieder auf es zurückweisen.' (14)

It will now be clear that the suggestions which I have made do not tally with the illuminating views on the frontiers of Mörike's 'Dingdichtung' expressed by Werner von Nordheim in an essay published in 1956. (15) I therefore propose to remark now briefly on the status of the poem in this special theoretical context. The points at which disagreement with Nordheim occurs will shortly become evident.

It will be recognized that the views advanced so far are aimed with some caution against any generalizing extension of the so-called 'Spätlingstheorie' which supports an image of Mörike as a poet left in the wake of deep poetic visions but not carried by them; as a poet, in Blake's terms, not of imagination but of memory. Against this theory I would submit that 'Auf eine Christblume' is written in language which reveals, more adequately than that of any other single poem by Mörike, what Hölderlin called 'die Sprache der Fremdlinge', meaning by this the gesture language in and through which a thing speaks for itself, and which can only be understood by visionary poets. In his poem 'Rousseau' Hölderlin thus writes:

Vernommen hast du sie, die Sprache der Fremdlinge,
Gedeutet ihre Seele! Dem Sehnenden war

Der Wink genug, und Winke sind
Von Alters her die Sprache der Götter. (16)

There are issues involved in this statement which cannot be discussed here; but two points should be noticed. First, a poet's command of this language is likely to depend on the degree of his creative (and therefore not necessarily conscious) insight into those things and transactions between things in nature which Novalis called ciphers and Friedrich Schlegel called hieroglyphs. This peculiar faculty may presumably be cultivated, by assimilation of the traditional language of symbolic equations to be found in the available iconologies. Secondly, a poet's command of this language, in terms of articulation rather than vision, will depend no less upon his capacity for using words in such a way that no partition exists between word and thing. Rudolf Kassner has written with great insight into this power of the authentic poetic imagination, 'die Zwischenwand einzuschlagen zwischen Wort und Ding'. (17) And in Mörike's poem the astonishing evocativeness of the language in which the poem rivets attention purely upon itself, can hardly be described without the use of some such terms as Kassner's, terms which are closely associated with Gerard Manley Hopkins's term 'inscape', but which have nothing at all to do with the referential language of description or representation. Here, for want of a better term, I shall be using the word 'iconicity' to designate poetic statements which communicate things in this totally illuminated way, and which thereby, as Eliseo Vivas has put it, 'capture attention *intransitively*' upon themselves. (18) Mörike's poems 'Götterwink' and 'Im Weinberg' show him wittily playing with the gesture language of things, though in neither of these poems is there any iconicity in the language. But in 'Auf eine Christblume' he has passed beyond the realm of witty play into the realm of pure imaginative play; and here there is iconicity. The whole imagination here has responded to its object. Therefore the poem is a more transparent vision of its 'thing' than any of the other poems which Mörike wrote about things. Therefore it explicates, more succinctly than Boucke's admirable commentaries ever could, the complex sense of the word 'rein' in Goethe's aphorism: 'Reines Anschauen des Äusseren und Innern ist sehr selten'. (19) A character in a story by Eduard Saenger has defined such vision nicely, if somewhat figuratively, when he compares a statue with 'einer Dichtung, die wörtlich meint, was sie sagt, und die in ihrer höchsten Vollendung das Ding

selbst ist, von dem sie spricht'. (20) I hope shortly to suggest that this iconicity (which is something like a perfect integration of literal and metaphoric statement) has to do with the sound of the poem. But first it should be observed that one is here far from that realm which Nordheim defines as the realm of Mörike's 'Dingdichtung', and within which he includes 'Auf eine Christblume'.

In Nordheim's view, Mörike's poems about things fall into two main groups: the poems about art-objects and the poems about objects in nature. The mode of perception in both groups is predominantly aesthetic; that is to say, the poems in both groups are about beauty. Moreover, the interpretation of beauty often becomes the threshold to religious experience. The emotional or psychological grounds for this concentration on isolated beautiful objects have been investigated by Nordheim in his remarkable unpublished thesis, *Die Einsamkeitserfahrung Eduard Mörikes* (Hamburg, 1954). He writes in his essay of 1956, on 'Auf eine Lampe': 'Für den Dichter selbst . . . bedeutet dieses Ergebnis, dass er am selbstgenügsamen überdauernden Kunst-Schönen, am beständigen "Ding", einen Halt gefunden hat, von dem aus er das Leiden unter dem Bewusstsein seiner Einsamkeit in dieser Zeit bestehen kann.' (21) And of Mörike's 'Dingdichtung' in general he writes here: 'Das Hervortreten der Dingdichtung bezeugt, dass die Geborgenheit im Glauben an die objektive Gültigkeit kosmisch-religiöser und zwischenmenschlicher Bindungen weithin verlorengegangen ist.' (22) Now it will be apparent that Nordheim's grouping of the poems is designed to establish the meanings of the poems in terms not of structure and of the quality of their language, but in terms of content and subject. He is concerned with treatment only in so far as he adopts Oppert's theory of the poems as interpretations within descriptions. (23) And it is questionable whether 'Auf eine Christblume' can be discussed adequately in such terms. The unique feature of the poem is not that it is an interpretative description of a beautiful Christmas Rose (or common 'Nieswurz'), but that the iconic language of the poem is somehow consubstantial with the flower perceived as an analogue of the soul in a condition of perfection. The vision which informs the structure marks, moreover, a momentary but decisive suspension of that loss of faith in 'cosmic and human relationships' which, in Nordheim's terms, constitutes the emotional or psychological grounds of Mörike's 'Dingdichtung'. Hence, it might

be added, the vision of the flower has its nocturnal setting not in that night of Hölderlin's which succeeds the recession of the 'gods', but in the purified night which betokens their elemental presences. Hence also the peculiarly unobtrusive language of negation in the poem, which shows us language transcending its ordinary function as a referential system of mediating signs, and finding another function, that of iconic statement.

No less important is another difference between 'Auf eine Christblume' and the other poems about things. The other poems, as 'Inschrift auf eine Uhr' (in Nordheim's group of poems about art-objects) and 'Corona Christi' (in Nordheim's group of poems about objects in nature), are concerned with things as isolated incarnations of beauty perceived in their relation to mind and interpreted in terms of mind. But in 'Auf eine Christblume' the object perceived is viewed throughout not as something *isolated*, but as something possessing *relations* within a cosmos of its own. The flower is 'Tochter des Walds', it is 'lilienverwandt', and it is 'Kind des Mondes', to mention only one set of relations involved. These relations are moreover defined, after the mind has made its comparisons, as relations existing really both in nature and in the soul. The process of interpretation here, as distinguished from that which is manifest in the other poems, discloses the object in the context of its relations, and so restores the object to its 'proper nature'. Schelling's 'Odyssee des Geistes' comes here full circle. For this reason, the poem reads like a plastic dialogue between the poet's imagination and its object, whereas the other poems, by comparison, read more like contemplative monologues.

Oppert, in his essay published in 1926, certainly pointed in this direction when he wrote: 'Deutung ist nicht gesagter Inhalt, Deutung ist Formsache'. (24) But Oppert did not work out the implications of this telling phrase 'Deutung ist Formsache', in terms of that word-music of which Mörike has always been considered a master. I propose now to indicate, tentatively, the nature of some of these implications, and to suggest, if nothing more, that what might be described as the *natural* sound patterns of the poem reflect its iconicity. The apparently natural patterns to be discussed do not seem to be as intentional as rhyme, assonance and alliteration. (25) But they do exist as patterns, and as David Masson has most perceptively demonstrated in a study of such patterns in verse, including German verse, they 'can be related to the poetic meaning in specific ways'. (26) No single

word in the poem, it will have been noticed, refers to sound.
(27) This is a rare thing in Mörike, for his poems most often
show several senses registering in succession (though seldom
synaesthetically), with the ear dominating. It may not be too
fanciful to suppose that here the ear is totally absorbed in the
poem itself, which is in turn enfolded by silence; and that this is
the silence of the purified night, with its 'heavenly chill', and
also that 'dämonische Stille' in which the seraphic stranger is
enshrined and so seems, like 'das Schöne' in the poem 'Auf eine
Lampe', 'selig in ihm selbst' (I, 105).

The second couplet of stanza 7 shows that here we have to do
with the fidelity of Mörike's ear—which Nietzsche called 'das
Gewissen des Ohrs'—rather than with any conscious hold on
rhetorical conventions.

Vor deiner mystischen Glorie steht er scheu
Neugierig still von fern und huscht vorbei.

The rhyme is deliberate; the chiastic internal assonance, 'deiner'—
'scheu'—'neugierig'—'vorbei', conceivably less so. But the de-
ciding factor is that rhyme and assonance alike are regulated by
vowels which seem to lie outside their pattern, namely by the
ie ('ier') of 'neugierig' and the u of 'huscht'. These sounds iso-
late and freeze respectively the upper and lower frequency
values of the eu of 'neugierig', and so prevent this eu from cross-
ing and reducing the eu—ei tones of the rhyme 'scheu'—'vorbei'
(this rhyme would have been to Mörike more effective than a
purer ei—ei rhyme). (28) Had this eu been allowed to interfere,
a toneless second line and end-rhyme would have resulted. As it
is, no comma is needed after 'scheu': the sound-pattern can
dispense with it.

Other patterns evince a like fidelity of ear, also a sure sense of
that slight asymmetry of sound which gives body to a poem's
music. The first line of the poem, 'Tochter des Walds, du lilien-
verwandte', contains a chiastic sequence of stops, spirants and
liquids. The first t of 'Tochter', the w of 'Walds', then the w and
t (dt) of '. . . verwandte' bracket the l and t (d) of 'Walds', the
d of 'du' and the two l's of 'lilien-. . .'. The chiastic sequence
here then is t-w-l-t-d-l-w-t. At the core of this pattern the rela-
tion between the surd t of 'Walds' and the sonant d of 'du'
could be a phonetic signature of the collection of emotional
stress into the familiar pronoun. Sounds then assonate to orga-
nize this stanza and to link it musically (thus not only semanti-
cally, as Storz says) with stanza 2. There is a clear run through

from the first couplet rhymes to 'Hand' (stanza 2); and a clear run from 'mir' (line 2, stanza 1) to the 'ir' of 'Kirchhof'. A pattern links the phrases ending lines 3 and 4 in stanza 1: 'öd und winterlich' gives *ö-int-ich*, and 'schöne, find ich dich' gives *ö-int(ind)-ich-ich*, a profusion of the former pattern. Among such tight patterns as these throughout the poem, the *ei* sound, opening out in the second stanza, perpetually shuttles, an insistent silver bell ringing through all the registers (like the little bell in Berlioz's 'Queen Mab' scherzo). In stanza 2 it sounds against a light background of front vowels and liquids, with the further chiastic sequence *ei-l-ie-l-ie-ei-l* in line 4 ('Ist's *ei*ne Jungfrau, *lieb*lich *fiel* ihr T*eil*'), with its sub-pattern *f-r-f-r* ('Jung*f*rau . . . *f*iel ih*r*'). In stanza 3 the *ei* sounds against a deepening background of back vowels and spirants, bracketing the perfect sequence *k-a-l-k-a-l* in line 3 ('Bei der *K*ape*l*le, am *k*rystal*l*nen Teich'). Then it both fills and seals off the repeated pattern *ts-u-ch-ts(z)-au-ch* of line 4 ('Dort *such*t ich deiner Heimat *Zau*berreich').

Stanzas 4 and 5 are rightly considered to constitute the climax of the vision into the flower itself. The vowel and consonant patterns here are therefore of singular interest. The pattern after 'Schön bist du' in line 1 of stanza 4, 'Schön bist du, Kind des Mondes, nicht der Sonne,' contains the following overlapping sequence (in which it is again unwise to unmix vocalic and consonantal members): *K-i-n-d* inverted as *d-n-i-ch*, with a further wing of sounds formed by the *ō-n* of 'Mondes' levelling into the *on* of 'Sonne', as *k* simultaneously tapers into *ch*. This levelling and tapering of the line towards its end throws a special emphasis on the first phrase of the line, 'Schön bist du', because in this way this phrase is felt to stand outside the rest of the pattern; and a special emphasis also falls on the phrase 'Kind des Mondes', with the sharp affricate and the long round *o* rising clear from the foregoing sibilant *Sch* and the modified *ö*. Here too there is a proliferation of assonances through the lines: 'Schön'—'tödlich' and 'wäre'—'nährt', with an added conjunction of *k*'s in 'keuschen' and 'Kälte'. A different kind of proliferation occurs when the first three phonemes of '*Blu*men' (stanza 4, line 2) separate to form the rounding-off of the stanza in '*b*alsamsüsse *Lu*ft'. In stanza 5, the back vowels and octave-like consonants of line 1 lead down into the 'Wohlgeruch' and golden heart of the flower. Considered in terms of Paget's phonated gestures, (29) these sounds belly out like the body of a vase or jug, with a

slender neck, the neck being phonated in the light 'gründet' and
'verkündet'. In the second couplet of the stanza, the consonant
pattern is dominated by the stops *d* and *b*, which form a chiastic
sequence in the following series: *d-b-b-d-b-t (d)* ('*d*uftete *b*e-
rührt'—'*b*ene*d*eiten'—'Brautgewan*d*'). Line 4 actually has a va-
riant pattern if the stop *t* is heard in conjunction with the other
stops as a kind of shadow of the *d* sound: *b-d-t-t (tt)-b-t-t (d)*.
Again the tightness of the texture is apparent, also the lightness
of it, which is due to the non-identity (asymmetry) of the
closely related sounds, and to the way in which, in this stanza,
the vowel-pitches fluctuate, making the pattern sonorous and
many-dimensioned. The *ei* sound has receded here, in the gene-
ral crystallization of back-vowel patterns. But in stanza 6 it has
returned, fresh-powered on release, and commands the whole
structure. In stanza 6 also, the liquid and stop pattern contains
asymmetrical sequences and dominates each line in different
configurations; *l-g-l-d* ('hei*l*'ge *L*ei*d*en'), *ch(g)-k-l-d* ('einzig *kl*ei-
*d*en'), *k-d-l-d* ('*k*in*d*lich zierst *d*u'), and then in the entire final
line *l-g-d-k-l-t(d)* ('*L*ichtgrün mit einem Hauch *d*ein weisses
*Kl*ei*d*'), a summa of all the members in which the *d*'s fade into
t. Stanzas 5 and 6 are musically associated by the assonances
between 'ber*üh*rt' (line 3, stanza 5) and 'w*ü*r*d*en' (line 1, stanza
6), and between 'bene*d*eiten' (line 4, stanza 5) and 'h*ei*l'ge
*L*e*i*den' (line 1, stanza 6). This does not necessarily contradict
Storz's statement that a pause separates these two stanzas. The
key of the thought may change in a pause without involving a
change in the melody of the thought. Stanza 6 is also musically
associated with the first couplet of stanza 7, where 'mitter-
nächt'ger' and 'lichterhellen' echo the liquid and stop pattern of
the previous stanza. Another pattern appears here also in the
phrase '. . . *t*'ger *St*unde Zum *T*anze geht'. The basic members
of this pattern are *t-g-scht* and *ts-t-g*. The *scht-ts* inversion is
here a kind of pivot in the exfoliation of *g*. This *g* gathers impe-
tus in 'Grunde', Glorie' and '. . .-gierig', and then tapers to fade
in the aspirate of 'huscht'.

In the second part of the poem, the *ei* sound still dominates
(another reason for not reading 'Auf eine Christblume' as two
distinct poems). Read as a phonetic whole, these last two stan-
zas, like stanzas 2 to 7, show the curious shuttling movement
of this sound from line to line. At first it is an end-rhyme, then
it shifts to the front and again to the end of line 1 in the last
stanza of all; then it passes to the front and then to the centre of

line 3 of this last stanza, and finally to the end of line 4, to conclude the poem. Other patterns are apparent here. The 'Blumenkeim' and 'Schmetterling, der einst um Busch und Hügel' are not only semantically linked. '*Blu*men*kei*m' and '*ei*nst um *B*usch und Hü*gel*' form together a pattern of phonemes: *blu-kei-ei-bu-gl*, in the tail of which the earlier member *k*, become *g*, has 'intruded, between the *b* and the *l*. (30) There is also here the perfect dispersed sequence *b-sch-b-sch* ('. . .*b*oden', '*sch*läft', '*B*lumenkeim', '*Sch*metterling'), which suddenly reappears knotted round the *u* of 'Busch'. In line 1 of the last stanza there is what might be described as a proliferation of echoic phonemes: 'Wer *a*ber *w*e*iss*, ob nich*t* sein *za*rter G*eist*' contains the pattern *a-r-eiss-t-ar-eist*. But the proliferation is also further in evidence, namely in the *ss* and *t* of 'weiss' and 'nicht', *ts (z)* of 'zart' and the *st* of 'Geist'. (31) Here again the pattern is a bracket, *sst-ts (z)-st*, and it extends into the *z* of 'Zier' and the *st* of 'dereinst', finishing only as the poem ends, in the *st* of 'umkreist'. The last word itself also belongs within another chiastic pattern, *un-b-b-um*, in 'Mir *un*sicht*b*ar, dich *b*lühende *um*kreist'.

One inference that can be drawn from this outline of the vowel and consonant patterns of 'Auf eine Christblume', is that this is an uncommonly harmonic poem in the musical sense. It will depend to some extent upon the individual reader's response, whether or not this harmonic organization can be recognized as constituting, together with the meanings insistent in the poem's imagery, the totally illuminated and autonomous character of the poem as a verbal icon. At most, this paper was an attempt to indicate that response to the poem can be reasonably extended in this direction, once it is recognized that a relation does exist between its structure as sound and its structure as meaning; and that we can come closer to appreciating this relation by thinking in such terms.

It may also aid appreciation if we are able to recognize the spirit which informs the poem. What we have to do with here is not a poem like 'Auf eine Lampe' which distils, with consummate grace and simplicity, the idealist aesthetic of Hegel out of Schiller. We have to do with a poem which crystallizes fresh values out of another aura of thought, out of that tradition of which Hegel was a late inheritor. (32) This is the Swabian tradition of mystical realism which had its great eighteenth-century exponent in the theologian Friedrich Christoph Oetinger (1702-82). It was Oetinger who kept the gnostic traditions alive against

the pressures of mechanistic philosophy in the eighteenth century, and whose theory of personality as a continuum of which spirit and body are indivisible reciprocal functions contained values which Hegel was later to reserve exclusively for the realm of aesthetics. And it is Oetinger's concept of *Geistleiblichkeit* which provides, I believe, the clue to the reciprocal relation of meaning, sound and image in the poem 'Auf eine Christblume'. For here if anywhere there is a poetic equivalent of Oetinger's pure 'ethereal body', and of what he called 'der Anfang des Geistes'. 'Liebhaftig sein', he wrote in his *Irdische und Himmlische Philosophie*, 'leibhaftig sein ist eine Realität oder Vollkommenheit, wann sie nämlich von den der irdischen Leiblichkeit anhangenden Mängeln gereinigt ist'. (33) This is the illuminated corporeality which is the condition of the Christmas Rose in Mörike's poem. It is also the kind of corporeality, or iconicity, which is the condition of the language of his poem. Carl August Auberlen, in his critical commentary on Oetinger's writings, thus explained in terms which again reflect upon the relation of meaning, sound and image in the poem: 'Keine Seele, kein Geist kann ohne Leib erscheinen, keine geistliche Sache kann ohne Leib vollkommen werden, alles, was geistlich ist, ist dabei auch leiblich'. (34) It may not be irrelevant to recall that Oetinger's books were among those whose golden titles the 'alter Turmhahn' deciphered one Sunday morning, as the sunlight crept into Mörike's room, through the window.

PATTERN WITHOUT PREDICTABILITY, OR PYTHAGORAS SAVED: A COMMENT ON KURT SCHWITTERS' 'GEDICHT 25'

The text:

GEDICHT 25, *elementar*

25

25, 25, 26

26, 26, 27

27, 27, 28

28, 28, 29

31, 33, 35, 37, 39

42, 44, 46, 48, 52

53

9, 9, 9

54

8, 8, 8

55

7, 7, 7

56

6, 6, 6

56

6, 6, 6

¾6

57

5, 5, 5

⅔5

58

4, 4, 4

½4

59

4, 4, 4

½4

25

4, 4, 4

½4

4, 4, 4

½4

4, 4

4

4

4

THIS POEM by Kurt Schwitters, from his collection *Die Blume Anna/Die neue Anna Blume* (1922), (1) looks at first sight like a prank and nothing more. No words, only numerals; no lexical sense and no sound-sense; not expressive, not lyrical, not euphonious. It is a dig at language, the language of poetry, especially the language of German poetry. It is a deflation, notably, of the declamatory mode in so-called Expressionist poetry (the school of pathos, Johannes R. Becher, and so forth). In addition, its structure, exact as only numerals can be, gives a fairly decisive freeze-off to Schwitters' own early master, August Stramm. Stramm's condensations were achieved by a dozen or so devices which Schwitters faithfully mimicked in his poems up to about 1919: coinages of compound nouns, verbs coined from nouns, adjectives from verbs, the agrammatical use of the pronoun as a third-person singular subject ('Du steht!'), the use of intransitive verbs as transitive verbs, and several other violent mannered disturbances. Yet Stramm-Deutsch was fought by Schwitters' genius for fooling. Its purple-faced compressedness involved verbal gestures which often ended up as gesticulation, and worse, as thunderous banality. Gesticulation and thunder were foreign to Schwitters as a poet and as a graphic artist.

What happens in the poem? There is no reason why it should begin with the number 25. Does this reflect none too well on the beginnings of all poems? Do all poems begin with an arbitrary point, which becomes inevitable only in retrospect, once that point has expanded into a structure? This does happen here. There are three 25s, broken into two groups (25/25 25) by the format. Likewise the next series, 26; and the next, 27, and the next, 28. By this time, this kind of series has become predictable. Whereupon 29 follows: one digit up, as before, but no repetition here. The pattern as formed to this point is broken by this incomplete series, 29. A new pattern now starts: odd numbers in one line, ascending from 31 to 39; and in the next line even numbers from 42 to 52. Inside this pattern there are two irregularities: the leap from a two-digit interval, between the odd numbers, to a three-digit interval (occurring between the lines): 39/42. Second irregularity: a four-digit interval occurs between 48 and 52 (50, the predictable number, has dropped out). So far, then, certain patterns have been forming; and they have changed at the precise moment when they might have become predictable. This is also the form in what follows.

Next comes 53 (a one-digit interval, this time, from 52),

standing all by itself; its isolation makes it a purely formal re-statement of the starting-point, while its quantity imports a new deviation from that point. The interval suddenly increases. A con-certina dialectic develops. Numbers ascending by one digit inter-weave with much lower numbers descending by one digit: 53/9, 9, 9/54/8, 8, 8—etc., up and down to a locking-point on the numeri-cal 6, where the concertina jams. This repetition breaks up the foregoing pattern again just at the moment when it was becoming predictable, though now the new pattern itself jams and cannot develop. With a comic supernumeral heave it unjams itself: the next numeral is not one from arithmetic, but from clock-time—a quarter to six (¾6). Now the former pattern tries to develop: 57/5, 5, 5. But the clock-time numeral pattern fights this and injects into the series an absurd version of itself: two-thirds to five (⅔5). Relentlessly, the former pattern surges over this block, to reach 58/4, 4, 4; then the counter-pattern of clock-time numerals re-asserts itself, this time without absurdity, as half past three (½4). This in turn, after a repetition, leads into a contentual repetition of the original number 25 (as if it were the tonic, in musical terms). Meanwhile, the 4 series has jammed, as 4, 4, 4/½4 occurs four times, combining straight numerals with clock-time numerals. The attentive reader, alerted by the pattern of repetition-with-variation so far, expects this series to change and modulate into some new order. The minimal variation which does occur is 4, 4, after the preceding triple 4s: this va-riation is purely formal (rhythmical), it functions only as a mo-ment of deceleration, a point of transition to the three conclud-ing single 4s. So the 4s carry on to the end. Yet the anticipation of variation is such, that the reader does not anticipate this repetitive end.

What we have here is a model of patterning and unpredictabi-lity in poetic art. Pattern begins at a point X, the inevitability of which becomes apparent only as the context of relations thus inaugurated unfolds. (The *logical* point of departure for a poem in numerals might be 1; but any number can be the *growing* point.) Pattern, establishing itself, grows in unpredictable (but not arbitrary) directions; is broken by variation; re-forms and re-defines itself by self-mockery; extends itself through new variations, in which now its base note (the tonic) is announced once more; and finally it desists in surprise, burning itself out in repetitions which, owing to what has preceded them, are not anti-cipated (one anticipates variation instead). The final repetitions

here bear no palpable relation to the starting-point, as 4 bears no arithmetical relation to 25 outside of their being related in function as numerals. Visualize this poem, and you see a series of arcs (the patterned numerical relations) evolving into a parabola which is eccentric because curly (the factor of unpredictability creating these relations). The parabola certainly does curl, in so far as 4 is all askew in its relation to 25.

A further point. The poem looks like a purely typographic form, symmetrical optically, in its spatial design. Yet the patterned variability of the intervals between the numerals establishes distinct rhythmical relations between the separate numerals and between their clusters. A temporal/rhythmical form haunts the spatial/typographical *look* of the poem. In amongst a set of signs which suppresses the poetry of lexical and oral values entirely, moves the phantom of those values: rhythm which is *elementar*, the spirit of surprise, once (after all) called 'Numbers'.

One might reasonably admire the artistry with which Schwitters here, at one blow, and with the simplest and most economial means, indulges the spirit of Dada anti-poetry, subverts lexical language, yet keeps the chaos at bay and contrives to sensitize and animate the medium of statistics. Numerical men plan the day when predictability shall be king. The web of technology, with numbers for its system, is blanketing the earth with calculation and exterminating all miracles. These deadly designs are answered by Schwitters in this poem with an art of animation which reveals miracle in banality, and which retrieves the breath of human life from the orifices of the robots. (Even the clock-time numerals make fun of the dead-metrical.)

In a much later poem, written in English during his refugee years, Schwitters persisted in this creation of forms structured by eccentric relations. Was this the real tenor of his art? Here too the system of relations is sensitive; again patterns evolve to modulate just as they are becoming predictable: 'Our phantic drsls and rlquars are full of whisked away formal life'. (2)

PERHAPS STRANGE (3)
 The world is full of goods-trains.
 The passengers are cows
 And milk and cheese
 And butter,
 And horses, bulls and flowers.
 The cow is mother to the milk,

And grandma both to cheese and butter,
Which two are sisters.
The horse is brother to the bull,
The husband of the cow
And father of the milk.
The horse is uncle to the milk.
And what are flowers?
Another family perhaps?
Perhaps!

NOTES ON SOME POEMS (1964/5)

(Informal Talk at the Goldsmiths' College, University of London)

> *We have our responsibility to refuse to cut hair in strange styles. Then we are truly serving the people.*
> Mr Li Yu-tao of the Hsin-hsin Barber Shop, Sian, Shensi Province, China (cited in a London newspaper)

I MEAN TO talk to you about poems as active structures of eccentric feeling, presenting truths of imagination. I shall also be suggesting that poems, to be stark, radical and relevant, should be other than descriptive, should not be ego-fascinated verbal tokens of this or that actual object or felt thought, but should be constructional in ways which enact the root life of imagination and intelligent feeling.

Paul Valéry described the vivid and special talk of poetry as a deviation from practical language. A deviation, he called it, from the 'finite functions of words'. He said: 'Poetry's special aim and own true sphere is the expression of what cannot be expressed in the finite functions of words'. This deviation, Valéry said, occurs in any literature that has reached a certain age; and then —'One could imagine that the language of poetry might develop to the point of constituting a system of notation as different from practical speech as is the artificial language of algebra or chemistry. The slightest poem contains all the germs and indications of this potential development.' For Valéry this did not entail a kind of 'dehumanization', rather it meant an enrichment of experience and of language, since these deviant forms of language 'give the illusion of the power or the purity or the depth of language'. Poetry, moreover, 'aims to arouse or reproduce the unity . . . of the living person, an extraordinary unity that shows itself when a man is possessed by an intense feeling that leaves none of his powers disengaged'. (1)

Those were Valéry's thoughts in 1927. In 1942, T. S. Eliot framed a historical perspective for this deviation of poetry from practical language. He didn't say 'practical language', he said 'colloquial speech'. The distinction is too fine to concern us at the moment. Eliot wrote: 'At some periods, the task is to explore the musical possibilities of an established convention of the relation of the idiom of verse to that of speech; at other periods, the task is to catch up with the changes in colloquial speech, which

are fundamental changes in thought and sensibility'. (2) The formulation is most interesting. But a single period or one poet can produce deviant poems as well as colloquial ones (as in Eliot's own work, or Neruda's).

I touch on these questions, quoting from these masters, for several reasons. One obvious inference is that both Valéry and Eliot tell us about poetry as something subject to changes in the language, historically speaking. Both, too, alert us to the fact that there is something fundamental (though not necessarily changeless) that happens in the language of poetry, whereas the 'finite words' or 'colloquial speech', as vehicles and reflectors of historical change and as nutrients for poetry, may not enshrine that fundamental element. Another thing: I do not believe that Eliot meant that poems mime colloquial speech, under certain historical circumstances, even though he would never have gone as far as, say, Nietzsche, in blasting 'those most unspeakably vain and loathsome frauds who are bent on parading as innocents, those moral masturbators who bring their stunted sensuality to market swathed in rhymes and other swaddling clothes and labelled "one hundred per cent pure" '. (Nietzsche was castigating poets who commit the 'idolatry of verisimilitude'.) Eliot is indicating rather that poetry transforms language under all circumstances—colloquial language, that is—and that its exploration of musical possibilities, under certain circumstances, may introduce kinds of deviation which are important.

I hope I have gone on long enough about this to have enabled you to see how my thoughts about certain poems of mine can be framed by the two concepts of deviation and colloquial speech. I have written poems of both kinds. While I was writing the poems in *Torse 3*, there came a moment (in the late 1950s) at which I wanted to see how far I could go in each direction, separately. The results were, respectively, 'Male Torso' and 'At Porthcothan'. It may be that the historical cycles described by Eliot are epitomized in the mental history of any poet whose abyssal life is shaped by successive phases of introversion and extraversion. A heartbeat on which everything depends, as Baudelaire said in his journal: 'Dans la concentration et l'évaporation du Moi, tout est là'.

To end with preliminaries, here are two poems in which the two moments, deviation from and return to colloquial speech, seem to be integrated. I chose one poem by Baudelaire and one by Gary Snyder, in order to show that a pure tone may animate

plain words in poems which differ diametrically in style, mentality and epoch. In both these poems, each word is sharp and resonant. Each poem is a definite eccentric cosmos affording its peculiar 'range of pleasure as sight, sound, and intellection' (Louis Zukofsky). Each poem realizes the peculiarly human 'sense of a universe' which Valéry called the essential poetic emotion (he did not say what kind of a universe).

[Baudelaire, 'Le recueillement'; Gary Snyder, 'Kyoto: March'.]

If my poems establish a cosmos at all, it's a cosmos without certainty. I'll try to show this in the poem 'Objects at Brampton Ash'. At first glance you'll detect a pastoral scene. Two phrases might seem cryptic: 'You thumb its edge [the claw's] and grass gets grassier'; and 'So you revolve in hearthsmoke's occult caves'. The relation of the last couplet to the rest is also not self-evident, unless you have read the poem closely, that is to say (I emphasize this), *verbatim*.

There's the pastoral scene. The cryptic details are matters of perspective. 'You' (who sees all this) shuttle between nearness and farness in a relation to things seen and sensed. The cocking of the thrush's head, for instance: it can be seen from some way off, not so the bunching of his pectoral muscles. The nearness is then diffused out among the details: the holly (spiky) with its shadow across the grass is said to hone the thrush's claw as, and only as, this claw is now part of the seer's provoked sensuousness. There is a dialectical sharpening here, participation. The oscillation outwards makes for a dialectical unity, if you like. Thumbing the claw's sharp edge increases, too, the sense of the grass's grassiness. All sense quickens through one sympathetic shock.

But this increase occurs in a context of observed endings. The thrush is halted, the claw's edge is an edge. This double-sense, sensing in the midst of life multiplied by being among endings, develops in the third couplet. The spire tapers and quits ascending. (The spire's point belongs in the image-set of holly, claw, edge.) The seer's perspective, as the spire quits ascending, now moves across to the smoke curling and turning over roofs. He's now inside this. Smoke curling over cottage roofs in winter has to vanish, on contact with frost. The words 'hearth' and 'banish' are tensed against each other. The smoke, as well as the 'you' inside its occult caves, both are banished. The you's banishment is the last enacted end.

So there are ends and ends. Some ends increase and stress the

vividness of what they confine. Here is Goethe's classic exclamation about the Venetian seaboard snails, limpets and crabs: 'Was ist doch ein Lebendiges für ein köstliches, herrliches Ding! Wie abgemessen zu seinem Zustande, wie wahr, wie seiend!'—How *being* a thing is, he says, how well fitted to its circumstance. But other ends, other confines, are pourings away of being, thus 'perpetual waste'. The poem stops in this moment of *horror vacui*, having passed through its two pairs of oscillations between sensuous identification with objects, and a more distant, detached 'seeing' of objects. The last line is a half line, the rest—vacuum. That *horror vacui* toward which the poem was moving (in about 1957) did have to do with the H-Bomb, but the poem doesn't make this explicit. Here is the poem 'Objects at Brampton Ash':

The quick thrush cocks his head,
bunching his pectorals, halted.

Long holly shadows hone his shining claw;
you thumb its edge and grass gets grassier.

The tapered spire, at anchor in its ring
of tomb and cedar, has to quit ascending.

So you revolve in hearth-smoke's occult caves,
banished by touch of frost beading the roofs.

What increase, could these ends outlast
perpetual waste.

Another poem, 'January 1919':

What if I know, Liebknecht, who shot you dead.
Tiergarten trees unroll
staggering shadow, in spite of it all.
I am among the leaves; the inevitable
voices
have left nothing to say, the holed head
bleeding across a heap of progressive magazines;
torn from your face,
trees that turned around—
we do not sanctify the land with our wandering.
Look upon our children, they are mutilated.

Here again there's oscillation, again not so much a viewpoint as a moving viewline. (I'm not writing poems on set subjects which are formulas translated into Appropriate Words.) You could plot

the viewline roughly as follows: from among the leaves of Tier-
garten trees (under which Liebknecht was shot by persons
known), to the bullet-holed head bleeding across the magazines,
back to the trees, now turned away ('turned from your face')
and looking elsewhere; then on to the wandering that doesn't
sanctify the land, and to the imperative about the children.

The 'materials' here were: the murder of Karl Liebknecht by
his military escort in the Berlin Tiergarten in January 1919, two
weeks after he had co-founded the German Communist Party; a
photomontage by John Heartfield showing Liebknecht's head in
a heap of progressive Socialist magazines; one line from a song
of the Brazilian politico-religious prophet of the phantom King
Sebastian ('We sanctify the land with our graves and wandering').
There are also allusions to linguistic material. 'In spite of it all'
is a translation of the last words, 'Trotz alledem', of Liebknecht's
last published call for a radical left-wing revolution. The whole
phrase, 'Torn from your face . . .' to 'wandering', is an allusion to
Christ's healing of the blind man who saw 'men as trees walking';
inside the imagery of leaves and trees there is also the biblical
topos of the 'generations of men like leaves'. The poem absorbs
Liebknecht's rhetorical phrase, only to turn it the other way
around—things don't change, in spite of it all, they go on and
on, as sure as the arrival of leaves in summer. It also turns round-
about the allusion to the blind-man miracle and the line from
the Brazilian song: the trees that wander here, not sanctifying
the land, are 'turned around', that is to say, blind to the mur-
dered Liebknecht, looking the other way. No miracle worker
heals the mutilated children, either.

The reader need not know all about these materials. What the
poem does is develop them as co-ordinates in a structure. The
structure is the insides of a scream of fright. It explains nothing,
and it is not naïve. There should be no need to explain that cer-
tain liberal dreams of progress were broken, after the Liebknecht
period (summer leaves after winter trees), as they are still bro-
ken, by military and police suppression, officially sanctioned
violence, machine-gunning in the streets. This is not an anti-
Communist poem. It is a gesture of the kind, I hope, of which
Kierkegaard said: 'The tension of the contrasting form is the
measure of the intensity of inwardness'. A scream of fright
lasting thirty seconds and returning with an offbeat rhyme to
the phrase in which it started: 'dead' . . . 'mutilated'.

The poem may not say much to unruffled English people.

Robert Bly, who is American, couldn't get the point about the children; he says—'Now that is going too far'. But Günter Kunert, aged thirty-five in East Berlin, says: 'It is an epitome of the *deutsche Misère*'. Or, if you like, the poem welds together certain selected pieces of historical junk. A Latin historian said of his work: 'I have heaped together everything I found' (*coacervavi omne quod inveni*). I might say that I did make fourteen closely written pages of notes on Liebknecht and the politics of his period before these eleven lines sprang out.

Other poems with moving viewlines, contrasted perspectives, and oscillations: 'Alba after Six Years', 'The Thousand Things', 'For a Junior School Poetry Book'.

In the last poem mentioned, it is the time perspective that shifts and oscillates. The children coming out of school become mothers waiting for their children to come out of school. The tense-changes in the last four lines do not sentimentalize the children. The mothers 'had' eyes, what they see with are now thus not eyes at all. The children 'have' eyes, but these are eyes that 'saw', not ones that see any more. These schoolchildren are already past the age of what Freud called polymorphous perversity, past the cosmic pleasure-visions of air and earth and all between—'owl and mountain and little mole'.

Deviating speech and colloquial speech collude in a variety of ways. By apparently casual tense-changes; by shifts in perspective; by a rhythmic patterning of apparently disjointed facets of phrase. Perhaps my way of writing has been touched by the optics of Cubism. What matters, though, is the precise, elegant and bodily articulations of the feel of being that some experience or other may provoke. This may involve 'distortion', not in spatial terms, but of the normal time-schemata. What matters, too, is the exploratory *parlando* holding words in place, however extreme the deviations may become. And the poem is taxidermy if it is written as if its experience has been finished before the poem began. Here is another quotation: Jules Laforgue said (it must have been in the 1880s): 'A poem is about an experience which did not exist before the poem'.

Everything I have said so far hinges on the relation of subject and object, as this relation is articulated, deviantly or colloquially, in the special talk of the poem. I shall discuss the next poem, 'The Child at the Piano', in terms of this subject-object relation. It is not a typical poem, nor is it an instance of a method. I try not to be conscious of method, for conscious method rapidly

becomes formula. I'm chiefly aware, before I write, of feelings
and intuitions that fluctuate according to the drift of an expe-
rience present or past. As the experience composes itself, some-
thing happens to lift the lid off something interior to me; and
then there is the crystallization of a word or phrase, out of
which the poem eventually takes shape. People speak of 'given
experience'. The locution implies a self which is a recipient, and
this is misleading. The experience consists not so much of the
receipt by a self of some previously external event or object,
rather it consists in the activity of creating, which the event or
object only goes so far as to provoke. There is a transference of
energy. Without this transference, the experience cannot achieve
unique, inevitable subjective form. One is creating, of course,
something that one doesn't know—that ignorance is crucial.
'The Child at the Piano':

> The child at the piano,
> plinking, planking, plonks.
> I stare and stare. Twigs
> angle the air with green outside.
>
> Handfuls of notes, all happening at once,
> her tunes do not occur; on their backs,
> round they whizz like stunned wasps; contour
> would crush that kind of mass.
>
> Telescoping flukes and faults, their
> tenuous terrain dislocates
> no spheres I know of. Her index rebounding
> off high C beckons no hell boulders up.
>
> The heroics, fatuous, ordain yet
> this act's assumption of her whole element.
> Boughs of sound swoop through the room,
> happily, for her to swing from.
>
> So I call my thought's bluff. My thumb
> struts down the keys too, pings
> to her plonks, on both white and black notes,
> while the green air outside lets us be.

The poem, it seems, starts before the transference of energy be-
tween subject and object has begun. There's no apparent rapport:
the child is playing, the speaker is staring and seeing something

else. Then the actual sound heard, in the second verse, is at once described and interpreted. The music has no order, no tune-contour. It is a mass so fragile that contour would crush it. The interpretation develops in verse 3. The first three and a half lines here relate this fragile mass of sounds to an idea in the mind of the speaker, 'I': the music of the spheres. No positive relation is found between fact and idea. The next one and a half lines relate this fragile mass of sounds to another, but connected, idea: Orpheus in the underworld, making the stones dance.

The 'I' as subject has stepped back, as it were, to look around inside his store of ideas and information, seeking a context in which this kind of noise might have meaning. The child's index finger, as it bounces, and it would be curved, off the keyboard, comes into a pan-up focus with the idea: the lyre-plucking Orphic finger as it commands the stones to dance. But no stones are apparent. Out of these negative findings, the interpretation turns back upon itself. The experience is unfolding in the words, *as these words*. Provoked by the thumping heroics of the child's playing, the comparisons, such as music of the spheres and Orphic music, haven't so far illuminated the *thisness* of this piano-playing. Now the sounds are found to be imitating much more a child's happy swinging from a bough through the air: the child's 'whole element'. In the last verse, 'thought' desists. Reflection goes out, and in comes a bodily action. The 'I' no longer 'stares', it collaborates in the music. The initial twigs have turned into the imaginary boughs of the penultimate stanza; even they have become now part of the act. They fill the air oustide with green as the notes are struck. The green lets 'us', the note-strikers, 'be'.

So here is a sort of conversation between reflection and being, between what an 'I' is doing and what this child is doing, subject and object. The conversation ends in favour of being. Another thing. At the start, the air outside was only 'angled' with green, but at the end there is green air. There has been an increase of green, a growing, a genesis. The green genesis could not have come to be, and to let be, without the surge of reflection toward an awareness, not only of being but also of *being with* another being. The child and 'I' *are*, together. They are participating in the human dream voiced in the archaic idea of music of the spheres and Orphic music. The fulfilment is perhaps tenuous. But here there is still the old dream of harmony in a radiant physical nature. Being, thus, presents what the

reflecting 'I' could only behold as *absence*. The decision seems to favour being. Actually the dialectical balance between being and reflecting is sustained to the end, for the two interpenetrate one another.

This has been a rather heavy reading of the poem, after the event. I wouldn't suggest that this paraphrase touches on the subjective form of the energy-transference, or that it 'explains' how the poem works. Nor would I suggest that 'I' was contriving all this while writing the poem: you make a nice tight bud, and only later do you notice the flower that was inside. What I should stress, too, is the intention to illuminate experience from the inside, by enacting it in a way that only these words in this order can do. The random is not cancelled out, rather it is built in. This is a different procedure from that in which objects, events or situations might be 'described' from a viewpoint outside them. It is a poem with an open subjective form, with little enough that's 'poetic' about it, though it is rather conventionally genteel, no doubt. Some tone-patterns, alliterations, but all unobtrusive. The phonics are such that abstract moments and sensual moments are harmonically linked. A short poem does need an appropriate tonal organization.

That's enough on how these few poems talk. I suppose it has been a quiet language, even cagey. Strident and turbulent it is not. I've tried not to give up and bluster with the times, but to meditate the times. Your language should be precise about complex feelings, and true to them, in a time that holds human feelings in contempt. Your first responsibility is always the purity and power of language.

Poems without feeling are common products of the culture-agony we are in; so are poems in which the feeling-words declare nothing, because there's no 'contrasting form'. So many poems seem to ooze and clatter, so few are dancing and singing, so few are pioneering future constructions, revolutionary transformations, of the whole human mind. My poems aren't what I'd like to be able to write. They are what I've been able to write so far, with much time spent in fumbling and confusion. They aren't written with readers in mind, or to assail people with calculated effects. They're just as vivid and special as I have been able to know how, as charged with meaning as I've been able to see why.

Do they communicate, and, if so, what is communicated? I do not and cannot write about whelks or tennis—but there are many realisms besides that of the language-camera. Brecht said:

'There are many ways in which the truth can be hushed up, and many ways in which it can be told'. What a poem communicates is not what is immediately understood, a 'message', or whatever. A poem enacts in language a whole way of beholding life: the 'how' is the only validation of the 'what'. Questions. Why should an English poem today about the terrible injustice and misery of the world be almost unthinkable? Is it because poets are still inside the whale that George Orwell described in a splendid essay, still 'buried behind the yards of blubber'? My own concern with the intangible might be another blubber-eater's indigestive daydream. Yet, abstruse as some of them are, my poems might talk in such a way that someone, one day, who comes homing in on their monologues, might look out on the world of practical language, of 'finite words', with a new and sensitive concern. Having seen things strange, you can, at least, give them a straight look. If it is a propositional message you want, I tell myself, then write a pamphlet. The poem goes further, it can reveal the life-project of a whole culture, as well as that of a poet as living person. Isn't 'The Child at the Piano' a product of the educated English upper-middle class of today? Notice the liberalism of 'on both white and black notes', notice the 'green air' which 'lets us be', notice the introversions and mythological allusions, the gentility, the sense of music, too,—these could never have applied in a Jamaican shack, or in a Stepney amusement arcade, or in the plains around old Novapavlovka.

A few more remarks in conclusion. I realize that my work so far is short not only of what phrase-making philistines call commitment, but also of something much more wonderful: the social promise of art. What is this? It isn't a message, isn't escape. It is the hope, detectable in solicitude about detail and structure, that pleasure should one day supersede work as the main activity of our species. Of pleasures, up and down the scale from simple to transcendent, poems often do speak, and of the thwartings of such pleasures too. Their kind of speaking can make opposites meet: pleasure and pain, love and death. A poem which accomplishes this conjunction or coincidence projects a Utopia of the mind, but only to the extent that the pleasure comes out on top. There *is* a chance, the reader tells himself. A chance for what? One may with reason come to suspect poetry profoundly, because its promises seem to be empty, its hopes only prolong the suffering, its utopian projects are annulled by all the evidence of history. Perhaps this substance called pleasure has to do with

what we call 'ideas of order'—and there can be so many doubts
about those ideas. What is this sense of order that a good poem
gives us, even a poem of terror? I cannot say. But for me it
comes across in poems as formally diverse as, say, George Her-
bert's 'Employment' ('He that is weary, let him sit . . .') and the
Rapel group of concrete poems by Ian Hamilton Finlay. Finlay's
idea of the concrete poem is that it is a 'model of order, even if
it is set in a space which is full of doubt' (quoted in *Kinetic Art*:
Concrete Poetry issue of *Image*). Doubt erodes imagination so
inexorably that our models of order, to tell at all, must con-
stantly be renewing themselves.

Even if we cannot salvage older ideas and models of order, we
can in poems nourish the spark of life with the same spirit and
the same love to be found celebrating order in the old poems.
Poetry doesn't all the time 'hatch quarrels with the sun', as
Boris Pasternak said nearly forty years ago. It hatches quarrels
with people who want to extinguish the sun, with ideologies
that bury the spark under schemes and ashes, with the gross-
ness of power, with all the defilers of human reality, who, for
want of pleasure, spread greyness everywhere.

NOTES ON RHYTHM

THE RHYTHM of a poem is a structure of variable tempos which realize its sounds as the radicles of meaning. *Rhythmos*—'measurable flow'—is a particularizing flow of sounds out of which a reality takes shape: the reality of the poem. In my practice, the act of writing is often prepared by a distinctive moment in experience, a moment at which everything, including the conventional code (language), seems to be decomposing. This (Dada) moment is announced by the birth of a phrase, which has a distinct rhythm and resonance. The phrase (or it may be a single word presenting itself at an angle not till now perceived) invades me. It has both destructive and creative force, which I cannot explain.

Such a phrase, bringing at once delight and perplexity, may function during the periods of writing as a rhythmical and harmonic model for the evolving poem. But I emphasize this moment of decomposition, or suspension, because it induces some kind of elevation, through the channels of *Sprachgefühl*, of probably unconscious substances. These are the substances that nourish the *revised* language which comes to be the poem. Yes, even colloquial poems are re-visions of the code.

I become more than ordinarily receptive, once the process of decomposition has begun. This receptiveness seems to have a rhythmic basis, more or less implicit, and the 'mood' is quite certainly volatile. The rhythm of a new reality has announced itself, but I have to make that reality be, work it out toward its unforeseeable conclusion, which may never be conclusive. I accept, in this volatile condition, a profound randomness. I scrape away the overlay of linguistic conventions which seem to be burying the reality I am generating. Mumbling, gnashing of teeth, clenching of fists, walking about, sudden raisings of the head, listenings. I excavate and assemble all sorts of fractions of language and experience, compelled, but also liberated, by the guiding rhythm.

This may involve an inversion of what rhythm is often thought to be—integrating flow, a continuity factor. Perhaps I must stop the flow, so that particular words and sound-patterns may achieve profile, independence, energy, but also coherence. What Harold Rosenberg called 'the beltline of rhetoric' has to be stopped, so that a genuine speech-event can happen. It is not that a scream has torn the normal night apart. Something

more complex than a scream, but no less urgent, is reordering the mysteries. Dream beings, some ghosts, provoked by a rhythm, reach out their hands for blood—and for grammar.

There are no unimportant words in the text. I seek to interdict the code, so that a true message may be generated. A variable and delicate process, touching the fingertips of the ghosts, and perhaps one is never really 'up' to it. The quality of the experience to be transformed into revised language is, itself, unique, on each occasion. The rhythmic 'form' of that quality differs, perceptibly, from poem to poem (and one poem may be rhythmically multiform). Yet a dominant measure may keep coming back, voicing a personal pulse, like Pound's adoneus, or Stravinsky's primal trochaic throb, beyond mere 'personality' (a pox on personality-cult and all its trumpery).

The old exact metres were traps for gods; everyone had to be careful with them, the gods, dangerous characters. The precision for which I strive may also be a survival of rituals which invoked 'real presences' while safeguarding points of entrance and exit. I do believe that Raymond Duchamp-Villon was right when he said: 'The sole purpose of the arts is neither description nor imitation, but the creation of unknown beings which are always present but never apparent'.

So the entrance of the real presences begins with a rending of the structures of the mind. But enormous differences lie between ancient practices and what is now possible. We live the variability, even indeterminacy, of the precarious personal occasion. Chance is a major factor in the time-feeling that dwells, with history, in our *Sprachgefühl*. Neither can one count on the ritual or the 'meaning' being shared as coherence. Poems have become experiences which did not exist before the poem.

So there is the question of variable periodicity, as opposed to regular periodicity. I'm not at all sure how my practices relate to 'sprung rhythm', but this line—'Tall snake without strut or buttress'—has four accents by my count, and it generates, in the poem 'Snake Rock', other lines with four accents but with intervening lighter accents: 'snake which talks in the rhythms of chemicals'. This expansion generates in turn five-accent or six-accent lines like 'animal of cellulose and lignin come into my house', or truncated lines (I prefer to think of these as lines which contain silence), like 'tell me where the spyholes are' or 'tell me tell me the rain'. A trochaic/dactylic base remains constant through thirty-nine lines; it weaves its way with sundry

modulations, alternate accentual massings and spacings, from phrase to phrase. Linear sequence *presto*, while the interweaving of images in transformation makes the whole field a structure of recurrences (quasi-simultaneous).

Regular periodicity I tend to avoid, unless the 'subject' asks for it (for example, description of a cool photographic study of an indoor nude in 'Le nu provençal', 1969). The variables of 'Snake Rock'—an unpunctuated text—set up some degree of expectation, but the point is to keep breaking that pattern of expectations by gentle shifts (Shklovsky in 1917, I discover, regarded the shift—*sdvig* in Russian—as the prime factor in 'making it new'). Syncopation and improvisation are the regulative features of the experience: 'Snake Rock' is a series of transformations in metaphor, based on three elements only—woman, tree and dog.

I am not aware of deriving the variable trochaic/dactylic measure of some of my poems since 1966 from North American language patterns. It does happen that Texans outdo other Americans in accenting first syllables: cīgarette, īnsurance, cément. On the other hand, much of the American I hear is so chaotic, or dead, that I seek firm ground inside my own (somewhat idiosyncratic) English. There may be a few shades of German and French hidden among the folds there. I do note that verb-forms are being marginalized in current American. There must be ideological reasons for this—are action and thinking being clandestinely suppressed by nominal dead-end signs which drop from the mouths of bureaucrats and behaviourists? The effect on speech-rhythms is devastating. A poem can fight this deadly undertow, by creating patterns of dissent, organized around verbs and present participles.

Poems that interdict the code, stop the flow, tend to assume more curious non-linear dispositions on the page than poems which have a strong through-rhythm. I was trying this out while writing 'The Fossil Fish' in 1969, fifteen micro-poems. Number 2, which is dialectal, says:

 them squads in
 helmets
 burning
 the dragonfly's eyeballs
 out
 is just ants

In this sequence of poems there are some with a muted regular

base, others syncopate with stoppings and violent shifts, for
example, Number 6:

> rock & bough
> tumbled over slammed against
> pluck out their fillets
> of necessary flesh [. . .]

In this case, the syncopation enacts falling over. Such enactive
structures are what I am usually after, in rhythm as in sound.
Rhythm must, traditionally, be a kind of psychic tightrope
along which a human mind dances when man answers a pro-
found psychic need to identify with not-self, to go forth and
meet 'the other': in ritual chant, in the movements of Bushmen
hunters, or in the Chinese Tai-Chi exercises, which enable you to
be a tiger, a crane, a dragon or whatever. To this extent poetry
isn't 'about' experience at all, it enacts (or is an icon of) rhyth-
mic/phonic 'deep structures' of experience. The act of imagina-
tive participation is structured by the sound/rhythm axis. Evi-
dence: the tsar's white-gloved hand in 'The Pogroms in Sebasto-
pol':

> but in particular
> the hand waves
> cupped and white, feeling
> its hollow through the hot
> horse flanks,
> inflexible dragoons,
>
> at Fania freshly combed [. . .]

Here the v/f/l: a/o series runs through from tsar-frame to Fania-
frame (as she sees the hand), like an Eisenstein visual motif which
acts also as a phonic one (the cupped hand, the hollow, the *o*).
An 'identification' occurs, polarized within an identificative pro-
jection. Here the unstopped lines 3-5 are the rhythmic crux.

In another recent poem I have arranged a variable rhythmic
structure for a consonantal series, *b/l*, which began with the
word *oblong*. The series modulates through six unrhymed and
densely punctuated quatrains, into *blotting, bald, destructible,
blue, Treblinka, public, book reflected, bush/table* ('Idiocy of
Rural Life, Variant 2'. This sort of sound-poetry
does not divest itself of lexicality or grammar. The very gram-
mar grows out of the rhythmic/phonic seed. Let me say, how-
ever, that this *b/l* series was not pre-selected. It 'happened' to
emerge during the dozen sittings which it took for the poem to

be written. I was not frontally aware of it until the last two sittings, except as a *something* that was helping to make the text sound as I felt it should.

Words are heard in the distance, words that do not want to be lost, struggling to resist the enormous pressure, the torrent of rhythmlessness. 'My hearth', says René Char, 'is without hope for your houses. And my cypress walking-stick laughs with all its heart for you'.

4

AN ENIGMA TRANSFIGURED
IN HERMANN HESSE'S *GLASPERLENSPIEL*

1.

MANY READERS of *Das Glasperlenspiel* have been perplexed or disappointed by the death of the protagonist, Josef Knecht. Knecht dies the moment he begins his new life outside Kastalien. He descends from the height of his magisterial office to enter the world's 'dark flood' of selfish impulse which, he is aware, imposes upon him a new vocation: sacrifice (6,490; and 6,362-3). (1) But the abrupt end of the narrative in a death of apparently obscure significance has induced many readers to assume that Hesse found himself unable to end his work appropriately. It is concluded that the massive and subtle structure of imagination embodied in the narrative fails to reach complete crystallization in the so-called 'legend' of Knecht's death. The death-scene itself is, however, anticipated by details earlier in the text which remove all likelihood that the death is due to accident or meaningless hazard. The following interpretation of the imagery of this crucial scene shows that certain meanings, lodged in the images of the scene, not only amplify related images and meanings given earlier in the book, but also illuminate what actually occurs when Knecht dies. The use of *I Ging* ideograms, as *Ken* and *Lu*, to mark significant stages in Knecht's progress through Kastalien in Hesse's narrative, suggests that such ideograms may also be involved in the imagery of this last and culminating stage of his life. Hesse mentions his studying the *I Ging* as early as 1925; (2) and this ancient Chinese book has obviously fed his mind, supplying him with images and other patterns of thought and perception as copiously as have other works of oriental legend, literature and iconology. Further, the reader is led to ponder the design of this death in all its dimensions by the 'biographer' himself, when he expressly affirms that Knecht's death should not be thought fortuitous (6,119; 6,360). Moreover, the culmination of a narrative in a kind of essential vision is common in Hesse; and we may expect something of the sort here also. *Demian*, *Klein und Wagner*, *Siddhartha*, *Der Steppenwolf* and *Die Morgenlandfahrt* all end in what Hesse calls 'Wesensschau' (or 'magic theatre'); and if such essential vision is not immediately evident in the language of the death-scene in *Das Glasperlenspiel*, this is because the subtlety of the vision required expression in metaphor. Here metaphor impregnates the simple

images and events of the scene with complexities of meaning. The images and events remain concrete, but become symbolic of these complexities.

2.

The 'legend' tells that Knecht leaves Kastalien to find that Tito, his future pupil, has gone to his father's house in the mountains. Knecht follows him, arrives in the evening, and on arrival is 'tired to death'. He is at Belpunt. This is a name which has, as often in Hesse, a symbolic function. It means 'beautiful bridge'. The italics in the phrase I am about to quote, explicate this. It is September: not the season of the spring sacrifice, but that of the sowing of the seed, the planting of the 'god', and of the Tessin 'Madonnenfest'. In Hesse's so-called 'private theology and mythology', in fact, September is the Madonna's month, and this Madonna he has described as 'the symbol of *the radiance which plies between opposites*' (3,896). Although these words were written in 1924 ('Madonnenfest in Tessin', in *Bilderbuch*), it will be seen that the sacrifice shortly to be enacted is dedicated to this Madonna.

Day comes, Knecht rises early and puts on the bathing-wrap which has been left at his bedside. He watches the lake by the house and waits for the sun to rise over the mountain opposite:

> jenseits ein steiler hoher Felsabhang, mit scharfem, schartigem Grat in den dünnen, grünlichen, kühlen Morgenhimmel schneidend, schroff und kalt im Schatten. Doch war hinter diesem Grat spürbar schon die Sonne aufgestiegen, ihr Licht blinkte da und dort . . . es konnte nur noch Minuten dauern, so würde . . . die Sonne erscheinen und See und Hochtal mit Licht überfluten. (6,537)

Into the conjunction of shadow and sun Knecht walks with Tito, the 'fiery youth' (6, 538). Then the sun comes dazzling over the ridge and Tito dances his invocation to the 'Earth-Mother' (6,539). Knecht now sees into Tito 'as the sun has seen into the valley' where they stand (6,539). This detail marks the first stage of an identification of Knecht with the sun which is shortly to be completed as the imagery develops. But now Knecht sees a pagan Tito, Pan-like, far-off, incomprehensible. Yet what follows implies that the two persons do somehow communicate: for Knecht's death touches Tito to the quick (6,543). It is the iconic language of the 'legend' which expresses this communication in its metaphor.

Knecht sees Tito dancing the dance of sacrifice (6,540). The dance done, Tito's trancelike state is broken, he wildly suggests a 'swimming-contest with the sun' (6,541), and dives into the lake. Now the lake is described: it lies half in the sun and half in the shade, with the sunlit side advancing upon the dark side as the sun mounts in the sky: 'wie die Hälfte der Seebreite noch in dem grossen Schatten lag, den der vom Morgenstrahl bezwungene Felsberg allmählich immer enger um seine Basis zusammenzog' (6,541). The water would be actually half emerald and half cobalt, as mountain lakes are coloured in September forenoons, with colours strictly divided. Knecht and Tito are facing east, facing the mountain over which the sun is rising. At their feet the lake would be sunlit; but towards the mountain it would be in shadow: for they aim to race the sunlight as it advances towards the darker far shore. Now, if this imagery is translated into *I Ging* ideograms, its function as metaphor is revealed.

From the earlier account of Knecht's sojourn with the 'Elder Brother' it is already known that 'mountain' is 'Gen' (='Ken'); and in the *I Ging* 'mountain' stands for quietude and meditation, a checking of the external world, a quickening of the inner world; and, further, it is the 'place' where life and death meet and fuse into one 'Stirb und Werde'. (3) 'Sun' meanwhile has the ideogram *Li*, meaning lucid fire, radiant fire, which is the equivalent of *Logos* (here the image of the sun over the mountain). Taken together, the ideograms *Ken* and *Li*, moreover, constitute the ideogram *Lu*; and *Lu*, as is known from Knecht's consulting the *I Ging* before going to Mariafels, is his own sign, meaning 'Wanderer'. The combination of signs given in the present scene corresponds then with the *I Ging* verses, 'Fire on the mountain: The image of the wanderer'. Now, therefore, as previously, Knecht is the wanderer, but at this stage he is invested with the further significant character of *Li*, identified thus with *Logos*, the 'sun' of incarnate wisdom. Further, the ideogram for 'lake', *Tui*, is appropriate to Knecht's September death, because it represents the end condition of the *yin* (i.e., shadow) side of being and belongs therefore to autumn. (4) The *water* of the lake is represented by the ideogram *K'an*, which, like *Ken* and *Lu*, was used to mark an earlier stage in Knecht's destiny: *K'an* also appeared during the sojourn with the Elder Brother. Moreover, in the *I Ging*, *K'an*, as water (also 'moon') stands in counter-position to *Li*, sun; while in Vedic iconology water is known as the 'Mother', who is 'distinguished from the Father in

the eternal act of generation as the sea is from the sun'. (5) Whence it is here the 'Madonna' who is the recipient, as specified in the metaphor, of the sacrifice of Knecht-*Li-Logos*.

The lake, meanwhile, being half light and half dark, constitutes an image of the complementary opposites *yang* and *yin*; whence, as Knecht now plunges into the lake, the metaphor presents a *coincidentia oppositorum*: 'light' suffuses the abyss of 'dark' as Knecht deliberately plunges into the unshadowed side of the lake with its attributes of icy cold and blaze of flame: 'diese grimmige Kälte, die ihn ringsum wie mit lodernden Flammen umfasste' (6,542). It is the leap into the elements in which, he had earlier thought, lies 'das Innere des Weltgeheimnisses' (6,197). His leap consummates his sacrifice, in a marriage of heaven and earth as this is alluded to by the 'biographer' in his reference to Lu Bu We's axiom on music: 'Die Musik beruht auf der Harmonie zwischen Himmel und Erde, auf der Übereinstimmung des Trüben und des Lichten' (6,100). The sacrifice thus consummates just such an integration of opposites: it is a fit death for Knecht the musician of Belpunt, the bridge of beauty.

Tito's function in the sacrifice must also be known, for without it the unity of the event would be impaired. This may also be shown in terms of the *I Ging*. Tito stands for the 'young', or 'new' man, who is born out of the elements in which the 'old' man (Knecht) is consumed. He becomes the 'fiery youth' in fact, the phoenix of western alchemy. He is *recreated* out of the marriage of the opposites, for 'the marriage of K'an and Li [i.e. of water and sun, passive and active principles in the elemental world] is the process which produces the child, the new man'. (6) Tito's awareness of his role in the enacted mystery is revealed when, apparently in a fit of absent-mindedness but actually with utter spontaneity, he puts on the Magister's discarded bathing-wrap. The receipt and wearing of another man's coat or cloak is in oriental lore a common symbol of the acceptance of transmitted authority. It means that the recipient accepts the donor of the cloak as his lord and master; and that the recipient is thus admitted into the lord's 'world' and becomes part of his 'person'. (7) Tito's recognition, that he is entering a new world of being, comes with a sense of guilt, the sense of guilt which often accompanies such development of character in Hesse: for it follows the knowledge of 'good and evil', that is to say, knowledge of 'the opposites'.

In summary: the pattern of Knecht's destiny is not broken

but fulfilled by his death. Here he performs the sacrifice by a kind of double mimesis: there is his imitation of Tito's 'dance of sacrifice'; and he imitates consequently, to the extent of being identified with, the specific action of the sun as this is figured in the metaphor. The imagery in which this double mimesis is expressed reflects moreover what happens in Knecht's deepest being: there is no dividing the 'elemental', the 'demonic' and the 'psychological' motives which create the given situation. In this death, Knecht realizes what he had earlier called 'den Mittelpunkt der eigenen Person' (6,491). To this centre of his being he has penetrated by the sacrifice which yokes inner and outer worlds. Further, by the identification of Knecht and the sun as *Logos (Li)*, that mystery which the Altmusikmeister called the 'godhead in you' has been revealed. Such a complex communication and integration of opposites in the act of sacrifice is then shown to have been effectual by Tito's act: his putting on the discarded bathing-wrap.

3.

If this last act completes the unity of the sacrifice, and if we have witnessed Knecht's veritable apotheosis, then much of the irony falls away from the view of the Magister Ludi as 'beinahe eine Gottheit', to which the 'biographer' alluded earlier in the book. One might also recall Hesse's statement of his ambition to regard human life 'als flüchtiges Gewand der Gottheit' (4,485), though still such a transparency of nature as he hoped to attain by 'magic' in the *Kurzgefasster Lebenslauf* (1925) needed many years of latent development before it could become the rare atmosphere of Kastalien. The language of the death-scene particularly brings to mind the remark of the 'biographer' on the sign-language of the Glasperlenspiel itself, however, which permits the player to communicate maximal complexities of meaning with complete simplicity, or at least 'das Komplizierteste ohne Ausschaltung der persönlichen Fantasie und Erfinderkraft in einer Weise *graphisch* auszudrücken, welche allen Gelehrten der Welt verständlich wäre' (6,108, my italics).

If the foregoing observations are correct, it might be added that Hesse's language at this point clearly reveals his degree of initiation into the Swabian school of magicianship; for in his *Theologia ex Idea Vitae deducta* (1765), Friedrich Christoph Oetinger (upon whom Hesse modelled the character of the Altmusikmeister) wrote of the true magician: 'Er glaubt ja, dass

das ganze Universum auf emblematische Art mit unzählig vielen harmonischen Anzeigen auf jenen Einen [den Heiligen] hinziele.' There may also be grounds for discerning in Josef Knecht certain qualities of an archetypal imago of the magus, healer and teacher of mankind, whose enduring presence in the depths of human consciousness is indeed most ripe for realization in times of agony and historical error, such as the years during which Hesse was writing his book.

HERMANN HESSE'S *MORGENLANDFAHRT*

Die Morgenlandfahrt (1932) was the first narrative after 'Kinder-seele' (1919) which Hesse wrote undisguisedly in the first person singular. *Der Steppenwolf* (1927) was quasi-autobiographical, but, like *Hermann Lauscher* (1901), it was also mock-anonymous. Even 'Kinderseele', like *Demian*, was first published under the Sinclair pseudonym. But the distance between author and work, which these stratagems aimed to provide, was not, in *Die Morgenlandfahrt*, filled in by the first person singular. On the contrary, Hesse was here to explore the scope of a new irony. It was this irony which was now to provide greater detachment than his narratives had hitherto shown. The unmistakable H.H., who is at once narrator and protagonist of *Die Morgenlandfahrt*, may be recognized as Hermann Heilner of *Unterm Rad* (1906), or again as Harry Haller of *Der Steppenwolf*; but he is already the future ironic biographer of Josef Knecht, the serene mandarin historian of *Das Glasperlenspiel* (1943). The following interpretation of *Die Morgenlandfahrt* shows that the new irony of this work is one among many other qualities of the narrative which made it a turning-point in Hesse's work. Earlier themes and figures, it will be shown, were here assembled, recreated by integration within the new metaphor of the 'voyage', and thereby matured into the substance of Hesse's final geometric vision of things.

H.H. writes his first two chapters in retrospect upon the halcyon days of his voyage. His experiences, he explains, must remain mostly inexplicable, because he has no documents, and because the arcana of the society which made the voyage cannot be divulged (6, 11). [1] He quotes:

Die Unerfahrenheit, ich kann mir's denken,
Wird meinem Sange wenig Glauben schenken.

Hence, if you are 'unerfahren', have no experience of the voyage yourself, then what he, H.H., now says about it you will consider absurd. Yet this is anomalous, because it will soon be found that H.H. is convinced that he is the sole surviving voyager, that 'you' (i.e. 'der Leser', 11) means in a sense H.H. himself, for he can be the only understander of his work, and that this work is consequently a monologue, or, to use a title found in *Eine Stunde hinter Mitternacht* (1899), 'ein Gespräch mit dem Stummen'. The ramifications of the enclosure of H.H. in himself, in solitary monologue, soon become evident. The verses quoted are also of course in part a warning to readers who are unfamiliar

with Hesse's previous works, his earlier monologic records of his voyage. Above all, however, they are a key to the echoing tunnels of association in the work, to the overtones of earlier work which here reverberate, to the network of experience which the narrative most succinctly maps out.

In his retrospect upon the society of the voyagers, H.H. explains that the route taken cannot be described in spatial terms. He relates that the journey was different from the spatial journeys Keyserling and Ossendowski made. For this voyage went 'actually into the heroic and the magical'. It went moreover 'ins Reich einer kommenden Psychokratie' (10). Later Klingsor will be found among the voyagers, the hero of *Klingsors Letzter Sommer* (1919), who painted in his self-portrait the soul's realm not as an ordered place of cult and cultivation, but as an archaic chaos of formative energies. Since it is later recounted that the 'Orient' meant the 'unison of all times and all places' (24), it is clear that the psychocracy to come was to be composed of men who dare to penetrate chaos and hell in themselves, seeking, like Klingsor and Haller, the 'golden track' of a divine cosmos in the welter of living in time. It is now also observed that the voyage was a Pilgrimage of Fools. Each voyager was impelled by his own childish aim (12). H.H. was drawn into the quest by his dream of the love of Princess Fatme (13). This is surely Hermann Lauscher's 'Lulu', the magician's daughter who, in 'Iris' (1918), became Anselm's beloved, personification of the soul as divine mystery in immanence, 'a fragment', as Lauscher had speculated, 'of the manuscript of the old philosopher' (I, 157). Leo, the master-voyager, we learn, joined the pilgrimage to learn the language of birds from Solomon's Key (22 f.). Here too there are analogies in Hesse's earlier writings. There is the hawk-image in *Demian*: Sinclair is made to eat the hawk-image in a dream. In *Der Steppenwolf* Haller is made to eat duck by Hermine, who finally initiates him into the Magic Theatre; and just before this initiation he eats chicken for his dinner, then finally at the masquerade, in the midst of chaos, he finds that he has 'lost his number' (in Jung's psychology these events would be introversion-figures expressive of a fertilization of the psyche). The bird-figure is taken up again in the story 'Vogel' (in *Traumfährte*, 1932). Here Vogel is exuberant spontaneity, subject to no laws of space and time. In *Piktors Verwandlungen* (1923) and in 'Iris' likewise he is a magic bird. His movements in *Piktor* —'wippte mit dem Schwanz, zwinkerte mit dem Auge' [2] —

anticipate the later 'wie er mit dem flinken Schwänzchen auf und nieder wippend Triller schlug' of 'Vogel' (4, 552). Also in *Piktor*, Vogel's home is 'das Innre der Erde'; and this is the home which Anselm seeks in 'Iris': the psyche as fountainhead of generation and regeneration. Consequently the 'bird' guides Anselm to the path which leads him finally 'ins blaue Geheimnis des Innern' (3, 382). Anselm then will appear among the voyagers in *Die Morgenlandfahrt*; Leo the psychocrat will whistle like a bird; and H.H. will write, 'unser Morgenland war . . . die Heimat und Jugend der Seele, es war das Überall und Nirgends, war das Einswerden aller Zeiten' (24).

H.H. counts himself among the faithful ('Treugebliebene', 13) who have kept the spirit of the voyage alive, though the society has dispersed. At present he cannot know the ambiguous character of his idea of himself as one who has *stayed firm* ('treugeblieben') in his faith in the *voyage*. It will clarify his present state at once if we refer back to his pun on 'Unerfahrenheit', and forward to his account of this present state. He is, in fact, not voyaging, for he is sedentary, in a town, and his writing has taken 'months and weeks' (54). Thus, while writing, he is conscious of that very 'Zahl und Zeit' (15) which the voyage had aimed to transcend. He thinks himself the sole surviving voyager, yet knows himself to be imprisoned in number and time. He has not 'lost his number', as Harry Haller had to do before he could enter the 'Magic Theatre'. H.H., while he is writing, is then, just as Haller was, enclosed in despair by egotism, but struggling by writing to extricate himself from this enclosure, and to relive the ecstatic voyage, to re-enter the society. This capsized condition he will recognize only when Leo retrieves him later and when he is given to understand that it was he himself, in his illusory isolation and in his *superbia*, who erred in thinking of himself as one of the faithful.

These points shed light on another aspect of the voyage as this can be seen, still in the first chapter, through the eyes of H.H. He writes: 'Die ganze Weltgeschichte scheint mir oft nichts andres zu sein als ein Bilderbuch, das die heftigste und blindeste Sehnsucht der Menschen spiegelt: die Sehnsucht nach Vergessen' (12). He admits: only fragmentary memories of the voyage remain to him. Again the quandary of his self-righteousness is made clear: he is writing the history of the voyage; but history, he says, happens in time, is blindness, is the longing to forget. His very office of historian defeats his aims. Reflection upon

the past breaks the shape of the past: the outsider's vision dislocates its object. Although this corruption in selfconsciousness is not diagnosed until later in the book, it is plainly Hesse's intention to show this at this point; for in this first chapter a kindred situation is revealed in the account of the young man who, having renounced the voyage, is 'cursed' by the 'spokesman', and suffers immediate loss of memory (18-19). It will thus be found that what makes the voyage for H.H. a dim radiance in the past is his own *superbia* and his own egotism. This is what causes his history to be, as he later comes to see it, 'wie Tapeten mit anmutig sinnlosem Ornamentgewirke' (59). And as Hesse's earlier writings very often showed a coincidence of sentimental despair and ornamental language, so now will H. H. confess that he cannot recreate the essential and solid form of his experience. He writes in a state of 'Verzweiflung', which is induced by egotism, and it is 'Verzweiflung' which has cut him off from the society and the voyage. Such despair induces loss of memory and loss of conscious life. Incoherence ensues. But it should be remarked at once that this 'Verzweiflung' will ultimately prove to have been a phase of the voyage, a transitional duality in an unbreakable unity. Despair is the trial of the voyager. It is a necessary darkness, without which, as his friend Lukas will later show H.H., no 'voyage to the home of the light' (15) would be conceivable.

Chapter II tells of Leo's 'desertion' and its consequences. Writing when sedentary in his town, H.H. explains that only later did he see that this was not an accident, but a 'link in the chain of persecutions by which the arch-enemy sought to spoil our undertaking' (28). But H.H. is still capsized. Not until the fifth chapter does he realize not only that he was himself the deserter, but also that the arch-enemy ('Erbfeind') was no radical evil but a trial arranged by the society of the voyage. Leo's absence means loss of faith in the voyage as it provokes despair over oneself and drains everything of meaning (30). Leo 'abandons' the group in Morbio Inferiore, a fair name for any area of hell, and each voyager begins to think that he has lost some object of value. If the lost objects are recovered, still the *Bundesbrief* cannot be found. Then confusion comes, because nobody knows what is the nature of this document. H.H. is sure that it is the 'original', not a copy of the document, which is missing (32); and he is certain that Leo has taken it. Since this document was the original, the *fons et origo* of the society, this

society now lacks a centre. The *idea* of the voyage is not lost, H.H. states; but the society now has neither unity nor security. It is significant that H.H. had faith in his belief that Leo had the 'original'; for, in fact, the possibility of unity in the society remains until at last he loses his faith (33). At this point he translates his account of these events into terms of his personal problem as historian of the society: 'Wo ist eine Mitte der Ereignisse, ein Gemeinsames, etwas, worauf sie sich beziehen, und was sie zusammenhält?'

This is the desperate question asked by all Hesse's men in monologue since Peter Camenzind: it is the cry of the *déraciné*, the outsider, the self-seeker and the God-seeker. Now memory is dismembered, experience has no coherence. The historian H.H. is now in hell, for the organism of faith has disintegrated. He is the rootless ego as Haller was, and he sees himself as a mirror in which a bursting mass of images is reflected, himself being nothing, 'ein Nichts . . . die oberste Haut einer Glasfläche' (35). With Leo gone, the old unity of the society breaks. 'Verzweiflung' induces the awareness that 'I' is 'nothing'. Whence H.H. will write that 'our history' is now undermined with doubt (36); for it is clear that he now sees this history as 'deine Geschichte', meaning in the monologue his own history, the ego's history, which is here without coherence in despair. Therefore H.H. writes his chronicle in Halleresque solitude: 'ich stehe noch immer dem Chaos gegenüber' (36).

Chapter III opens with a glimpse of the truth which dawns upon H.H. in chapter V. He writes now that the voyage went towards the light, that it was an unbreakable procession through darkness. He is already partly aware that his desperate egotism is itself an aspect of the voyage: this ambivalence of the voyage, light in darkness moving towards light, will soon make itself known through H.II.'s darkness, when Leo emerges from a dark house. But first H.H. has to describe how he came to find Leo's address.

It is recalled that the *idea* of the voyage is now not in doubt. What H.H. doubts is himself. His problem, as a fragmentary isolated ego, is to conquer despair and recover unity of self by recovering his faith. He knows that it is necessary to get beyond the idea, whose 'grounds in the intellect' (37) have not the power of faith to unify the self which is 'verzweifelt'. As the idea of the voyage replaced the faith of the voyage when Leo vanished, so now the tenuous idea is insufficient for H.H. [3]

He now takes the first step towards the recovery of faith in a way which echoes Sinclair's experience in *Demian*: H.H. finds that his experience is shared by another person. His friend Lukas, who is for H.H. a light in the darkness as Lukas is the same as *lux*, tells him how he relived and reunited his scattered memories of the war by writing them down—which is just what H.H. has tried to do with his memories of the society. Lukas also tells H.H. exactly what he has already told himself: 'Vielleicht hat der Mensch nächst dem Hunger nach Erlebnis keinen stärkeren Hunger als den nach Vergessen' (40). Lukas describes how he wrote his memoirs in grisly monologue among his remembered dead, as H.H. is also writing his, as a means to conquering despair, and to save himself from suicide: 'es war die einzige Möglichkeit meiner Rettung vor dem Nichts' (40). H.H. is now ready to work on memory as a threshold of faith: 'durch meinen Dienst am Gedächtnis jener hohen Zeit mich selbst etwas zu reinigen und zu erlösen, mich wieder in Verbindung mit dem Bund zu bringen' (53).

The labour of despair now finds a simple reward: Lukas looks up Leo in the telephone directory. The number of his house is 69 a. The number is a unity, divisible, but divisible only by the number 3, which is itself indivisible. Thus 69 a symbolizes the voyage in despair as a moment of division within an unbreakable unity. The number 69 also remains 69 when stood on its head; and it is thus a symbolic number for the Heraclitan conception of the voyage, towards which H.H.'s mind in its monologue is working: 'the way up and the way down are one and the same': [4] faith and despair are both predicates of the process called 'voyage'. The letter *a* here would signify 'beginning'; and Leo has, or is, the 'original'. And the street where Leo lives is 'Seilergraben', the significance of which will become clear when Leo appears in chapter IV and H.H. notes that he is wearing canvas shoes with rope soles. [5]

Writing his last two chapters, not piecemeal as the first three, but at a single sitting, H.H. is no longer cut off from the society and the voyage. Chapter IV tells of his meeting with Leo two evenings before; and chapter V recounts the consequences of this meeting. He is now writing on the day after his readmission to the society. He says: 'ich weiss noch nicht, ist meine Sache . . . eigentlich gefördert worden order nicht'; and then: 'vorgestern abend ist mein Wunsch in Erfüllung gegangen. Oh, und wie ist er in Erfüllung gegangen!' (43). The mixed feelings with

which he ends his book show that he is not yet wholly delivered from despair; and, as his 'wish' was to meet Leo again (the mood at this meeting is by no means exultant), it is not to be supposed either that this wish was a triumphal re-entry into the society, or that its fulfilment implied a complete recovery of faith. It is the crowning irony of *Die Morgenlandfahrt* that its last words are here hidden, at the beginning of the penultimate chapter: 'ich weiss noch nicht, ist meine Sache . . . eigentlich gefördert worden oder nicht.'

H.H. stands outside Seilergraben 69 and hears someone whistling upstairs. These birdnotes ('Vogeltöne'), commonplace as they are, seem sweetness itself to him (44). An old man passes, with a sickly and sunken face, stops, listens, smiles to H.H., then passes on. Here there is an echo of *Kurgast* (1925), for H.H. listening to the whistler is the Hesse who asked there for a moment's ecstasy from his invalid body, and the old man who passes is the ageing Hesse of 1932. Thus in the monologue, the moment this 'old man' leaves H.H., the latter knows that this must be Leo the lithe psychocrat whistling, servant of the society, the master-voyager, the self who is fully alive and delivered from afflictions of 'Zahl und Zeit'. It is twilight, and the house is unlit. Leo walks out into the gathering darkness; and H.H. now recognizes him as the comrade of 'ten or more years ago', whistling, he is now sure, the music of the pilgrimage (45). He notes: Leo walks with an elastic gait, is wearing sandals or gym-shoes: yet he is 'abendlich'. This light gait, and this 'Abend-mensch' quality, are both characteristics of Hesse himself, as works diverse as *Knulp* and *Der Steppenwolf* show, and they appear now recreated in H.H.'s Halleresque monologue, as Hesse projects himself into the antinomies of H.H. and Leo. Leo is no bright-faced Max Demian. His face is not shown at all. But here he is characteristically the man in whom light and dark are entwined, himself a personification of the ambivalent voyage. So now, as H.H. follows Leo unobserved, streetlamps are lit, and the surrounding light increases (45). But under the trees in the park, where Leo halts, it is 'quite dark', except for Leo's bright grey eyes (46). This park lies near 'St Paul's Tor'. Here H.H. will now play the egoist, just as he does the next day when Leo enters the 'Pauluskirche' (66). The pun on the word 'Tor' here does not prove significant until, under trial, H.H. learns how ridiculous his 'novice's fooleries' have been, for this is what his errors will be called; then he will see how wrong was his irreverent

egotism in such proximity to the apostolic spirit, whether sym-bolized in the hidden Pauline sense of 'Tor', or personified in Leo as he later appears in papal regalia.

H.H. now sees that Leo is wearing canvas shoes with rope soles: there is now complete clarity of vision in the closed mo-nologue. Here is signified the encounter of the divided ('verzwei-felt') H.H. with the single-minded Leo: for Leo not only lives in 'Seilergraben', he also wears shoes with *rope* soles: there is con-sistency of where he *stays* with what he *moves* on. This in itself would succinctly represent the conjunction of the opposites: H.H. at odds with himself, and Leo at one with himself. But there are other possible implications in this rope-imagery; they may seem far-fetched, but such remote associations are not un-usual in Hesse. It may be that he is here associating Leo with the conception of the *Bhagavad Gita*, that the universe is a necklace *strung* with God. Whence Leo might be associated with the 'Inner Controller' of the *Brhadaranyaka Upanishad*, that 'thread who from within controls this and the other world and all beings'. Another possible implication is that idea which very often recurs in Hesse's work and which he expressed in a letter dated 1930: 'wir sind Fäden im Schleier' and 'wir werden gelebt'. [6] Again, Leo does now appear to be enacting Nietzsche's image in *Zarathustra*, an image which also underlay *Der Steppenwolf*: 'Der Mensch ist ein Seil, geknüpft zwischen Tier und Über-mensch,—ein Seil über einem Abgrunde'. [7] It is not necessary to bear these possible significations of the rope-imagery in mind, however, as long as Leo's capacity as 'Inner Controller' gradual-ly asserts itself in the narrative of H.H.'s monologue of its own accord, and as long as we recognize the emergence, at this stage in the metaphor of the voyage, of H.H.'s new conception of its meaning: namely the Taoist concept of *yu*, which is 'a spiritual not a bodily journey'. [8]

Leo seems not to recognize H.H. When H.H. says that he was a musician, but sold his violin, Leo remarks that this could only happen in despair, and that he is reminded of the story of Saul and David (47-8). H.H. does not recognize that Leo's words echo the story he has told already himself, of the young man who was cursed by the spokesman. For now, like Saul, H.H. lies under a curse, the curse of despair: he only hopes that Leo will deliver him, as David with his harp delivered Saul from the evil spirit (cf. 'Erbfeind', 29). On this level of the monologue, then, Leo and H.H. personify Hesse's faith and despair respectively.

Thus, when Leo gets up to go, he still does not recognize H.H., for the latter has still no faith in him: H.H. remains cursed, 'verzweifelt', as he expressly states (49). He is rejected by Leo, as he is rejected by the dog which Leo summons out of the darkness, because he has rejected Leo, and because he has no faith in him. He says he is too weary to 'stroll through the night', as Leo proposes. This fatigue springs from his fear of humiliation (51). But if the proud and desperate egotist goes home refusing humiliation, at home his despair rises to such a pitch that he writes to Leo his full confession (53). Once his despair has reached that depth at which it bursts through into penitence, engaging the whole self, Leo the next morning comes of his own will into the room where H.H. is sleeping. He is now ready to learn of the ambivalence of the spiritual journey, for he has traversed despair, and has got beyond the brittle realm of ideas. Yet, even at the end of the fourth chapter, H.H. is still thinking of the voyage as time past. In the fifth chapter, therefore, he must suffer an increase of self-knowledge. Before he can re-enter the realm of faith, he has to descend deeper into the shaft of his memory. Soon in his monologue he will look into the dark archive of his memory and find there the voyage as a perpetual process. He will look into the last recess, where Leo, the 'Inner Controller', and H.H. stand undivided, the one receiving fullness and form from the other.

It is the egotist H.H. who is awakened the next morning by Leo's entering his room: 'Man erinnerte sich meiner, man rief mich, man wollte mich anhören, mich vielleicht zur Rechenschaft ziehen . . . Ich war bereit . . . zu gehorchen' (54-5). Later called the 'egotism of impatience' (66), this mentality clings to H.H. as Leo guides him to the headquarters of the society. He is kept waiting when Leo goes to pray in the Pauluskirche, the route they take seems unnecessarily devious, for, he says: 'alles stand für mich auf dem Spiel, mein ganzes künftiges Leben würde sich entscheiden, mein ganzes gewesenes Leben würde jetzt seinen Sinn erhalten oder vollends verlieren' (55). This agitated self-concern persists when they enter the society's buildings: they see Klingsor at work but, H.H. writes: 'ich wagte ihn nicht zu begrüssen, dazu war noch nicht die Zeit, ich war erwartet, ich war vorgeladen' (56). The spirit of selflessness, however, which rules the society, is evident the moment Leo and H.H. arrive on the top floor: 'Niemand kümmerte sich um uns, alles war lautlos beschäftigt' (56). It is recalled that Leo, when

H.H. found him, was living at the top of a house (his whistling came from an upstairs window). In his case it might appear that the top of a building represents, in the monologue, a residence of 'higher powers', just as in this present case of the headquarters of the society. In Leo's case, it is the power of joy, elasticity, ecstasy; in the second case, it is the power of judgement, particularly of self-judgement. The meaning is found earlier also in Hesse, namely in 'Kinderseele': 'Unten in unsrer Wohnung waren Mutter und Kind zu Hause, dort wehte harmlose Luft; hier oben wohnten Macht und Geist, hier waren Gericht und Tempel und das Reich des Vaters' (3, 437). So now, as H.H. realizes that he is in the registry of the universe, as Leo sings, as the vast silent archive dissolves and becomes a hall of judgement, as Leo vanishes, H.H. is left in solitude to face his judges, and he is called a 'self-accuser' (57). [9]

The purpose of the trial which now ensues is to show H.H. the vanity of egotism. He is allowed to continue writing his history of the society, and given access to the archives; but when he finds his own manuscript there he is utterly dismayed, for in it the fragmentary ego stands revealed as inadequate to its task; in the imagery of erasure, correction and meaningless ornament he finds how wrong he has been. But now at least he is able to refer to the 'original', to the *Bundesbrief*, because, in the monologue, his egotism is undergoing purgation and is in decline. He finds the document in the 'Chrysostom File, Cycle V, Strophe 39, 8'. But the script is unintelligible as was Sinclair's dream of incest in *Demian*, and Haller's neon-sign between the church and the clinic in *Der Steppenwolf*: in all three cases the inability to grasp the meaning of the 'original' in memory, or in the imagery which the protagonist projects upon the cavern wall of his monologue, is due to insufficient self-knowledge. Thus now H.H. will accuse himself afresh, of having tried to write the history of the society while he remained in ignorance of himself: 'mich selber nicht begreifend' (62). Only by self-judgement then can he arrive in the monologue at the recognition that it is his 'Verzweiflung' which has separated him from his 'Inner Controller' by splitting his individuality. Only now in the monologue can he humbly hear Leo pronounce forgiveness for his sins: and Leo now appears to him in papal regalia, which recalls his role as servant, since 'Servant of the servants of God' has been a papal title since Gregory the Great. Leo explains that H.H. is still in the midst of despair (68), but that this despair must be overcome

if the soul is to be 'awakened' (68). And here one recalls Leo's reference to the story of Saul and David, and that the 'evil spirit', which afflicted Saul, was 'from God' (1 Sam. 16:23).

From Leo's words it may now be deduced how the *Bundesbrief* came to be in the Chrysostom File. We may now even translate 'Zyklus V, Strophe 39, 8' into '*Gesammelte Dichtungen*, V, 308': for it is here in *Narziss und Goldmund* that Narziss realizes that Goldmund has traversed hell without losing sight of God. In the terms of *Die Morgenlandfahrt*: it is possible and necessary to traverse despair ('Verzweiflung') without losing faith in the society ('Bund'). Implicit here is H.H.'s understanding this. It is the principle of the monologic form that all events in the narrative are events in the psyche of the protagonist. Thus H.H. looks for the original *Bundesbrief*, the document of unity and faith, in the Chrysostom File, his self-projecting author, Hermann Hesse, having deliberately put it there.

The burning of the papers which now follows consequently signifies H.H.'s readiness at this stage to look through the forms of purgatory into the realities they contain. The forms here, as they were to Anselm in 'Iris', and as they were to Haller in *Der Steppenwolf* up to the moment when he took the image for the reality, are the envelopes of essences, not the essences themselves. H.H. announces that he is prepared to 'ask the archive about himself'. Now begins his last 'Blick ins Chaos', the last stage of this quest of his identity. So he recognizes the chaos implicit in the three unreconcilable accounts of Leo's desertion in Morbio; and then he approaches a dark recess in the 'Hesse Archive' ('Chattorum res gestae'). He descends, as once Sinclair had done, into his ancestral memory.

Here he finds an image: it is a double figure with a single back, 'eine alt und mitgenommen aussehende Plastik aus Holz oder Wachs, mit blassen Farben, eine Art Götze oder barbarisches Idol' (75). From what he has read in Leo's archive, the formula 'Archiepisc.XIX.Diacon.D.VII.*cornu Ammon*.6' (my italics), we should already be prepared here for a final representation of the spiritual continuum of the voyage, its primitive and pre-Christian content, as well as its function in a Christian civilization. The image which H.H. now discerns is indeed this final representation. He lights a candle, and he sees that the image is, on the one hand, an image of corruption and transience, while on the other hand it is firmly coloured and formed as far as concerns the 'other figure' (75). This 'other figure' he recognizes

as Leo. He lights a second candle and sees that the surface of the double figure is transparent, and that there is a gradual process of transubstantiation from the one figure into the other. It is recalled that he had earlier written of his 'Ich' as 'die oberste Haut einer Glasfläche' (35). But now this image is transformed in the light of his new knowledge. This same 'Ich' is no longer sheer fragile surface reflecting dismembered illusions; it is a transparent envelope of the Janus-like unity of the double figure: the unity of the ego and the *imago* of the 'Inner Controller'. The connection between the two aspects of the figure, it might be added, recalls the process of individuation which Hesse has elsewhere called 'Seelengestaltung'. H.H. thus now sees, 'dass mein Bild im Begriffe war, sich mehr und mehr an Leo hinzugeben und zu verströmen, ihn zu nähren und zu stärken . . . Er musste wachsen, ich musste abnehmen' (76). Trying to understand this process, H.H. recalls an earlier saying of Leo's, that poets transfuse their life into their creations as mothers transfuse theirs into their unborn children. By this is meant, in other terms, that despair may have its place as a fructifying force, however humble and insecure, in the hierarchy of faith. The image would thus endorse Nietzsche's axiom: 'Ein höheres Wesen, als wir selber sind, zu schaffen ist *unser* Wesen. Über uns hinaus schaffen!' [10]

H.H. then goes to find a place where he can sleep. Thus he ends his fifth chapter as he ended his fourth, in sleep, so indicating that the desperate insomnia of unremitting and sterile reflection, from which Haller suffered, is at least for the present ended, even if his fate must remain for the time being undecided. For, he has already concluded, 'ich weiss noch nicht, ist meine Sache dadurch eigentlich gefördert worden oder nicht.'

In the foregoing analysis I have tried to show how, in *Die Morgenlandfahrt*, Hesse was recreating themes and figures out of his earlier writings into a concise verbal representation of the essentials of his own mental history. To achieve this end, he used a form of symbologistic monologue (a form whose scope he had already begun to explore in *Demian*, and which he had developed extensively for *Der Steppenwolf*), and he used a metaphor (that of the voyage) to substantialize the rarest regions of his thought. [11] In a letter dated 1935 he called the book an articulation of faith. [12] But his narrative exhibits also an enaction of that conflict between faith and unfaith which Goethe judged to be the crucial theme of history. [13] This faith is not

merely that of a literary man in search of a religion. The special, symbologistic form of monologue shows that *Die Morgenlandfahrt* was Hesse's *anima poetae* in a stricter sense; and it is clear that this faith means an unshakeable awareness of relations existing between the whole being of the individual and the holy. Thus in a letter of 1932 Hesse discourses on what he calls 'das Heilige' in his book, meaning by this 'the possibility of human society and its real meaning'. [14] Though he treated of these relations here only within the scope of an imagined hierarchy of human beings, the 'Bund', Hesse does by implication articulate a faith in an inner coherence among human beings of all sorts. He does this by showing for ordinary things or events corresponding psychic events, the correspondences being established in the monologic form. For the world of this monologue is as it is manifest in the psyche. All that the narrative exhibits is at once psychic and phenomenal. The conflict of which the book tells thus concerns the desperations of solipsism, and the struggle to arrive at authentic vision by cleansing the gates of perception. It is the struggle to arrive at the substantial and sacred grounds of being. In Hesse's later writing, as in Rilke's, all things do seem to turn upon an awareness of an order in things devolving from their sacred centre, which is called 'invisible'. Leo thus has this in common with the Angel of the *Duineser Elegien*, that he stands for his creator's awareness of a relation with this 'invisible'. So is Hesse's H.H. lost in rootlessness the moment he 'clings to the visible', as Rilke has it in the letter to von Hulewicz. And as Rilke knew the 'terror' of the Angel, so has Hesse known the tempter 'despair' which besets the creative imagination in an age of unbelief. The monologic form of *Die Morgenlandfahrt* was appropriate, for the book was Hesse's final exploration of the world of despair. *Das Glasperlenspiel*, in which Leo is transformed into Josef Knecht, was to be a book of faith in the invisible. Thus Hesse wrote at the head of *Das Glasperlenspiel*:

nichts entzieht sich der Darstellung durch Worte so sehr und nichts ist doch notwendiger, den Menschen vor Augen zu stellen, als gewisse Dinge, deren Existenz weder beweisbar noch wahrscheinlich ist, welche aber eben dadurch, dass fromme und gewissenhafte Menschen sie gewissermassen als seiende Dinge behandeln, dem Sein und der Möglichkeit des Geborenwerdens um einen Schritt näher geführt werden.

THOMAS MANN'S LETTERS TO
PAUL AMANN AND KARL KERÉNYI

THOMAS MANN may well have revealed more of his personality more informally in other letters than those written to Paul Amann and Karl Kerényi; in his letters to these two scholars there is little for readers who enjoy the letters of poets for their warmth and colour alone. He does not observe the sparrow outside his window and pick about the gravel; he does not glance inward into the mysterious pulsations of the intuitive life of the mind; nor is he the rustic engineer of a new style, helping and swotting and hitting out: no—there is nothing in Mann's letters here to link him with such prodigals of liveliness as Keats, Mörike or Pound. His mind is riveted on his work. He addresses his correspondents not as selves but as intellects. They, in turn, address him as the admired author and function as willing stimuli: Amann more as a goad, Professor Kerényi more as a rather foxy library attendant, feeding the great man with hunks of lore.

The letters to Paul Amann, forty-eight of them, including postcards, are dated between 1915 and 1952. But the majority, letters 1-30, cover the period 1915-18, when Mann was writing his *Reflections of a Non-Political Man*. It is this period which produced the important letters; and this collection, with its excellent apparatus by Herr Herbert Wegener, will be valuable both to source-hunters and for critics who are interested not only in Mann's political and literary attitudes during the First World War but also in the tortured shiftings of his mind which underlay them.

Amann, nine years younger than Mann, was fighting for much of this time, while Mann himself, if one can credit the allusion in *The Tables of the Law*, stood like Moses with raised arms at home on his hill of prayer. Amann was, moreover, in the radical camp, sharing with Mann a great love of France, but believing, unlike Mann, that no new ideas could come out of Germany, that progress lay with the radicals whom Mann viewed with distaste as 'political literati', standing for what he later styled 'Communist' attitudes. It cannot be doubted that Amann's letters, or perhaps even more the personality in them (which emerges vigorously in the one letter from him dated 1915, included in the book), caused Mann to rethink his first thoughts, obstinate as he was, and to view his effort finally, as he put it in the now reprinted *Sketch of My Life* (1930), as a 'last retreat action of a

romantic *bourgeoisie* in the face of the triumphant "new" '.

Yet the problems which enter his letters are not wholly political or historical ones. There are revealing allusions here to his fiction, to *Death in Venice* and *The Magic Mountain* (begun in 1912). Moreover, there are as ever the symptoms of Mann's constitutional self-division, which insinuates itself into so much of his thought: a self-division wrought to full pitch in the argument between Settembrini and Naphta in *The Magic Mountain*, and later in the relationship between Zeitblom and Leverkühn in *Doktor Faustus*.

There might seem to be little to connect the letters to Amann with the Kerényi correspondence; but a connection exists and it shows how consistent Mann's thinking could be, in spite of his self-division and all those contradictions which made him conform to the type of the hero of the idea. The connection is evident when one observes his prepossessions during the years after 1918, when the 'Communist' camp in Germany had already been split into ultra-left and Fascist reaction. In his essay *Goethe and Tolstoy* (1922), he ponders 'whether this Mediterranean, classic, humanistic tradition is commensurate with humanity and thus coeval with it, or whether it is only the intellectual expression and apanage of the bourgeois liberal epoch and destined to perish with its passing.' This is not only the major question in *The Magic Mountain*; it is also the threshold to Mann's third creative phase: the phase in which myth provided the orientation, in an attempt to recover, or to re-create, an image of humanity that should be commensurate and coeval with its own inner psychic antiquity, myth being the 'timeless schema, the pious formula into which life flows when it reproduces its traits out of the unconscious'—as he later wrote in his Freud address (1936). The Kerényi correspondence covers almost the whole of this period, the period beginning with the Joseph novels, in which Mann was exploring these possibilities and thus obliquely dealing once more with the phenomenon of bourgeois society, and it ends only with Mann's death in 1955.

Altogether there are fifty-seven letters by Mann and forty-six by Professor Kerényi. Only the letters written between February 1945 and June 1955 are new. Those written between January 1934 and early February 1945 were published in 1945 under the title *Romandichtung und Mythologie*. However, two more letters of this first period have been added, both by Professor Kerényi, dated 1939 and 1944, and numbered 14 and 16

respectively (the numbering goes wrong after letter 8, since there is no letter numbered 9, and the letter numbered 10 was number 9 in the 1945 edition). Also certain excisions in the 1945 edition have been replaced, in some cases to an important extent. The fourth, fifth and seventh letters from Professor Kerényi have a total of thirty-nine lines replaced; letters 20 and 23 from Mann are also now complete, forty-one lines being replaced in letter 20, dated 2.8.39. The five lines replaced in letter 23 will also please truffle-hunters; in them Mann shows that, as late as 1941, he envisaged resuming relations with his Budapest publisher; doubtless this might have compromised him politically in 1945.

These letters are, again, a mine of information for the seekers of sources, since they touch on so many of the later novels, not excluding *Felix Krull*. Professor Kerényi provided Mann with most of his publications and he repeatedly inquired of Mann his views on particular images and mythologems. He is not a Zeitblom, but he does like to think that he contributed to the build-up of this persona, under which Mann voiced, as he so laconically puts it in his letter 25, 'infinite devotion to the cold demon' (i.e. Leverkühn).

One tires pretty quickly of the mutual brain-picking which marks most of the 1934-41 letters. But one does not tire of Mann's flow of information regarding his mythic materials, even though he does not once unlatch those chambers of his mind in which his unique assimilative processes were enacted. Though in the second period these letters are, on Professor Kerényi's part at least, aimed at a definition of modern humanism—as classical and mythological studies—in the context of modern society and education, they also reveal a concern first with what myth is, and secondly with the relation between myth and fiction in Mann's last novels.

It is Professor Kerényi who handles (also in his introduction) the first point. His views on myth have not been very well received in this country, except by Mr J. C. Powys and Professor W. K. C. Guthrie. Quite apart from his scholarship, these letters show him maturing as a person and as an intellect, rather more through his own sufferings than through contact with the rather detached master. It is the master, as much by his silences as by his statements, who leads into the second point: the relationship between myth and the novel (a relationship which Professor Kerényi seldom fully appreciates, because his delight in mythological

correspondences as such often overrules his critical judgement in literary matters).

This complete correspondence appears at a proper moment, even at a crucial juncture, Professor Kerényi might be tempted to say, in what he calls 'the autonomous movement of the mythic material'. For it comes at a time when the mythic novel, as diversely created by Joyce, Mann and Hermann Broch, seems to be becoming superseded by a form of novel which could be styled anti-mythic.

Hermann Broch defined the focus of the modern mythic novelist clearly enough in his 1945 essay *Die mythische Erbschaft der Dichtung*. Myth, he supposed, provided a synoptic view of experience such as could not be obtained by observation alone; myth illuminated the 'darkly anonymous' regions of the human mind, the inscrutable fluid of human behaviour; mythic novels came into being at periods of dislocation, like the present, which called for a new coherence. To Mann, of course, the creative use of mythic material was also a challenge to the irrationalism undermining the German intelligence of the period 1918-33: the mythic novelist had to wrest the mythic substance from the distortions to which Fascism subjected it.

He understood also that the 'synoptics' of myth could never be authentic without assent to the inexorable force of present moments in life as it is lived. But, like Joyce and Broch, he manipulated myth from an Archimedean point in the attempt to behold things in their immediacy and in their cosmic orientation and to arrive at an affirmative grasp of the perennial relationships between things. Assent to the mythic order was a confession of mankind's *misère*—the hitching of the wagon to the myth's star—and at the same time it was a way of suggesting the contrary, the *gloire*.

Yet Mann's mythic novels hinge again upon his old self-division: the rift between acting a part and being a self. This division does not exist in his mythic world, for here all is relation, symptomatic of which is the 'sacred repetition' whereby ancestral conduct reanimates the ancestor in the present moment. Mann followed this process of mythic identification in the behaviour of ancient characters, like Joseph, attributing it, in the Kerényi letters as elsewhere, to the unfixity of ancient man's ego, and to his being more finely geared, as a conscious being, to his unconscious mind. But there is a histrionic streak in Mann's telling of the Joseph novels, a streak which is so strong that one

feels the famous irony to be a means—an extremely sophisticated means—of banishing the histrionic interference: the interference, *mutatis mutandis*, between acting a part and being a self.

However skilfully he composes and superimposes mythic images, drawing on his formidable store of assimilated learning, and with his hypersensitive nose for correspondences, Mann uses irony not infrequently as a Procrustes bed, upon which the values of myth are decimated. It might well be asked: did he not make good bourgeois of his mythic figures, much as he confessedly made a good bourgeois, in earlier days, of Nietzsche? This question is raised often enough; but here it relates particularly to the problem mentioned above—the one that Mann confronts in his essay on Goethe and Tolstoy. Probably it is to the obliquely mythic novels—*Doktor Faustus* and *Felix Krull*—that one must turn for criteria of Mann's authentic grasp as a re-teller of myth. Here, certainly, it is far more a question of actual creation than a question of recall; and it is at root this creation which the mythic substance, with its predilection for present moments and hairline distinctions, seems to foster more maternally.

The ironic decimation has had a strong aesthetic appeal; and it remains to be seen how far this is the appeal of a durable because adequate vehicle. It is certainly challenged, however, by the anti-mythic novel. For the anti-mythic novel casts doubt on the justice that Mann's particular mode of mythological gaze does to the amorphous and manifold realm of present experience and to the actual lives men live. The anti-mythic novelist (who is neither the observational or non-mythic novelist, nor the novelist of ideas) does not assent to any Archimedean vantage-point; he does not make the mythic novelist's *petitio principii*, and so he cannot plant his world of observation, such as it is, in the soil of myth—as was found practical in the economy of the writers of Mann's generation.

Instead of the humane use of myth as a source for a deep synoptic view of the psyche in its synchronicity and power, the anti-mythic novelist (Beckett, for instance) gets depth by analysing the psyche as it writhes, from moment to moment, in its decrepitude and impotence. If the psyche is the object here at all, it is a psyche from which the formative mythic substance has been drained away. Alternatively, he uses an exclusively *descriptive* technique, as does M. Robbe-Grillet, and so again asserts his anti-mythic will, for the mythic novelist is pre-eminently engaged in the contrary task, which is radical to myth: the task of

telling. Here, too, the focus of the anti-mythic novelist is the discontinuum of particular present moments; it is no longer the myth as a perennial order which embraces, fills and informs the whole structure of human experience.

For the mythic novelist the world of observable events fluctuates according to the pull and thrust of the mythic imponderables; but for the anti-mythic novelist, the isolation of things and of present moments has the effect of making the observable itself that which is exclusively real and entirely imponderable. This paralysing disorientation can also assume another form, and actually does so in a recent first novel by the German poet Erich Fried, *Ein Soldat und ein Mädchen*. Here there are profound insights into the psychology of stress, fortified by Herr Fried's masterfully varied and invariably sharp language, as well as by his unusually vivid and retentive power of recall. But this is psychology which does not penetrate into myth. There are only splinters of mythic material and embryo-images of a possible coherence of self within the mythic structure. No mythic structure is evolved, and only at one point is there a trial of assent to a traditional body of lore about mankind—though it is just such a body that might resolve into an intelligible unity the deep psychic dislocation which the novelist is exploring here.

Herr Fried's novel was published almost simultaneously with the Mann-Kerényi letters; and it illuminates in several ways the present shift of accent, from mythic to anti-mythic, which surely also underlies Professor Kerényi's doubtings in his introduction, as well as the title he has given to the section of later letters: *Humanismus* (meaning quest of myth)—*schweres Glück* ('a hard joy'). This novel illuminates the situation, moreover, in a disturbing way. For its confession of mankind's *misère* takes the form of a challenge to the prevailing deep-seated apathy of spirit: an apathy that is far from hitching the wagon to any myth's star, and is only too near to relinquishing the reins to demons glad of the chance to steer it into the pit.

Thomas Mann, *Letters to Paul Amann, 1915-1952*, ed. Herbert Wegener, translated Richard and Clara Winston. *A Sketch of My Life*, translated H. T. Lowe-Porter, London, Secker & Warburg.
Thomas Mann and Karl Kerényi, *Gespräch in Briefen*, Zürich, Rhein-Verlag.

TWO MOUNTAIN SCENES IN NOVALIS AND
THE QUESTION OF SYMBOLIC STYLE

1 Die ganze Gegend ward nun sichtbar, und der Widerschein der Figuren, das Getümmel der Spiesse, der Schwerter, der Schilder, und der Helme, die sich nach hier und da erscheinenden Kronen, von allen Seiten neigten, und endlich wie diese verschwanden, und einem schlichten, grünen Kranze Platz machten, um diesen her einen weiten Kreis schlossen: alles dies spiegelte sich in dem starren Meere, das den Berg umgab, auf dem die Stadt lag, und auch der ferne hohe Berggürtel, der sich rund um das Meer herzog, ward bis in die Mitte mit einem milden Abglanz überzogen. Man konnte nichts deutlich unterscheiden; doch hörte man ein wunderliches Getöse herüber, wie aus einer fernen ungeheuren Werkstatt. (Novalis, *Heinrich von Ofterdingen, c.* 1798-1801, Chapter 9)

2 Es kam ihm vor, als ginge er in einem dunkeln Walde allein. Nur selten schimmerte der Tag durch das grüne Netz. Bald kam er vor eine Felsenschlucht, die bergan stieg. Er musste über bemooste Steine klettern, die ein ehemaliger Strom herunter gerissen hatte. Je höher er kam, desto lichter wurde der Wald. Endlich gelangte er zu einer klèinen Wiese, die am Hange des Berges lag. Hinter der Wiese erhob sich eine hohe Klippe, an deren Fuss er eine Öffnung erblickte, die der Anfang eines in den Felsen gehauenen Ganges zu sein schien. Der Gang führte ihn gemächlich eine Zeitlang eben fort, bis zu einer grossen Weitung, aus der ihm schon von fern ein helles Licht entgegen glänzte. Wie er hineintrat, ward er einen mächtigen Strahl gewahr, der wie aus einem Springquell bis an die Decke des Gewölbes stieg, und oben in unzählig Funken zerstäubte, die sich unten in einem grossen Becken sammelten; der Strahl glänzte wie entzündetes Gold; nicht das mindeste Geräusch war zu hören, eine heilige Stille umgab das herrliche Schauspiel. Er näherte sich dem Becken, das mit unendlichen Farben wogte und zitterte ... Ein unwiderstehliches Verlangen ergriff ihn sich zu baden, er entkleidete sich und stieg in das Becken ... Die Flut schien eine Auflösung reizender Mädchen, die an dem Jünglinge sich augenblicklich verkörperten ... (Heinrich falls asleep in his dream and later wakes up) . . . Er fand sich auf einem weichen Rasen am Rande einer Quelle, die in die Luft hinausquoll und sich darin zu verzehren schien. Dunkelblaue Felsen mit bunten Adern erhoben sich in einiger Entfernung; das Tageslicht, das ihn umgab, war heller und milder

als das gewöhnliche, der Himmel war schwarzblau und völlig rein. Was ihn aber mit voller Macht anzog, war eine hohe lichtblaue Blume, die zunächst an der Quelle stand, und ihn mit ihren breiten, glänzenden Blättern berührte. Rund um sie her standen unzählig Blumen von allen Farben, und der köstlichste Geruch erfüllte die Luft. Er sah nichts als die Blume, und betrachtete sie lange mit unnennbarer Zärtlichkeit. Endlich wollte er sich ihr nähern, als sie auf einmal sich zu bewegen und zu verändern anfing; die Blätter wurden glänzender und schmiegten sich an den wachsenden Stengel, die Blume neigte sich nach ihm zu, und die Blütenblätter zeigten einen blauen ausgebreiteten Kragen, in welchem ein zartes Gesicht schwebte. Sein süsses Staunen wuchs mit der sonderbaren Verwandlung, als ihn plötzlich die Stimme seiner Mutter weckte, und er sich in der elterlichen Stube fand, die schon die Morgensonne vergoldete. (Novalis, *Heinrich von Ofterdingen*, Chapter 1)

1.

One of the more notorious German symbolic texts is the 'Märchen' narrated by the poet Klingsohr in Novalis' unfinished novel *Heinrich von Ofterdingen* (*c*. 1798-1801). When this 'Märchen' was written profound changes were affecting German ideas about poetic symbolism. Novalis himself speculated that language could be made to function as a nonreferential sign-system, like music or mathematics, with the 'Märchen' as its principal literary form. He envisaged this 'higher language'—*Sprache in zweiter Potenz*—as being so far removed from ordinary language that it would be autonomous, an *absolute Kombinatorik*, developed as a poetic corollary to Fichte's *absolutes Denken*. (1)

In Klingsohr's 'Märchen', the *absolute Kombinatorik* does not take effect in the linguistic structure but, if anywhere, in the order of the events narrated. The language is not structurally changed: what it does is to articulate fabulous rather than feasible events, much as Goethe's *Das Märchen* of 1795 had done, though without the ingenuous clairvoyance of actual folk tale. To some minds, the text yields a coherent, if kaleidoscopic, narrative about the coming of a Golden Age. The symbolism pointing this chiliastic way involves some rather arbitrary fusions of stock images and motifs from Greek and Germanic mythology. But it contains also some images which control the play with motifs and make the narrative look at points less like a churning than a patterned confluence of mythic materials. My intention is to

trace the lineage of one of these images back into antique roots, indicating what conventions make the image symbolic. I shall then examine the lineage of another aspect of the same image occurring elsewhere in *Heinrich von Ofterdingen*, with a view to making some suggestions about symbolic style in general.

2.

The first phase of Klingsohr's 'Märchen' opens in a kind of cosmic city which is perched on a mountaintop. Slowly a reddish light, turning to milky blue, begins to flood the city. The streets become visible; throngs of spears, swords, shields, helmets and crowns appear. Then these make room for a simple green garland, around which they form a circle. All this (I now translate) 'was reflected in the frozen sea which surrounded the mountain on which the city lay; and also the distant high range of mountains which encircled the sea was covered to the centre with a mild reflected radiance' (*mit einem milden Abglanz*). This paragraph then ends with more description of the city, its sounds, the symmetry of its buildings, the flowers of ice and snow in clay pots by all the windows. I do not know how much significance should be attached to the detail about the events in the city being reflected in the frozen sea. But this detail does introduce the cosmorama of central mountain, encircling sea, and distant ring of mountains, almost as if it were by afterthought, even with some carelessness in the visual presentation. The cosmorama seems to flash into the paragraph as an incidental detail. Yet it is here that crucial events are to occur; and the cosmorama is ancient. Its original could be the description of Atlantis in Plato's *Timaeus*. But Plato's Atlantis is related in turn to older types of mountain scene. In these older types, too, a structure of concentricity inheres. This appears in the Novalis detail first as the garland with the ring of armoury around it, then more significantly in the sea around the central mountain and in the ring of mountains around that sea: like a wheel whose axle is the central mountain on which the city of Arctur stands.

The Novalis detail begins to look like a palimpsest on which recessed versions of a symbolism of the cosmic centre can be discerned. Does the Novalis context allow this to be immediately inferred? Yes, but less from the topography given at this point than from a property of the mountain which is soon accented: its being magnetic. We may not find the topography immediately expressive without support from the context because we are

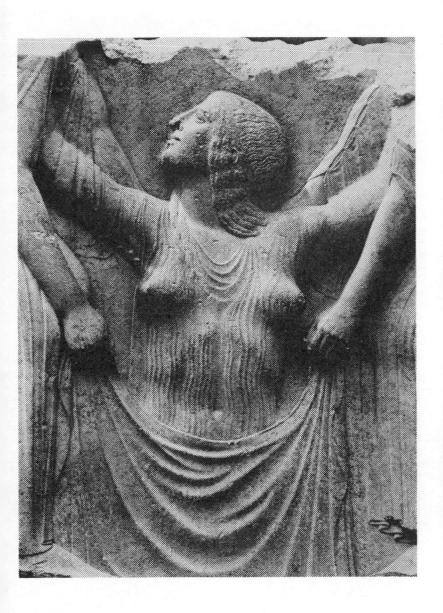

1. Detail, centre, Ludovici Throne, 'Birth of Aphrodite', *c*. 460 B.C. Museo del Terme, Rome. Photo Jeannine Le Brun.

2. *Multiplication*, from S. Michelspacher, *Cabala, Spiegel der Kunst und Natur: In Alchymia* (1616). British Museum.

3. *Conjunction*, source as for 2.

4. The 'Twelfth Figure', from Lambspring, *Ein herrlicher teutscher Traktat vom philosophischen Steine* (1625). British Museum.

5. Sargonid seal (*c*. 2500 B.C.), showing Shamash (sun god) rising from mountains. Frankfort, Plate xix a.

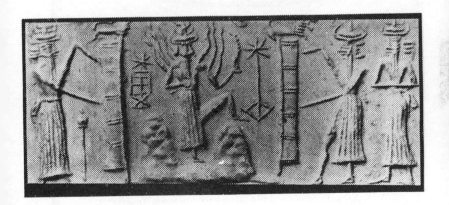

6. Sargonid seal (*c*. 2500 B.C.), showing Shamash (sun god) between mountain peaks. Frankfort, Plate xviii a.

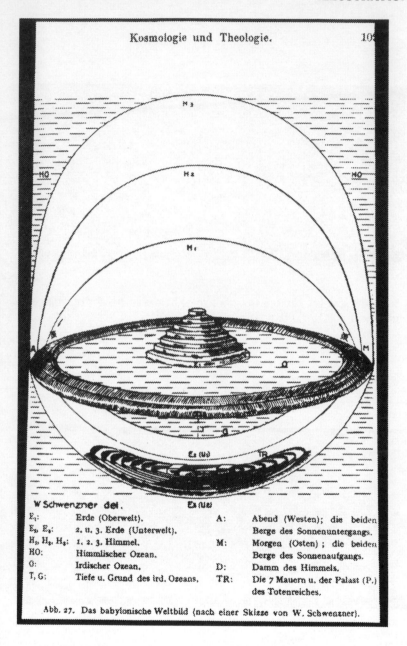

7. Babylonian World-Picture, diagram from B. Meissner, *Babylonien und Assyrien*, Bd. 2.

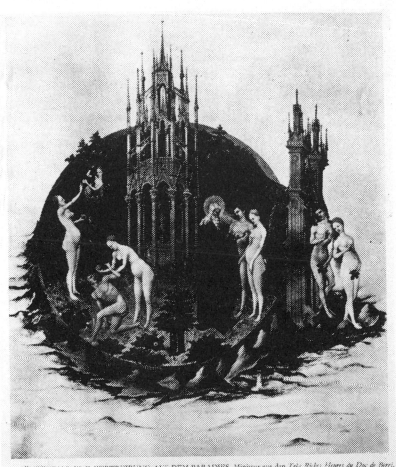

8. Expulsion from Paradise, from the *Très Riches Heures du Duc de Berri*. Musée Condé, Chantilly..

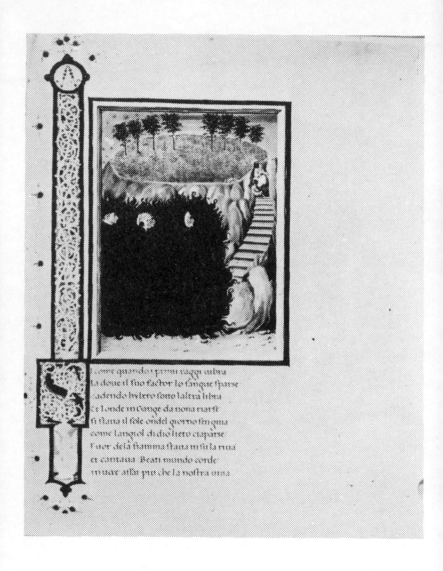

9. Mountain of Purgatory, illustration (fifteenth-century) to Dante, *Purgatorio* xxvii. Vatican.

dead to its meaningful convention, or because it is an apparent marginal detail. If the second reason is the more obvious one, this could be accounted for by the fact that Novalis was writing before realism entered German fiction and so he could still confidently annex notions and motifs external to a literary work itself without compulsion to establish them concretely in the work: indication was enough, full realization was not necessary. His cosmorama here is not one detail in a symbolism that is contained in its context and analytic in its function, like Kafka's, for instance, in *Das Schloss*, where the topography is not dissimilar, for there, while the Castle hill and the village straggling around it constitute a single labyrinth, the village main street forms at least an indefinitely extended arc, if not a perimeter circling the central enigma of the hilltop castle. Into Novalis' time there had even survived the tendency of later romances to turn symbolic motifs into sketchy stage properties. All the more telling, therefore, is the syntactical arrangement which inserts his mountain cosmorama into full view here: the unemphatic and succinct phrasing suggests at least that here we are not in the presence of mere stage properties.

Now in the *Timaeus*, Atlantis is a mountainous island belonging to Poseidon. Poseidon, for amorous reasons, enclosed the mountain near the central plain with three concentric rings of sea and two concentric rings of land. Later, an acropolis was built on the island, three kinds of stone being used: white, black and red. (2) The outer wall was coated with brass, the middle one with tin, and the wall of the acropolis itself with orichalcum, 'glancing red like fire' (these metallurgic details are varied in Klingsohr's 'Märchen'). This city, standing on an oblong plain, was surrounded by an enormous fosse, and, further off, by mountains. Was this plain a high mountain plateau? The text does not say this in so many words; but the other details imply that this was the case. Plato made of this material a political fable; but the material itself comes from oriental sources, in which the same structure of concentricity appears. There are four main sources, from any one of which the material might have come: the Indian holy mountain Meru, and the worldpictures of Sumer, Babylon and Iran. All these fabulous or nearfabulous cosmic topographies involve mountains. The Iranian one stood immediately behind the view, current in Germanic legend and in medieval Vision literature, that the Terrestrial Paradise, or alternatively a divine city, was on a mountaintop.

Possibly Novalis would have known, or at least heard of, certain subsequent modified versions of the antique world-pictures. Their survival into his time was due in part to engravings in alchemy books, like S. Michelspacher's *Cabala, Spiegel der Kunst und Natur: in Alchymia* (Augsburg: 1616), or Libavius' *Alchymia* (1606); or Lambspring's *Ein herrlicher teutscher Traktat vom philosophischen Steine* (1625; Plates 2-4). Novalis is known to have studied such books. It is important that his cosmorama retains the ancient structure of concentricity; this had been lost in most medieval legends, Visions and romances, and it does not (as far as I have been able to find) survive in any alchemical engravings.

The mythic geography of Meru, 'central peak of the world, the main pin of the universe, the vertical axis', (3) of which the Chinese had two counterparts, Kw'en Lun and T'ai Chan, is described by Coomaraswamy as follows: (4)

> There are seven island continents surrounded by seven seas. Jambudwīpa (the world) is the innermost of these; in the centre of this continent rises the golden mountain Meru, rising 84,000 leagues above the earth. Around the foot of Meru are the boundary mountains of the earth, of which Himalaya lies to the south . . . Meru is buttressed by four other mountains, each 10,000 leagues in height . . . On the summit of Meru is the city of Brahma, extending 14,000 leagues, renowned in Heaven . . . Above the city of Brahma flows the Ganges, encircling the city; according to one account, the river divides in four, flowing in opposite directions; according to another, Ganges . . . divides into the seven sacred rivers of India.

Of course, folklore all over the world abounds with sacred mountains; J. A. MacCulloch's article 'Mountains, Mountain Gods', in *Hastings' Encyclopedia*, gives ten columns of details. The Siberian versions are related to Meru and follow the same pattern: number and colour symbolisms may vary, but it is the same story of a central heavenly mountain, like the more familiar Scandinavian Himinbjorg, sometimes located on the axis of the earth-disc, sometimes actually situated in heaven. One central Asiatic tale has a rectangular mountain: recalling the oblong plain of Atlantis. (5)

The Sumerians, though plainsmen, appear to have actually built their mountain as a sacral centre and source of cosmic orientation. (6) In the epic which Kramer calls *Enmerkar and the*

Lord of Aratta, come the two lines: 'Purify for me Eridu like a mountain,/Cause to appear for me the holy chapel of the Abzu like a cavern.' (7) The temple is projected as a symbolic heaven-and-earth mountain, axle of the cosmos; and this mountain plays a rich part in the sacred literature of the Sumerians. The sanctuary, so the same epic tells, was to be built of rocks from mountains; Sir Leonard Woolley's excavations at Ur showed, too, that the weeper-hole drainage system of the structure gave grounds for believing that the temple-as-mountain was covered with earth and planted with trees. (8) The ziggurats at Ur and Nippur were, to this extent, 'cosmic mountains', and Eliade writes of them as 'symbolic images' of the cosmos: 'its seven tiers represented the seven planetary heavens; when he ascended them, the priest was mounting to the summit of the universe.' (9)

Mountains, seemingly, were located at the periphery of this otherwise flat, or even concave, Sumerian earth-disc. (10) When Gilgamesh in the Babylonian epic travels to Dilmun, he had to go through the mountain which bars his way. Then from Dilmun he crosses the waters on his doggéd voyage onward for consultation with Utnapishtim. How much of this topography was explicit in the Sumerian proto-Gilgamesh cannot of course be stated exactly.

The mountain through which Gilgamesh goes in the Akkadian text, according to E. A. Speiser's translation, is a mountain range called Mashu, which means 'twins'. It is Mashu 'which daily keeps watch over sun [rise and sunset] /—whose peaks [reach to] the vault of heaven/[And] whose breasts reach to the nether world below' (Plates 5-6). (11) The Akkadian *Etana* myth testifies that this 'range' has its base in certain surrounding waters. Here, when the eagle has carried Etana up into the air, it says: 'See, my friend, how the land appears!/Peer at the sea at the sides of E[kur]!' [Ekur in the sense of 'world-mountain'] ; and Etana replies: 'The land has indeed become a hill.' (12) Yet the relation between the world-mountain and the Mashu range through which Gilgamesh went remains problematic. This is due in some measure to the complexity of the Sumerian word *Kur*, meaning 'mountain'. The pictograph represented three mountains. Apart from the normal early tilt, this sign showed no change from the earliest records around 3000 B.C. down to neo-Assyrian around 1000 B.C. But its senses ramified: besides 'mountain', *Kur* could also mean 'foreign land', 'earth', 'land', or (like *ki-gal*) 'nether-world'; and it also designated the monster Kur, who, like

the Babylonian Tiamat, dwelled in the 'great below' between the earth's concave crust and the primeval waters under it. (13) 'He has gone into Ekur', or 'he has gone into the mountain', meant 'he is dead'; yet Ekur was also the name of the great ziggurat of Enlil at Nippur. (14) Possibly the iconography on cylinder seals, where the sun god Shamash often appears on one of the twin peaks of Mashu, led to a contraction, in prevailing thought, of the mountain cosmorama into a single two-peaked mountain as an image of how the cosmos was organized around a sacral centre.

A reconstruction of the Babylonian world-picture by Meissner clearly establishes its structure of concentricity (Plate 7). (15) Here there is a seven-tiered mountain as central axis; a sea lies between this axis and the surrounding range; and the surrounding range contains the western and eastern twin-peaked 'solar gate' mountains used by the Sumerian Shamash. It might look as if Meissner was too systematic; or as if he mistook the notion of a navel-point of creation, exemplified in the ziggurat as symbolic mountain, for a cosmological image in which the earth as such is regarded as a mountain. Yet the latter view does have parallels in central Asiatic folklore; moreover, it is consistent with several texts. Alfred Jeremias asserted, with an eye on the cylinder seals, that the Babylonian world-mountain was envisaged as being twin-peaked: the two peaks representing the high and the low points reached by sun and moon at the solstices. (16) The identification of solar-gate mountain and central world-mountain is also suggested (though not dated) by a fragment quoted by Kramer (who gives no source): 'Mountain of heaven and earth, the place where the sun rose.' (17)

Possibly what we are observing here is the gradual shift from the Babylonian world-picture, with its Sumerian levels still active, toward what was to become the Iranian world-picture. The Iranian world-picture has a definite surrounding range with the centre as axis. The surrounding range, Alburj (Arabic *Qāf*) includes the highest and holiest mountain range, Haraberezaiti, and the highest peak, Mount Hukairya. The mountain circle is described in several Muslim traditions, (18) and the same idea occurs in the *Hexaemeron* of pseudo-Epiphanius, with the circle as a barrier protecting earth from the surrounding waters. Here, too, Haraberezaiti or Harati surrounds the earth on east and west (*Bundehesh*, Yasht 19, 1) and also holds in the sea called Vôuru-kasha, which surrounds the earth (*Bundehesh*, Yasht 13).

Another mountain, Cekât-dâitik, is also supposed to stand at the earth's centre. From this mountain a bridge leads across to heaven (the bridge occurs later in Celtic legend and in medieval Visions). (19) The Iranian cosmorama was a very elaborate one; but it was still anchored in an image of space inherited from Sumer and widely shared among Semitic peoples. Among the latter, too, 'sanctuary', 'mountain' and 'navel' are conceptions which overlap: thus the Samaritan Gerizim, the Iranian Shiz and the Hebrew Sion. (20) The Iranian cosmorama was also coherent. It became one source of western traditions which tell of a mountaintop paradise, or of a bridge, or again a sea, which has to be crossed before that paradise can be reached (in Latin patristic writings, Paradise often became an island). (21) It is probably from here, and not from Genesis (which has no explicit mountain site for Eden), that the idea of a mountaintop paradise was transmitted into western versions of fabulous topography. Traces of this transmission are found in *The Book of the Cave of Treasures* (*c.* A.D. 350?), (22) in the geography of Cosmas Indicopleustes, in the encyclopaedic writings of John of Damascus, in numerous iconographic sources (for example, those analysed by Ringbom in his book *Paradisus Terrestris*, like the apse mosaic in S. Giovanni in Laterano; cf. Plate 8), (23) and certain Latin patristic writings from Bede onward (eighth century); not to mention Dante's *Purgatorio*, where the Mountain of Purgatory marks a dense and intricate confluence of oriental, classical and Christian motifs (cf. Plate 9). (24)

There was, then, continuity in the transmission of these images, even though the metaphysical sense which they originally symbolized often got lost. Howard Rollin Patch, in his *The Other World*, traces the variety of the grips which the images exerted on men's minds from the third century A.D. on. My sketch suggests a few cardinal details in the remoter background. But does the recurrence of the details in Novalis around 1800 authenticate his 'Märchen' scene as one in which a cosmic centre is apparent and an active symbol in a poetic narrative? The recurrence itself is a clue, perhaps, to how a poetic imagination works when it is creating symbols, singly or in clusters. (The transmission of symbols, from one conscious recipient to the next, or grafted into a consciousness by some neural accident, is not the question here.) But the recurrence alone is no authentication of the scene as symbolic. I shall come back to this question soon. For the moment I would say merely that an old

pattern recurs only if it is born anew and scaled to an original mind's depth of experience; and that such re-creation is here the case. Casual as they seem, the two phrases in Novalis undercut the elaborate intervening advance of geophysical science and evoke in its entirety one of the primal landscapes of the human mind. (25)

3.

This evoking was to become a norm of symbolist utterance in poetry after de Nerval and Baudelaire; but during the nineteenth century the subtle aura of association captured by this or that magic phrase became something increasingly less settled within traditional categories of meaning, such as those to which Novalis' mountain cosmorama was still related. One asks: can narrative fiction effectively confine symbolism to brief deep evocation of this kind? It does not always do so; modern symbolic styles tend rather to sustain or diffuse the moment in which meaning laughs at literal expression. Whole fabrics of symbolism evolve, to carry the complexities of meaning which the modern imagination, at once more realistic and less determinate, rustles from its manifold concrete world. In *Moby Dick*, Ahab nails to the *Pequod*'s mast one of the relatively few coins struck with a mountain scene on its reverse: a doubloon of Ecuador. It is, Ahab says, a 'medal of the sun', and it comes 'from a country planted in the middle of the world and beneath the great equator.' (26) There are three mountains on the coin: Ahab, Starbuck and Stubb variously apostrophize it, explicating its zodiacal symbolism. And to Stubb, again, it comes to look like the ship's navel—consistent, by coincidence or not, with the old oriental convention in which mountain and navel are both terms for cosmic centre. Yet, since the narrative keeps its frontal focus on the ship, its crew and their adventure, the symbolism is braced by solidity of specification in an historical perspective. This is a form of contextual control to which Novalis' symbolic style is both antecedent and in principle opposed. The mountain detail in the 'Märchen' is not an isolated one,—a fabric connects that detail and others—but even then, when the hero comes to explore the interior of a mountain in Chapter 1 of *Heinrich von Ofterdingen*, he does this in a dream and in language with a largely lyrical impulse. Here again, whether or not Novalis knew it, myth contaminates the fiction, but in such a way that the symbolism becomes a fiction of feeling, not a cosmological fiction.

In his dream Heinrich lives through an entire tumultuous life and finally comes to a small meadow on a mountain slope to which he has ascended up a dry creek bed. Beyond the meadow is a cliff, and he sees at its foot an opening which looks to him like the start of a pathway hewn into the rock. He walks through, and eventually he reaches a cavern. A great fountain irradiates the cavern with a sort of liquid light. Heinrich strips and bathes in the fountain's basin. The water's touch rouses marvellous images in his mind, and (I now translate) 'every wave snuggled against him like a tender bosom. The water seemed like a solution of charming girls who instantaneously assumed bodily shape against the young man.' (27) He falls into a kind of sleep; waking later, he finds himself on soft grass in the open air. Dark-blue rocks with bright-coloured veins loom up at some distance; the light is brighter and more mild than usual, the sky dark blue and quite clear. Beside a spring, he sees a light-blue flower with broad shining petals; other flowers of all colours are there, and a delicious fragrance fills the air. Irresistibly drawn to the large blue flower, which moves in response to him, Heinrich sees in its corolla a delicately featured face. At this point he wakes up, roused by his mother.

The dream contains no trace of the uneasiness, oedipal or otherwise, which a Freudian might expect. Its mood is one of marvelling delight, of most subtle sensuous enchantment, of passive and unquestioning bliss. The images recall several precedents in medieval Vision literature, where the visionary or dreamer comes to a paradisal place. For instance: the widely known *Vision of Tundale* (middle of the twelfth century), of which Italian, German, Dutch and English versions exist. Tundale dreams that, after witnessing a mountain purgatory, he comes to a 'field of joy and the fountain of life. Here was a door that opened of its own accord, and within was a beautiful meadow filled with flowers and sweet odors, in which was a great multitude of souls.' (28) The shared detail is the paradisal field of flowers, which is, of course, a familiar *locus amoenus* detail in Courtly Love literature, and has a rich medieval iconography. In the thirteenth-century *Vision of Thurkel* there are again the purgatory details, followed by details of a great church on the slopes of the Mountain of Joy (=Paradise Mountain), standing in a field which also contains a fountain, over which there grows a tree of great size. (29) The *Vision of Thurkel* also begins in a church, where, from what appears to be a font, a

huge flame rises to light the whole edifice. This would parallel
the luminary fountain in the cavern in Novalis. Symbolic rela-
tions between mountain and temple, and between mountain and
cavern, are normal in the traditional system of correspondences,
as Guénon has shown. (30) A medieval instance of this relation
is the Minnegrotte in *Tristan*. The Minnegrotte is actually a ca-
vern inside a mountain slope: 'gehouwen in den wilden berc'.
(31) It is possible that Gottfried was alluding here, for all his
ecclesia allegory, to a Temple of Venus, like the one in the 'Epi-
thalamium' of Sidonius, where the temple is on the mountain,
though not apparently in it. (32)

For erotic and other antecedents one can go even further
back. The Syrian *Book of the Cave of Treasures* (*c*. A.D. 350),
of which the earliest MS. is not older than the sixth century,
tells how Adam and Eve, when expelled from Paradise, 'went
down in . . . [hiatus in text] . . . of spirit over the mountains of
Paradise and they found a cave in the top of the mountain.'
Here Adam consecrates the Cave of Treasures, Me'ârath Gazzê,
as a house of prayer; but, from what ensues, it would also seem
that Eve and he learned copulation there. (33) The Tannhäuser
legend, perhaps the best known Venusberg story, with its va-
rious folklore versions, is sometimes thought to combine motifs
of remote oriental origin. (34) If Andrea di Barberino's story
Guerino detto il Meschino was indebted to the fourteenth-
century Franco-Venetian *Huon d'Auvergne*, this could certainly
be argued, since the Turin text of *Huon d'Auvergne* does intro-
duce its mysterious oriental enchantress as dwelling (Cybele-
wise) *in* the mountain—'yn quela montagna'. (35) The dark-blue
colour detail in Novalis has its place in his own colour symbol-
ism; but there is a lapis-lazuli mountain in Sumerian sources, for
example, the *Song to Martu*. (36) Gilgamesh is evidently the
prototype of many subsequent explorers of mountain interiors
in western literature.

Yet there are differences between Heinrich's dream and the
older visions and tales of mountains and mountain interiors.
Whereas the vision bristles with details of barriers to be sur-
mounted, of ordeals to be suffered, of perilous bridges to be
crossed, Heinrich finds what 'looks like a path' already hewn
into the rock. The earlier part of his dream contained no ordeal
of the harsh and spiritual kind which figures in the visions; and
the part which concerns us contains no ordeal either. The moun-
tain here is a place not of trial but of etherealization, as indicated

by Heinrich's feelings in the fountain. In other details, too, there is a mollifying of tones and contours. The Vision literature tells of violent temperatures, roasting heat and icy cold; but the only time when temperature registers at all in Heinrich's dream is when the light is said to be mild (even that sensation is oblique). And the flower—this is no huge Tree of Life, but an animated plant which responds to the dreamer. In sum: certain points of contact exist between the Novalis dream and the older types; these may be coincidental, as far as one can tell; but when comparison is made one sees that Novalis has none of the dimension of ordeal, anguish, and purgation which the Vision literature, at least, did embody as a dialectical concomitant to the vision of paradise. Without that dimension, the dream of paradise is a supreme and radiant fiction of feeling, far from any stereotype, but not consubstantial with the vision.

4.

If this inference is correct, this analysis has shown that fiction-of-feeling symbolism in Novalis ought to be distinguished from the cosmological symbolism which occurred in the mountain cosmorama. Different intensities of imagination have resulted in differing scopes of discourse. Yet such comparisons as these can warp the exegesis and evaluation of texts in which traditional symbols, including radically modified ones, are vehicles of meaning. The worst snags occur when the investigator disregards or misjudges a text's lineage and its internal peculiar intricacies. Myth probers and archetype diviners are known to err quite often because what they find is what they are looking for. My comparisons, which allow for the pervasive tender modulation of Novalis' prose, could indicate that any symbolism which is open-ended and soft-centred can have no more than a sort of detective contact with mythic material, seldom if ever an activating contact, or contact to the core. This might be due to the absence, from such symbolism, of unimpeded give toward objects: it is much more a concentrated vocalization of local feeling. German Romantic symbolism, we know, like much symbolism since, was not structurally suited to functioning as a vehicle of envisioned metaphysical ends—despite its theory. None the less, it has to be realized that Novalis' symbolic style exemplifies that stage in the growth of imaginative genius which Hofmannsthal called pre-existence, occurring in a given man in a definite cultural epoch. He cannot be seriously regarded as an angel

marooned on the desert isle of human discourse; but he is also
not to be discredited on the grounds that some other style, say
Kafka's, authenticates its vision of reality more substantially, or
falsifies the stuff of myth correspondingly less.

An historical and comparative investigation of symbolic styles
would have little scientific value unless it kept in prospect the
discovery of certain laws of symbolic style, even if such laws
differed from language to language. Discoveries of that order
have I none; but I do have three suspicions: that any symbolic
style is unique and inimitable, that the solidity of specification
peculiar to the masterly styles is intimately linked with the
question of tone, and that poetic symbols are active in a way
that others are not, not even the complex traditional symbols
in non-imaginative contexts. Tone, as it carries the whole ges-
ture of style, is at least one factor which makes a style unique,
though tone is probably more evasive than factors which are
accessible to semantic investigation. Klingsohr begins his 'Mär-
chen' in *Heinrich von Ofterdingen* with the words: 'Die lange
Nacht war eben angegangen'; this 'long night' figure is symbolic
in context—the narrative proceeds and we find that the night is
an aeon of darkness whose end inaugurates a Golden Age: but
we know at once that a pretty fanciful story is on the way, and
that the fabulous planes of discourse are probably going to
evolve independently of any literal planes. The tonal factor is
worth emphasizing, because poverty of tone and vaporizing do
often consort in writing which, though it may be treating mythic
material, treats it usuriously, under the pretext of 'shadowing
forth' or 'expressing' truths called 'universal'.

But even the tonally controlled presence of universals is not
enough to authenticate a symbolic style. Far from it. And the
question as to how, by its internality, a poetic symbol differs
from any other, is not answered in such technically relevant
writings on traditional symbolism as those of Coomaraswamy,
Guénon, Eliade and others. It seems that, because poetic ver-
sions of traditional symbols, like the mountain symbol, some-
times resemble traditional symbols outside imaginative literature,
their differences often get overlooked. The demarcation lines
are hard to draw; a confusion occurs between making meaning
and knowing it. It is one of the truisms of the idealist theory of
symbolism, where the confusion does arise, that (to quote Philip
Sherrard) 'the poet, through his use of myth and symbol, seeks
to give expression to certain archetypal patterns of experience

and to certain universal truths in terms of the particular time and place in which he finds himself.' (37) But these stereotype terms, 'use of', 'give expression to', and 'in terms of', show how shakily such arguments are yoked to fallacious expression theory. One standard consequence is the view that 'poetry . . . is concerned less with the small data of sensory observation or the memory of natural experience, than with the inner nature of life; less with individual vagaries of thought and feeling than with perennial issues.' (38) Can this be so? The alternatives are false. For millennia poets have been exploring the symbolizing resources of language not simply for the transmission of meanings ready-made, but for the inaugural making of meaning; and symbolism, in religious as well as poetic language, is a control which makes meaning not via the formula but in a frontal contest with raw existence. Where imagination is at work, making and transmitting are less rigid alternatives than requisite conditions for each other, as 'Kubla Khan' shows; but when Sherrard pre-establishes his self-evident universals, he smothers the question of making, and gives a very shallow and schematic picture of the relation between traditional symbols, as registers of the 'inner nature of life', and the moment-to-moment life of imagination in the midst of concrete experience.

If we say that literature becomes a form of gnosis only when it is poesis, this does not imply that all poets are incorrigible primitives. All the same, the making of meaning does involve a kind of unknowing (not to be identified with the unconscious). By his intelligence, a poet's unknowing is actually nourished, though, as in Coleridge's case, the system of unknowing can sever its ties with the intelligence it supports. By his unknowing the poet is exposed in the way described by Rilke in his well-known poem, exposed on the 'mountains of the heart'. It is here that his knowledge can silence the knower who hears the ignorant plant sing. This subtly perceptive and profoundly receptive unknowing could be one source of the internality peculiar to poetic symbols and to poetic versions of traditional symbols: it is certainly a deep motive in the searching discipline of making, as this is undergone by the spirit unappeasable and peregrine. 'When great art is spoken of as having universal significance,' Philip Wheelwright has said, 'we should keep our fingers crossed. What it really tends to have is an eccentric and adventuring *style* of universality.' (39)

Philip Wheelwright's own ideas about this eccentric and

adventuring style are to some extent corroborated by Wallace Stevens's poem 'Credences of Summer'. Since this is a theoretical poem about the genesis of active symbols in poetry, we should listen to what it says. All through the poem the phrase 'it is' recurs. The phrase has no antecedent subject, and it rapidly comes to sound like a celebration of being, from which soon images emerge defining the complex of perspectives in which imagination and being confront each other. The celebration begins only after obfuscating value-stereotypes like 'physical' and 'metaphysical' have been purged away with 'the hottest fire of sight':

Look at it in its essential barrenness
And say this, this is the center that I seek . . .

. . . Exile desire
For what is not. This is the barrenness
Of the fertile thing that can attain no more . . .

It is the natural tower of all the world . . .

It is the old man standing on the tower . . .

And later:

It is a mountain half way green and then
The other immeasurable half, such rock
As placid air becomes. But it is not

A hermit's truth, nor symbol in hermitage. (40)

In the last sentence, the word 'symbol' is pulling negatively against the affirmative recurring 'it is'. The dialectic of imaginative process involves a non-vital force which devises verbal make-believe of the kind often associated with symbolism, and a vital factor which creates radical metaphors with ontological status. (41) The poem's seventh section shows how, in this dialectic, distancing and the capture of reality red-handed are interdependent, if successive, moments in a single act of vital imagining. The act moreover culminates not in a statement of the meaning of the object which imagination captures; it culminates in a proclaiming of the 'meaning of the capture'; that is to say, language not merely declaring imagination's arrival at a certain point of orientation in experience, but enacting the whole dynamic of mind which brought it there.

Far in the woods they sang their unreal songs,
Secure. It was difficult to sing in face
Of the object. The singers had to avert themselves
Or else avert the object. Deep in the woods
They sang of summer in the common fields.

They sang desiring an object that was near,
In face of which desire no longer moved,
Nor made of itself that which it could not find . . .
Three times the concentered self takes hold, three times
The thrice concentered self, having possessed

The object, grips it in savage scrutiny,
Once to make captive, once to subjugate
Or yield to subjugation, once to proclaim
The meaning of the capture, this hard prize,
Fully made, fully apparent, fully found.

The symbol of being as this occurs outside imaginative language
communicates itself by other means: it need not be 'fully made,
fully apparent, fully found.' But without this threefold fullness
in poetic meaning, the 'meaning of the capture' is transmitted
only by way of the 'symbol in hermitage', the symbol, that is,
in retreat from the object and in retreat from being, not dynamic
in its condition of exposure to them.

APPENDIX 1:
Translations of German Passages in the Texts
(all translations are by the author)

THE RISE OF PRIMITIVISM

p. 27 'Ebenso wie . . . Je freier': Like ourselves, these pure artists sought in their works to present the interior essentials, their renunciation of external accidentals followed quite naturally . . . The more freely formal abstraction is disposed, the more pure and thus more primitive it sounds.

'aus demselben': . . . for reasons identical with those of artists seeking help from the primitives.

'das Innerlich-Wesentliche . . . Konstruktion': the interior essentials; more subtle psychic vibrations; the objectivity of form; construction for the purpose of composition.

p. 28 'Die Mystik': Mysticism awoke in people's souls, and, together with it, primeval elements of art.

'Schaffen von Formen': The creating of forms means: living. Are not children creators, drawing directly from the mystery of their feeling, to a greater degree than imitators of Greek form? Are not the primitive artists, having their own forms, strong as the form of thunder?

p. 29 'Das rein Kompositionelle': The purely compositional.

p. 30 'Die Logik': Logic has no foundation at all; the material world and our notions never correspond; Lord . . . I was created to know and to see, but your world is not made for these; it recedes from us; we are worldless.

'In einer Zeit': In such times as ours, when people are assailed daily by the most monstrous things, without being able to clarify their impressions, in such times aesthetic production becomes a diet. But all living art will be irrational, primitive, and fraught with complexes; it will have a secret language and leave behind it documents not of edification but of paradox.

p. 31 'Die Welt': The world is once again seen for the first time, and with an immediacy, what is more, which is ordinarily proper only to the child and the primitive; and thus the world expressed is that of the child, the primitive, the dreamer: this expression occurs by an act of new language-creation . . . Out of this, something altogether new has abruptly emerged: the primal symbolism of an irrational and unmediated vision of the world.

'Umwortung aller Worte': Trans-wording of all words (a pun on Nietzsche's 'transvaluation of all values', or 'Umwertung aller Werte').

p. 32 'flache . . . zu einem': flat surface; ideal surface; a being that hovers in the air, equivalent to the painterly expansion of space.

pp. 32-3 'Scheinbarkeit': appearance (with a touch of the adjectival 'scheinbar', probable or seeming). 'Als ob . . . Der Gegensatz': As if there would be any world left if one were to subtract the perspectival aspects! . . . The antithesis between apparent world and true world is reduced to the antithesis 'world' and 'nothing'.

p. 34 'innerste Alchimie des Wortes': the inmost alchemy of the word.

p. 35 'Unsinn': nonsense. 'Gegensinn': anti-sense or counter-sense (Arp's terms). 'seit kindesarmen': (quite literally) since children's arms but (in usage) since babyhood. Other puns, e.g. catafalcons/catasparrows.

p. 36 'Die Genesis': Genesis as formal movement is the work's essence.

DADA VERSUS EXPRESSIONISM

p. 63 'und die Erneuerung': and the renewal of Germany.

'Wir wollen': we want to enter paradise, as living beings.

'Wir leben': we are not living in freedom, but in hell, my dear.

'Schöntuerei': (false) beautification.

p. 64 'die Wiedergeburt': the rebirth of society out of the union of all artistic media and powers.

'die Konvention': to break through the conventions and show that the world is still as young as on the first day.

'Um den Menschen': Man is the question, not art, at least art is not the primary question.

'Erlösungsbedürfnis': need for redemption.

p. 65 'Ist die Zeichensprache': is the language of signs the real language of paradise?

'Kandinskys': Kandinsky's decorative curves—: are they perhaps only coloured carpets (for sitting on, whereas we hang them on the wall)?

p. 66 'Verhaspelung': entanglement of reason in reflection.

'Ich bin': I am only an artist in small matters, a cabarettist and performer. Why should I want to preach morality?

p. 67 'Fiktionen': fictions and images.

'Die Dadaisten': the Dadaists . . . are infants of a new age.

p. 68 'Die heutige Dichtung': The poetry of today will become once more a poetry of values. It is already becoming, in a renewed sense, political.

'Ohne-Sinn': without-sense, which does not mean non-sense.

'Zwischen': I find Socialism and art altogether incompatible.

'Es ist ein Bestreben': An effort is being made to apprehend the innermost frame, the ultimate prison of the spiritual person. Endeavours thus far have touched on that prophetic line which borders madness. Between this sphere and the senile present lies a whole (social, political, cultural and emotional) world whose notions the artist renounces. The struggle against the phantasms arising from that world constitutes his asceticism.

p. 69 'Den Jargon': Avoid the jargon of abstraction.

'Den Sinn': Sharpen your sense for the unique special quality of a thing. Avoid dependent clauses. Keep forging ahead in a straight line, directly.

'Nicht für': It (the new kind of poem) is not written for soft voices, but for loud resonant expressions . . . And this 'New Pathos' . . . is, above all, the joy, strength, and will that generate ecstasy.

p. 70 'Neuro-Mantik': Neu(new)ro-Manticism.

p. 72 'Der Mensch': Man is Good.

'Den Künstler': The artist, whose calling is to raise the intellectual and emotional level of the people, should be regarded by the state as an official, and recompensed accordingly . . . Without an ethic, economic considerations have no foundation. Ethics without aesthetic saturation to illuminate them are like a mineral without its energy-field.

p. 73 'Trottelbuch': Idiot Book.

'Proktatur': Proktatorship of the Dilettariat (the pun has a Greek element, prokt-=backside, which reverses the implied Latin element in the phrase 'Diktatur des Proletariats').

p. 74 'Abkehr': turning away from all concreteness . . . internalization, abstraction.

'Unter dem Vorwand': Under the pretext of propagating the soul, they (the Expressionists) in their struggle against Naturalism have reverted to abstract-emotional gesticulations which presuppose life without contents, comfortable and sedentary.

'Der Expressionismus': Expressionism, which was discovered in a foreign country, and has become in Germany, in the way that Germans favour, an obese idyll and expectation of a good pension, has no longer anything to do with the endeavours of active people.

'nun mit allen Mitteln': to proceed now against this culture, using all available means of satire, bluff, irony, eventually also force. In violent group action, what is more. Dada is a German Bolshevist affair.

p. 75 'die ungeheuere': the monstrous and immense fantasmagoria of the present with its thousandfold depths and bottomless gulfs, human existence entire, including murder and misery and veal cutlets.

'ein Fliehen': an evasion of the hard edginess of things.

p. 76 'Die höchste Kunst': The highest art will be the one that, in its conscious substance, presents the thousandfold problems of the age. Of such art one can say that it has hurled itself in the face of last week's explosions.

'nur': only a means for propagating a revolutionary idea.

'für uns': for us, the spirit lay not only in the poet's artistic achievement; it was an absurdity to our way of thinking, the attempt to make man more intelligent and better (Meliorism), since in our opinion the metaphysical value of a 'spiritual' person could not by any kind of intellectual manipulation be distinguished from that (to use a random example) of a watering can.

'Wir wollten': we wanted to show them the way to a new primitive life.

p. 77 'dass ihre Vorstellung': that their notion of art and spirit was only an ideological superstructure which they were trying in this case to acquire for money, in order to justify their daily shady market dealings.

MÖRIKE'S MOONCHILD

p. 191 'der Nachdenklichkeit': of thoughtfulness or entrancement.

p. 192 'freudig': the poet seems to be turning away, with gladness, from

meditation to gaze once more (at the flower).

'die Ergriffenheit': being entranced by the mystery of beauty as by the mystery of nature, a state of rapture which bears marks of love and passion. ('Ergriffenheit' connotes in German critical phraseology an act or state of rapt imaginative communion between subject and object.)

p. 194 'Wo der Mondstrahl': Where the moonbeam trembled around lilies.

p. 195 'Eile zur Lilie du': Hurry, to the lily.

'Könnt ich': If only, O soul, I could frame you/As you are, in the purest mirror,/Confront you with all that is uniquely your own,/As if it were alien (external) to you.

'das Göttliche': the divine as presence of a flower.

'das Wort am Anfang': the Word that was in the Beginning.

p. 196 'das schöne Kind': the lovely child; not so very childlike; a child of earth at play; the strange child.

'aus eisiger Nacht': from icy night the melting rose (or 'dewing').

p. 197 'Die Pflanze hat': the plant resembles somewhat the waterlily.

p. 198 'Sie wirft die Larve ab': It [time] throws off its mask and suddenly stands/As eternity before me, in my astonishment.

'Zaubergürtel': magic girdle.

'dämonische Stille': demonic stillness.

'Der Sonnenblume': like the sunflower my soul is open.

'der Schönheit Götterstille': beauty's divine stillness.

'nur in gleichsam': only, as it were, in an oblique form.

p. 200 'sanfter Geist': gentle spirit of seriousness poured around the whole form.

'hintergründig, verschlüsselt': with hidden background, encoded.

'Der Deutende': the interpreter must apply categories, interpretative concepts, but these concepts must be drawn from the image itself, yield themselves, as it were, from the image, and refer back to it.

'Vernommen hast du sie': You heard it, the language of the strangers,/You interpreted its soul! To one who had the longing/The sign was enough, and signs have been/From time everlasting the language of the gods.

p. 201 'die Zwischenwand': to break down the partition between word and thing.

'Reines Anschauen': the pure gaze, attentive to external and internal features, is very rare.

'einer Dichtung': a poem which means literally what it says and which, in its highest perfection, is the thing of which it speaks.

p. 202 'Für den Dichter': For the poet himself . . . the outcome means that he has found in the self-sufficient, enduring, beautiful art-object, in the permanent 'thing', a foothold which enables him to endure in his period of time his painful consciousness of solitude.

'Das Hervortreten': The emergence of 'Dingdichtung' (thing-poetry) shows that, for the most part, belief in cosmic-religious and human relationships

no longer provides any shelter.

p. 203 'Odyssee des Geistes': Odyssey of consciousness (or of 'spirit').

'Deutung ist nicht': (in Mörike's poems about things) interpretation (of a thing) is not a statement of content, it is a formal matter.

p. 208 'Geistleiblichkeit': spirit-bodiliness.

'leibhaftig sein': being corporeal is a reality or perfection when it is purified of the defects attaching to earthly corporeality.

'Keine Seele': No soul, no spirit, can appear without body, no spiritual thing can become perfect without body, everything that is spiritual is at the same time corporeal.

AN ENIGMA TRANSFIGURED
IN HERMANN HESSE'S *GLASPERLENSPIEL*

p. 233 'Wesensschau': vision of essence.

p. 234 'jenseits': beyond, a steep and high scree, its sharp serrated ridge cutting into the thin, greenish, cool morning sky, abrupt and cold in the shadow. Yet behind this ridge the sun had evidently risen, its light glittered here and there . . . only a few moments, and then the sun would appear and flood the lake and mountain valley with light.

p. 235 'wie die Hälfte': one half of the lake's width still lay in the great shadow, which the mountain, pressed by the ray of morning light, was gradually contracting, more and more tightly, around its base.

p. 236 'diese grimmige Kälte': this harsh coldness which gripped him on all sides as with blazing flames.

'das Innere': the interior of the world's mystery (or secret).

'Die Musik': Music is based on the harmony between heaven and earth, on the concord between the dark and the light.

p. 237 'den Mittelpunkt': the centre of one's own person.

'als flüchtiges Gewand': as fugitive apparel of the Godhead.

'das Komplizierteste': to express the most complicated things, without excluding personal fantasy and invention, in a graphic way that would be intelligible to all scholars in the world.

'Er glaubt ja': Indeed, he believes that, in an emblematic fashion, with countless harmonious signs, the entire universe indicates that One (the Holy One), toward which it is directed.

HERMANN HESSE'S *MORGENLANDFAHRT*

p. 239 'Die Unerfahrenheit': . . . Inexperience, I can well think,/Will hardly believe my song. ('Fahren'=to travel, 'erfahren'=experience.)

'der Leser': the reader

'ein Gespräch': a conversation with the speechless (person).

p. 240 'ins Reich': into the realm of a coming psychocracy.

'wippte mit dem Schwanz': flipped his tail, winked his eye.

p. 241 'wie er': as up and down he flipped his spry tail and sang trills.

'das Innre': the earth's interior.

'ins blaue': into the blue secret of the interior.

'unser Morgenland': our Orient was . . . the homeland and youth of the soul, it was the everywhere and the nowhere, was the unification of all times.

'Zahl und Zeit': number and time.

'Die ganze Weltgeschichte': The whole of world history often seems to me nothing but a picturebook which mirrors the most violent and blind human longing: the longing to forget.

p. 242 'wie Tapeten': like tapestries with gracefully meaningless ornamental designs.

'Verzweiflung': despair (literally, splitting in two).

'Bundesbrief': document of federation.

p. 243 'Wo ist eine Mitte': where is a centre to the events, a common factor, something to which they refer and which holds them together?

'ein Nichts': a nothing . . . the topmost skin of a glass surface.

'ich stehe noch': I am still face to face with chaos.

p. 244 'Vielleicht': Perhaps, besides his hunger for experience, man's strongest hunger is for oblivion.

'es war die einzige': it was the only possible way in which I might be saved from nothingness.

'durch meinen Dienst': through my performing a service to the memory of that high time, to purify and redeem myself somewhat, to re-establish my relation to the society.

'Seilergraben': (street name applied to streets where rope-makers practised their trade).

'ich weiss noch nicht': I do not know yet . . . whether my case has made any progress or not.

'vorgestern abend': two evenings ago my wish was fulfilled. Oh, and how it was fulfilled!

p. 245 'abendlich . . . Abendmensch': (the word 'Abend', evening, has a wide range of functions in Hesse, e.g. connoting a late phase in western civilization).

'Tor' (n.): gate. 'Tor' (m.): fool.

p. 246 'wir sind Fäden': we are threads in the Veil.

'wir werden gelebt': we are lived (i.e. something lives through us).

'Der Mensch': Man is a rope tied between animal and superman,—a rope across an abyss.

p. 247 'Man erinnerte sich': Someone had remembered me, someone had summoned me, wanted to call me to account, perhaps . . . I was ready . . . to obey..

'alles stand': Everything for me was in the balance, my whole future life would be decided, my whole past life would now acquire meaning or lose it altogether.

'ich wagte': I did not dare to greet him, it was not yet the right moment,

I was expected, I had been summoned.

'Niemand': Nobody took any notice of us, everyone was silently occupied.

p. 248 'Unten in unsrer Wohnung': Downstairs, in our house, was the place for mother and child, there the atmosphere was harmless; here, upstairs, dwelled power and spirit, here were judgement and temple, and the realm of the father.

'mich selber nicht begreifend': not comprehending myself.

p. 249 'eine alt und mitgenommen aussehende Plastik': a sculpture, old-and worn-looking, of wood or wax, in pale colours, a sort of fetish-figure or barbaric idol.

p. 250 'Seelengestaltung': soul-formation.

'dass mein Bild': that my image was in the process of surrendering more and more to Leo, fusing with him, nourishing and strengthening him . . . He had to grow, I had to diminish.

'Ein höheres Wesen': It is *our* essence to create a higher being than ourselves. To create beyond ourselves!

'nichts entzieht sich': nothing is more apt to evade verbal expression, and yet what most needs to be set before people's eyes are certain things whose existence is neither provable nor probable, which, however, treated by pious and conscientious men as things to some extent in being, do come one step closer to being and to the possibility of birth.

APPENDIX 2:
Translations of Texts by Mörike and Novalis

Eduard Mörike: 'To a Christmas Rose'

1.
Daughter of the woods, thou kin of the lily
So long sought by me, unknown one,
In an alien churchyard, empty and wintry,
For the first time, O lovely one, I find you.

What hand cared for you, as you flowered here,
I do not know, nor whose grave you guard;
If it is a boy's, then sacred favour was his,
If it was a girl's, then her share was sweet.

In the nocturnal grove canopied with snow-light,
Where devoutly the grazing deer goes past you,
Near the chapel, by the crystal pond,
There I sought your dwelling's magic realm.

Beautiful you are, child of the moon, not of the sun;
For you the other flowers' delights would be deadly,
The balm-sweet air of celestial coldness
Nourishes you, your chaste body full of frost and fragrance.

Deep in the golden fullness of your bosom is
A perfume which hardly announces itself;
Thus fragrant, touched by the angel's hand,
Was the wedding dress of the blessèd Mother.

Sign of the holy passion, five crimson drops,
Would robe you beautifully and uniquely:
Yet childlike you adorn, around Christmas time,
Light-green with a breath your white robe.

The elf who in the midnight hour
Goes to the dance in the illumined vale,
Before your mystic glow he stands, shy,
Inquisitively still, afar, and flits past.

2.
In the winter soil sleeps, a flower seed,
The butterfly which later, around bush and hill,
In nights of spring will wave his velvet wing;
Never shall he taste your nectar.

But who knows, perhaps his delicate spirit,
When every adornment of summer has dropped away,
Sometime, drunk with your gentle fragrance,
Invisible to me, circles (will circle) you as you flower.

Novalis: Scenes from Chapters 9 and 1 of *Heinrich von Ofterdingen*.

1. . . . The whole region now became visible, and the reflection of the
figures, the throng of spears, swords, shields and helmets slanting from all
sides toward crowns that were appearing here and there, and finally these
disappearing to make room for a simple, green garland around which
they formed a wide circle: all of this was mirrored in the frozen sea that
surrounded the mountain on which the city lay, and also the distant high
range of mountains which encircled the sea was covered to the centre
with a mild reflected radiance. One could not distinguish anything clearly;
yet one heard a wondrous tumult coming across, as from a vast far-off
workshop.

2. . . . It seemed to him that he was walking alone in a dark forest. The day-light glinted only on rare occasions through the network of green. Soon he came to a crevasse which went up the mountain slope. He had to scramble over moss-covered rocks, which a stream had once brought down. The higher he climbed, the lighter the forest became. Finally he reached a small meadow, situated on the mountain slope. Beyond this meadow rose a tall cliff, at the foot of which he saw an opening that seemed to be the beginning of a corridor hewn into the rock. The corridor took him along comfortably for a time, toward a large open cavern from which, even before he reached it, a bright light shone in his direction. As he entered the cavern he saw a great jet rising up like a fountain to the roof and scattering in countless sparks that collected below in a great basin; the jet shone like burning gold; not a sound was to be heard, a holy stillness surrounded the glorious spec-tacle. He approached the basin, which was filled with waves and tremblings of bright colours . . . He felt an irresistible desire to bathe, undressed and entered the basin . . . The water seemed like a solution of charming girls who instantaneously assumed bodily shape against the young man . . .

[Heinrich falls asleep, in his dream, and later wakes up, though still dreaming] :

. . . He found himself on soft turf beside a spring which welled up into the air and seemed to exhaust itself there. Dark blue rocks with bright veins rose up some distance away; the daylight surrounding him was more bright and mild than ordinary daylight, the sky was blue black and completely clear. But what attracted him overwhelmingly was a tall light-blue flower which stood close to him beside the spring, and its broad shining leaves stirred feelings in him. Around it stood countless flowers in all colours, and a most delicious fragrance filled the air. He saw nothing but the blue flower, and he looked at it for a long time, with a feeling of ineffable tenderness. Finally, as he was wanting to approach it, it suddenly began to move and change: the leaves shone more brightly and clung to the stem, which was growing, the flower inclined toward him, the petals were seen as a blue outspread collar, with a delicate face floating in the midst of it. His sweet astonishment was mounting as this strange transformation occurred, when suddenly his mother's voice awoke him and he found himself in the parental room, which was already gilded by the morning sun.

NOTES
(All translations are by the author)

p. 7, INTRODUCTION

1. *In Job's Balances*, London, J. M. Dent, 1932 (translated by Camilla Coventry and C. A. Macartney), p. 175. The first ellipses belong in the original, those in brackets are mine.

2. *The Illusion*, New York, Harper Colophon Books, 1951, p. 162.

3. Published by University of Texas Press (Austin, Texas).

4. Further details can be found in the notes on poems, e.g. pp. 247-8, 250-1, in my *Selected Poems of Friedrich Hölderlin and Eduard Mörike*. Chicago, University of Chicago Press, 1972.

5. New York, Harcourt Brace & World Inc. (no date)

6. In R. L. Gregory and E. H. Gombrich (eds.), *Illusion in Nature and Art*, London, Duckworth, 1973.

7. In his *The Night Country*, New York, Scribner's, 1971, p. 224.

8. Preface to *Die Verbesserung von Mitteleuropa*, Hamburg, Rowohlt, 1968 (translation by Joachim Neugroschel, in *Extensions* [New York], 8, 1974).

9. 'Linguistics and Poetics', in Thomas A. Sebeok (ed.), *Style in Language*, Cambridge (Mass.), M.I.T. Press, 1960, p. 356.

10. Quoted from an article published in 1922, in Nadezhda Mandelstam, *Hope Abandoned*, New York, Atheneum Press, 1974, p. 45.

11. Letter to Benjamin Bailey, 22 November 1817; *Complete Works*, ed. H. Buxton Forman, Glasgow, 1901, vol. IV, p. 48.

p. 23, THE RISE OF PRIMITIVISM

1. Harold Rosenberg, *The Tradition of the New*, London, 1962, p. 89. cf. Herwarth Walden (in *Der Sturm*, 1915): 'The cultured person must forget or lose his culture, if he wants to be an artist, that is, a person who shapes the forms of culture' (quoted from P. Pörtner, *Literatur-Revolution*, Bd. 1, Neuwied, 1960, p. 398).

2. There had been much interest in Japanese woodcuts among artists during the 1880s and 1890s. Pierre Loti's writings also were widely read (Henri Rousseau painted his portrait, *c*. 1890). Late nineteenth-century ethnology tended to regard primitive artefacts as implements, not as works of art; the important revaluations, and their sequel in official aesthetics (Hein, Stolpe), also the growth of museums, are discussed by Robert J. Goldwater in his *Primitivism in Modern Painting*, New York and London, 1938 (Vintage Books, rev. edn., 1967). Artists preceded scholars in encouraging the decisive revaluations early in the twentieth century.

3. Cf. W. G. Archer and R. Melville, *40,000 Years of Modern Art*, London, n.d., p. 24, where the differing views of Henri Kahnweiler and Christian Zervos are quoted. Let it be said that supposedly primitive works

from Africa came from cultures once deeply sophisticated, like the western Sudanese Timbuktu culture of the sixteenth century. These cultures had been eroded by over four centuries of slavery (between 1444 and 1850, 20,000,000 Africans were sold into slavery in the New World, another 20,000,000 died in captivity before getting there). Europe grew fat on slavery during the eighteenth and nineteenth centuries: in some ways the term 'primitive' is still tainted by European cultural pride, ignorance and guilt. See Lerone Bennett, *Before the Mayflower*, Baltimore, 1966, pp. 18-30.

4. In *Das Werk Edvard Munchs*, Berlin, 1894. My source: Evert Sprinchorn's introduction to A. Strindberg, *Inferno, Alone, and Other Writings*, New York, 1968, p. 44.

5. They met in the salon of William and Ida Molnard in the Rue Vercingétorix. Henri Rousseau lived nearby and was sometimes a visitor. See Strindberg, p. 58, also Roger Shattuck, *The Banquet Years*, New York, 1958, p. 56. Sex was a powerful force in the proto-primitivism of Munch, Strindberg and Przybyszewski in Berlin and Paris. In Berlin there had been Dagny; in Paris there was Mme Lecain, the English sculptress ('a demon, a man-eater' [Gauguin]). For Przybyszewski, whose experiments were extreme and disastrous, the 'loved one . . . is merely a projection of the hero's Unconscious' (Strindberg, p. 74).

6. Strindberg, p. 64.

7. Strindberg, p. 132. Gauguin introduced Strindberg to Balzac's mystical fiction *Séraphita*, a work which influenced him decisively. The link between primitivism, as a psychological *descensus ad inferos*, and mysticism is not unusual among German heirs of the 1890s symbiosis. Hugo Ball passed via political journalism from Dada to the study of mystical doctrines in the Eastern Church (*Byzantinisches Christentum*, 1923). The madman in Georg Heym's story 'Der Irre' becomes a murderous animal ('like a hyena') and then a visionary. Kafka's Gregor Samsa trembles on this threshold: 'Was he an animal that music should take such a hold on him? He felt the way that led to the longed-for unknown nourishment was opening before him' (*Erzählungen und kleine Prosa*, Berlin, 1935, pp. 119-20).

8. Strindberg, p. 167.

9. Hans Arp, *Unsern täglichen Traum . . .*, Zürich, 1955, p. 12: 'In Ascona with brush and ink I drew broken-off branches, roots, grasses, stones, which the lake had washed ashore. I simplified these forms and integrated their essentials in dynamic ovals, images of the eternal transformation and coming-to-be of bodies.' See also Hugo Ball, *Die Flucht aus der Zeit*, Lucerne, 1947, p. 74.

10. The date 1904, from Kirchner's *Chronik der Brücke* (1916), is upheld by Goldwater (1938 and 1967), whereas H. K. Röthel gives 1905 ('Die Brücke', in *Der deutsche Expressionismus: Formen und Gestalten*, ed. Hans Steffen, Göttingen, 1965, p. 192).

11. Archer and Melville, p. 9. Gauguin, in *Avant et après* (1903), also seems to have sparked the interest in children's art: 'Sometimes I went very far back, further than the horses of the Parthenon . . . to the wooden rocking-horse of my childhood' (quoted from Oto Behalji-Merin, *Modern Primitives*, London, 1961, p. 17).

12. *Über das Geistige in der Kunst*, Munich, 1912 (2nd edn.), p. 4. Kandinsky had certainly read Nietzsche, cf. p. 116: 'This principle [of unlimited freedom . . . on the basis of inner necessity] is the principle not only of art but also of life. It is the authentic superman's great weapon against the Philistines.' Nietzsche's *Der Wille zur Macht* (1901, 1904) contained numerous statements on such lines as 'The "savage" person (or, in moral terms, the *evil* person) is a return to nature—and, in a sense, a restoration of nature, its recovery from the sickness of "culture"; . . . the courage to be psychologically *naked* . . . in order to struggle upward out of that chaos and to achieve this structure—a certain compulsion is necessary . . . Problem: where are the *barbarians* of the twentieth century?' (*Werke in drei Bänden*, ed. K. Schlechta, Bd. 3, Munich, 1956, pp. 742, 690).

13. op. cit., p. 60. R. N. Maier's analysis of abstraction in poetry, *Paradies der Weltlosigkeit*, Stuttgart, 1964, includes much detail about theories of painting, but nothing is said about primitivism or contacts between primitivism and abstraction.

14. op. cit., p. 5. cf. Franz Marc's aphorisms 39 and 78, of early 1915.

15. op. cit., p. 107.

16. op. cit., p. 112.

17. Shattuck, p. 112. J. de Rotonchamp's book on Gauguin had appeared in Paris in 1906.

18. *Der blaue Reiter: dokumentarische Neuausgabe*, ed. Klaus Lankheit, Munich, 1965. There were also Japanese pen drawings and woodcuts, Egyptian silhouette figures, and a Gabon mask wrongly identified as Chinese. Old German woodcuts and children's drawings had also been an influence on the painters of *Die Brücke*.

19. op. cit., p. 30.

20. op. cit., p. 48: 'The newly discovered rule of the aforementioned artists is only a resuscitated tradition whose origin we see in works of "barbaric" art: of the Egyptians, Assyrians, Scythians, etc.' Burliuk's anti-academicism predates Italian Futurism by three or four years. See V. Markov, *Russian Futurism: A History*, Berkeley and Los Angeles, 1968, ch. 2 ('Hylaea'). Burliuk's terms in *Der blaue Reiter* anticipated those of the (undated) *Vital English Art* manifesto of Marinetti and C. R. W. Nevinson (*c*. 1914); but that manifesto attacked all 'Neo-Primitives'.

21. op. cit., p. 55. The statement is flanked by reproductions of a stooping carved figure from the Easter Islands, and a carved wooden block from the Cameroons.

22. Paul S. Wingert, *Primitive Art: Its Traditions and Styles*, Cleveland

and New York, 1965, p. 9.

23. Details in William W. Austin, *Music in the Twentieth Century*, New York, 1966, e.g., p. 258: 'his beats are often marked by a thud in the accompaniment while the main melody has a gasp of silence, and then the motions of the melody occur as syncopated accents of the second or third unit with the beat' (the 'Glorification' and 'Victim's Dance' sections of *Sacre du printemps*). The main features here are violent contrast, eruptiveness, unpredictability, syncopation, staccato accents. See also the analysis of 'violently syncopated accents' and of the 'innumerable changes of time signature' in Eric Walter White, *Stravinsky: The Composer and His Works*, Berkeley and Los Angeles, 1966, pp. 172-6. White describes the instrumentation as a 'highly sophisticated means . . . employed to get a deliberately primitive effect' (p. 175).

24. *Der blaue Reiter*, p. 172.

25. Goldwater, p. 92, stressed the emotional side of primitivism in *Die Brücke*, notably in Max Pechstein's and Emil Nolde's paintings of 1911-15: 'the romantic-symbolic attitude toward nature and toward the primitive in its union with nature that we have seen in Gauguin and the *fauves*.' At the same time, Goldwater distinguished the primitivism of 1904-5 from its romantic precedents: 'Where the nineteenth century thought of the primitive . . . as calm and reasonable, the twentieth sees it as violent and overwhelming' (p. 95). The (Nietzschean) revaluation even occurs in Rilke's poem 'Geburt der Venus' (early 1904): the dolphin as bloody uterus from which the goddess is born. Rilke's predilection at that time for supposedly archaic (pre-fourth-century) Greek sculpture is realized in the phonics of the poem: see my 'Rilke's "Birth of Venus" ', reprinted here (pp. 173-189).

26. Worringer had probably not read Lévy-Bruhl's *Les fonctions mentales dans les sociétés inférieures* (Paris, 1910). His concept of abstraction excludes the careful distinction made by Lévy-Bruhl between 'abstraction mystique' and 'abstraction logique' in ch. 3. There is also Lévy-Bruhl's argument that the primitive mind, as revealed in drawings, has no conception of homogeneous space: the meaning of an image may vary according to where it is placed (pp. 124-31, 2nd edn., 1912). Worringer's idea about 'plane surfaces' was good for Munich or Paris, but not for central Australia. In fact, his 'primitive man' was a bold figment in Ur-Gothic costume, e.g.: 'He must therefore endeavour to recast the incomprehensible relativity of the phenomenal world into constant absolute values' (*Form in Gothic*, New York, 1964, p. 16).

27. Notably (in Jung) the theory that each individual psyche contains an epitome of the psychic history of mankind. Georg Heym uses a Freudian term ('Sexualverdrängung') in his journal for 20 Dec. 1910 (Hamburg, 1960, p. 154). The morning after writing *Das Urteil*, in Sept., 1912, Kafka noted in his *Tagebücher*: 'Gedanken an Freud natürlich' (New York and Frankfurt, 1954, p. 294).

28. From his fragmentary foreword to *Galgenlieder*: M. Bauer, *Christian Morgensterns Leben und Werk*, Munich, n.d., p. 152: 'dieses "Kind im Menschen" ist der unsterbliche Schöpfer in ihm'.

29. *The Diaries of Paul Klee 1898-1918*, Berkeley and Los Angeles, 1968, p. 266: (on *Der blaue Reiter*) 'These are primitive beginnings in art . . . Children also have artistic ability, and there is wisdom in their having it! The more helpless they are, the more instructive are the examples they furnish us . . . Parallel phenomena are provided by the works of the mentally diseased; neither childish behaviour nor madness are insulting words here . . . All this is to be taken very seriously.' Siegfried Levinstein's *Kinderzeichnungen bis zum 14. Lebensjahr* had appeared in 1905 (Leipzig). Goldwater (p. 187) mentions a German translation (1906) of the first book on children's art, published in Italian in 1887, but does not name author or title.

30. *The Diaries*, p. 288.

31. George Grosz, *A Little Yes and a Big No*, New York, pp. 26-9. cf. Jean Dubuffet's engraving, 'Venus of the Sidewalks' (1946), reproduced in René Huyghe, *Art and the Spirit of Man*, New York, 1962, fig. 278.

32. Reprinted in Carl Einstein, *Gesammelte Werke*, ed. by Ernst Nef, Wiesbaden, 1962, pp. 80-103. Primitivism in Herwarth Walden's momentous exhibition of 1913 ('Erster deutscher Herbstsalon') had drawn from some Berlin critics vituperations like 'Hottentots in shirts' and 'babies in tuxedoes' (Robert Breuer). The question was even discussed on 12 April 1913, in parliament, where 443 delegates agreed that paintings akin to savage art and child art were 'krankhaft' and unfit for museums. See Nell Walden and Lothar Schreyer, *Der Sturm: ein Erinnerungsbuch*, Baden-Baden, 1954, pp. 121-2 (quoting also Fritz Stahl's racist defamation of negroid features).

33. *Gesammelte Werke*, pp. 227, 230, 234.

34. Einstein's own poems were influenced by Stramm, who is said to have composed 'Negersagen' as a young man ('Anything aboriginal was attractive to him', his daughter said). See August Stramm, *Das Werk*, Wiesbaden, 1963, p. 403.

35. *The Diaries*, p. 312. The period is also one of large-scale pioneering research into African languages (Meinhof) and cultural systems (Frobenius). Einstein's book on Negro sculpture was written largely in Brussels, where there was by now a large ethnological collection.

36. *Die Flucht aus der Zeit*, p. 70. cf. Richard Huelsenbeck's later statement about the search for 'a new beauty' in Zürich Dada: 'With Nietzsche we had learned the relativity of things and the value of being unscrupulous . . . elaborate methods, intellectuality of all kinds had to be abandoned, from afar we understood the meaning of primitivity—Dada, the babblings of children, Hottentottcry—primitivity, of which the age seemed to be giving signs, in its predilection for Negro sculpture, Negro literature

and music' (*Dada siegt*, Berlin, 1920, pp. 12-13). In retrospect on early Dada, Ball himself wrote in a letter to August Hoffmann, 7 Oct. 1916: 'My idea of Dadaism . . . the idea of absolute simplification, of absolute negritude, to match the primitive adventures of our times' (*Briefe 1911-27*, Einsiedeln—Zürich—Cologne, 1957, p. 66).

37. Goldwater (pp. 130-40) discusses primitivistic traits in Suprematism (Malevich), Purism (Ozenfant) and Neo-Plasticism (Van Doesburg); 'plastic and associative elements heretofore used by painters are to be simplified, purified, or eliminated altogether, and the admittedly desirable synthesis of these analytic parts is to be obtained only from a combination of the barren remnants . . . and in so far as the combination of such elements is deliberately limited in its richness and complication, we may correctly speak of the "primitivising" tendency of such theories' (p. 133). cf. Malevich, *Die gegenstandslose Welt*, Munich, 1927, p. 74, where the use of geometrical elements is compared to primitive marks of primitive men 'which in their ensemble do not portray an ornament but the impression of rhythm'. Malevich's early work is contemporaneous with primitivism in Russian poetry.

38. From 'Hofmannsthal und seine Zeit', *Dichten und Erkennen*, Bd. 1, Zürich, 1955, p. 58. In the 'Zerfall der Werte' sections of *Huguenau oder die Sachlichkeit* (1932) Broch had traced abstraction in western thought back to the break-up of a supposedly unified value-system, that of the Christian Middle Ages. He implicated abstraction in the secular malaise of modern times, with God 'submerged in the infinite neutrality of the absolute', and society, emptied of actual unifying value-content, splitting into countless isolated and purely functional sub-systems, or 'Wertgebiete'. Does the *dialectical* relation of primitivism and abstraction before 1914 imply that the former was a counter-agent to abstraction so construed? There are signs (Picasso, Klee, Hugo Ball) that the momentum of abstraction had by 1912-14 reached a point at which it became polarized into abstraction and primitivism, with primitivism as an attempt to resuscitate, or reify, the sense of the numinous—that 'God' which abstraction had turned into a neutral absolute, exiled from a polluted world. Three of Broch's examples of 'Sprachschöpfer' in the later essay are Van Gogh, Cézanne and Henri Rousseau.

39. For Morgenstern, Palmström meant freedom from 'that condition of being wholly "immersed" in the world of appearances, a condition which keeps man today so much imprisoned and hamstrung'. The play of language might shake off 'the oppressive heaviness and clumsiness of the so-called physical level of reality, which is nowadays decreed, with all the earnestness of an epoch deprived of God and spirit, to be the sole and only redeeming quality' (Morgenstern's words, quoted in M. Bauer, *Christian Morgenstern*, pp. 177, 186).

40. Examples of motifs: Jakob van Hoddis, 'Carthago'; Georg Heym,

'Das infernalische Abendmahl' (section II); possibly Heym's 'Die Gorillas'; Benn, 'Hier ist kein Trost' and 'Gesänge' (II). I would exclude Elsa Lasker-Schüler's child-persona poems, but not Kurt Schwitters's 'Grünes Kind' and his prose collage 'Aufruf! ein Epos' (in *Anna Blume und ich*, Zürich, 1965, pp. 201-4). Schwitters's version of primitivism is one of the liveliest spectacles of the period; his use of 'base' material in collage is one aspect of it.

41. *Über das Geistige in der Kunst*, pp. 94-5. Heinrich Hoerle (later a Constructivist) published in *Die Aktion* in 1917 (20 Jan.) a note in praise of plain surface in Picasso: 'Picasso turned away from pictorial representation and returned—true primitive that he was—to the fundamental thing= the picture surface' (*Ich schneide die Zeit aus*, ed. Paul Raabe, Munich, 1964, p. 269).

42. Source as in note 26, above.

43. *Werke in drei Bänden*, Bd. 3, pp. 705-6. cf. Paul Hatvani (in *Die Aktion*, 17 March 1917), linking relativity theory with Expressionist dynamism in terms of perspective: 'the "psychocentric orientation" of thought and feeling forbids adoption of standpoints. Thus everything flows back to where it once came from: into consciousness . . . motion: everything depends on that' (*Ich schneide die Zeit aus*, pp. 276-7).

44. Correspondences between the last section of 'Helian' and Paul Klee's painting *Scheidung abends* are discussed in a perceptive article by Jürgen Walter, 'Orientierung auf der formalen Ebene', in *DVS* 42, Nov. 1968. At points Walter's argument about Trakl's open texture verges on the plane-surface problem: 'Trakl's poem does not give the impression of something "external", nor is it a receptive expression of something "internal", it is neither a vision rooted wholly in emotion, vision pressing "necessarily" toward a definite formal structure, nor does it set out to "catch up with" some kind of project, mood, or memory which it might grasp formally as content and realize as a poem' (p. 647).

45. *Die Flucht aus der Zeit*, p. 100.

46. *Briefe 1911-27*, Einsiedeln—Zürich—Cologne, 1957, pp. 278-9: 'The Futurists' word-analyses were naturalistic, but our own experiments, dear Arp, are magical' (22 Nov. 1926). Ball's later study of mystical ceremonies did not shake his idea that primitivizing could be a form of ritual regression to psychic origins: 'An inexhaustible meaning dwells in the rites and ceremonies. Nobody can resist their divine influence. Lanterns and candles in glowing symmetry; a primitive mixture of animals' sounds and children's sounds; a music which vibrates in cadences now long vanished; all this astonishes the soul and reminds it of its original home' (*Byzantinisches Christentum*, Munich-Leipzig, 1923, p.132). In Mann's *Doktor Faustus*, such magic is in the terms of Leverkühn's contract with the devil ('the archaic, the primal dawn-time, things long since never attempted'). In Leverkühn's *Apocalypsis cum figuris*, there is a choral music with elements akin to

Ball's idea: 'choruses thus, which pass through all the nuances of finely graded whisperings, distributed speech, semi-singing, to the most polyphonic song,—accompanied by sounds which begin as mere noise, as magical, fantastic, negroid drumming and clangour of gongs, and extend to the loftiest music' (Moderne Klassiker edn., Frankfurt am Main, 1967, p. 373; the 'das Archaische' phrase, p. 237).

47. There might have been sources for 'Katzen und Pfauen', 'Totenklage', 'Gadji beri bimba' and 'Karawane' (Gesammelte Gedichte, Zürich, 1963). Three possibilities: Carl Meinhof's linguistic writings, Jan Ephraim (much-travelled proprietor of the Holländische Meierei), and 'die dicke Negerin Miss Ranovalla de Singapore', whom Ball met in a Basel Wirtsstube in Nov. 1915 (Die Flucht aus der Zeit, p. 58). I am grateful to Dr Marcel van Spaandonck of the Merelbeke Institute for information about African words in these poems.

48. See R. Brinkmann, ' "Abstrakte" Lyrik im Expressionismus und die Möglichkeit symbolischer Aussage', in Der deutsche Expressionismus, esp. pp. 105-9.

49. Die Flucht aus der Zeit, pp. 98-100.

50. Gesammelte Gedichte, Bd. 1, Zürich, 1963, pp. 163, 161.

51. Personal Knowledge, Chicago and London, 1958; also 'Sense-Giving and Sense-Reading', Philosophy, 42 (1967), no. 162.

52. V. Markov, Russian Futurism: A History, p. 14. See also p. 141, on Victor Boris Shklovski's early views on 'making it strange' and the startling renewal of the poetic image by word-distortion (Voskresenie slova, 1914). On 'Zaum' see Markov, pp. 345-50, where Kruchenykh's 'Declaration of Transrational Language' (1921) is translated.

53. Paul Klee, Das bildnerische Denken, Schriften zur Form und Gestaltungslehre, Basle, 1964, p. 457.

54. See Eldridge Cleaver, Soul on Ice, New York, 1968, pp. 202-4.

55. Herbert Marcuse, An Essay on Liberation, Boston, 1969, p. 45. Erich Kahler (in The Disintegration of Form, New York, 1968) views with profound suspicion the desublimations in which Marcuse detects cathartic changes in 'the historical topos of the aesthetic' leading towards a 'transformation of the Lebenswelt' (op. cit., p. 45). It seems to me that Marcuse does disregard a real difference between sensibility which creates and that which can only destroy.

p. 38, 'BOLSHEVISM IN ART'

1. En Avant Dada, Hanover, 1920; English translation in R. Motherwell, The Dada Painters and Poets, New York, 1951.

2. Quoted in Georges Hugnet, L'Aventure Dada, Paris, 1957, p. 24. Cited hereafter as Hugnet.

3. R. Hausmann, Courrier Dada, Paris, 1958, cited hereafter as Hausmann; G. Grosz, A Little Yes and a Big No, New York, 1946; R. Huelsenbeck,

Mit Witz, Licht und Grütze, Wiesbaden, 1957.

4. Hugnet, p. 23.

5. H. Ball, *Die Flucht aus der Zeit*, Lucerne, 1946, p. 81.

6. ibid., p. 92.

7. Reprinted in H. Arp, R. Huelsenbeck and T. Tzara, *Die Geburt des Dada*, Zürich, 1957, p. 171.

8. Hugnet, p. 21, includes this event in a description of the other details which relate to the Waag manifestation.

9. Tristan Tzara, *7 Manifestes Dada*, Paris, n.d. (1921), pp. 25-7. Cited hereafter as *Manifestes*.

10. *Manifestes*, pp. 20-21.

11. Hausmann, p. 26.

12. The *Der Einzige* article is included in Hausmann, pp. 33-6, 'Dadaistische Abrechnung' in *Expressionismus: Literatur und Kunst* (catalogue of the 1960 exhibition, Schiller National Museum, Marbach), pp. 231-2.

13. *Dada-Almanach*, ed. R. Huelsenbeck, Berlin, 1920, p. 59.

14. Full text in *Expressionismus*, pp. 236-7.

15. W. Mehring, *Berlin Dada*, Zürich, 1959, p. 69.

16. W. Mehring, *The Lost Library*, London, 1951, p. 148.

17. Hausmann, p.24. Grosz supposedly joined the KPD in Dec. 1918.

18. Account in his pamphlet *Schutzhaft*, Berlin, 1919.

19. A report on the trial, by Ignaz Wrobel, appeared in *Die Weltbühne*, XVII, 1 (1921), pp. 454-7.

20. Hausmann, p. 79.

21. Hausmann, pp. 86-8.

22. Hausmann, p. 81.

23. K. Mann, *The Turning Point*, New York, 1942, p. 122.

24. Berlin, 1921.

25. *Merz*, ed K. Schwitters (Hanover, April 1923), Heft 2, p. 32.

26. Hausmann, p. 91, quoting from his 'PREsentisme' manifesto, which appeared in *De Stijl*, ed. Theo van Doesburg (Leyden, May 1921).

27. G. Grosz and W. Herzfelde, *Die Kunst ist in Gefahr*, Berlin, 1925, p. 24. This and the next statement are both made in first-person-singular contexts; the footnote to p. 13 says that all such statements in the book are by Grosz.

28. ibid., p. 44.

29. In the original: 'Dada était un combat pour un nouvel équilibre intérieur convergent et contradictoire' (Hausmann, p. 145).

30. Hugnet, p. 53.

31. *Die Kunst ist in Gefahr*, p. 45.

32. Hugnet, p. 79.

33. Paris, 1920, p. 14.

34. *Manifestes*, p. 49.

35. *Manifestes*, p. 75. Untranslatable word-play is intrinsic to the state-

ment: 'Dada place avant l'action et au-dessus de tout: Le Doute. DADA doute de tout. Dada est tatou. Tout est Dada. Méfiez-vous de Dada. L'anti-Dadaisme est une maladie: la selfcleptomanie, l'état normal de l'homme est Dada. Mais les vrais dadas sont contre DADA.'

36. *Manifestes*, p. 82.

37. Quoted by Maurice Nadeau, *Histoire du Surréalisme* (1945), Paris, 1958, p. 24.

38. Hugnet, p. 72. An apter transposition of the four last words is not unthinkable.

39. *Littérature*, ed. L. Aragon, A. Breton, P. Soupault (Paris, March 1921), pp. 1-7. The same issue does contain three pages, two of them by Pierre Drieu de La Rochelle, on the Socialist leader G. Dazet, who had just died.

40. *Manifestes*, p. 84.

41. 'Like a gyroscope, [the elusive *form* of art in the twentieth century] sustains itself by a concentration of forces in self-reflexiveness, art turning upon itself', R. Shattuck, *The Banquet Years*, New York, 1958, p. 271; Anchor Books edition, 1961, p. 352.

42. 'André Breton devient le moraliste du mouvement Dada. Qui en sera l'esthéticien?' (*Projecteur*, Paris, 21 May 1920 [5th unnumbered page]).

43. See Nadeau, *Histoire du Surréalisme*, p. 29.

44. M. Cowley, *Exile's Return* (1934), London, 1961, p. 153.

45. ibid., p. 154.

46. ibid., p. 162.

47. *Littérature*, ed. A. Breton, Nouvelle Série, Paris, no. 4 (1922), p. 2.

p. 62, DADA VERSUS EXPRESSIONISM

1. H. Arp, *Unsern täglichen Traum* . . ., Wiesbaden, 1955, pp. 56-7.

2. H. Ball, *Briefe 1911-27*, Einsiedeln-Cologne, 1947, pp. 81-2: letter dated 26 June 1917, to August Hoffmann.

3. H. Ball, *Die Flucht aus der Zeit* (1st ed., Munich, 1927), Luzern, 1947, p. 24. To facilitate reference, subsequent page references are square-bracketed as plain figures in the text.

4. Ball was model for Vorlang in Frank's novel *Der Todessprung im Zirkus*.

5. *Der Aufbruch zum Paradies*, 1922, cited by A. Soergel, *Im Banne des Expressionismus*, Leipzig, 1927, p. 369.

6. *Briefe*, cit., p. 118: letter to Emmy Hennings, 1918.

7. W. Worringer, *Abstraktion und Einfühlung*, 3rd. enlarged ed., Munich, 1911, p. 135 f.

8. The relevant extract is in P. Pörtner, *Literatur-Revolution*, vol. 1, Darmstadt, 1960, pp. 136-40. The extract has hitherto been available only in Emmy Ball-Hennings's doctored versions, *Ruf und Echo*, Einsiedeln-Cologne, 1953, pp. 95-7.

9. *Flucht*, cit., p. 158: 'Metaphor, imagination and magic itself, if they are not based on revelation and tradition, are abbreviations, and they only

guarantee the pathways into nothingness; they are trickery and diabolism. Perhaps all associative art, with which we think to entrap the times, is self-deception. The source to which we are moving will be the natural paradise; the mystery we experience will be that of natural genesis. In other words: there is no way to sustain a purely pictorial antithesis to nature and to events.'

10. *Briefe*, cit., p. 106, on Rubiner's 'gesticulation'. cf. p. 88: 'Do not envisage the main accent as one that falls on propaganda about humanity, on that rhetoric which is only binding in a literary way, not in a public way.'

11. *Hochland*, vol. XIV, 1926-7, p. 129 f. and p. 325 f.

12. *Literatur-Revolution*, cit., p. 240.

13. H. Arp, *Unsern täglichen Traum* . . ., cit., p. 50: 'Dada is for the "without-sense" of art, which does not mean nonsense. Dada is without sense, as nature is.'

14. In *Poèmes et dessins de la fille née sans mère*, Lausanne, 1918.

15. Ball repeats this view of modernity in art in his *Hochland* essay: 'The constitutive element of appearances and thus everything uncanny and mysterious stemming from the dream world, but also their law—it is the ultimate prison of the soul that has to be apprehended and made visible.' *Hochland*, XIV, cit., p. 139 (Ball's religious crisis of 1920 is reflected in the change here of 'geistige Person' into 'Seele').

16. See his foreword to P. Pörtner, *Literatur-Revolution*, cit. Emrich also tends to over-generalize Dada, which had in effect four separate epiphanies: Zürich, 1916-19; Berlin, 1918-20; Cologne, 1919-20; Paris, 1920-2 (omitting Merz in Hanover, 1919 f.)

17. Entry for 1 March 1916: 'Arp declares his opposition to the bombast of the god-almighties of paint (Expressionists) . . . He would like to purify the imagination and attend exclusively to the revealing not so much of imagination's images as of what constitutes those images'.

18. *Literatur-Revolution*, cit., p. 234.

19. *Tarr*, London, 1918, p. 8.

20. E. Stadler, *Dichtungen*, vol. I (ed. K. L. Schneider), Hamburg, n.d., p. 166. L. Rubiner, *Das himmlische Licht*, Munich, 1920 (2nd ed.), pp. 19-21. In the famous poem 'Lächeln Atmen Schreiten' (*Einander*, 1914-5), Werfel's attempt at immediacy of diction and image also achieves only a fustian effect in all but a few lines. This is again symptomatic of the Expressionist failure to create a living idiom for vital convictions, whether of revolt or of revolution. The first four lines of Werfel's poem rely on the canonical image of the magician in whose hands water forms a sphere; but when this (literary) image elides with his own 'smile' image, they erase each other: 'smile, happy moisture, stretched all over the face'.

21. The 'Dada-Rede' appeared in *Dada-Almanach*, Berlin, 1920; the pamphlets were published respectively by Steegemann, Hannover, and Malik Verlag, Berlin; the article appeared in *Die neue Rundschau*, vol. XXXI, pp.

972-9. Hereafter the last is cited in the text as *NR*, with plain figures for page references. *En Avant Dada* is cited as such, also with plain figures. One other document is Raoul Hausmann's attack on the 'serene' poets and on Expressionism, in the magazine *Der Einzige*, 20 April 1919; but it is not discussed here since it corresponds in most details, and in its tone, with Huelsenbeck's version of anti-Expressionism: the anti-bourgeois accent, the hostility to 'sedentary' middle-class literature as something poisoned by capitalist economy and bogus idealism.

22. Account in his *Schutzhaft*, Berlin, Malik Verlag, 1919.

23. Under the headline 'Künstler und Revolution', in *Vorwärts*, 26 March 1919. The reading from Becher here shows how fluid political alignments could be at the time. In 1918 he had joined the Communist Party; and he was a member of the *Spartakusbund* (see *Expressionismus*, catalogue of the Marbach Exhibition, 1960, p. 205).

24. cf. G. Lukács, *Probleme des Realismus*, Berlin, 1955, p. 146 f. There is common ground between Dada criticism of Expressionism and that of Lukács, but two distinctions must be made: (1) Berlin Dada followed Lenin, but before Lenin's 1921 concessions over ownership, capital and coercion, and before the rift between the Bolshevik Party and the proletariat, which the Tenth Party Congress in 1921 tried to heal (see Paul Levi, introduction to R. Luxemburg, *Die russische Revolution*, Berlin, 1922, p. 40 f.); (2) Lukács wrote his essay on Expressionism in the Stalin period (1938); and Berlin Dada would not have accepted his inferences even if it had conceded his premises.

25. Huelsenbeck, *Mit Witz, Licht und Grütze*, Wiesbaden, 1957, p. 124; and R. Hausmann, *Courrier Dada*, Paris, 1958, p. 24.

26. e.g. *Die Pleite*, January 1919 f., *Der blutige Ernst*, February [?] 1919 f., *Jedermann sein eigener Fussball*, February 1919.

27. Hausmann, *Courrier Dada*, cit., p. 24, refutes Hugnet's allegation (*L'esprit Dada en Allemagne*, 1932) that all the Berlin Dadaists were Communists. Hugnet, it is known, was prompted in many details by Tzara, and the degree of rectitude in Tzara's views on Berlin Dada can be assessed from his statement that Dada in Berlin 'helped to bring on the German Revolution' (in his article written for *Vanity Fair*, 1927, reprinted in E. Wilson, *Axel's Castle*, New York, 1931 (cf. ibid., p. 309).

28. Jung's *Die Technik des Glücks*, 1921, is significant not least for its blending into the terms of Otto Gross's socio-psychology such Dadaist notions as 'livingness' ('lebendiges Erleben'), spontaneity, social *rhythm* (as opposed to *structure*) and simultanism. Jung, like Huelsenbeck, later became a psychiatrist.

29. A more familiar analysis of the strenuous relation between the intellectual and the masses is that contained in the dialogues between the Woman and the Nameless One in Toller's *Masse-Mensch*, 1919.

30. *Courrier Dada*, cit., p. 26.

31. W. Paulsen (*Expressionismus und Aktivismus*, Bern-Leipzig, 1935, p. 63) noted that Dada and Activism differ in that Huelsenbeck rejects Activist meliorism. But, like several writers since, Paulsen missed the ironic strain of certain statements by Huelsenbeck, and took his nihilism and opportunism too much at face value. Neither did Paulsen appreciate Dada's self-appointed role in the conflict of class, or the abrogation of the 'aesthetic attitude' which Huelsenbeck also proclaimed in *Dada siegt*.

32. Anti-art and the technique of public provocation were not the only bequest of Futurism to Dada. For an account of Futurist provocations in Florence and Prato, see Theodor Däubler's pamphlet *Im Kampfe um die moderne Kunst* (written 1918), Berlin, 1919. Däubler underscored the fact that such provocations could be lucrative.

33. Huelsenbeck moderated his tone for readers of *Die neue Rundschau*. In *Dada siegt* (p. 37) the bourgeois has his Goethe in one hand and in the other his bayonet.

34. Again Huelsenbeck toned his language down. He meant: 'Dada ist eine deutsche bolschewistische Angelegenheit.'

35. Cited by Guido Severini, *The Artist and Society*, London, 1946, p. 23.

36. In *Die Erhebung* (ed. A. Wolfenstein), vol. I, Berlin, n.d. [1919], p. 360 f.

37. See 'Erklärung des Club Dada' in *Dada-Almanach*, Berlin, 1920, p. 133 (unsigned): 'Everything human beings and bodies do and do not do, happens as an entertainment for heaven, in its amusedness, a game of the loftiest kind, which is seen and experienced in ways whose varied multiplicity equals that of the units of consciousness confronting its occurrence.'

p. 95. THE PICTURE OF NOBODY

1. Whenever possible the edition cited is Robert Walser, *Dichtungen in Prosa* (Geneva, Holle Verlag), of which [1957] 3 vols. have appeared: *Aufsätze und Kleine Dichtungen*, 1953 (hereafter *AKD*), *Unveröffentlichte Prosadichtungen*, 1954 (hereafter *UP*) and *Der Gehülfe*, 1955. Works or extracts from works not yet included in this edition are cited from editions as follows (unless otherwise indicated, page numbers in the text refer to the work under discussion in the edition as given): *Fritz Kochers Aufsätze*, Leipzig, Insel, 1904; *Geschwister Tanner*, Zürich, Rascher, 1933; *Jakob von Gunten*, Zürich, Steinberg, 1951; *Aufsätze*, Leipzig, Wolff, 1913; *Geschichten*, Leipzig, Wolff, 1914; *Kleine Dichtungen*, Leipzig, Wolff, 1915 (some pieces from this edition, which followed a first limited edition dated 1914, are omitted from *AKD*); *Prosastücke*, Zürich, Rascher, 1917; *Kleine Prosa*, Berne, Francke, 1917; *Der Spaziergang*, Frauenfeld-Leipzig, Huber, 1917; *Poetenleben*, Frauenfeld-Leipzig, Huber, 1918; *Seeland*, Zürich, Rascher, 1919 (this includes a version of *Der Spaziergang* differing slightly from the 1917 version); *Die Rose*, Berlin, Rowohlt, 1925; and *Grosse kleine Welt*, Erlenbach/Zürich-Leipzig, Rentsch, 1937; a selection,

ed. C. Seelig.

A bibliography of Walser's book-publications appeared in *Der Schweizer Buchhandlungsgehilfe*, Berne, XXXVIII, 2 (1957).

2. Gottfried Keller, *Briefe und Tagebücher*, 1830-55, Zürich, Rascher, 1943, p. 384.

3. Christian Morgenstern, *Ein Leben in Briefen*, Wiesbaden, Insel, 1952, p. 243.

4. The biographical sketch given here is pieced together from Carl Seelig, *Wanderungen mit Robert Walser*, St Gall, Tschudy, 1957, hereafter cited as Seelig, O. Zinniker, *Robert Walser der Poet*, Zürich, Classen, 1947, and from *feuilletons* as follows: H. Bänziger, 'Pfarrer J. U. Walser aus Grub', *Neue Zürcher Zeitung*, 8 Aug. 1956, Wb (=W. Weber), 'Robert Walser', *Neue Zürcher Zeitung*, 29 Dec. 1956, and C. Seelig, 'Am Grab von Robert Walser', *National Zeitung*, Basel, 5-6 Jan., 1957. Walser's own biographical sketch published in *Der Lesezirkel*, Zürich, VIII, 2 (1920) is reprinted in *Du, Schweizerische Monatschrift*, Zürich, 1957, no. 10. Carl Seelig promises a documentary biography. Letters by Walser are to be included in the collected edition.

5. *Der Gehülfe*, pp. 20-6 and p. 316; cf. Seelig, p. 119.

6. Again published by Cassirer. Probably all four were written earlier. 'Aschenbrödel' appeared in *Die Insel* (ed. O. J. Bierbaum, A. W. Heymel and R. A. Schröder), II, 10 (Berlin, July 1901), 'Schneewitzchen' in *Die Insel*, II, 12 (Sept. 1901), and the prose dramolet 'Die Knaben', which echoes *Fritz Kochers Aufsätze*, in *Die Insel* (ed. O. J. Bierbaum), III, 9 (June 1902).

7. Samuel Beckett, *Proust*, New York, Grove, n.d. p. 22.

8. For pertinent remarks on some formal peculiarities of the *Icherzählung*, see K. Hamburger, *Die Logik der Dichtung*, Stuttgart, Klett, 1957, p. 220 ff. It is surprising that there should be no mention in this section of H.'s book of those aspects of Kafka's narrative technique which F. Beissner examines in his *Der Erzähler Franz Kafka*, Stuttgart, Kohlhammer, 1952.

9. In 'Der Dichter und diese Zeit', *Ges. Werke, Prosa II*, Frankfurt, 1951, p. 272.

10. See for instance Steffen's novel *Der rechte Liebhaber seines Schicksals* (1916; 4. Aufl, Dornach: Verlag für schöne Wissenschaften, n.d.), pp. 351-71.

11. See the 'Note on Walser and Kafka' below.

12. R.v.d.R. Woolley, in *Sunday Times* (London), 3 Nov. 1957.

13. Such apparently unmotivated suddenness of behaviour is reminiscent of nineteenth-century Russian fictional characters. In conversation with Seelig (Seelig, *passim*), Walser refers several times to Dostoevsky, once to Gogol and once to Gontcharov.

14. Robert Musil, *Tagebücher, Aphorismen, Essays und Reden*, Hamburg, Rowohlt, 1955, pp. 686-7.

15. cf. *Geschichten*, p. 79. In 'Das Götzenbild' (*Kleine Dichtungen*, 1914, *AKD*) as in the story 'Kleist in Thun' (*Geschichten*) the subject is again the *terror* of the elemental, the *pull* of the demonic.

16. For a fuller statement (literature as 'Lebensparallelismus'), see 'Meine Bemühungen', in *Grosse kleine Welt*, cit.

17. Helbling is an elaboration of the earlier 'Kommis' (of *Fritz Kochers Aufsätze*) and enters four other stories, viz. 'Ein Vormittag' (*Geschichten*), 'Das Büebli' and 'Germer' (*Aufsätze*, *AKD*), and 'Helbling' (*Kleine Prosa*). Helbling's chameleonic opposite, Tobold, merits attention, appearing in three pieces: 'Tobold' (*Kleine Dichtungen*, not in *AKD*), 'Tobold' (*Kleine Prosa*, a masterly story which Kafka might well have read before or while writing *Das Schloss*), and 'Aus Tobolds Leben' (*Poetenleben*).

18. Longer parodies of officialese come in *Der Spaziergang* during interviews with a bank clerk and an income-tax official.

19. The following remarks and those on contrariness ('Gegenläufigkeit') are indebted to Professor Karl Schmid's searching 'Versuch über die schweizerische Nationalität' in his *Aufsätze und Reden*, Zürich, Artemis, 1957.

20. W. B. Yeats, *Autobiographies*, London, Macmillan, 1955, p. 249.

21. Quoted by J. Pfeiffer in his *Über das Dichterische und den Dichter*, Hamburg, Meiner, 1957, p. 79.

p. 173, RILKE'S BIRTH OF VENUS

1. H. Berend, *Rainer Maria Rilkes Neue Gedichte: Versuch einer Deutung*, Bonn, 1957, p. 187. For a convenient summary of the Renaissance iconography of the myth, see Jean Seznec, *The Survival of the Pagan Gods* (1953), New York, Torchbooks, 1963, pp. 112 ff., citing the studies of A. Warburg (1932) and E. H. Gombrich (1945).

2. Quotations from Rilke are from *Sämtliche Werke* (Insel Verlag), vol. I (1955) for the poem, vol. V (1955) for extracts from *Rodin*.

3. *Sämtliche Werke*, V, p. 157 (the 1903 monograph).

4. *Sämtliche Werke*, V, pp. 219-20 (the 1905-7 'Vortrag').

5. J.-F. Angelloz tells of Rodin's once undertaking to show Rilke a sculpture in motion: *Rainer Maria Rilke—Evolution spirituelle du poète*, Paris, 1936, p. 194.

6. *Sämtliche Werke*, V, p. 171 (1903).

7. ibid., p. 198.

8. cf. the letter to Lou Andreas-Salomé, dated 15 January 1904, describing a Greek fresco: 'Thus in this picture rest and movement were juxtaposed, not in contrast, rather as a metaphor, as a finite unity, which slowly closed like a wound healing; for the movement, too, was rest . . .' (*Briefe I*, 1950, p. 68). This passage is also quoted by Theodore Ziolkowski in his penetrating work on equilibrium and associated ideas in Rilke: 'Rilke's "Portal" Sonnets', *PMLA*, LXX, 1959, pp. 298-305.

9. 'die kleine Welle . . . den Lenden' (see paragraph four of prose translation

at head of text). Berend (pp. 188-9) seems to take this as a literal ripple: he claims that the sea, throughout the poem, is shaping itself into Venus: 'the radiant joy of the inert sea-stuff, which is exterior, as it transforms itself, in birth, into the living, shining interior of the spirit-form . . .' This dualistic reading, with eyes averted from the goddess as nude, is not supported by the text. *Welle* as ripple denotes by analogy the groin muscle.

10. The speaking of the line, as with several others in the poem, necessitates mouth movements of the kind which David I. Masson has analysed in several essays, and which he calls 'illustrative mime' ('Sound and Sense: Mechanisms of a Middle Rilkean Sonnet', *MLR*, LIX, 1964, p.239). I have risked the simpler and commoner term 'voicing' where such activities are the case.

11. cf. Kenneth Clark, *The Nude*, New York, Anchor, 1959, p. 225: 'To place on a naked body a head with so much individual character is to jeopardize the whole premise of the nude. . .'

12. Hans Schwerte, in 'Rilkes "Geburt der Venus" ', *GRM* (*Neue Folge* I, 1950), pp. 155-9, has discussed the classical sources of the dolphin and its association with Aphrodite. See also C. G. Jung and C. Kerényi, *Essays on a Science of Mythology*, New York, Torchbooks, 1963, pp. 49-51. Schwerte suggests that one source for Rilke's implicit equation of dolphin and womb might have been the 1887 edition of Otto Keller's *Thiere des klassischen Alterthums in kulturgeschichtlicher Beziehung*, Innsbruck, 1887, p. 224. Keller noted the supposed (originally Phoenician) etymological link between *delphis* and *delphus*, as well as the association of the dolphin with Aphrodite. Rilke could also have been familiar with several pictorial and sculptural sources in which the dolphin occurs, e.g., the Medici Venus, and Ingres' 'Venus Anadyomene' (whose arms are raised, one of them above her head, and bear a remarkable resemblance to the necks of swans).

13. Letter of 26 September 1902, *Gesammelte Briefe*, Bd. 1, Leipzig, Insel, 1939. Not in *Briefe I* of 1950.

14. See John Barron, *Greek Sculpture*, New York, 1965, pp. 64-5.

15. Schwerte, p. 156.

16. 'Simplifying, one can say: the entire central portion of the poem, all of it, that is, except the first and last strophes, receives its life from the tone of the early "Mädchenlieder" . . . and of the *Buch der Bilder*—even though this assertion does not apply to the new-found linguistic means; thus these central strophes are a transition to the special form of the *Neue Gedichte*. Yet the inner imaginative space still reverberates with those early verses . . . This "Birth" is clearly still "Botticelli", Rilke-esque Springtime and Maiden Renaissance, mingled perhaps with a memory of the sweet uplifting of the Aphrodite depicted on the Ludovici throne.'

p. 190, MÖRIKE'S MOONCHILD

1. The ed. cit., is Eduard Mörike, *Sämtliche Werke*, Stuttgart (J. G. Cotta'sche Buchhandlung Nachfolger), n.d., in 2 vols., ed. G. Baumann. The first line of the poem in this edition reads not 'Tochter des Walds' but 'Tochter des Waldes'. As 'Walds' is found in the 1848 edition of Mörike's poems and in all subsequent editions down to that of Maync, 'Waldes' would appear to be a misprint. The reading 'Walds' has been retained.

2. In *Die deutsche Lyrik*, ed. by Benno von Wiese, Düsseldorf, Bagel, 1956, pp. 79-90. Storz's is the only independent account published at the time of writing (cf. the lists of interpretations in *MDU*, XLIX, 5; also H. W. Eppelsheimer, *Bibliographie der deutschen Literaturwissenschaft*, 2 vols. covering the periods 1945-53 and 1954-6 respectively, Frankfurt am Main, V. Klostermann, 1957 and 1958). The poem is discussed in B. von Wiese, *Eduard Mörike*, Tübingen, Wunderlich, 1950. E. Minwegen's thesis, *Die Sprache der Blumen* (Bonn, 1949), contains an account of the flower's vicissitudes in earlier literature as well as a discussion of the poem.

3. Werner von Nordheim sees the poem as a first climax of the later verse in his thesis *Die Einsamkeitserfahrung Eduard Mörikes und ihre Aussprache im dichterischen Werk*, Hamburg, 1954, p. 70: 'A further, new, concretely realistic kind of poem, the thing-poem, after certain preliminaries in 1837, reaches its first peak in 1841-2: 'Auf eine Christblume', and 'Die schöne Buche' are the most characteristic examples.'

4. cf. W. Zemp, in his introduction to Eduard Mörike, *Briefe*, Zürich, Manesse, 1949, p. 42: 'The development thus outlined brings with it, as the poet's later work manifests, an entirely new joy in small and tangible objects, even in tiny objects, a joy at perceiving God in detail.' The water-colour called 'Blick durch das Schlüsselloch der Kirche von Wermutshausen' is often cited as a playful example of this. cf. also B. Müller, *Eduard Mörike/ Grundriss seines Dichtertums*, Winterthur, P. G. Keller, 1955, p. 62: 'The smallness of the thing is a kind of counterpoint to the infinite distance which opens up in the lyrical moment.'

5. See the remarks on the lily in G. H. Schubert, note 9, below.

6. See A. Beck's interpretation of 'An einem Wintermorgen' in *Euph.*, XLVI, 1952, pp. 370-93, especially p. 388: 'As a commitment to day and action . . . the "Wintermorgen" poem distances itself from the sphere of "Peregrina" . . . from the "dark shafts" in which the secret forces of life mesh, understandable in moments of insight, but formless; it distances itself from the perilous and ultimately altogether disenchanting descent into the Hades of the soul.'

7. A. Mohrhenn, *Lebendige Dichtung*, Heidelberg, L. Schneider, 1956, pp. 33 f. Beck (see note 6 above), p. 389, also notes this characteristic of the protean Mörike: 'The two basic impulses . . . appear sometimes separately, each in a pure form of its own, sometimes in a delicious blend, sometimes in a dangerous tension.'

8. B.v.Wiese, *Eduard Mörike*, cit., p. 78.

9. The letter is reproduced in *Eduard Mörikes Briefe*, ed. by K. Fischer and R. Krauss, Berlin, 1903 f., and in extract in W. Zemp's selection, cited above (pp. 267-9). Pastor Müller describes the flower in paragraph 73 (pp. 68-9) of his little book, under the heading 'De plantis fibrosis. Von den zaselichten Gewächsen'. Since it cannot be unlikely that Mörike had read G. H. Schubert's *Ansichten von der Nachtseite der Naturwissenschaft*, two points made in these lectures might here be noticed. Schubert stresses the sun's conditioning of plants—which would make Mörike's 'Kind des Mondes' all the more strange and remote; and he stresses the pristine quality of the lily in terms which make a curious coincidence with Mörike's 'lilienverwandt': 'Who might not, when contemplating the tall tranquil lily, be reminded of that early time of aboriginal purity and innocence, of which the lily appears as a symbol, and thus recognize lilies and all kindred plants as children of a most ancient period of the world, which has long since subsided' (*Ansichten*, Dresden, 1827 [3rd ed.] p. 194).

10. E. Staiger, 'Mörike: Das verlassene Mägdlein', in *Die Kunst der Interpretation*, Zürich, Atlantis, 1955; and E. Trümpler, *Mörike und die vier Elemente*, St Gall, Eirene, 1954, chap. I, *passim*. cf. Beck, cit., p. 380 on lines 5 and 6 of 'An einem Wintermorgen': ' "Now" [the soul] feels once more utterly undefiled, flashing like the virgin crystal in the *pure* ray of light'.

11. cf. A. Langen, *Der Wortschatz des Pietismus*, Tübingen, Niemeyer, 1954, p. 302.

12. See his introduction to Eduard Mörike, *Briefe*, cit., p. 48.

13. It seems likely that this image also sprang from the notion of 'early bloom' which Mörike found in Pastor Müller.

14. Preface to Goethe, *Das Märchen*, Iserlohn, Silva, 1948, p. 23.

15. W.v.Nordheim, 'Die Dingdichtung Eduard Mörikes, erläutert am Beispiel des Gedichtes "Auf eine Lampe" ', *Euph.*, L, 1956, pp. 71-85.

16. *Grosse Stuttgarter Ausgabe*, 1951, 2, I, p. 13.

17. See his *Grundlagen der Physiognomik*, Leipzig, Insel, 1922, p. 105. Similar problems arising in Rilke and Hofmannsthal are discussed at length by F. W. Wodtke in his essay 'Das Problem der Sprache beim späten Rilke', *OL*, XI, 1956, 1/2.

18. E. Vivas, *Creation and Discovery*, New York, Noonday, 1954, p. 106. On his use of the term 'intransitive', see his 'Definition of Aesthetic Experience (op. cit., pp. 93-9). Vivas disparages the term 'icon' in this context (p. 107).

19. *Maximen und Reflexionen*, no. 533, *Artemis Ausgabe*, IX (ed. by P. Stöcklein), p. 567.

20. E. Saenger, 'Mira', in *German Short Stories of To-day*, ed. E. H. Schumann and G. M. Wolff, London, Harrap, 1952 (2nd imp.), p. 91.

21. *Euph.*, L, p. 85.

22. ibid., p. 75.

23. K. Oppert, 'Das Dinggedicht: eine Kunstform bei Mörike, Meyer und Rilke, *DVS*, IV, 1926, pp. 747-83.

24. ibid., p. 768.

25. In his *Über Klangmittel im Vers-Innern, aufgeziegt an der Lyrik Eduard Mörikes*, Bern, Francke, 1920, A. Fischli discussed assonance and alliteration, also cognate patterns, in a way which first proved how even Maync had erred in writing of Mörike: 'Alliteration occurs very rarely in his work, assonance never' (H. Maync,*Eduard Mörike, Sein Leben und Dichten*, Berlin-Stuttgart, 1913 [2nd edn.], p. 262). Fischli's work does not seem to have had the recognition it deserves. He shows what intricate internal patterns in Mörike's lines offset his not infrequently faulty rhymes.

26. David I. Masson, 'Vowel and Consonant Patterns in Poetry', *Journal of Aesthetics and Art Criticism*, XII, 1953, pp. 213-27, p. 227. The most relevant research by any phonetician prior to that of Masson is M. M. Macdermott, *Vowel Sounds in Poetry*, London, Kegan Paul, 1940, where only English verse is discussed.

27. The only word which might suggest sound to some ears is 'huscht' in stanza 7.

28. See Macdermott, *Vowel Sounds*, cit., for an account of the pitch series of English vowels. German vowels are included within the range of her phonetic symbols.

29. R. A. S. Paget, *Human Speech*, London, Kegan Paul, 1930, especially pp. 135, 137, 154-5 (cf. Masson, cit., p. 222).

30. Masson, cit., p. 215.

31. The 2nd and 3rd eds. of Mörike's poems read 'hold' for 'zart'. Fischli, cit., p. 13, notes a change from vocalic to consonantal linking in the later revision, rather than a mixture of both. He also asserts that the 2nd and 3rd eds. read 'Spur' for 'Zier'; but 'Zier' is found already in the 2nd (1848) ed., where the poem appeared after being first published in the *Morgenblatt für gebildete Stände*, 1842, no. 22.

32. See R. Minder, ' "Herrlichkeit" chez Hegel, ou le monde des pères souabes', *EG*, VI, 1951, pp. 275-90; J. Klaiber, *Hölderlin, Hegel und Schelling in ihren Jugendjahren*, Stuttgart, 1877; and, for a thorough study of Swabian schools of thought, H. O. Burger, *Die Gedankenwelt der grossen Schwaben*, Tübingen-Stuttgart, Wunderlich, 1951.

33. F. C. Oetinger, *Swedenborgs und anderer irdische und himmlische Philosophie*, 1765, II, p. 341.

34. C. A. Auberlen, *Die Theosophie Friedrich Christoph Oetingers nach ihren Grundzügen*, Tübingen, 1847, p. 147 f. The most accessible modern guide to the intricacies of Oetinger's thought is W.-A. Hauck, *Das Geheimnis des Lebens*, Heidelberg, winter, 1947.

p. 209, PATTERN WITHOUT PREDICTABILITY

1. [poems 1918-22] : Verlag der Sturm, p. 18. The poem is reprinted in *Anna Blume und ich* (ed. Ernst Schwitters), Zürich, Arche Verlag, 1965; also in the DTV anthology *Das war Dada* (ed. Paul Pörtner), 1963. It did not appear in *Anna Blume*, 1919.

2. From the preface to *Pin* (ed. Jasia Reichardt), London, Gaberbocchus Press, 1962, p. 23.

3. Stefan Themerson, *Kurt Schwitters in England*, London, Gaberbocchus Press, 1958, p. 50.

p. 214, NOTES ON SOME POEMS

1. Paul Valéry, *The Art of Poetry*, New York, Vintage Books, 1961, pp. 171 and 211 (translation by Denise Folliot).

2. T. S. Eliot, 'The Music of Poetry', in *On Poets and Poetry*, London, Faber, 1957, p. 35.

p. 233, AN ENIGMA TRANSFIGURED

1. Figures in brackets refer throughout to volume and page numbers in *Gesammelte Dichtungen*, Berlin, Suhrkamp, 1952.

2. cf. 'Erinnerung an Lektüre', *Die Neue Rundschau*, XXXVI, 1925, Heft 9.

3. R. Wilhelm and C. G. Jung, *The Secret of the Golden Flower*, London, (1931) 1950, p. 19 (1st German ed. 1929).

4. ibid.

5. A. K. Coomaraswamy, *A New Approach to the Vedas*, London, 1933, p. 67.

6. *The Secret of the Golden Flower*, p. 19. cf. R. Guénon, *Le Symbolisme de la Croix*, Paris (1931) 1950, p. 69, note 1.

7. F. W. Buckler, *The Epiphany of the Cross*, Cambridge, 1938, pp. 100 f.

p. 239, HERMANN HESSE'S *MORGENLANDFAHRT*

[N.B. Note numbers appear here in square brackets, page references in round brackets.]

1. Unless otherwise indicated the source of quotations and references throughout this essay is Hermann Hesse, *Gesammelte Dichtungen*, in six volumes (Frankfurt, 1952). Hereafter only page numbers will be given for references to *Die Morgenlandfahrt*, which is contained in vol. VI.

2. *Piktors Verwandlungen* is not included in *Gesammelte Dichtungen*. It was originally circulated as an illustrated manuscript in Hesse's own hand. Bücherfreunde Chemnitz printed seven hundred copies for limited circulation, but not for sale, in 1925. The Suhrkamp edition of 1954 is a facsimile of the manuscript, and also includes four unnumbered pages of printed text.

3. Carlsson (in *Dank an Hermann Hesse*, Frankfurt, 1952, p. 96) proposes that H.H. finally knows in triumph the 'timelessness of his idea'. But this is

to introduce Hegel where he has no place.

4. Diels, *Fragmente der Vorsokratiker*, vol. I, fr. 60.

5. Seilergraben in Zürich may be the source of this street-name, as Morbio (5 km. east of Mendrisio, in Italian Switzerland) is the source of Morbio Inferiore.

6. Hermann Hesse, *Briefe*, Berlin-Frankfurt, 1951, p. 36.

7. *Also sprach Zarathustra* (Musarion ed., XIII, 11). Nietzsche's image itself is a variation of *Bhagavad Gita*, VII, 7, and of *Brhadaranyaka Upanishad*, III, 7, 1. Homer and Plato used kindred images: see *Iliad* VIII. 18 f., *Laws*, 644 and 803-44, and *Theatetus*, 155 D. Likewise Hölderlin in the poem called 'Blödigkeit'. Hesse's interest in oriental thought dates from *Gertrud* (1910).

8. A. Waley, *Three Ways of Thought in Ancient China*, London, 1946, p. 61.

9. It is appropriate that Albertus Magnus should number among H.H.'s judges. His Neoplatonism stressed the kenotic 'Entwerdungsmystik' of Augustine, and his commentaries on Dionysius the Areopagite were treasuries for early Swabian religious thinkers (cf. H. O. Bürger, *Die Gedankenwelt der grossen Schwaben*, Stuttgart-Tübingen, 1951, pp. 71 ff.). Himself a Swabian, Hesse writes of the conquest of the empirical ego in its theological context in a letter dated Jan. 1933: 'giving oneself away, or, as the German mystics once called it, de-becoming' (*Briefe*, p. 102).

10. *Die Unschuld des Werdens*, Leipzig, 1931, II, 446.

11. An account of the evolution of the monologic form in Hesse's writings is given in my dissertation, *Hermann Hesse as Humanist* (Diss. D. Phil., Oxford, 1954).

12. *Briefe*, p. 170.

13. *Noten und Abhandlungen zum West-Östlichen Diwan*, Jubiläums-Ausgabe, V, 247-8.

14. *Briefe*, p. 73.

p. 258, TWO MOUNTAIN SCENES IN NOVALIS

1. cf. B. A. Sørensen, *Symbol und Symbolismus in den ästhetischen Theorien des 18. Jahrhunderts und der deutschen Romantik*, Copenhagen, Munksgaard, 1963, pp. 201-3. The Novalis ed. cit. is Novalis, *Schriften, Erster Band: Das dichterische Werk*, ed. Paul Kluckhohn and Richard Samuel, Stuttgart, W. Kohlhammer Verlag, 1960; extracts to which reference is made are pp. 290-1 and 196-7 respectively.

2. The colour details appear with variants in the original oriental symbolism of Kw'en Lun and Meru, also in Kalmuck folklore of Meru (U. Holmberg, *Finno-Ugrian, Siberian Mythology*, Boston, Marshall Jones Co., 1927, pp. 346-7: see also note 4, below). On Atlantis in the *Timaeus*: J. A. Stewart, *The Myths of Plato* (1904), London, Centaur Press, 1960, pp. 410 ff.

3. H. Zimmer, *Myths and Symbols in Indian Art and Civilization*, New York, Pantheon Books, 1946, p. 52.

4. A. K. Coomaraswamy, *Myths of the Hindus and Buddhists*, London, Harrap, 1916, pp. 395-6. On the central and south-eastern Asiatic elaboration, see U. Holmberg, op. cit., pp. 346-7: 'Round Sumeru there are seven circular golden mountain chains, divided from this and from each other by seven seas. Naturally these seas are also ring-shaped . . . Sumeru itself is shaped like a pyramid slightly broken off at the top . . . The sides of the pyramid facing the different points of the compass glow with different colours. The southern side is blue, the western red, the northern yellow, and the eastern white. These different colours are said to come from the jewel or metal coverings on the different sides . . . These four colours are reflected in the parts of the world facing them, and for this reason the south is called the blue, the west the red, the north the yellow, and the east the white point of the compass.' F. D. K. Bosch (*The Golden Germ*, 'sGravenhage, Mouton & Co., 1960, pp. 95 ff.), gives further details: Meru as macrocosmic version of the Lotus.

5. Holmberg, *Mythology*, pp. 341 ff.

6. M. Eliade's *The Sacred and the Profane*, New York, Harper (Torchbooks) 1961, discusses the Sumerian and subsequent sacred mountains in terms of a religious conception of non-homologous space, which he formulates as follows: (a) a sacred place constitutes a break in the homogeneity of space; (b) this break is symbolized by an opening by which passage from one cosmic region to another is made possible (from heaven to earth and vice versa; from earth to the underworld); (c) communication with heaven is expressed by one or another of certain images, all of which refer to the *axis mundi*, pillar (cf. the *universalis columna*), ladder (cf. Jacob's ladder), mountain, tree, vine, etc.; (d) around the cosmic axis lies the world (=our world), hence the axis is located 'in the middle', at the 'navel of the earth'; it is the 'Center of the World' (p. 37). Other versions of the axis: Gerizim, Golgotha.

7. S. N. Kramer, *History Begins at Sumer*, New York, Doubleday (Anchor Books), 1950, p. 23. The Abzu is the 'watery abyss', dwelling of Enki, Lord of Wisdom; to him Inanna, queen of heaven, goes to acquire goods for the city of Erech; S. N. Kramer, *Sumerian Mythology*, New York, Harper (Torchbooks), 1961, pp. 64 ff.

8. Leonard Woolley, *Excavations at Ur*, London, Faber and Faber, 1954, p. 133.

9. M. Eliade, *Images et Symboles*, Paris, Gallimard, 1952, pp. 53 ff.; also *The Sacred and the Profane*, pp. 40 ff. Dur-an-ki, the name used for the Nippur sanctuary, and others later, means 'Link between Heaven and Earth'. See also H. Frankfort, *The Birth of Civilization in the Near East*, New York, Doubleday (Anchor Books), n.d., pp. 56 ff.

10. On the disc notion, see Thorkild Jacobsen's contribution, 'Mesopo-

tamia', to H. Frankfort (ed.), *Before Philosophy*, Harmondsworth, Penguin, 1949, p. 186 (published by University of Chicago Press, 1946, under the title *The Intellectual Adventure of Ancient Man*).

11. J. B. Pritchard (ed.), *Ancient Near Eastern Texts*, Princeton, Princeton University Press, 1955, 2nd ed., p. 88.

12. ibid., p. 118.

13. Kramer, *Sumerian Mythology*, p. 76.

14. cf. J. B. Pritchard, op. cit., p. 436.

15. B. Meissner, *Babylonien und Assyrien*, Heidelberg, Carl Winter Verlag, 1920, II, chap. 15, with diagram, p. 109.

16. A. Jeremias, *Handbuch der orientalischen Geisteskultur*, Berlin-Leipzig, J. C. Hinrich, 1929, 2nd ed., pp. 130 ff. H. Frankfort, *Cylinder Seals: A Documentary Essay on the Art and Religion of the Ancient Near East*, London, 1939, Plate xix (a), described pp. 105 ff., also shows the connection between mountain and fertility. Ea, the water god, is depicted officiating at the liberation of the sun god, Shamash, from a mountain grave. Sargonid seals, c. 2500 B.C., depict Ishtar at the mountain grave of Tammuz (ibid., pp. 116 ff.). The motif survives into the First Babylonian Dynasty, c. 2000-1700 B.C. Sacral, cereal and social levels of the symbol are related by Frankfort in his *The Birth of Civilization* (see note 9), p. 57: 'The vivifying rain is also brought from the mountain by the weather god. Thus the mountain is essentially the mysterious sphere of activity of the superhuman powers. The Sumerians created the conditions under which communication with the gods became possible when they erected the artificial mountains for their temples. In doing so they also strengthened their political cohesion.'

17. Kramer, *History Begins at Sumer*, p. 88. The parallelism with Parnassus may be no coincidence. Parnassus is not only the classical Greek earth-navel; it is also said to be two-peaked (as opposed to many-peaked). The epithet was adopted by numerous authors of the Renaissance and after, e.g., Spenser, 'Virgil's Gnat', st. 3: 'mount Parnasse . . ./Doth his broad forehead like two horns divide'. Euripides, *Phoenissae*, 270 ff., tells that the supposed two peaks were shared by the brothers Dionysus and Apollo; Nonnos and Lucan repeat this. It is suggested in Pauly-Wissowa, *Real-Encyclopädie der classischen Altertumswissenschaft* (Waldsee-Stuttgart, 1949), XVIII, 4 (article by Johanna Schmidt), that the 'shining' of the supposed two peaks, as described in classical authors, might indicate cult worship there—torchlight and sacrificial fires for Apollo and Artemis on one peak, for Dionysus and Semele on the other, unless this attribution was a transference to the mountain itself of the pediment imagery in the Temple of Apollo at Delphi (though Euripides, *Bacchae*, lines 306 ff., says: 'you shall see himself [=Dionysus] above the Delphic rocks, crossing the upland between the two peaks'). E. R. Dodds (in his Clarendon edition of the *Bacchae*, 1944, p. 105) subscribes to the view that the two summits

were the Phaedriades rocks above Delphi (making Dionysus' hierodrome the Livadi plateau). The question remains: Parnassus has not got two *peaks*, properly speaking. My rash guess is that the conception of a sacred two-peaked mountain could have been transmitted, via Crete, from Syria or elsewhere: Parnassus was said to have two peaks because as a sacred mountain at the navel of the earth it *had* to have two peaks, regardless of actual topography. A Minoan signet ring, c. 1500 B.C. (*Annual of the British School of Athens*, VII, 29, fig. 9 [1900-01]), reproduced and discussed in J. E. Harrison's article 'Mountain-Mother', in Hastings, *Encyclopedia of Religion and Ethics*, shows the Mountain-Mother standing on a single peak, flanked by lions and faced by an ecstatic male worshipper; H. T. Bossert, *The Art of Ancient Crete*, London, A. Zwemmer, 1937, pl. 503, reproduces a small (13.7 cm.) north Syrian ivory relief from Minet el-Beida showing the goddess with corn sheaves in her hands standing on two peaks between goats.

18. Discussed in A. Wensinck, *The Ideas of the Western Semites Concerning the Navel of the Earth*, Amsterdam, J. Müller, 1916, pp. 5 ff. For Christian ideas about the earth-navel, see C. R. Beazley, *The Dawn of Modern Geography*, Oxford, Oxford University Press, 1897-1906, I, pp. 338 ff.

19. F. Spiegel, *Erânische Alterthumskunde* (Leipzig, 1871-8), I, 191-2. The original of this conception is probably the Sumerian sanctuary Dur-an-ki, Link between Heaven and Earth. Spiegel, *Avesta* (Leipzig, 1852), II, 37-8, n. 4, comments on the etymology of Alburj: 'It is also notable that the name Burj is preceded by the Semitic *Ar* . . . Mountain, not by the Iranian *gairi*. Perhaps the idea came into Iran from Semitic sources.'

20. Wensinck, *Ideas of the Western Semites*, pp. 12 ff., also discusses the conjunction of navel, mountain (-top) and sanctuary. The sacred symbolic mountain can be said to 'start' at its highest point; here the sanctuary (or Paradise) is located, since at this primal point the cosmogenesis begins. The Samaritans believed that Gerizim was never submerged by the Deluge: 'The sanctuary is the type and representation of Cosmos and of Paradise and as such a power diametrically opposed to Chaos; when the Semites maintain that the sanctuary was not reached by the Deluge, this is not only due to opinion that the sanctuary is the highest place in the world, but also to the conviction that Chaos cannot gain a complete victory over Cosmos; for behind the latter is the creative power of the supreme being' (ibid., pp. 15-6). cf. George Sandys, reporting on the pyramids in 1615: 'The name is derived from a flame of fire, in regard to their shape, broad below, and sharpe above, like a pointed Diamond. By such the ancient did express the originall of things, and that formlesse forme-taking substance. For as a pyramis beginning at a point, and the principall height by little and little dilateth into all parts: so Nature proceeding from one undevidable fountaine (even God the sovereigne Essence) receiveth diversitie of forms; effused into several kinds and multitudes of figures: uniting all in the

supreme head, from whence all excellencies issue' (*A Relation of a Journey Begun An.Dom. 1610*, London, 1615; 4th ed. 1637, p. 127). On the relevant Pythagorean cosmogonic theory, see F. M. Cornford, *Plato and Parmenides*, London, Kegan Paul, 1939, e.g. p. 21: 'Cosmogony would thus begin with formation of the first solid, probably a pyramid, the fiery seed from which the world is to grow.'

21. Isidore, and the writers who locate Paradise on an island, followed the Vulgate's *Genesis* translation *ad orientem*, not *a principio*, as location of Paradise. See C. Stornajolo, *Le Miniature della topografia cristiana di Cosma Indicopleuste*, Milan, 1908, p. 26. Remoteness rather than altitude was often a criterion for the Paradise location, once the earlier mountain symbolism had become obscure, and with the advance of empirical topography. For a useful synopsis of late-classical and patristic views, see H. R. Patch, *The Other World* (Cambridge, Mass., Harvard University Press, 1950), chaps. 1 and 5. Isidore himself, in *Etymologiae*, Bk. XIV, chap. III, describes Paradise as a *locus amoenus*, but does not explicitly consign it to a mountaintop. In René Daumal's marvel story *Mount Analogue* (c. 1944; published 1953; English translation by Roger Shattuck, London, Vincent Stuart, 1959), the mountain is itself an island (like Atlantis in the *Timaeus*). Here there is an ingenious transference of the old solar gate symbolism into a pataphysical frame of reference: the sun, at the proper moment, penetrates and opens the 'shell of curvature' with which the island-mountain surrounds itself.

22. *The Book of the Cave of Treasures*, ed. E. A. W. Budge (London, 1927), this was an early source of the Alexander epic versions of paradise journeys. See Patch, *The Other World*, 'Journeys to Paradise'; also G. Cary, *The Medieval Alexander*, Cambridge, Cambridge University Press, 1956.

23. L. Ringbom, *Paradisus Terrestris. Myt, Bild och Verklighet*, Helsinki, Acta Societatis Scientiarum Fennicae, 1958, Plate 8, from the *Très Riches Heures du Duc de Berri* (c. 1410), probably shows a paradise-mountain scene (not in Ringbom) structurally akin to Iranian versions, though the iconography is commonly interpreted otherwise.

24. Patch, *The Other World*, pp. 148 ff.: 'By the twelfth century . . . the idea of the Earthly Paradise was fairly well established in many respects: it is located in the east, it is cut off from the rest of the world by its high location, or its ocean barrier, or perhaps by a fiery wall, its features are the familiar ones in Genesis described with almost a traditional form and vocabulary' (though, it should be noted, Genesis contains no *explicit* details about a mountain).

25. M. H. Nicolson, *Mountain Gloom and Mountain Glory* (Ithaca, New York, Cornell University Press, 1959), traces in religious, imaginative and scientific writings from medieval times to the last quarter of the eighteenth century the gradual move away from mythological attitudes to mountains. She does not mention Blake and Hölderlin, in whom some characteristics

of the old attitudes are preserved.

26. Herman Melville, *Moby Dick*, World's Classics ed., Oxford, Oxford University Press, 1920, chap. XCIX, p. 513.

27. Edition cited, p. 127.

28. Patch, *The Other World*, pp. 112-3.

29. ibid., pp. 120-1.

30. R. Guénon, *Symboles fondamentaux de la science sacrée*, Paris, Gallimard, 1962, pp. 218-26 and 261-5 (in the chapters on 'Symbolisme de la forme cosmique' and 'Symbolisme constructif')' See also appendix 3 on the Muslim synthesis of mountain and name symbolism, pp. 462-8.

31. R. Bechstein (ed.), *Tristan*, Leipzig, 1923, fourth edition, XXVII, 16697.

32. *Sidonius: Poems and Letters, with an English Translation*, ed. W. B. Anderson, Loeb Library, I, pp. 201 ff.; Patch, *The Other World*, p. 177.

33. E. A. W. Budge (ed.), *The Book of the Cave Treasures*, pp. 68-9.

34. L. Bechstein's collection of Thuringian legends, *Der Sagenschatz und die Sagenkreise des Thüringerlandes*, Hildburghausen, 1835-8, contains several tales about people wandering into mountains. Novalis could have known such legends from oral tradition (he was a Thuringian). Bechstein's versions have been styled by the collector, who may himself have been influenced by Novalis. The thirteenth-century Thuringian *Wartburgkrieg* contains a section concerning the cavern of King Arthur; see Simrock (ed.), 1963, 83-4; also F. Mess, *Heinrich von Ofterdingen: Wartburgkrieg und verwandte Dichtungen*, Weimar, H. Böhlau, 1963, pp. 162-3.

35. The Berlin text differs: 'une dame daleç celle montagne'=beyond this mountain. The 'yn' of the Turin text might also mean 'on', even though it would have to be 'su' to have this sense after about the mid-fourteenth century. The Padua text has 'deça de la montagne'=on this side of the mountain (see lines 6672-3 in E. Stengel's text, 'Huon d'Auvergnes Keuschheitsprobe', in *Mélanges de philologie romaine et d'histoire littéraire offerts à M. Maurice Wilmotte*, Paris, 1910, pp. 687-713). Other related questions are discussed in W. Pabst, *Venus und die missverstandene Dido* (Hamburg, Kommissionsverlag Cram, De Gruyter & Co., 1955), which names Johannes de Altavilla's eleventh-century Latin poem *Architrenius* as the earliest traceable literary source for the mountaintop dwelling of Venus in post-classical literature.

36. A. Falkenstein, *Sumerische Götterlieder*, Heidelberg, C. Winter Verlag, 1959, I.

37. Philip Sherrard, *The Marble Threshing Floor*, London, Vallentine, Mitchell, 1956, p. 242.

38. ibid., p. 241.

39. Philip Wheelwright, *The Burning Fountain*, Bloomington, Indiana University Press, 1954, p. 99.

40. *The Collected Poems of Wallace Stevens*, London, Faber, 1955,

pp. 372-8.
 41. cf. Wheelwright, *The Burning Fountain*, pp. 93 ff., on 'Metaphoric Imagining'.